ART AS EXPERIENCE

Books by John Dewey

THE QUEST FOR CERTAINTY
INDIVIDUALISM OLD AND NEW
PHILOSOPHY AND CIVILIZATION
ART AS EXPERIENCE

Art as Experience

by John Dewey

A Perigee Book

THE BERKLEY PUBLISHING GROUP
Published by the Penguin Group
Penguin Group (USA) Inc.
375 Hudson Street, New York, New York 10014, USA
Penguin Group (Canada), 10 Alcorn Avenue, Toronto, Ontario M4V 3B2, Canada
(a division of Pearson Penguin Canada Inc.)
Penguin Books Ltd., 80 Strand, London WC2R 0RL, England
Penguin Group Ireland, 25 St. Stephen's Green, Dublin 2, Ireland (a division of Penguin Books Ltd.)
Penguin Group (Australia), 250 Camberwell Road, Camberwell, Victoria 3124, Australia
(a division of Pearson Australia Group Pty. Ltd.)
Penguin Books India Pvt. Ltd., 11 Community Centre, Panchsheel Park, New Delhi—110 017, India
Penguin Group (NZ), Cnr. Airborne and Rosedale Roads, Albany, Auckland 1310, New Zealand
(a division of Pearson New Zealand Ltd.)
Penguin Books (South Africa) (Pty.) Ltd., 24 Sturdee Avenue, Rosebank, Johannesburg 2196,
South Africa

Penguin Books Ltd., Registered Offices: 80 Strand, London WC2R 0RL, England

ISBN: 0-399-53197-1

PRINTING HISTORY
First Perigee printing: 1980
Perigee trade paperback edition / August 2005

PERIGEE is a registered trademark of Penguin Group (USA) Inc.
The "P" design is a trademark belonging to Penguin Group (USA) Inc.

Library of Congress Catalog Card Number: 58-59756

PRINTED IN THE UNITED STATES OF AMERICA

10 9 8 7 6 5 4 3 2 1

TO ALBERT C. BARNES
IN GRATITUDE

IN the winter and spring of 1931, I was invited to give a series of ten lectures at Harvard University. The subject chosen was the Philosophy of Art; the lectures are the origin of the present volume. The Lectureship was founded in memory of William James and I esteem it a great honor to have this book associated even indirectly with his distinguished name. It is a pleasure, also, to recall, in connection with the lectures, the unvarying kindness and hospitality of my colleagues in the department of philosophy at Harvard.

I am somewhat embarrassed in an effort to acknowledge indebtedness to other writers on the subject. Some aspects of it may be inferred from authors mentioned or quoted in the text. I have read on the subject for many years, however, more or less widely in English literature, somewhat less in French and still less in German, and I have absorbed much from sources which I cannot now directly recall. Moreover, my obligations to a number of writers

are much greater than might be gathered from allusions to them in the volume itself.

My indebtedness to those who have helped me directly can be more easily stated. Dr. Joseph Ratner gave me a number of valuable references. Dr. Meyer Schapiro was good enough to read the twelfth and thirteenth chapters and to make suggestions which I have freely adopted. Irwin Edman read a large part of the book in manuscript and I owe much to his suggestions and criticism. Sidney Hook read many of the chapters, and their present form is largely the result of discussions with him; this statement is especially true of the chapters on criticism and the last chapter. My greatest indebtedness is to Dr. A. C. Barnes. The chapters have been gone over one by one with him, and yet what I owe to his comments and suggestions on this account is but a small measure of my debt. I have had the benefit of conversations with him through a period of years, many of which occurred in the presence of the unrivaled collection of pictures he has assembled. The influence of these conversations, together with that of his books, has been a chief factor in shaping my own thinking about the philosophy of esthetics. Whatever is sound in this volume is due more than I can say to the great educational work carried on in the Barnes Foundation. That work is of a pioneer quality comparable to the best that has been done in any field during the present generation, that of science not excepted. I should be glad to think of this volume as one phase of the widespread influence the Foundation is exercising.

I am indebted to the Barnes Foundation for permission to reproduce a number of illustrations and to Barbara and Willard Morgan for the photographs from which the reproductions were made.

J. D.

Contents

	Preface	vii
1	The Live Creature	1
2	The Live Creature and "Etherial Things"	20
3	Having an Experience	36
4	The Act of Expression	60
5	The Expressive Object	85
6	Substance and Form	110
7	The Natural History of Form	139
8	The Organization of Energies	168
9	The Common Substance of the Arts	194
10	The Varied Substance of the Arts	222
11	The Human Contribution	255
12	The Challenge to Philosophy	283
13	Criticism and Perception	310
14	Art and Civilization	339
	Index	365

ART AS EXPERIENCE

1 The Live Creature

BY one of the ironic perversities that often attend the course of affairs, the existence of the works of art upon which formation of an esthetic theory depends has become an obstruction to theory about them. For one reason, these works are products that exist externally and physically. In common conception, the work of art is often identified with the building, book, painting, or statue in its existence apart from human experience. Since the actual work of art is what the product does with and in experience, the result is not favorable to understanding. In addition, the very perfection of some of these products, the prestige they possess because of a long history of unquestioned admiration, creates conventions that get in the way of fresh insight. When an art product once attains classic status, it somehow becomes isolated from the human conditions under which it was brought into being and from the human consequences it engenders in actual life-experience.

When artistic objects are separated from both conditions of origin and operation in experience, a wall is built around them that renders almost opaque their general significance, with which esthetic theory deals. Art is remitted to a separate realm, where it is cut off from that association with the materials and aims of every other form of human effort, undergoing, and achievement. A primary task is thus imposed upon one who undertakes to write upon the philosophy of the fine arts. This task is to restore continuity between the refined and intensified forms of experience that are works of art and the everyday events, doings, and sufferings that are universally recognized to constitute experience. Mountain peaks do not float unsupported; they do not even just rest upon the earth. They *are* the earth in one of its manifest operations. It is the business of those who are concerned with the theory of the earth, geographers and geologists, to make this fact evident in its various implications. The theorist who would deal philosophically with fine art has a like task to accomplish.

If one is willing to grant this position, even if only by way of temporary experiment, he will see that there follows a conclusion at first sight surprising. In order to understand the meaning of artistic products, we have to forget them for a time, to turn aside from them and have recourse to the ordinary forces and conditions of experience that we do not usually regard as esthetic. We must arrive at the theory of art by means of a detour. For theory is concerned with understanding, insight, not without exclamations of admiration, and stimulation of that emotional outburst often called appreciation. It is quite possible to enjoy flowers in their colored form and delicate fragrance without knowing anything about plants theoretically. But if one sets out to *understand* the flowering of plants, he is committed to finding out something about the interactions of soil, air, water and sunlight that condition the growth of plants.

By common consent, the Parthenon is a great work of art. Yet it has esthetic standing only as the work becomes an experience for a human being. And, if one is to go beyond personal enjoyment into the formation of a theory about that large republic of art of which the building is one member, one has to be willing at some

point in his reflections to turn from it to the bustling, arguing, acutely sensitive Athenian citizens, with civic sense identified with a civic religion, of whose experience the temple was an expression, and who built it not as a work of art but as a civic commemoration. The turning to them is as human beings who had needs that were a demand for the building and that were carried to fulfillment in it; it is not an examination such as might be carried on by a sociologist in search for material relevant to his purpose. The one who sets out to theorize about the esthetic experience embodied in the Parthenon must realize in thought what the people into whose lives it entered had in common, as creators and as those who were satisfied with it, with people in our own homes and on our own streets.

In order to *understand* the esthetic in its ultimate and approved forms, one must begin with it in the raw; in the events and scenes that hold the attentive eye and ear of man, arousing his interest and affording him enjoyment as he looks and listens: the sights that hold the crowd—the fire-engine rushing by; the machines excavating enormous holes in the earth; the human-fly climbing the steeple-side; the men perched high in air on girders, throwing and catching red-hot bolts. The sources of art in human experience will be learned by him who sees how the tense grace of the ball-player infects the onlooking crowd; who notes the delight of the housewife in tending her plants, and the intent interest of her goodman in tending the patch of green in front of the house; the zest of the spectator in poking the wood burning on the hearth and in watching the darting flames and crumbling coals. These people, if questioned as to the reason for their actions, would doubtless return reasonable answers. The man who poked the sticks of burning wood would say he did it to make the fire burn better; but he is none the less fascinated by the colorful drama of change enacted before his eyes and imaginatively partakes in it. He does not remain a cold spectator. What Coleridge said of the reader of poetry is true in its way of all who are happily absorbed in their activities of mind and body: "The reader should be carried forward, not merely or chiefly by the mechanical impulse of curiosity, not by a restless desire to arrive

at the final solution, but by the pleasurable activity of the journey itself."

The intelligent mechanic engaged in his job, interested in doing well and finding satisfaction in his handiwork, caring for his materials and tools with genuine affection, is artistically engaged. The difference between such a worker and the inept and careless bungler is as great in the shop as it is in the studio. Oftentimes the product may not appeal to the esthetic sense of those who use the product. The fault, however, is oftentimes not so much with the worker as with the conditions of the market for which his product is designed. Were conditions and opportunities different, things as significant to the eye as those produced by earlier craftsmen would be made.

So extensive and subtly pervasive are the ideas that set Art upon a remote pedestal, that many a person would be repelled rather than pleased if told that he enjoyed his casual recreations, in part at least, because of their esthetic quality. The arts which today have most vitality for the average person are things he does not take to be arts: for instance, the movie, jazzed music, the comic strip, and, too frequently, newspaper accounts of love-nests, murders, and exploits of bandits. For, when what he knows as art is relegated to the museum and gallery, the unconquerable impulse towards experiences enjoyable in themselves finds such outlet as the daily environment provides. Many a person who protests against the museum conception of art, still shares the fallacy from which that conception springs. For the popular notion comes from a separation of art from the objects and scenes of ordinary experience that many theorists and critics pride themselves upon holding and even elaborating. The times when select and distinguished objects are closely connected with the products of usual vocations are the times when appreciation of the former is most rife and most keen. When, because of their remoteness, the objects acknowledged by the cultivated to be works of fine art seem anemic to the mass of people, esthetic hunger is likely to seek the cheap and the vulgar.

The factors that have glorified fine art by setting it upon a far-off pedestal did not arise within the realm of art nor is their influ-

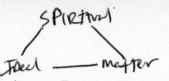

ence confined to the arts. For many persons an aura of mingled awe and unreality encompasses the "spiritual" and the "ideal" while "matter" has become by contrast a term of depreciation, something to be explained away or apologized for. The forces at work are those that have removed religion as well as fine art from the scope of the common or community life. The forces have historically produced so many of the dislocations and divisions of modern life and thought that art could not escape their influence. We do not have to travel to the ends of the earth nor return many millennia in time to find peoples for whom everything that intensifies the sense of immediate living is an object of intense admiration. Bodily scarification, waving feathers, gaudy robes, shining ornaments of gold and silver, of emerald and jade, formed the contents of esthetic arts, and, presumably, without the vulgarity of class exhibitionism that attends their analogues today. Domestic utensils, furnishings of tent and house, rugs, mats, jars, pots, bows, spears, were wrought with such delighted care that today we hunt them out and give them places of honor in our art museums. Yet in their own time and place, such things were enhancements of the processes of everyday life. Instead of being elevated to a niche apart, they belonged to display of prowess, the manifestation of group and clan membership, worship of gods, feasting and fasting, fighting, hunting, and all the rhythmic crises that punctuate the stream of living.

Dancing and pantomime, the sources of the art of the theater, flourished as part of religious rites and celebrations. Musical art abounded in the fingering of the stretched string, the beating of the taut skin, the blowing with reeds. Even in the caves, human habitations were adorned with colored pictures that kept alive to the senses experiences with the animals that were so closely bound with the lives of humans. Structures that housed their gods and the instrumentalities that facilitated commerce with the higher powers were wrought with especial fineness. But the arts of the drama, music, painting, and architecture thus exemplified had no peculiar connection with theaters, galleries, museums. They were part of the significant life of an organized community.

The collective life that was manifested in war, worship, the fo-

rum, knew no division between what was characteristic of these places and operations, and the arts that brought color, grace, and dignity, into them. Painting and sculpture were organically one with architecture, as that was one with the social purpose that buildings served. Music and song were intimate parts of the rites and ceremonies in which the meaning of group life was consummated. Drama was a vital reënactment of the legends and history of group life. Not even in Athens can such arts be torn loose from this setting in direct experience and yet retain their significant character. Athletic sports, as well as drama, celebrated and enforced traditions of race and group, instructing the people, commemorating glories, and strengthening their civic pride.

Under such conditions, it is not surprising that the Athenian Greeks, when they came to reflect upon art, formed the idea that it is an act of reproduction, or imitation. There are many objections to this conception. But the vogue of the theory is testimony to the close connection of the fine arts with daily life; the idea would not have occurred to any one had art been remote from the interests of life. For the doctrine did not signify that art was a literal copying of objects, but that it reflected the emotions and ideas that are associated with the chief institutions of social life. Plato felt this connection so strongly that it led him to his idea of the necessity of censorship of poets, dramatists, and musicians. Perhaps he exaggerated when he said that a change from the Doric to the Lydian mode in music would be the sure precursor of civic degeneration. But no contemporary would have doubted that music was an integral part of the ethos and the institutions of the community. The idea of ‛art for art's sake’ would not have been even understood.

There must then be historic reasons for the rise of the compartmental conception of fine art. Our present museums and galleries to which works of fine art are removed and stored illustrate some of the causes that have operated to segregate art instead of finding it an attendant of temple, forum, and other forms of associated life. An instructive history of modern art could be written in terms of the formation of the distinctively modern institutions of museum and exhibition gallery. I may point to a few outstanding facts. Most European museums are, among other things, memori-

als of the rise of nationalism and imperialism. Every capital must have its own museum of painting, sculpture, etc., devoted in part to exhibiting the greatness of its artistic past, and, in other part, to exhibiting the loot gathered by its monarchs in conquest of other nations; for instance, the accumulations of the spoils of Napoleon that are in the Louvre. They testify to the connection between the modern segregation of art and nationalism and militarism. Doubtless this connection has served at times a useful purpose, as in the case of Japan, who, when she was in the process of westernization, saved much of her art treasures by nationalizing the temples that contained them.

The growth of capitalism has been a powerful influence in the development of the museum as the proper home for works of art, and in the promotion of the idea that they are apart from the common life. The _nouveaux riches_, who are an important byproduct of the capitalist system, have felt especially bound to surround themselves with works of fine art which, being rare, are also costly. Generally speaking, the typical collector is the typical capitalist. For evidence of good standing in the realm of higher culture, he amasses paintings, statuary, and artistic _bijoux_, as his stocks and bonds certify to his standing in the economic world.

Not merely individuals, but communities and nations, put their cultural good taste in evidence by building opera houses, galleries, and museums. These show that a community is not wholly absorbed in material wealth, because it is willing to spend its gains in patronage of art. It erects these buildings and collects their contents as it now builds a cathedral. These things reflect and establish superior cultural status, while their segregation from the common life reflects the fact that they are not part of a native and spontaneous culture. They are a kind of counterpart of a holier-than-thou attitude, exhibited not toward persons as such but toward the interests and occupations that absorb most of the community's time and energy.

Modern industry and commerce have an international scope. The contents of galleries and museums testify to the growth of economic cosmopolitanism. The mobility of trade and of populations, due to the economic system, has weakened or destroyed the

connection between works of art and the *genius loci* of which they were once the natural expression. As works of art have lost their indigenous status, they have acquired a new one—that of being specimens of fine art and nothing else. Moreover, works of art are now produced, like other articles, for sale in the market. Economic patronage by wealthy and powerful individuals has at many times played a part in the encouragement of artistic production. Probably many a savage tribe had its Maecenas. But now even that much of intimate social connection is lost in the impersonality of a world market. Objects that were in the past valid and significant because of their place in the life of a community now function in isolation from the conditions of their origin. By that fact they are also set apart from common experience, and serve as insignia of taste and certificates of special culture.

Because of changes in industrial conditions the artist has been pushed to one side from the main streams of active interest. Industry has been mechanized and an artist cannot work mechanically for mass production. He is less integrated than formerly in the normal flow of social services. A peculiar esthetic "individualism" results. Artists find it incumbent upon them to betake themselves to their work as an isolated means of "self-expression." In order not to cater to the trend of economic forces, they often feel obliged to exaggerate their separateness to the point of eccentricity. Consequently artistic products take on to a still greater degree the air of something independent and esoteric.

Put the action of all such forces together, and the conditions that create the gulf which exists generally between producer and consumer in modern society operate to create also a chasm between ordinary and esthetic experience. Finally we have, as the record of this chasm, accepted as if it were normal, the philosophies of art that locate it in a region inhabited by no other creature, and that emphasize beyond all reason the merely contemplative character of the esthetic. Confusion of values enters in to accentuate the separation. Adventitious matters, like the pleasure of collecting, of exhibiting, of ownership and display, simulate esthetic values. Criticism is affected. There is much applause for the wonders of appreciation and the glories of the transcendent beauty of

art indulged in without much regard to capacity for esthetic perception in the concrete.

My purpose, however, is not to engage in an economic interpretation of the history of the arts, much less to argue that economic conditions are either invariably or directly relevant to perception and enjoyment, or even to interpretation of individual works of art. It is to indicate that *theories* which isolate art and its appreciation by placing them in a realm of their own, disconnected from other modes of experiencing, are not inherent in the subject-matter but arise because of specifiable extraneous conditions. Embedded as they are in institutions and in habits of life, these conditions operate effectively because they work so unconsciously. Then the theorist assumes they are embedded in the nature of things. Nevertheless, the influence of these conditions is not confined to theory. As I have already indicated, it deeply affects the practice of living, driving away esthetic perceptions that are necessary ingredients of happiness, or reducing them to the level of compensating transient pleasurable excitations.

Even to readers who are adversely inclined to what has been said, the implications of the statements that have been made may be useful in defining the nature of the problem: that of recovering the continuity of esthetic experience with normal processes of living. The understanding of art and of its rôle in civilization is not furthered by setting out with eulogies of it nor by occupying ourselves exclusively at the outset with great works of art recognized as such. The comprehension which theory essays will be arrived at by a detour; by going back to experience of the common or mill run of things to discover the esthetic quality such experience possesses. Theory can start with and from acknowledged works of art only when the esthetic is already compartmentalized, or only when works of art are set in a niche apart instead of being celebrations, recognized as such, of the things of ordinary experience. Even a crude experience, if authentically an experience, is more fit to give a clue to the intrinsic nature of esthetic experience than is an object already set apart from any other mode of experience. Following this clue we can discover how the work of art develops and accentuates what is characteristically valuable in things of

everyday enjoyment. The art product will then be seen to issue from the latter, when the full meaning of ordinary experience is expressed, as dyes come out of coal tar products when they receive special treatment.

Many theories about art already exist. If there is justification for proposing yet another philosophy of the esthetic, it must be found in a new mode of approach. Combinations and permutations among existing theories can easily be brought forth by those so inclined. But, to my mind, the trouble with existing theories is that they start from a ready-made compartmentalization, or from a conception of art that "spiritualizes" it out of connection with the objects of concrete experience. The alternative, however, to such spiritualization is not a degrading and Philistinish materialization of works of fine art, but a conception that discloses the way in which these works idealize qualities found in common experience. Were works of art placed in a directly human context in popular esteem, they would have a much wider appeal than they can have when pigeon-hole theories of art win general acceptance.

A conception of fine art that sets out from its connection with discovered qualities of ordinary experience will be able to indicate the factors and forces that favor the normal development of common human activities into matters of artistic value. It will also be able to point out those conditions that arrest its normal growth. Writers on esthetic theory often raise the question of whether esthetic philosophy can aid in cultivation of esthetic appreciation. The question is a branch of the general theory of criticism, which, it seems to me, fails to accomplish its full office if it does not indicate what to look for and what to find in concrete esthetic objects. But, in any case, it is safe to say that a philosophy of art is sterilized unless it makes us aware of the function of art in relation to other modes of experience, and unless it indicates why this function is so inadequately realized, and unless it suggests the conditions under which the office would be successfully performed.

The comparison of the emergence of works of art out of ordinary experiences to the refining of raw materials into valuable products may seem to some unworthy, if not an actual attempt to reduce works of art to the status of articles manufactured for

commercial purposes. The point, however, is that no amount of ecstatic eulogy of finished works can of itself assist the understanding or the generation of such works. Flowers can be enjoyed without knowing about the interactions of soil, air, moisture, and seeds of which they are the result. But they cannot be *understood* without taking just these interactions into account—and theory is a matter of understanding. Theory is concerned with discovering the nature of the production of works of art and of their enjoyment in perception. How is it that the everyday making of things grows into that form of making which is genuinely artistic? How is it that our everyday enjoyment of scenes and situations develops into the peculiar satisfaction that attends the experience which is emphatically esthetic? These are the questions theory must answer. The answers cannot be found, unless we are willing to find the germs and roots in matters of experience that we do not currently regard as esthetic. Having discovered these active seeds, we may follow the course of their growth into the highest forms of finished and refined art.

It is a commonplace that we cannot direct, save accidentally, the growth and flowering of plants, however lovely and enjoyed, without understanding their causal conditions. It should be just a commonplace that esthetic understanding—as distinct from sheer personal enjoyment—must start with the soil, air, and light out of which things esthetically admirable arise. And these conditions are the conditions and factors that make an ordinary experience complete. The more we recognize this fact, the more we shall find ourselves faced with a problem rather than with a final solution. *If* artistic and esthetic quality is implicit in every normal experience, how shall we explain how and why it so generally fails to become explicit? Why is it that to multitudes art seems to be an importation into experience from a foreign country and the esthetic to be a synonym for something artificial?

We cannot answer these questions any more than we can trace the development of art out of everyday experience, unless we have a clear and coherent idea of what is meant when we say "normal ex-

perience." Fortunately, the road to arriving at such an idea is open and well marked. The nature of experience is determined by the essential conditions of life. While man is other than bird and beast, he shares basic vital functions with them and has to make the same basal adjustments if he is to continue the process of living. Having the same vital needs, man derives the means by which he breathes, moves, looks and listens, the very brain with which he coördinates his senses and his movements, from his animal forbears. The organs with which he maintains himself in being are not of himself alone, but by the grace of struggles and achievements of a long line of animal ancestry.

Fortunately a theory of the place of the esthetic in experience does not have to lose itself in minute details when it starts with experience in its elemental form. Broad outlines suffice. The first great consideration is that life goes on in an environment; not merely *in* it but because of it, through interaction with it. No creature lives merely under its skin; its subcutaneous organs are means of connection with what lies beyond its bodily frame, and to which, in order to live, it must adjust itself, by accommodation and defense but also by conquest. At every moment, the living creature is exposed to dangers from its surroundings, and at every moment, it must draw upon something in its surroundings to satisfy its needs. The career and destiny of a living being are bound up with its interchanges with its environment, not externally but in the most intimate way.

The growl of a dog crouching over his food, his howl in time of loss and loneliness, the wagging of his tail at the return of his human friend are expressions of the implication of a living creature in a natural medium which includes man along with the animal he has domesticated. Every need, say hunger for fresh air or food, is a lack that denotes at least a temporary absence of adequate adjustment with surroundings. But it is also a demand, a reaching out into the environment to make good the lack and to restore adjustment by building at least a temporary equilibrium. Life itself consists of phases in which the organism falls out of step with the march of surrounding things and then recovers unison with it—either through effort or by some happy chance. And, in a

growing life, the recovery is never mere return to a prior state, for it is enriched by the state of disparity and resistance through which it has successfully passed. If the gap between organism and environment is too wide, the creature dies. If its activity is not enhanced by the temporary alienation, it merely subsists. Life grows when a temporary falling out is a transition to a more extensive balance of the energies of the organism with those of the conditions under which it lives.

These biological commonplaces are something more than that; they reach to the roots of the esthetic in experience. The world is full of things that are indifferent and even hostile to life; the very processes by which life is maintained tend to throw it out of gear with its surroundings. Nevertheless, if life continues and if in continuing it expands, there is an overcoming of factors of opposition and conflict; there is a transformation of them into differentiated aspects of a higher powered and more significant life. The marvel of organic, of vital, adaptation through expansion (instead of by contraction and passive accommodation) actually takes place. Here in germ are balance and harmony attained through rhythm. Equilibrium comes about not mechanically and inertly but out of, and because of, tension.

There is in nature, even below the level of life, something more than mere flux and change. Form is arrived at whenever a stable, even though moving, equilibrium is reached. Changes interlock and sustain one another. Wherever there is this coherence there is endurance. Order is not imposed from without but is made out of the relations of harmonious interactions that energies bear to one another. Because it is active (not anything static because foreign to what goes on) order itself develops. It comes to include within its balanced movement a greater variety of changes.

Order cannot but be admirable in a world constantly threatened with disorder—in a world where living creatures can go on living only by taking advantage of whatever order exists about them, incorporating it into themselves. In a world like ours, every living creature that attains sensibility welcomes order with a response of harmonious feeling whenever it finds a congruous order about it.

For only when an organism shares in the ordered relations of its environment does it secure the stability essential to living. And when the participation comes after a phase of disruption and conflict, it bears within itself the germs of a consummation akin to the esthetic.

The rhythm of loss of integration with environment and recovery of union not only persists in man but becomes conscious with him; its conditions are material out of which he forms purposes. Emotion is the conscious sign of a break, actual or impending. The discord is the occasion that induces reflection. Desire for restoration of the union converts mere emotion into interest in objects as conditions of realization of harmony. With the realization, material of reflection is incorporated into objects as their meaning. Since the artist cares in a peculiar way for the phase of experience in which union is achieved, he does not shun moments of resistance and tension. He rather cultivates them, not for their own sake but because of their potentialities, bringing to living consciousness an experience that is unified and total. In contrast with the person whose purpose is esthetic, the scientific man is interested in problems, in situations wherein tension between the matter of observation and of thought is marked. Of course he cares for their resolution. But he does not rest in it; he passes on to another problem using an attained solution only as a stepping stone from which to set on foot further inquiries.

The difference between the esthetic and the intellectual is thus one of the place where emphasis falls in the constant rhythm that marks the interaction of the live creature with his surroundings. The ultimate matter of both emphases in experience is the same, as is also their general form. The odd notion that an artist does not think and a scientific inquirer does nothing else is the result of converting a difference of tempo and emphasis into a difference in kind. The thinker has his esthetic moment when his ideas cease to be mere ideas and become the corporate meanings of objects. The artist has his problems and thinks as he works. But his thought is more immediately embodied in the object. Because of the comparative remoteness of his end, the scientific worker operates with symbols, words and mathematical signs. The artist does his think-

ing in the very qualitative media he works in, and the terms lie so close to the object that he is producing that they merge directly into it.

The live animal does not have to project emotions into the objects experienced. Nature is kind and hateful, bland and morose, irritating and comforting, long before she is mathematically qualified or even a congeries of "secondary" qualities like colors and their shapes. Even such words as long and short, solid and hollow, still carry to all, but those who are intellectually specialized, a moral and emotional connotation. The dictionary will inform anyone who consults it that the early use of words like sweet and bitter was not to denote qualities of sense as such but to discriminate things as favorable and hostile. How could it be otherwise? Direct experience comes from nature and man interacting with each other. In this interaction, human energy gathers, is released, dammed up, frustrated and victorious. There are rhythmic beats of want and fulfillment, pulses of doing and being withheld from doing.

All interactions that effect stability and order in the whirling flux of change are rhythms. There is ebb and flow, systole and diastole: ordered change. The latter moves within bounds. To overpass the limits that are set is destruction and death, out of which, however, new rhythms are built up. The proportionate interception of changes establishes an order that is spatially, not merely temporally patterned: like the waves of the sea, the ripples of sand where waves have flowed back and forth, the fleecy and the black-bottomed cloud. Contrast of lack and fullness, of struggle and achievement, of adjustment after consummated irregularity, form the drama in which action, feeling, and meaning are one. The outcome is balance and counterbalance. These are not static nor mechanical. They express power that is intense because measured through overcoming resistance. Environing objects avail and counteravail.

There are two sorts of possible worlds in which esthetic experience would not occur. In a world of mere flux, change would not be cumulative; it would not move toward a close. Stability and rest would have no being. Equally is it true, however, that a world that

is finished, ended, would have no traits of suspense and crisis, and would offer no opportunity for resolution. Where everything is already complete, there is no fulfillment. We envisage with pleasure Nirvana and a uniform heavenly bliss only because they are projected upon the background of our present world of stress and conflict. Because the actual world, that in which we live, is a combination of movement and culmination, of breaks and re-unions, the experience of a living creature is capable of esthetic quality. The live being recurrently loses and reëstablishes equilibrium with his surroundings. The moment of passage from disturbance into harmony is that of intensest life. In a finished world, sleep and waking could not be distinguished. In one wholly perturbed, conditions could not even be struggled with. In a world made after the pattern of ours, moments of fulfillment punctuate experience with rhythmically enjoyed intervals.

Inner harmony is attained only when, by some means, terms are made with the environment. When it occurs on any other than an "objective" basis, it is illusory—in extreme cases to the point of insanity. Fortunately for variety in experience, terms are made in many ways—ways ultimately decided by selective interest. Pleasures may come about through chance contact and stimulation; such pleasures are not to be despised in a world full of pain. But happiness and delight are a different sort of thing. They come to be through a fulfillment that reaches to the depths of our being—one that is an adjustment of our whole being with the conditions of existence. In the process of living, attainment of a period of equilibrium is at the same time the initiation of a new relation to the environment, one that brings with it potency of new adjustments to be made through struggle. The time of consummation is also one of beginning anew. Any attempt to perpetuate beyond its term the enjoyment attending the time of fulfillment and harmony constitutes withdrawal from the world. Hence it marks the lowering and loss of vitality. But, through the phases of perturbation and conflict, there abides the deep-seated memory of an underlying harmony, the sense of which haunts life like the sense of being founded on a rock.

Most mortals are conscious that a split often occurs between

their present living and their past and future. Then the past hangs upon them as a burden; it invades the present with a sense of regret, of opportunities not used, and of consequences we wish undone. It rests upon the present as an oppression, instead of being a storehouse of resources by which to move confidently forward. But the live creature adopts its past; it can make friends with even its stupidities, using them as warnings that increase present wariness. Instead of trying to live upon whatever may have been achieved in the past, it uses past successes to inform the present. Every living experience owes its richness to what Santayana well calls "hushed reverberations."*

To the being fully alive, the future is not ominous but a promise; it surrounds the present as a halo. It consists of possibilities that are felt as a possession of what is now and here. In life that is truly life, everything overlaps and merges. But all too often we exist in apprehensions of what the future may bring, and are divided within ourselves. Even when not overanxious, we do not enjoy the present because we subordinate it to that which is absent. Because of the frequency of this abandonment of the present to the past and future, the happy periods of an experience that is now complete because it absorbs into itself memories of the past and anticipations of the future, come to constitute an esthetic ideal. Only when the past ceases to trouble and anticipations of the future are not perturbing is a being wholly united with his environment and therefore fully alive. Art celebrates with peculiar intensity the moments in which the past reënforces the present and in which the future is a quickening of what now is.

* "These familiar flowers, these well-remembered bird notes, this sky with its fitful brightness, these furrowed and grassy fields, each with a sort of personality given to it by the capricious hedge, such things as these are the mother tongue of our imagination, the language that is laden with all the subtle inextricable associations the fleeting hours of our childhood left behind them. Our delight in the sunshine on the deep-bladed grass today might be no more than the faint perception of wearied souls, if it were not for the sunshine and grass of far-off years, which still live in us and transform our perception into love." George Eliot in *The Mill on the Floss*.

To grasp the sources of esthetic experience it is, therefore, necessary to have recourse to animal life below the human scale. The activities of the fox, the dog, and the thrush may at least stand as reminders and symbols of that unity of experience which we so fractionize when work is labor, and thought withdraws us from the world. The live animal is fully present, all there, in all of its actions: in its wary glances, its sharp sniffings, its abrupt cocking of ears. All senses are equally on the *qui vive*. As you watch, you see motion merging into sense and sense into motion—constituting that animal grace so hard for man to rival. What the live creature retains from the past and what it expects from the future operate as directions in the present. The dog is never pedantic nor academic; for these things arise only when the past is severed in consciousness from the present and is set up as a model to copy or a storehouse upon which to draw. The past absorbed into the present carries on; it presses forward.

There is much in the life of the savage that is sodden. But, when the savage is most alive, he is most observant of the world about him and most taut with energy. As he watches what stirs about him, he, too, is stirred. His observation is both action in preparation and foresight of the future. He is as active through his whole being when he looks and listens as when he stalks his quarry or stealthily retreats from a foe. His senses are sentinels of immediate thought and outposts of action, and not, as they so often are with us, mere pathways along which material is gathered to be stored away for a delayed and remote possibility.

It is mere ignorance that leads then to the supposition that connection of art and esthetic perception with experience signifies a lowering of their significance and dignity. Experience in the degree in which it *is* experience is heightened vitality. Instead of signifying being shut up within one's own private feelings and sensations, it signifies active and alert commerce with the world; at its height it signifies complete interpenetration of self and the world of objects and events. Instead of signifying surrender to caprice and disorder, it affords our sole demonstration of a stability that is not stagnation but is rhythmic and developing. Because

experience is the fulfillment of an organism in its struggles and achievements in a world of things, it is art in germ. Even in its rudimentary forms, it contains the promise of that delightful perception which is esthetic experience.

2 The Live Creature and "Etherial Things"*

WHY is the attempt to connect the higher and ideal things of experience with basic vital roots so often regarded as betrayal of their nature and denial of their value? Why is there repulsion when the high achievements of fine art are brought into connection with common life, the life that we share with all living creatures? Why is life thought of as an affair of low appetite, or at its best a thing of gross sensation, and ready to sink from its best to the level of lust and harsh cruelty? A complete answer to the question would involve the writing of a history of morals that would set forth the conditions that have brought about contempt for the body, fear of the senses, and the opposition of flesh to spirit.

One aspect of this history is so relevant to our problem that it

*The Sun, the Moon, the Earth and its contents, are material to form greater things, that is, etherial things—greater things than the Creator himself made.—JOHN KEATS.

must receive at least passing notice. The institutional life of mankind is marked by disorganization. This disorder is often disguised by the fact that it takes the form of static division into classes, and this static separation is accepted as the very essence of order as long as it is so fixed and so accepted as not to generate open conflict. Life is compartmentalized and the institutionalized compartments are classified as high and as low; their values as profane and spiritual, as material and ideal. Interests are related to one another externally and mechanically, through a system of checks and balances. Since religion, morals, politics, business has each its own compartment, within which it is fitting each should remain, art, too, must have its peculiar and private realm. Compartmentalization of occupations and interests brings about separation of that mode of activity commonly called "practice" from insight, of imagination from executive doing, of significant purpose from work, of emotion from thought and doing. Each of these has, too, its own place in which it must abide. Those who write the anatomy of experience then suppose that these divisions inhere in the very constitution of human nature.

Of much of our experience as it is actually lived under present economic and legal institutional conditions, it is only too true that these separations hold. Only occasionally in the lives of many are the senses fraught with the sentiment that comes from deep realization of intrinsic meanings. We undergo sensations as mechanical stimuli or as irritated stimulations, without having a sense of the reality that is in them and behind them: in much of our experience our different senses do not unite to tell a common and enlarged story. We see without feeling; we hear, but only a second-hand report, second hand because not reënforced by vision. We touch, but the contact remains tangential because it does not fuse with qualities of senses that go below the surface. We use the senses to arouse passion but not to fulfill the interest of insight, not because that interest is not potentially present in the exercise of sense but because we yield to conditions of living that force sense to remain an excitation on the surface. Prestige goes to those who use their minds without participation of the body and who act vicariously through control of the bodies and labor of others.

Under such conditions, sense and flesh get a bad name. The moralist, however, has a truer sense of the intimate connections of sense with the rest of our being than has the professional psychologist and philosopher, although his sense of these connections takes a direction that reverses the potential facts of our living in relation to the environment. Psychologist and philosopher have in recent times been so obsessed with the problem of knowledge that they have treated "sensations" as mere elements of knowledge. The moralist knows that sense is allied with emotion, impulse and appetition. So he denounces the lust of the eye as part of the surrender of spirit to flesh. He identifies the sensuous with the sensual and the sensual with the lewd. His moral theory is askew, but at least he is aware that the eye is not an imperfect telescope designed for intellectual reception of material to bring about knowledge of distant objects.

"Sense" covers a wide range of contents: the sensory, the sensational, the sensitive, the sensible, and the sentimental, along with the sensuous. It includes almost everything from bare physical and emotional shock to sense itself—that is, the meaning of things present in immediate experience. Each term refers to some real phase and aspect of the life of an organic creature as life occurs through sense organs. But sense, as meaning so directly embodied in experience as to be its own illuminated meaning, is the only signification that expresses the function of sense organs when they are carried to full realization. The senses are the organs through which the live creature participates directly in the on-goings of the world about him. In this participation the varied wonder and splendor of this world are made actual for him in the qualities he experiences. This material cannot be opposed to action, for motor apparatus and "will" itself are the means by which this participation is carried on and directed. It cannot be opposed to "intellect," for mind is the means by which participation is rendered fruitful through sense; by which meanings and values are extracted, retained, and put to further service in the intercourse of the live creature with his surroundings.

Experience is the result, the sign, and the reward of that interaction of organism and environment which, when it is carried to the full, is a transformation of interaction into participation and communication. Since sense-organs with their connected motor

apparatus are the means of this participation, any and every derogation of them, whether practical or theoretical, is at once effect and cause of a narrowed and dulled life-experience. Oppositions of mind and body, soul and matter, spirit and flesh all have their origin, fundamentally, in fear of what life may—bring forth. They are marks of contraction and withdrawal. Full recognition, therefore, of the continuity of the organs, needs and basic impulses of the human creature with his animal forbears, implies no necessary reduction of man to the level of the brutes. On the contrary, it makes possible the drawing of a ground-plan of human experience upon which is erected the superstructure of man's marvelous and distinguishing experience. What is distinctive in man makes it possible for him to sink below the level of the beasts. It also makes it possible for him to carry to new and unprecedented heights that unity of sense and impulse, of brain and eye and ear, that is exemplified in animal life, saturating it with the conscious meanings derived from communication and deliberate expression.

Man excels in complexity and minuteness of differentiations. This very fact constitutes the necessity for many more comprehensive and exact relationships among the constituents of his being. Important as are the distinctions and relations thus made possible, the story does not end here. There are more opportunities for resistance and tension, more drafts upon experimentation and invention, and therefore more novelty in action, greater range and depth of insight and increase of poignancy in feeling. As an organism increases in complexity, the rhythms of struggle and consummation in its relation to its environment are varied and prolonged, and they come to include within themselves an endless variety of sub-rhythms. The designs of living are widened and enriched. Fulfillment is more massive and more subtly shaded.

Space thus becomes something more than a void in which to roam about, dotted here and there with dangerous things and things that satisfy the appetite. It becomes a comprehensive and enclosed scene within which are ordered the multiplicity of doings and undergoings in which man engages. Time ceases to be either the endless and uniform flow or the succession of instantaneous points which some philosophers have asserted it to be. It, too, is

the organized and organizing medium of the rhythmic ebb and flow of expectant impulse, forward and retracted movement, resistance and suspense, with fulfillment and consummation. It is an ordering of growth and maturations—as James said, we learn to skate in summer after having commenced in winter. Time as organization in change is growth, and growth signifies that a varied series of change enters upon intervals of pause and rest; of completions that become the initial points of new processes of development. Like the soil, mind is fertilized while it lies fallow, until a new burst of bloom ensues.

When a flash of lightning illumines a dark landscape, there is a momentary recognition of objects. But the recognition is not itself a mere point in time. It is the focal culmination of long, slow processes of maturation. It is the manifestation of the continuity of an ordered temporal experience in a sudden discrete instant of climax. It is as meaningless in isolation as would be the drama of *Hamlet* were it confined to a single line or word with no context. But the phrase "the rest is silence" is infinitely pregnant as the conclusion of a drama enacted through development in time; so may be the momentary perception of a natural scene. Form, as it is present in the fine arts, is the art of making clear what is involved in the organization of space and time prefigured in every course of a developing life-experience.

Moments and places, despite physical limitation and narrow localization, are charged with accumulations of long-gathering energy. A return to a scene of childhood that was left long years before floods the spot with a release of pent-up memories and hopes. To meet in a strange country one who is a casual acquaintance at home may arouse a satisfaction so acute as to bring a thrill. Mere recognitions occur only when we are occupied with something else than the object or person recognized. It marks either an interruption or else an intent to use what is recognized as a means for something else. To see, to perceive, is more than to recognize. It does not identify something present in terms of a past disconnected from it. The past is carried into the present so as to expand and deepen the content of the latter. There is illustrated the translation of bare continuity of external time into the vital order and

organization of experience. Identification nods and passes on. Or it defines a passing moment in isolation, it marks a dead spot in experience that is merely filled in. The extent to which the process of living in any day or hour is reduced to labeling situations, events, and objects as "so-and-so" in mere succession marks the cessation of a life that is a conscious experience. Continuities realized in an individual, discrete, form are the essence of the latter.

Art is thus prefigured in the very processes of living. A bird builds its nest and a beaver its dam when internal organic pressures coöperate with external materials so that the former are fulfilled and the latter are transformed in a satisfying culmination. We may hesitate to apply the word "art," since we doubt the presence of directive intent. But all deliberation, all conscious intent, grows out of things once performed organically through the interplay of natural energies. Were it not so, art would be built on quaking sands, nay, on unstable air. The distinguishing contribution of man is consciousness of the relations found in nature. Through consciousness, he converts the relations of cause and effect that are found in nature into relations of means and consequence. Rather, consciousness itself is the inception of such a transformation. What was mere shock becomes an invitation; resistance becomes something to be used in changing existing arrangements of matter; smooth facilities become agencies for executing an idea. In these operations, an organic stimulation becomes the bearer of meanings, and motor responses are changed into instruments of expression and communication; no longer are they mere means of locomotion and direct reaction. Meanwhile, the organic substratum remains as the quickening and deep foundation. Apart from relations of cause and effect in nature, conception and invention could not be. Apart from the relation of processes of rhythmic conflict and fulfillment in animal life, experience would be without design and pattern. Apart from organs inherited from animal ancestry, idea and purpose would be without a mechanism of realization. The primeval arts of nature and animal life are so much the material, and, in gross outline, so much the model for the intentional achievements of man, that the theologically minded have imputed conscious intent to the structure of

nature—as man, sharing many activities with the ape, is wont to think of the latter as imitating his own performances.

The existence of art is the concrete proof of what has just been stated abstractly. It is proof that man uses the materials and energies of nature with intent to expand his own life, and that he does so in accord with the structure of his organism—brain, sense-organs, and muscular system. Art is the living and concrete proof that man is capable of restoring consciously, and thus on the plane of meaning, the union of sense, need, impulse and action characteristic of the live creature. The intervention of consciousness adds regulation, power of selection, and redisposition. Thus it varies the arts in ways without end. But its intervention also leads in time to the *idea* of art as a conscious idea—the greatest intellectual achievement in the history of humanity.

The variety and perfection of the arts in Greece led thinkers to frame a generalized conception of art and to project the ideal of an art of organization of human activities as such—the art of politics and morals as conceived by Socrates and Plato. The ideas of design, plan, order, pattern, purpose emerged in distinction from and relation to the materials employed in their realization. The conception of man as the being that uses art became at once the ground of the distinction of man from the rest of nature and of the bond that ties him to nature. When the conception of art as the distinguishing trait of man was made explicit, there was assurance that, short of complete relapse of humanity below even savagery, the possibility of invention of new arts would remain, along with use of old arts, as the guiding ideal of mankind. Although recognition of the fact still halts, because of traditions established before the power of art was adequately recognized, science itself is but a central art auxiliary to the generation and utilization of other arts.*

*I have developed this point in *Experience and Nature*, in Chapter Nine, on Experience, Nature and Art. As far as the present point is concerned, the conclusion is contained in the statement that "art, the mode of activity that is charged with meanings capable of immediately enjoyed possession, is the complete culmination of nature, and that science is properly a handmaiden that conducts natural events to this happy issue." (P. 358.)

It is customary, and from some points of view necessary, to make a distinction between fine art and useful or technological art. But the point of view from which it is necessary is one that is extrinsic to the work of art itself. The customary distinction is based simply on acceptance of certain existing social conditions. I suppose the fetiches of the negro sculptor were taken to be useful in the highest degree to his tribal group, more so even than spears and clothing. But now they are fine art, serving in the twentieth century to inspire renovations in arts that had grown conventional. But they are fine art only because the anonymous artist lived and experienced so fully during the process of production. An angler may eat his catch without thereby losing the esthetic satisfaction he experienced in casting and playing. It is this degree of completeness of living in the experience of making and of perceiving that makes the difference between what is fine or esthetic in art and what is not. Whether the thing made is put to use, as are bowls, rugs, garments, weapons, is, *intrinsically* speaking, a matter of indifference. That many, perhaps most, of the articles and utensils made at present for use are not genuinely esthetic happens, unfortunately, to be true. But it is true for reasons that are foreign to the relation of the "beautiful" and "useful" as such. Wherever conditions are such as to prevent the act of production from being an experience in which the whole creature is alive and in which he possesses his living through enjoyment, the product will lack something of being esthetic. No matter how useful it is for special and limited ends, it will not be useful in the ultimate degree—that of contributing directly and liberally to an expanding and enriched life. The story of the severance and final sharp opposition of the useful and the fine is the history of that industrial development through which so much of production has become a form of postponed living and so much of consumption a superimposed enjoyment of the fruits of the labor of others.

Usually there is a hostile reaction to a conception of art that connects it with the activities of a live creature in its environment. The hostility to association of fine art with normal processes of living

is a pathetic, even a tragic, commentary on life as it is ordinarily lived. Only because that life is usually so stunted, aborted, slack, or heavy laden, is the idea entertained that there is some inherent antagonism between the process of normal living and creation and enjoyment of works of esthetic art. After all, even though "spiritual" and "material" are separated and set in opposition to one another, there must be conditions through which the ideal is capable of embodiment and realization—and this is all, fundamentally, that "matter" signifies. The very currency which the opposition has acquired testifies, therefore, to a widespread operation of forces that convert what might be means of executing liberal ideas into oppressive burdens and that cause ideals to be loose aspirations in an uncertain and ungrounded atmosphere.

While art itself is the best proof of the existence of a realized and therefore realizable, union of material and ideal, there are general arguments that support the thesis in hand. Wherever continuity is possible, the burden of proof rests upon those who assert opposition and dualism. Nature is the mother and the habitat of man, even if sometimes a stepmother and an unfriendly home. The fact that civilization endures and culture continues—and sometimes advances—is evidence that human hopes and purposes find a basis and support in nature. As the developing growth of an individual from embryo to maturity is the result of interaction of organism with surroundings, so culture is the product not of efforts of men put forth in a void or just upon themselves, but of prolonged and cumulative interaction with environment. The depth of the responses stirred by works of art shows *their* continuity with the operations of this enduring experience. The works and the responses they evoke are continuous with the very processes of living as these are carried to unexpected happy fulfillment.

As to absorption of the esthetic in nature, I cite a case duplicated in some measure in thousands of persons, but notable because expressed by an artist of the first order, W. H. Hudson. "I feel when I am out of sight of living, growing grass, and out of the sound of birds' voices and all rural sounds, that I am not properly alive." He goes on to say, ". . . when I hear people say that they have not found the world and life so agreeable and interesting as

to be in love with it, or that they look with equanimity to its end, I am apt to think that they have never been properly alive, nor seen with clear vision the world they think so meanly of or anything in it—not even a blade of grass." The mystic aspect of acute esthetic surrender, that renders it so akin as an experience to what religionists term ecstatic communion, is recalled by Hudson from his boyhood life. He is speaking of the effect the sight of acacia trees had upon him. "The loose feathery foliage on moonlight nights had a peculiar hoary aspect that made this tree seem more intensely alive than others, more conscious of me and of my presence. . . . Similar to a feeling a person would have if visited by a supernatural being if he was perfectly convinced that it was there in his presence, albeit silent and unseen, intently regarding him and divining every thought in his mind." Emerson is often regarded as an austere thinker. But it was Emerson as an adult who said, quite in the spirit of the passage quoted from Hudson: "Crossing a bare common, in snow puddles, at twilight, under a clouded sky, without having in my thought any occurrence of special good fortune, I have enjoyed a perfect exhilaration. I am glad to the brink of fear."

I do not see any way of accounting for the multiplicity of experiences of this kind (something of the same quality being found in every spontaneous and uncoerced esthetic response), except on the basis that there are stirred into activity resonances of dispositions acquired in primitive relationships of the living being to its surroundings, and irrecoverable in distinct or intellectual consciousness. Experiences of the sort mentioned take us to a further consideration that testifies to natural continuity. There is no limit to the capacity of immediate sensuous experience to absorb into itself meanings and values that in and of themselves—that is in the abstract—would be designated "ideal" and "spiritual." The animistic strain of religious experience, embodied in Hudson's memory of his childhood days, is an instance on one level of experience. And the poetical, in whatever medium, is always a close kin of the animistic. And if we turn to an art that in many ways is at the other pole, architecture, we learn how ideas, wrought out at first perhaps in highly technical thought like that

of mathematics, are capable of direct incorporation in sensuous form. The sensible surface of things is never merely a surface. One can discriminate rock from flimsy tissue-paper by the surface alone, so completely have the resistances of touch and the solidities due to stresses of the entire muscular system been embodied in vision. The process does not stop with incarnation of other sensory qualities that give depth of meaning to surface. Nothing that a man has ever reached by the highest flight of thought or penetrated by any probing insight is inherently such that it may not become the heart and core of sense.

The same word, "symbol," is used to designate expressions of abstract thought, as in mathematics, and also such things as a flag, crucifix, that embody deep social value and the meaning of historic faith and theological creed. Incense, stained glass, the chiming of unseen bells, embroidered robes accompany the approach to what is regarded as divine. The connection of the origin of many arts with primitive rituals becomes more evident with every excursion of the anthropologist into the past. Only those who are so far removed from the earlier experiences as to miss their sense will conclude that rites and ceremonies were merely technical devices for securing rain, sons, crops, success in battle. Of course they had this magical intent, but they were enduringly enacted, we may be sure, in spite of all practical failures, because they were immediate enhancements of the experience of living. Myths were something other than intellectualistic essays of primitive man in science. Uneasiness before any unfamiliar fact doubtless played its part. But delight in the story, in the growth and rendition of a good yarn, played its dominant part then as it does in the growth of popular mythologies today. Not only does the direct sense element—and emotion is a mode of sense—tend to absorb all ideational matter but, apart from special discipline enforced by physical apparatus, it subdues and digests all that is merely intellectual.

The introduction of the supernatural into belief and the all too human easy reversion to the supernatural is much more an affair of the psychology that generates works of art than of effort at scientific and philosophic explanation. It intensifies emotional thrill and punctuates the interest that belongs to all breaks in familiar

routine. Were the hold of the supernatural on human thought an exclusively—or even mainly—intellectual matter, it would be comparatively insignificant. Theologies and cosmogonies have laid hold of imagination because they have been attended with solemn processions, incense, embroidered robes, music, the radiance of colored lights, with stories that stir wonder and induce hypnotic admiration. That is, they have come to man through a direct appeal to sense and to sensuous imagination. Most religions have identified their sacraments with the highest reaches of art, and the most authoritative beliefs have been clothed in a garb of pomp and pageantry that gives immediate delight to eye and ear and that evokes massive emotions of suspense, wonder, and awe. The flights of physicists and astronomers today answer to the esthetic need for satisfaction of the imagination rather than to any strict demand of unemotional evidence for rational interpretation.

Henry Adams made it clear that the theology of the middle ages is a construction of the same intent as that which wrought the cathedrals. In general this middle age, popularly deemed to express the acme of Christian faith in the western world, is a demonstration of the power of sense to absorb the most highly spiritualized ideas. Music, painting, sculpture, architecture, drama and romance were handmaidens of religion, as much as were science and scholarship. The arts hardly had a being outside of the church, and the rites and ceremonies of the church were arts enacted under conditions that gave them the maximum possible of emotional and imaginative appeal. For I do not know what would give the spectator and auditor of the manifestation of the arts a more poignant surrender than the conviction that they were informed with the necessary means of eternal glory and bliss.

The following words of Pater are worth quoting in this connection. "The Christianity of the middle ages made its way partly by its esthetic beauty, a thing so profoundly felt by the Latin hymn writers, *who for one moral or spiritual sentiment had a hundred sensuous images.* A passion of which the outlets are sealed begets a tension of nerve in which the sensible world comes to one with a reinforced brilliancy and relief—all redness turned into blood, all water into tears. Hence a wild convulsed sensuousness in all the

poetry of the middle ages, in which the things of nature began to play a strange delirious part. Of the things of nature, the medieval mind had a deep sense; but its sense of them was not objective, no real escape to the world without us."

In his autobiographical essay, *The Child in the House*, he generalizes what is implicit in this passage. He says: "In later years he came upon philosophies which occupied him much in the estimate of the proportions of the sensuous and ideal elements in human knowledge, the relative parts they bear in it; and, in his intellectual scheme, was led to assign very little to the abstract thought, and much to its sensible vehicle or occasion." The latter "became the necessary concomitant of any perception of things, real enough to have any weight or reckoning, in his house of thought. . . . He came more and more to be unable to care for, or think of soul but as in an actual body, or of any world but that wherein are water and trees, and where men and women look, so or so, and press actual hands." The elevation of the ideal above and beyond immediate sense has operated not only to make it pallid and bloodless, but it has acted, like a conspirator with the sensual mind, to impoverish and degrade all things of direct experience.

In the title of this chapter I took the liberty of borrowing from Keats the word "etherial" to designate the meanings and values that many philosophers and some critics suppose are inaccessible to sense, because of their spiritual, eternal and universal characters—thus exemplifying the common dualism of nature and spirit. Let me re-quote his words. The artist may look "upon the Sun, the Moon, the Stars, and the Earth and its contents as material to form greater things, that is etherial things—greater things than the Creator himself made." In making this use of Keats, I had also in mind the fact that he identified the attitude of the artist with that of the live creature; and did so not merely in the implicit tenor of his poetry but in reflection expressed the idea explicitly in words. As he wrote in a letter to his brother: "The greater part of men make their way with the same instinctiveness, the same unwandering eye from their purposes as the Hawk. The Hawk wants a mate, so does the man—look at them both, they set about and procure one in the same manner. They both want a nest and they

both set about it in the same manner—they get their food in the same manner. The noble animal Man for his amusement smokes his pipe—the Hawk balances about in the clouds—this is the only difference of their leisures. This is that which makes the amusement of Life to a speculative mind. I go out among the Fields and catch a glimpse of a Stoat or a field mouse hurrying along—to what? The creature has a purpose and his eyes are bright with it. I go amongst the buildings of a city and see a Man hurrying along—to what? The Creature has a purpose and his eyes are bright with it. . . .

"Even here though I am pursuing the same instinctive course as the veriest human animal I can think of [though] I am, however young, writing at random straining at particles of light in the midst of great darkness, without knowing the bearing of any assertion, of any one opinion. Yet may I not in this be free from sin? May there not be superior beings amused with any graceful, though instinctive, attitude my mind may fall into as I am entertained with the alertness of a Stoat or the anxiety of a Deer? Though a quarrel in the streets is to be hated, the energies displayed in it are fine; the commonest Man has a grace in his quarrel. Seen by a supernatural Being our reasonings may take the same tone—though erroneous, they may be fine. *This is the very thing in which consists poetry.* There may be reasonings, but when they take an instinctive form, like that of animal forms and movements, they are poetry, they are fine; they have grace."

In another letter he speaks of Shakespeare as a man of enormous "Negative Capability"; as one who was "capable of being in uncertainties, mysteries, doubts, without any irritable reaching after fact and reason." He contrasts Shakespeare in this respect with his own contemporary Coleridge, who would let a poetic insight go when it was surrounded with obscurity, because he could not intellectually justify it; could not, in Keats' language, be satisfied with "*half*-knowledge." I think the same idea is contained in what he says, in a letter to Bailey, that he "never yet has been able to perceive how anything can be known for truth by consecutive reasoning. . . . Can it be that even the greatest Philosopher ever arrived at his Goal without putting aside numerous objections":

asking, in effect, Does not the reasoner have also to trust to his "intuitions," to what come upon him in his immediate sensuous and emotional experiences, even against objections that reflection presents to him. For he goes on to say "the simple imaginative mind may have its rewards in the repetitions of its own silent workings coming continually on the Spirit with a fine suddenness"—a remark that contains more of the psychology of productive thought than many treatises.

In spite of the elliptical character of Keats' statements two points emerge. One of them is his conviction that "reasonings" have an origin like that of the movements of a wild creature toward its goal, and they may become spontaneous, "instinctive," and when they become instinctive are sensuous and immediate, poetic. The other side of this conviction is his belief that no "reasoning" as reasoning, that is, as excluding imagination and sense, can reach truth. Even "the greatest philosopher" exercises an animal-like preference to guide his thinking to its conclusions. He selects and puts aside as his imaginative sentiments move. "Reason" at its height cannot attain complete grasp and a self-contained assurance. It must fall back upon imagination—upon the embodiment of ideas in emotionally charged sense.

There has been much dispute as to what Keats meant in his famous lines:

> "Beauty is truth, truth beauty—that is all
> Ye know on earth, and all ye need to know,"

and what he meant in the cognate prose statement—"What imagination seizes as beauty must be truth." Much of the dispute is carried on in ignorance of the particular tradition in which Keats wrote and which gave the term "truth" its meaning. In this tradition, "truth" never signifies correctness of intellectual statements about things, or truth as its meaning is now influenced by science. It denotes the wisdom by which men live, especially "the lore of good and evil." And in Keats' mind it was particularly connected with the question of justifying good and trusting to it in spite of the evil and destruction that abound. "Philosophy" is the attempt

to answer this question rationally. Keats' belief that even philosophers cannot deal with the question without depending on imaginative intuitions receives an independent and positive statement in his identification of "beauty" with "truth"—the particular truth that solves for man the baffling problem of destruction and death—which weighed so constantly on Keats—in the very realm where life strives to assert supremacy. Man lives in a world of surmise, of mystery, of uncertainties. "Reasoning" must fail man—this of course is a doctrine long taught by those who have held to the necessity of a divine revelation. Keats did not accept this supplement and substitute for reason. The insight of imagination must suffice. "This is all ye know on earth and all ye need to know." The critical words are "on earth"—that is amid a scene in which "irritable reaching after fact and reason" confuses and distorts instead of bringing us to the light. It was in moments of most intense esthetic perception that Keats found his utmost solace and his deepest convictions. This is the fact recorded at the close of his Ode. Ultimately there are but two philosophies. One of them accepts life and experience in all its uncertainty, mystery, doubt, and half-knowledge and turns that experience upon itself to deepen and intensify its own qualities—to imagination and art. This is the philosophy of Shakespeare and Keats.

EXPERIENCE occurs continuously, because the interaction of live creature and environing conditions is involved in the very process of living. Under conditions of resistance and conflict, aspects and elements of the self and the world that are implicated in this interaction qualify experience with emotions and ideas so that conscious intent emerges. Oftentimes, however, the experience had is inchoate. Things are experienced but not in such a way that they are composed into *an* experience. There is distraction and dispersion; what we observe and what we think, what we desire and what we get, are at odds with each other. We put our hands to the plow and turn back; we start and then we stop, not because the experience has reached the end for the sake of which it was initiated but because of extraneous interruptions or of inner lethargy.

In contrast with such experience, we have *an* experience when the material experienced runs its course to fulfillment. Then and

then only is it integrated within and demarcated in the general stream of experience from other experiences. A piece of work is finished in a way that is satisfactory; a problem receives its solution; a game is played through; a situation, whether that of eating a meal, playing a game of chess, carrying on a conversation, writing a book, or taking part in a political campaign, is so rounded out that its close is a consummation and not a cessation. Such an experience is a whole and carries with it its own individualizing quality and self-sufficiency. It is *an* experience.

Philosophers, even empirical philosophers, have spoken for the most part of experience at large. Idiomatic speech, however, refers to experiences each of which is singular, having its own beginning and end. For life is no uniform uninterrupted march or flow. It is a thing of histories, each with its own plot, its own inception and movement toward its close, each having its own particular rhythmic movement; each with its own unrepeated quality pervading it throughout. A flight of stairs, mechanical as it is, proceeds by individualized steps, not by undifferentiated progression, and an inclined plane is at least marked off from other things by abrupt discreteness.

Experience in this vital sense is defined by those situations and episodes that we spontaneously refer to as being "real experiences"; those things of which we say in recalling them, "that *was* an experience." It may have been something of tremendous importance—a quarrel with one who was once an intimate, a catastrophe finally averted by a hair's breadth. Or it may have been something that in comparison was slight—and which perhaps because of its very slightness illustrates all the better what is to be an experience. There is that meal in a Paris restaurant of which one says "that *was* an experience." It stands out as an enduring memorial of what food may be. Then there is that storm one went through in crossing the Atlantic—the storm that seemed in its fury, as it was experienced, to sum up in itself all that a storm can be, complete in itself, standing out because marked out from what went before and what came after.

In such experiences, every successive part flows freely, without seam and without unfilled blanks, into what ensues. At the same

time there is no sacrifice of the self-identity of the parts. A river, as distinct from a pond, flows. But its flow gives a definiteness and interest to its successive portions greater than exist in the homogenous portions of a pond. In an experience, flow is from something to something. As one part leads into another and as one part carries on what went before, each gains distinctness in itself. The enduring whole is diversified by successive phases that are emphases of its varied colors.

Because of continuous merging, there are no holes, mechanical junctions, and dead centers when we have *an* experience. There are pauses, places of rest, but they punctuate and define the quality of movement. They sum up what has been undergone and prevent its dissipation and idle evaporation. Continued acceleration is breathless and prevents parts from gaining distinction. In a work of art, different acts, episodes, occurrences melt and fuse into unity, and yet do not disappear and lose their own character as they do so—just as in a genial conversation there is a continuous interchange and blending, and yet each speaker not only retains his own character but manifests it more clearly than is his wont.

An experience has a unity that gives it its name, *that* meal, that storm, that rupture of friendship. The existence of this unity is constituted by a single *quality* that pervades the entire experience in spite of the variation of its constituent parts. This unity is neither emotional, practical, nor intellectual, for these terms name distinctions that reflection can make within it. In discourse *about* an experience, we must make use of these adjectives of interpretation. In going over an experience in mind *after* its occurrence, we may find that one property rather than another was sufficiently dominant so that it characterizes the experience as a whole. There are absorbing inquiries and speculations which a scientific man and philosopher will recall as "experiences" in the emphatic sense. In final import they are intellectual. But in their actual occurrence they were emotional as well; they were purposive and volitional. Yet the experience was not a sum of these different characters; they were lost in it as distinctive traits. No thinker can ply his occupation save as he is lured and rewarded by total integral experiences that are intrinsically worthwhile. Without them he would

never know what it is really to think and would be completely at a loss in distinguishing real thought from the spurious article. Thinking goes on in trains of ideas, but the ideas form a train only because they are much more than what an analytic psychology calls ideas. They are phases, emotionally and practically distinguished, of a developing underlying quality; they are its moving variations, not separate and independent like Locke's and Hume's so-called ideas and impressions, but are subtle shadings of a pervading and developing hue.

We say of an experience of thinking that we reach or draw a conclusion. Theoretical formulation of the process is often made in such terms as to conceal effectually the similarity of "conclusion" to the consummating phase of every developing integral experience. These formulations apparently take their cue from the separate propositions that are premises and the proposition that is the conclusion as they appear on the printed page. The impression is derived that there are first two independent and ready-made entities that are then manipulated so as to give rise to a third. In fact, in an experience of thinking, premises emerge only as a conclusion becomes manifest. The experience, like that of watching a storm reach its height and gradually subside, is one of continuous movement of subject-matters. Like the ocean in the storm, there are a series of waves; suggestions reaching out and being broken in a clash, or being carried onwards by a coöperative wave. If a conclusion is reached, it is that of a movement of anticipation and cumulation, one that finally comes to completion. A "conclusion" is no separate and independent thing; it is the consummation of a movement.

Hence *an* experience of thinking has its own esthetic quality. It differs from those experiences that are acknowledged to be esthetic, but only in its materials. The material of the fine arts consists of qualities; that of experience having intellectual conclusion are signs or symbols having no intrinsic quality of their own, but standing for things that may in another experience be qualitatively experienced. The difference is enormous. It is one reason why the strictly intellectual art will never be popular as music is popular. Nevertheless, the experience itself has a satisfying emotional qual-

ity because it possesses internal integration and fulfillment reached through ordered and organized movement. This artistic structure may be immediately felt. In so far, it is esthetic. What is even more important is that not only is this quality a significant motive in undertaking intellectual inquiry and in keeping it honest, but that no intellectual activity is an integral event (is *an* experience), unless it is rounded out with this quality. Without it, thinking is inconclusive. In short, esthetic cannot be sharply marked off from intellectual experience since the latter must bear an esthetic stamp to be itself complete.

The same statement holds good of a course of action that is dominantly practical, that is, one that consists of overt doings. It is possible to be efficient in action and yet not have a conscious experience. The activity is too automatic to permit of a sense of what it is about and where it is going. It comes to an end but not to a close or consummation in consciousness. Obstacles are overcome by shrewd skill, but they do not feed experience. There are also those who are wavering in action, uncertain, and inconclusive like the shades in classic literature. Between the poles of aimlessness and mechanical efficiency, there lie those courses of action in which through successive deeds there runs a sense of growing meaning conserved and accumulating toward an end that is felt as accomplishment of a process. Successful politicians and generals who turn statesmen like Caesar and Napoleon have something of the showman about them. This of itself is not art, but it is, I think, a sign that interest is not exclusively, perhaps not mainly, held by the result taken by itself (as it is in the case of mere efficiency), but by it as the outcome of a process. There is interest in completing an experience. The experience may be one that is harmful to the world and its consummation undesirable. But it has esthetic quality.

The Greek identification of good conduct with conduct having proportion, grace, and harmony, the *kalon-agathon*, is a more obvious example of distinctive esthetic quality in moral action. One great defect in what passes as morality is its anesthetic quality. Instead of exemplifying wholehearted action, it takes the form of grudging piecemeal concessions to the demands of duty. But il-

lustrations may only obscure the fact that any practical activity will, provided that it is integrated and moves by its own urge to fulfillment, have esthetic quality.

A generalized illustration may be had if we imagine a stone, which is rolling down hill, to have an experience. The activity is surely sufficiently "practical." The stone starts from somewhere, and moves, as consistently as conditions permit, toward a place and state where it will be at rest—toward an end. Let us add, by imagination, to these external facts, the ideas that it looks forward with desire to the final outcome; that it is interested in the things it meets on its way, conditions that accelerate and retard its movement with respect to their bearing on the end; that it acts and feels toward them according to the hindering or helping function it attributes to them; and that the final coming to rest is related to all that went before as the culmination of a continuous movement. Then the stone would have an experience, and one with esthetic quality.

If we turn from this imaginary case to our own experience, we shall find much of it is nearer to what happens to the actual stone than it is to anything that fulfills the conditions fancy just laid down. For in much of our experience we are not concerned with the connection of one incident with what went before and what comes after. There is no interest that controls attentive rejection or selection of what shall be organized into the developing experience. Things happen, but they are neither definitely included nor decisively excluded; we drift. We yield according to external pressure, or evade and compromise. There are beginnings and cessations, but no genuine initiations and concludings. One thing replaces another, but does not absorb it and carry it on. There is experience, but so slack and discursive that it is not *an* experience. Needless to say, such experiences are anesthetic.

Thus the non-esthetic lies within two limits. At one pole is the loose succession that does not begin at any particular place and that ends—in the sense of ceasing—at no particular place. At the other pole is arrest, constriction, proceeding from parts having only a mechanical connection with one another. There exists so much of one and the other of these two kinds of experience that

unconsciously they come to be taken as norms of all experience. Then, when the esthetic appears, it so sharply contrasts with the picture that has been formed of experience, that it is impossible to combine its special qualities with the features of the picture and the esthetic is given an outside place and status. The account that has been given of experience dominantly intellectual and practical is intended to show that there is no such contrast involved in having an experience; that, on the contrary, no experience of whatever sort is a unity unless it has esthetic quality.

The enemies of the esthetic are neither the practical nor the intellectual. They are the humdrum; slackness of loose ends; submission to convention in practice and intellectual procedure. Rigid abstinence, coerced submission, tightness on one side and dissipation, incoherence and aimless indulgence on the other, are deviations in opposite directions from the unity of an experience. Some such considerations perhaps induced Aristotle to invoke the "mean proportional" as the proper designation of what is distinctive of both virtue and the esthetic. He was formally correct. "Mean" and "proportion" are, however, not self-explanatory, nor to be taken over in a prior mathematical sense, but are properties belonging to an experience that has a developing movement toward its own consummation.

I have emphasized the fact that every integral experience moves toward a close, an ending, since it ceases only when the energies active in it have done their proper work. This closure of a circuit of energy is the opposite of arrest, of *stasis*. Maturation and fixation are polar opposites. Struggle and conflict may be themselves enjoyed, although they are painful, when they are experienced as means of developing an experience; members in that they carry it forward, not just because they are there. There is, as will appear later, an element of undergoing, of suffering in its large sense, in every experience. Otherwise there would be no taking in of what preceded. For "taking in" in any vital experience is something more than placing something on the top of consciousness over what was previously known. It involves reconstruction which may be painful. Whether the necessary undergoing phase is by itself pleasurable or painful is a matter of particular conditions.

It is indifferent to the total esthetic quality, save that there are few intense esthetic experiences that are wholly gleeful. They are certainly not to be characterized as amusing, and as they bear down upon us they involve a suffering that is none the less consistent with, indeed a part of, the complete perception that is enjoyed.

I have spoken of the esthetic quality that rounds out an experience into completeness and unity as emotional. The reference may cause difficulty. We are given to thinking of emotions as things as simple and compact as are the words by which we name them. Joy, sorrow, hope, fear, anger, curiosity, are treated as if each in itself were a sort of entity that enters full-made upon the scene, an entity that may last a long time or a short time, but whose duration, whose growth and career, is irrelevant to its nature. In fact emotions are qualities, when they are significant, of a complex experience that moves and changes. I say, when they are *significant,* for otherwise they are but the outbreaks and eruptions of a disturbed infant. All emotions are qualifications of a drama and they change as the drama develops. Persons are sometimes said to fall in love at first sight. But what they fall into is not a thing of that instant. What would love be were it compressed into a moment in which there is no room for cherishing and for solicitude? The intimate nature of emotion is manifested in the experience of one watching a play on the stage or reading a novel. It attends the development of a plot; and a plot requires a stage, a space, wherein to develop and time in which to unfold. Experience is emotional but there are no separate things called emotions in it.

By the same token, emotions are attached to events and objects in their movement. They are not, save in pathological instances, private. And even an "objectless" emotion demands something beyond itself to which to attach itself, and thus it soon generates a delusion in lack of something real. Emotion belongs of a certainty to the self. But it belongs to the self that is concerned in the movement of events toward an issue that is desired or disliked. We jump instantaneously when we are scared, as we blush on the instant when we are ashamed. But fright and shamed modesty are not in this case emotional states. Of themselves they are but automatic reflexes. In order to become emotional they must become

parts of an inclusive and enduring situation that involves concern for objects and their issues. The jump of fright becomes emotional fear when there is found or thought to exist a threatening object that must be dealt with or escaped from. The blush becomes the emotion of shame when a person connects, in thought, an action he has performed with an unfavorable reaction to himself of some other person.

Physical things from far ends of the earth are physically transported and physically caused to act and react upon one another in the construction of a new object. The miracle of mind is that something similar takes place in experience without physical transport and assembling. Emotion is the moving and cementing force. It selects what is congruous and dyes what is selected with its color, thereby giving qualitative unity to materials externally disparate and dissimilar. It thus provides unity in and through the varied parts of an experience. When the unity is of the sort already described, the experience has esthetic character even though it is not, dominantly, an esthetic experience.

Two men meet; one is the applicant for a position, while the other has the disposition of the matter in his hands. The interview may be mechanical, consisting of set questions, the replies to which perfunctorily settle the matter. There is no experience in which the two men meet, nothing that is not a repetition, by way of acceptance or dismissal, of something which has happened a score of times. The situation is disposed of as if it were an exercise in bookkeeping. But an interplay may take place in which a new experience develops. Where should we look for an account of such an experience? Not to ledger-entries nor yet to a treatise on economics or sociology or personnel-psychology, but to drama or fiction. Its nature and import can be expressed only by art, because there is a unity of experience that can be expressed only as an experience. The *experience* is of material fraught with suspense and moving toward its own consummation through a connected series of varied incidents. The primary emotions on the part of the applicant may be at the beginning hope or despair, and elation or disappointment at the close. These emotions qualify the experience as a unity. But as the interview proceeds, secondary emotions are

evolved as variations of the primary underlying one. It is even possible for each attitude and gesture, each sentence, almost every word, to produce more than a fluctuation in the intensity of the basic emotion; to produce, that is, a change of shade and tint in its quality. The employer sees by means of his own emotional reactions the character of the one applying. He projects him imaginatively into the work to be done and judges his fitness by the way in which the elements of the scene assemble and either clash or fit together. The presence and behavior of the applicant either harmonize with his own attitudes and desires or they conflict and jar. Such factors as these, inherently esthetic in quality, are the forces that carry the varied elements of the interview to a decisive issue. They enter into the settlement of every situation, whatever its dominant nature, in which there are uncertainty and suspense.

There are, therefore, common patterns in various experiences, no matter how unlike they are to one another in the details of their subject matter. There are conditions to be met without which an experience cannot come to be. The outline of the common pattern is set by the fact that every experience is the result of interaction between a live creature and some aspect of the world in which he lives. A man does something; he lifts, let us say, a stone. In consequence he undergoes, suffers, something: the weight, strain, texture of the surface of the thing lifted. The properties thus undergone determine further doing. The stone is too heavy or too angular, not solid enough; or else the properties undergone show it is fit for the use for which it is intended. The process continues until a mutual adaptation of the self and the object emerges and that particular experience comes to a close. What is true of this simple instance is true, as to form, of every experience. The creature operating may be a thinker in his study and the environment with which he interacts may consist of ideas instead of a stone. But interaction of the two constitutes the total experience that is had, and the close which completes it is the institution of a felt harmony.

An experience has pattern and structure, because it is not just

doing and undergoing in alternation, but consists of them in relationship. To put one's hand in the fire that consumes it is not necessarily to have an experience. The action and its consequence must be joined in perception. This relationship is what gives meaning; to grasp it is the objective of all intelligence. The scope and content of the relations measure the significant content of an experience. A child's experience may be intense, but, because of lack of background from past experience, relations between undergoing and doing are slightly grasped, and the experience does not have great depth or breadth. No one ever arrives at such maturity that he perceives all the connections that are involved. There was once written (by Mr. Hinton) a romance called "The Unlearner." It portrayed the whole endless duration of life after death as a living over of the incidents that happened in a short life on earth, in continued discovery of the relationships involved among them.

Experience is limited by all the causes which interfere with perception of the relations between undergoing and doing. There may be interference because of excess on the side of doing or of excess on the side of receptivity, of undergoing. Unbalance on either side blurs the perception of relations and leaves the experience partial and distorted, with scant or false meaning. Zeal for doing, lust for action, leaves many a person, especially in this hurried and impatient human environment in which we live, with experience of an almost incredible paucity, all on the surface. No one experience has a chance to complete itself because something else is entered upon so speedily. What is called experience becomes so dispersed and miscellaneous as hardly to deserve the name. Resistance is treated as an obstruction to be beaten down, not as an invitation to reflection. An individual comes to seek, unconsciously even more than by deliberate choice, situations in which he can do the most things in the shortest time.

Experiences are also cut short from maturing by excess of receptivity. What is prized is then the mere undergoing of this and that, irrespective of perception of any meaning. The crowding together of as many impressions as possible is thought to be "life," even though no one of them is more than a flitting and a sipping. The sentimentalist and the day-dreamer may have more fancies

and impressions pass through their consciousness than has the man who is animated by lust for action. But his experience is equally distorted, because nothing takes root in mind when there is no balance between doing and receiving. Some decisive action is needed in order to establish contact with the realities of the world and in order that impressions may be so related to facts that their value is tested and organized.

Because perception of relationship between what is done and what is undergone constitutes the work of intelligence, and because the artist is controlled in the process of his work by his grasp of the connection between what he has already done and what he is to do next, the idea that the artist does not think as intently and penetratingly as a scientific inquirer is absurd. A painter must consciously undergo the effect of his every brush stroke or he will not be aware of what he is doing and where his work is going. Moreover, he has to see each particular connection of doing and undergoing in relation to the whole that he desires to produce. To apprehend such relations is to think, and is one of the most exacting modes of thought. The difference between the pictures of different painters is due quite as much to differences of capacity to carry on this thought as it is to differences of sensitivity to bare color and to differences in dexterity of execution. As respects the basic quality of pictures, difference depends, indeed, more upon the quality of intelligence brought to bear upon perception of relations than upon anything else—though of course intelligence cannot be separated from direct sensitivity and is connected, though in a more external manner, with skill.

Any idea that ignores the necessary rôle of intelligence in production of works of art is based upon identification of thinking with use of one special kind of material, verbal signs and words. To think effectively in terms of relations of qualities is as severe a demand upon thought as to think in terms of symbols, verbal and mathematical. Indeed, since words are easily manipulated in mechanical ways, the production of a work of genuine art probably demands more intelligence than does most of the so-called thinking that goes on among those who pride themselves on being "intellectuals."

* * *

I have tried to show in these chapters that the esthetic is no in-truder in experience from without, whether by way of idle luxury or transcendent ideality, but that it is the clarified and intensified development of traits that belong to every normally complete ex-perience. This fact I take to be the only secure basis upon which esthetic theory can build. It remains to suggest some of the impli-cations of the underlying fact.

We have no word in the English language that unambiguously includes what is signified by the two words "artistic" and "es-thetic." Since "artistic" refers primarily to the act of production and "esthetic" to that of perception and enjoyment, the absence of a term designating the two processes taken together is unfortu-nate. Sometimes, the effect is to separate the two from each other, to regard art as something superimposed upon esthetic material, or, upon the other side, to an assumption that, since art is a pro-cess of creation, perception and enjoyment of it have nothing in common with the creative act. In any case, there is a certain verbal awkwardness in that we are compelled sometimes to use the term "esthetic" to cover the entire field and sometimes to limit it to the receiving perceptual aspect of the whole operation. I refer to these obvious facts as preliminary to an attempt to show how the con-ception of conscious experience as a perceived relation between doing and undergoing enables us to understand the connection that art as production and perception and appreciation as enjoy-ment sustain to each other.

Art denotes a process of doing or making. This is as true of fine as of technological art. Art involves molding of clay, chipping of marble, casting of bronze, laying on of pigments, construction of buildings, singing of songs, playing of instruments, enacting rôles on the stage, going through rhythmic movements in the dance. Every art does something with some physical material, the body or something outside the body, with or without the use of in-tervening tools, and with a view to production of something visi-ble, audible, or tangible. So marked is the active or "doing" phase of art, that the dictionaries usually define it in terms of skilled ac-

tion, ability in execution. The *Oxford Dictionary* illustrates by a quotation from John Stuart Mill: "Art is an endeavor after perfection in execution" while Matthew Arnold calls it "pure and flawless workmanship."

The word "esthetic" refers, as we have already noted, to experience as appreciative, perceiving, and enjoying. It denotes the consumer's rather than the producer's standpoint. It is gusto, taste; and, as with cooking, overt skillful action is on the side of the cook who prepares, while taste is on the side of the consumer, as in gardening there is a distinction between the gardener who plants and tills and the householder who enjoys the finished product.

These very illustrations, however, as well as the relation that exists in having an experience between doing and undergoing, indicate that the distinction between esthetic and artistic cannot be pressed so far as to become a separation. Perfection in execution cannot be measured or defined in terms of execution; it implies those who perceive and enjoy the product that is executed. The cook prepares food for the consumer and the measure of the value of what is prepared is found in consumption. Mere perfection in execution, judged in its own terms in isolation, can probably be attained better by a machine than by human art. By itself, it is at most technique, and there are great artists who are not in the first ranks as technicians (witness Cézanne), just as there are great performers on the piano who are not great esthetically, and as Sargent is not a great painter.

Craftsmanship to be artistic in the final sense must be "loving"; it must care deeply for the subject matter upon which skill is exercised. A sculptor comes to mind whose busts are marvelously exact. It might be difficult to tell in the presence of a photograph of one of them and of a photograph of the original which was of the person himself. For virtuosity they are remarkable. But one doubts whether the maker of the busts had an experience of his own that he was concerned to have those share who look at his products. To be truly artistic, a work must also be esthetic—that is, framed for enjoyed receptive perception. Constant observation is, of course, necessary for the maker while he is producing. But if his perception is not also esthetic in nature, it is a colorless and

cold recognition of what has been done, used as a stimulus to the next step in a process that is essentially mechanical.

In short, art, in its form, unites the very same relation of doing and undergoing, outgoing and incoming energy, that makes an experience to be an experience. Because of elimination of all that does not contribute to mutual organization of the factors of both action and reception into one another, and because of selection of just the aspects and traits that contribute to their interpenetration of each other, the product is a work of esthetic art. Man whittles, carves, sings, dances, gestures, molds, draws and paints. The doing or making is artistic when the perceived result is of such a nature that *its* qualities *as perceived* have controlled the question of production. The act of producing that is directed by intent to produce something that is enjoyed in the immediate experience of perceiving has qualities that a spontaneous or uncontrolled activity does not have. The artist embodies in himself the attitude of the perceiver while he works.

Suppose, for the sake of illustration, that a finely wrought object, one whose texture and proportions are highly pleasing in perception, has been believed to be a product of some primitive people. Then there is discovered evidence that proves it to be an accidental natural product. As an external thing, it is now precisely what it was before. Yet at once it ceases to be a work of art and becomes a natural "curiosity." It now belongs in a museum of natural history, not in a museum of art. And the extraordinary thing is that the difference that is thus made is not one of just intellectual classification. A difference is made in appreciative perception and in a direct way. The esthetic experience—in its limited sense—is thus seen to be inherently connected with the experience of making.

The sensory satisfaction of eye and ear, when esthetic, is so because it does not stand by itself but is linked to the activity of which it is the consequence. Even the pleasures of the palate are different in quality to an epicure than in one who merely "likes" his food as he eats it. The difference is not of mere intensity. The epicure is conscious of much more than the taste of the food. Rather, there enter into the taste, as directly experienced, qualities

that depend upon reference to its source and its manner of production in connection with criteria of excellence. As production must absorb into itself qualities of the product as perceived and be regulated by them, so, on the other side, seeing, hearing, tasting, become esthetic when relation to a distinct manner of activity qualifies what is perceived.

There is an element of passion in all esthetic perception. Yet when we are overwhelmed by passion, as in extreme rage, fear, jealousy, the experience is definitely non-esthetic. There is no relationship felt to the qualities of the activity that has generated the passion. Consequently, the material of the experience lacks elements of balance and proportion. For these can be present only when, as in the conduct that has grace or dignity, the act is controlled by an exquisite sense of the relations which the act sustains—its fitness to the occasion and to the situation.

The process of art in production is related to the esthetic in perception organically—as the Lord God in creation surveyed His work and found it good. Until the artist is satisfied in perception with what he is doing, he continues shaping and reshaping. The making comes to an end when its result is experienced as good—and that experience comes not by mere intellectual and outside judgment but in direct perception. An artist, in comparison with his fellows, is one who is not only especially gifted in powers of execution but in unusual sensitivity to the qualities of things. This sensitivity also directs his doings and makings.

As we manipulate, we touch and feel, as we look, we see; as we listen, we hear. The hand moves with etching needle or with brush. The eye attends and reports the consequence of what is done. Because of this intimate connection, subsequent doing is cumulative and not a matter of caprice nor yet of routine. In an emphatic artistic-esthetic experience, the relation is so close that it controls simultaneously both the doing and the perception. Such vital intimacy of connection cannot be had if only hand and eye are engaged. When they do not, both of them, act as organs of the whole being, there is but a mechanical sequence of sense and movement, as in walking that is automatic. Hand and eye, when the experience is esthetic, are but instruments through which the

entire live creature, moved and active throughout, operates. Hence the expression is emotional and guided by purpose.

Because of the relation between what is done and what is undergone, there is an immediate sense of things in perception as belonging together or as jarring; as reënforcing or as interfering. The consequences of the act of making as reported in sense show whether what is done carries forward the idea being executed or marks a deviation and break. In as far as the development of an experience is *controlled* through reference to these immediately felt relations of order and fulfillment, that experience becomes dominantly esthetic in nature. The urge to action becomes an urge to that kind of action which will result in an object satisfying in direct perception. The potter shapes his clay to make a bowl useful for holding grain; but he makes it in a way so regulated by the series of perceptions that sum up the serial acts of making, that the bowl is marked by enduring grace and charm. The general situation remains the same in painting a picture or molding a bust. Moreover, at each stage there is anticipation of what is to come. This anticipation is the connecting link between the next doing and its outcome for sense. What is done and what is undergone are thus reciprocally, cumulatively, and continuously instrumental to each other.

The doing may be energetic, and the undergoing may be acute and intense. But unless they are related to each other to form a whole in perception, the thing done is not fully esthetic. The making for example may be a display of technical virtuosity, and the undergoing a gush of sentiment or a revery. If the artist does not perfect a new vision in his process of doing, he acts mechanically and repeats some old model fixed like a blueprint in his mind. An incredible amount of observation and of the kind of intelligence that is exercised in perception of qualitative relations characterizes creative work in art. The relations must be noted not only with respect to one another, two by two, but in connection with the whole under construction; they are exercised in imagination as well as in observation. Irrelevancies arise that are tempting distractions; digressions suggest themselves in the guise of enrichments. There are occasions when the grasp of the dominant idea

grows faint, and then the artist is moved unconsciously to fill in until his thought grows strong again. The real work of an artist is to build up an experience that is coherent in perception while moving with constant change in its development.

When an author puts on paper ideas that are already clearly conceived and consistently ordered, the real work has been previously done. Or, he may depend upon the greater perceptibility induced by the activity and its sensible report to direct his completion of the work. The mere act of transcription is esthetically irrelevant save as it enters integrally into the formation of an experience moving to completeness. Even the composition conceived in the head and, therefore, physically private, is public in its significant content, since it is conceived with reference to execution in a product that is perceptible and hence belongs to the common world. Otherwise it would be an aberration or a passing dream. The urge to express through painting the perceived qualities of a landscape is continuous with demand for pencil or brush. Without external embodiment, an experience remains incomplete; physiologically and functionally, sense organs are motor organs and are connected, by means of distribution of energies in the human body and not merely anatomically, with other motor organs. It is no linguistic accident that "building," "construction," "work," designate both a process and its finished product. Without the meaning of the verb that of the noun remains blank.

Writer, composer of music, sculptor, or painter can retrace, during the process of production, what they have previously done. When it is not satisfactory in the undergoing or perceptual phase of experience, they can to some degree start afresh. This retracing is not readily accomplished in the case of architecture—which is perhaps one reason why there are so many ugly buildings. Architects are obliged to complete their idea before its translation into a complete object of perception takes place. Inability to build up simultaneously the idea and its objective embodiment imposes a handicap. Nevertheless, they too are obliged to think out their ideas in terms of the medium of embodiment and the object of ultimate perception unless they work mechanically and by rote. Probably the esthetic quality of medieval cathedrals is due in some

measure to the fact that their constructions were not so much controlled by plans and specifications made in advance as is now the case. Plans grew as the building grew. But even a Minerva-like product, if it is artistic, presupposes a prior period of gestation in which doings and perceptions projected in imagination interact and mutually modify one another. Every work of art follows the plan of, and pattern of, a complete experience, rendering it more intensely and concentratedly felt.

It is not so easy in the case of the perceiver and appreciator to understand the intimate union of doing and undergoing as it is in the case of the maker. We are given to supposing that the former merely takes in what is there in finished form, instead of realizing that this taking in involves activities that are comparable to those of the creator. But receptivity is not passivity. It, too, is a process consisting of a series of responsive acts that accumulate toward objective fulfillment. Otherwise, there is not perception but recognition. The difference between the two is immense. Recognition is perception arrested before it has a chance to develop freely. In recognition there is a beginning of an act of perception. But this beginning is not allowed to serve the development of a full perception of the thing recognized. It is arrested at the point where it will serve some *other* purpose, as we recognize a man on the street in order to greet or to avoid him, not so as to see him for the sake of seeing what is there.

In recognition we fall back, as upon a stereotype, upon some previously formed scheme. Some detail or arrangement of details serves as cue for bare identification. It suffices in recognition to apply this bare outline as a stencil to the present object. Sometimes in contact with a human being we are struck with traits, perhaps of only physical characteristics, of which we were not previously aware. We realize that we never knew the person before; we had not seen him in any pregnant sense. We now begin to study and to "take in." Perception replaces bare recognition. There is an act of reconstructive doing, and consciousness becomes fresh and alive. *This* act of seeing involves the cooperation of motor elements even though they remain implicit and do not become overt, as well as coöperation of all funded ideas that may serve to complete the new

picture that is forming. Recognition is too easy to arouse vivid consciousness. There is not enough resistance between new and old to secure consciousness of the experience that is had. Even a dog that barks and wags his tail joyously on seeing his master return is more fully alive in his reception of his friend than is a human being who is content with mere recognition.

Bare recognition is satisfied when a proper tag or label is attached, "proper" signifying one that serves a purpose outside the act of recognition—as a salesman identifies wares by a sample. It involves no stir of the organism, no inner commotion. But an act of perception proceeds by waves that extend serially throughout the entire organism. There is, therefore, no such thing in perception as seeing or hearing *plus* emotion. The perceived object or scene is emotionally pervaded throughout. When an aroused emotion does not permeate the material that is perceived or thought of, it is either preliminary or pathological.

The esthetic or undergoing phase of experience is receptive. It involves surrender. But adequate yielding of the self is possibly only through a controlled activity that may well be intense. In much of our intercourse with our surroundings we withdraw; sometimes from fear, if only of expending unduly our store of energy; sometimes from preoccupation with other matters, as in the case of recognition. Perception is an act of the going-out of energy in order to receive, not a withholding of energy. To steep ourselves in a subject-matter we have first to plunge into it. When we are only passive to a scene, it overwhelms us and, for lack of answering activity, we do not perceive that which bears us down. We must summon energy and pitch it at a responsive key in order to *take* in.

Everyone knows that it requires apprenticeship to see through a microscope or telescope, and to see a landscape as the geologist sees it. The idea that esthetic perception is an affair for odd moments is one reason for the backwardness of the arts among us. The eye and the visual apparatus may be intact; the object may be physically there, the cathedral of Notre Dame, or Rembrandt's portrait of Hendrik Stoeffel. In some bald sense, the latter may be "seen." They may be looked at, possibly recognized, and have their

correct names attached. But for lack of continuous interaction between the total organism and the objects, they are not perceived, certainly not esthetically. A crowd of visitors steered through a picture-gallery by a guide, with attention called here and there to some high point, does not perceive; only by accident is there even interest in seeing a picture for the sake of subject matter vividly realized.

For to perceive, a beholder must *create* his own experience. And his creation must include relations comparable to those which the original producer underwent. They are not the same in any literal sense. But with the perceiver, as with the artist, there must be an ordering of the elements of the whole that is in form, although not in details, the same as the process of organization the creator of the work consciously experienced. Without an act of recreation the object is not perceived as a work of art. The artist selected, simplified, clarified, abridged and condensed according to his interest. The beholder must go through these operations according to his point of view and interest. In both, an act of abstraction, that is of extraction of what is significant, takes place. In both, there is comprehension in its literal signification—that is, a gathering together of details and particulars physically scattered into an experienced whole. There is work done on the part of the percipient as there is on the part of the artist. The one who is too lazy, idle, or indurated in convention to perform this work will not see or hear. His "appreciation" will be a mixture of scraps of learning with conformity to norms of conventional admiration and with a confused, even if genuine, emotional excitation.

The considerations that have been presented imply both the community and the unlikeness, because of specific emphasis, of *an* experience, in its pregnant sense, and esthetic experience. The former has esthetic quality; otherwise its materials would not be rounded out into a single coherent experience. It is not possible to divide in a vital experience the practical, emotional, and intellectual from one another and to set the properties of one over against the characteristics of the others. The emotional phase binds parts together

into a single whole; "intellectual" simply names the fact that the experience has meaning; "practical" indicates that the organism is interacting with events and objects which surround it. The most elaborate philosophic or scientific inquiry and the most ambitious industrial or political enterprise has, when its different ingredients constitute an integral experience, esthetic quality. For then its varied parts are linked to one another, and do not merely succeed one another. And the parts through their experienced linkage move toward a consummation and close, not merely to cessation in time. This consummation, moreover, does not wait in consciousness for the whole undertaking to be finished. It is anticipated throughout and is recurrently savored with special intensity.

Nevertheless, the experiences in question are dominantly intellectual or practical, rather than *distinctively* esthetic, because of the interest and purpose that initiate and control them. In an intellectual experience, the conclusion has value on its own account. It can be extracted as a formula or as a "truth," and can be used in its independent entirety as factor and guide in other inquiries. In a work of art there is no such single self-sufficient deposit. The end, the terminus, is significant not by itself but as the integration of the parts. It has no other existence. A drama or novel is not the final sentence, even if the characters are disposed of as living happily ever after. In a distinctively esthetic experience, characteristics that are subdued in other experiences are dominant; those that are subordinate are controlling—namely, the characteristics in virtue of which the experience is an integrated complete experience on its own account.

In every integral experience there is form because there is dynamic organization. I call the organization dynamic because it takes time to complete it, because it is a growth. There is inception, development, fulfillment. Material is ingested and digested through interaction with that vital organization of the results of prior experience that constitutes the mind of the worker. Incubation goes on until what is conceived is brought forth and is rendered perceptible as part of the common world. An esthetic experience can be crowded into a moment only in the sense that a climax of prior long enduring processes may arrive in an out-

standing movement which so sweeps everything else into it that all else is forgotten. That which distinguishes an experience as esthetic is conversion of resistance and tensions, of excitations that in themselves are temptations to diversion, into a movement toward an inclusive and fulfilling close.

Experiencing like breathing is a rhythm of intakings and outgivings. Their succession is punctuated and made a rhythm by the existence of intervals, periods in which one phase is ceasing and the other is inchoate and preparing. William James aptly compared the course of a conscious experience to the alternate flights and perchings of a bird. The flights and perchings are intimately connected with one another; they are not so many unrelated lightings succeeded by a number of equally unrelated hoppings. Each resting place in experience is an undergoing in which is absorbed and taken home the consequences of prior doing, and, unless the doing is that of utter caprice or sheer routine, each doing carries in itself meaning that has been extracted and conserved. As with the advance of an army, all gains from what has been already effected are periodically consolidated, and always with a view to what is to be done next. If we move too rapidly, we get away from the base of supplies—of accrued meanings—and the experience is flustered, thin, and confused. If we dawdle too long after having extracted a net value, experience perishes of inanition.

The *form* of the whole is therefore present in every member. Fulfilling, consummating, are continuous functions, not mere ends, located at one place only. An engraver, painter, or writer is in process of completing at every stage of his work. He must at each point retain and sum up what has gone before as a whole and with reference to a whole to come. Otherwise there is no consistency and no security in his successive acts. The series of doings in the rhythm of experience give variety and movement; they save the work from monotony and useless repetitions. The undergoings are the corresponding elements in the rhythm, and they supply unity; they save the work from the aimlessness of a mere succession of excitations. An object is peculiarly and dominantly esthetic, yield-

ing the enjoyment characteristic of esthetic perception, when the factors that determine anything which can be called *an* experience are lifted high above the threshold of perception and are made manifest for their own sake.

EVERY experience, of slight or tremendous import, begins with an impulsion, rather *as* an impulsion. I say "impulsion" rather than "impulse." An impulse is specialized and particular; it is, even when instinctive, simply a part of the mechanism involved in a more complete adaptation with the environment. "Impulsion" designates a movement outward and forward of the whole organism to which special impulses are auxiliary. It is the craving of the living creature for food as distinct from the reactions of tongue and lips that are involved in swallowing; the turning toward light of the body as a whole, like the heliotropism of plants, as distinct from the following of a particular light by the eyes.

Because it is the movement of the organism in its entirety, impulsion is the initial stage of any complete experience. Observation of children discovers many specialized reactions. But they are not, therefore, inceptive of complete experiences. They enter into

the latter only as they are woven as strands into an activity that calls the whole self into play. Overlooking these generalized activities and paying attention only to the differentiations, the divisions of labor, which render them more efficient, are pretty much the source and cause of all further errors in the interpretation of experience.

Impulsions are the beginnings of complete experience because they proceed from need; from a hunger and demand that belongs to the organism as a whole and that can be supplied only by instituting definite relations (active relations, interactions) with the environment. The epidermis is only in the most superficial way an indication of where an organism ends and its environment begins. There are things inside the body that are foreign to it, and there are things outside of it that belong to it *de jure,* if not *de facto;* that must, that is, be taken possession of if life is to continue. On the lower scale, air and food materials are such things; on the higher, tools, whether the pen of the writer or the anvil of the blacksmith, utensils and furnishings, property, friends and institutions—all the supports and sustenances without which a civilized life cannot be. The need that is manifest in the urgent impulsions that demand completion through what the environment—and it alone—can supply, is a dynamic acknowledgment of this dependence of the self for wholeness upon its surroundings.

It is the fate of a living creature, however, that it cannot secure what belongs to it without an adventure in a world that as a whole it does not own and to which it has no native title. Whenever the organic impulse exceeds the limit of the body, it finds itself in a strange world and commits in some measure the fortune of the self to external circumstance. It cannot pick just what it wants and automatically leave the indifferent and adverse out of account. If, and as far as, the organism continues to develop, it is helped on as a favoring wind helps the runner. But the impulsion also meets many things on its outbound course that deflect and oppose it. In the process of converting these obstacles and neutral conditions into favoring agencies, the live creature becomes aware of the intent implicit in its impulsion. The self, whether it succeed or fail, does not merely restore itself to its former state. Blind surge has been

changed into a purpose; instinctive tendencies are transformed into contrived undertakings. The attitudes of the self are informed with meaning.

An environment that was always and everywhere congenial to the straightaway execution of our impulses would set a term to growth as surely as one always hostile would irritate and destroy. Impulse forever boosted on its forward way would run its course thoughtless, and dead to emotion. For it would not have to give an account of itself in terms of the things it encounters, and hence they would not become significant objects. The only way it can become aware of its nature and its goal is by obstacles surmounted and means employed; means which are only means from the very beginning are too much one with an impulsion, on a way smoothed and oiled in advance, to permit of consciousness of them. Nor without resistance from surroundings would the self become aware of itself; it would have neither feeling nor interest, neither fear nor hope, neither disappointment nor elation. Mere opposition that completely thwarts, creates irritation and rage. But resistance that calls out thought generates curiosity and solicitous care, and, when it is overcome and utilized, eventuates in elation.

That which merely discourages a child and one who lacks a matured background of relevant experiences is an incitement to intelligence to plan and convert emotion into interest, on the part of those who have previously had experiences of situations sufficiently akin to be drawn upon. Impulsion from need starts an experience that does not know where it is going; resistance and check bring about the conversion of direct forward action into reflection; what is turned back upon is the relation of hindering conditions to what the self possesses as working capital in virtue of prior experiences. As the energies thus involved re-enforce the original impulsion, this operates more circumspectly with insight into end and method. Such is the outline of every experience that is clothed with meaning.

That tension calls out energy and that total lack of opposition does not favor normal development are familiar facts. In a general

way, we all recognize that a balance between furthering and retarding conditions is the desirable state of affairs—provided that the adverse conditions bear intrinsic relation to what they obstruct instead of being arbitrary and extraneous. Yet what is evoked is not just quantitative, or just more energy, but is qualitative, a transformation of energy into thoughtful action, through assimilation of meanings from the background of past experiences. The junction of the new and old is not a mere composition of forces, but is a re-creation in which the present impulsion gets form and solidity while the old, the "stored," material is literally revived, given new life and soul through having to meet a new situation.

It is this double change which converts an activity into an act of expression. Things in the environment that would otherwise be mere smooth channels or else blind obstructions become means, media. At the same time, things retained from past experience that would grow stale from routine or inert from lack of use, become coefficients in new adventures and put on a raiment of fresh meaning. Here are all the elements needed to define expression. The definition will gain force if the traits mentioned are made explicit by contrast with alternative situations. Not all outgoing activity is of the nature of expression. At one extreme, there are storms of passion that break through barriers and that sweep away whatever intervenes between a person and something he would destroy. There is activity, but not, from the standpoint of the one acting, expression. An onlooker may say "What a magnificent expression of rage!" But the enraged being is only raging, quite a different matter from *expressing* rage. Or, again, some spectator may say "How that man is expressing his own dominant character in what he is doing or saying." But the last thing the man in question is thinking of is to express his character; he is only giving way to a fit of passion. Again the cry or smile of an infant may be expressive to mother or nurse and yet not be an act of expression of the baby. To the onlooker it is an expression because it tells something about the state of the child.

But the child is only engaged in doing something directly, no more expressive from his standpoint than is breathing or sneezing—activities that are also expressive to the observer of the infant's condition.

Generalization of such instances will protect us from the error—which has unfortunately invaded esthetic theory—of supposing that the mere giving way to an impulsion, native or habitual, constitutes expression. Such an act is expressive not in itself but only in reflective interpretation on the part of some observer—as the nurse may interpret a sneeze as the sign of an impending cold. As far as the act itself is concerned, it is, if purely impulsive, just a boiling over. While there is no expression, unless there is urge from within outwards, the welling up must be clarified and ordered by taking into itself the values of prior experiences before it can be an act of expression. And these values are not called into play save through objects of the environment that offer resistance to the direct discharge of emotion and impulse. Emotional discharge is a necessary but not a sufficient condition of expression.

There is no expression without excitement, without turmoil. Yet an inner agitation that is discharged at once in a laugh or cry, passes away with its utterance. To discharge is to get rid of, to dismiss; to express is to stay by, to carry forward in development, to work out to completion. A gush of tears may bring relief, a spasm of destruction may give outlet to inward rage. But where there is no administration of objective conditions, no shaping of materials in the interest of embodying the excitement, there is no expression. What is sometimes called an act of self-expression might better be termed one of self-exposure; it discloses character—or lack of character—to others. In itself, it is only a spewing forth.

The transition from an act that is expressive from the standpoint of an outside observer to one intrinsically expressive is readily illustrated by a simple case. At first a baby weeps, just as it turns its head to follow light; there is an inner urge but nothing to express. As the infant matures, he learns that particular acts effect different consequences, that, for example, he gets attention if he

cries, and that smiling induces another definite response from those about him. He thus begins to be aware of the *meaning* of what he does. As he grasps the meaning of an act at first performed from sheer internal pressure, he becomes capable of acts of true expression. The transformation of sounds, babblings, lalling, and so forth, into language is a perfect illustration of the way in which acts of expression are brought into existence and also of the difference between them and mere acts of discharge.

There is suggested, if not exactly exemplified, in such cases the connection of expression with art. The child who has learned the effect his once spontaneous act has upon those around him performs "on purpose" an act that was blind. He begins to manage and order his activities in reference to their consequences. The consequences undergone because of doing are incorporated as the meaning of subsequent doings because the relation between doing and undergoing is perceived. The child may now cry for a purpose, because he wants attention or relief. He may begin to bestow his smiles as inducements or as favors. There is now art in incipiency. An activity that was "natural"—spontaneous and unintended—is transformed because it is undertaken as a means to a consciously entertained consequence. Such transformation marks every deed of art. The result of the transformation may be artful rather than esthetic. The fawning smile and conventional smirk of greeting are artifices. But the genuinely gracious act of welcome contains also a change of an attitude that was once a blind and "natural" manifestation of impulsion into an act of art, something performed in view of its place or relation in the processes of intimate human intercourse.

The difference between the artificial, the artful, and the artistic lies on the surface. In the former there is a split between what is overtly done and what is intended. The appearance is one of cordiality; the intent is that of gaining favor. Wherever this split between what is done and its purpose exists, there is insincerity, a trick, a simulation of an act that intrinsically has another effect. When the natural and the cultivated blend in one, acts of social intercourse are works of art. The animating impulsion of genial

friendship and the deed performed completely coincide without intrusion of ulterior purpose. Awkwardness may prevent adequacy of expression. But the skillful counterfeit, however skilled, goes *through* the form of expression; it does not have the form of friendship and abide in it. The substance of friendship is untouched.

An act of discharge or mere exhibition lacks a medium. Instinctive crying and smiling no more require a medium than do sneezing and winking. They occur through some channel, but the means of outlet are not used as immanent means of an end. The act that *expresses* welcome uses the smile, the outreached hand, the lighting up of the face as media, not consciously but because they have become organic means of communicating delight upon meeting a valued friend. Acts that were primitively spontaneous are converted into means that make human intercourse more rich and gracious—just as a painter converts pigment into means of expressing an imaginative experience. Dance and sport are activities in which acts once performed spontaneously in separation are assembled and converted from raw, crude material into works of expressive art. Only where material is employed as media is there expression and art. Savage taboos that look to the outsider like mere prohibitions and inhibitions externally imposed may be to those who experience them media of expressing social status, dignity, and honor. Everything depends upon the way in which material is used when it operates as medium.

The connection between a medium and the act of expression is intrinsic. An act of expression always employs natural material, though it may be natural in the sense of habitual as well as in that of primitive or native. It becomes a medium when it is employed in view of its place and rôle, in its relations, an inclusive situation— as tones become music when ordered in a melody. The same tones might be uttered in connection with an attitude of joy, surprise, or sadness, and be natural outlets of particular feelings. They are *expressive* of one of these emotions when other tones are the medium in which one of them occurs.

Etymologically, an act of expression is a squeezing out, a pressing forth. Juice is expressed when grapes are crushed in the

wine press; to use a more prosaic comparison, lard and oil are rendered when certain fats are subjected to heat and pressure. Nothing is pressed forth except from original raw or natural material. But it is equally true that the mere issuing forth or discharge of raw material is not expression. Through interaction with something external to it, the wine press, or the treading foot of man, juice results. Skin and seeds are separated and retained; only when the apparatus is defective are they discharged. Even in the most mechanical modes of expression there is interaction and a consequent transformation of the primitive material which stands as raw material for a product of art, in relation to what is actually pressed out. It takes the wine press as well as grapes to ex-press juice, and it takes environing and resisting objects as well as internal emotion and impulsion to constitute an *expression* of emotion.

Speaking of the production of poetry, Samuel Alexander remarked that "the artist's work proceeds not from a finished imaginative experience to which the work of art corresponds, but from passionate excitement about the subject matter. . . . The poet's poem is wrung from him by the subject which excites him." The passage is a text upon which we may hang four comments. One of these comments may pass for the present as a reënforcement of a point made in previous chapters. The real work of art is the building up of an integral experience out of the interaction of organic and environmental conditions and energies. Nearer to our present theme is the second point: The thing expressed is wrung from the producer by the pressure exercised by objective things upon the natural impulses and tendencies—so far is expression from being the direct and immaculate issue of the latter. The third point follows. The act of expression that constitutes a work of art is a construction in time, not an instantaneous emission. And this statement signifies a great deal more than that it takes time for the painter to transfer his imaginative conception to canvass and for the sculptor to complete his chipping of marble. It means that the expression of the self in and through a medium, constituting the work of art, is *itself* a prolonged interaction of something issuing from the self with objective conditions, a process in which both of

them acquire a form and order they did not at first possess. Even the Almighty took seven days to create the heaven and the earth, and, if the record were complete, we should also learn that it was only at the end of that period that he was aware of just what He set out to do with the raw material of chaos that confronted Him. Only an emasculated subjective metaphysics has transformed the eloquent myth of Genesis into the conception of a Creator creating without any unformed matter to work upon.

The final comment is that when excitement about subject matter goes deep, it stirs up a store of attitudes and meanings derived from prior experience. As they are aroused into activity they become conscious thoughts and emotions, emotionalized images. To be set on fire by a thought or scene is to be inspired. What is kindled must either burn itself out, turning to ashes, or must press itself out in material that changes the latter from crude metal into a refined product. Many a person is unhappy, tortured within, because he has at command no art of expressive action. What under happier conditions might be used to convert objective material into material of an intense and clear experience, seethes within in unruly turmoil which finally dies down after, perhaps, a painful inner disruption.

Materials undergoing combustion because of intimate contacts and mutually exercised resistances constitute inspiration. On the side of the self, elements that issue from prior experience are stirred into action in fresh desires, impulsions and images. These proceed from the subconscious, not cold or in shapes that are identified with particulars of the past, not in chunks and lumps, but fused in the fire of internal commotion. They do not seem to come from the self, because they issue from a self not consciously known. Hence, by a just myth, the inspiration is attributed to a god, or to the muse. The inspiration, however, is initial. In itself, at the outset, it is still inchoate. Inflamed inner material must find objective fuel upon which to feed. Through the interaction of the fuel with material already afire the refined and formed product comes into existence. The act of expression is not something which supervenes upon an inspiration already complete. It is the

carrying forward to completion of an inspiration by means of the objective material of perception and imagery.*

An impulsion cannot lead to expression save when it is thrown into commotion, turmoil. Unless there is com-pression nothing is ex-pressed. The turmoil marks the place where inner impulse and contact with environment, in fact or in idea, meet and create a ferment. The war dance and the harvest dance of the savage do not issue from within except there be an impending hostile raid or crops that are to be gathered. To generate the indispensable excitement there must be something at stake, something momentous and uncertain—like the outcome of a battle or the prospects of a harvest. A sure thing does not arouse us emotionally. Hence it is not mere excitement that is expressed but excitement-about-something; hence, also, it is that even mere excitement, short of complete panic, will utilize channels of action that have been worn by prior activities that dealt with objects. Thus, like the movements of an actor who goes through his part automatically, it simulates expression. Even an undefined uneasiness seeks outlet in song or pantomime, striving to become articulate.

Erroneous views of the nature of the act of expression almost all have their source in the notion that an emotion is complete in itself within, only when uttered having impact upon external material. But, in fact, an emotion is *to* or *from* or *about* something objective, whether in fact or in idea. An emotion is implicated in a situation, the issue of which is in suspense and in which the self that is moved in the emotion is vitally concerned. Situations are depressing, threatening, intolerable, triumphant. Joy in the victory

*In his interesting "The Theory of Poetry," Mr. Lascelles Abercrombie wavers between two views of inspiration. One of them takes what seems to me the correct interpretation. In the poem, an inspiration "completely and exquisitely defines itself." At other times, he says the inspiration *is* the poem; "something self-contained and self-sufficient, a complete and entire whole." He says that "each inspiration is something which did not and could not originally exist as words." Doubtless such is the case; not even a trigonometric function exists merely as words. But if it is already self-sufficient and self-contained, why does it seek and find words as a medium of expression?

won by a group with which a person is identified is not something internally complete, nor is sorrow upon the death of a friend anything that can be understood save as an interpenetration of self with objective conditions.

This latter fact is especially important in connection with the individualization of works of art. The notion that expression is a direct emission of an emotion complete in itself entails logically that individualization is specious and external. For, according to it, fear is fear, elation is elation, love is love, each being generic, and internally differentiated only by differences of intensity. Were this idea correct, works of art would necessarily fall within certain types. This view has infected criticism but not so as to assist understanding of concrete works of art. Save nominally, there is no such thing as *the* emotion of fear, hate, love. The unique, unduplicated character of experienced events and situations impregnates the emotion that is evoked. Were it the function of speech to reproduce that to which it refers, we could never speak of fear, but only of fear-of-this-particular-oncoming-automobile, with all its specifications of time and place, or fear-under-specified-circumstances-of-drawing-a-wrong-conclusion from just-such-and-such-data. A lifetime would be too short to reproduce in words a single emotion. In reality, however, poet and novelist have an immense advantage over even an expert psychologist in dealing with an emotion. For the former build up a concrete situation and permit *it* to evoke emotional response. Instead of a description of an emotion in intellectual and symbolic terms, the artist "does the deed that breeds" the emotion.

That art is selective is a fact universally recognized. It is so because of the rôle of emotion in the act of expression. Any predominant mood automatically excludes all that is uncongenial with it. An emotion is more effective than any deliberate challenging sentinel could be. It reaches out tentacles for that which is cognate, for things which feed it and carry it to completion. Only when emotion dies or is broken to dispersed fragments, can material to which it is alien enter consciousness. The selective operation of materials so powerfully exercised by a developing emotion in a series of continued acts extracts matter from a multitude of

objects, numerically and spatially separated, and condenses what is abstracted in an object that is an epitome of the values belonging to them all. This function creates the "universality" of a work of art.

If one examines the reason why certain works of art offend us, one is likely to find that the cause is that there is no personally felt emotion guiding the selecting and assembling of the materials presented. We derive the impression that the artist, say the author of a novel, is trying to regulate by conscious intent the nature of the emotion aroused. We are irritated by a feeling that he is manipulating materials to secure an effect decided upon in advance. The facets of the work, the variety so indispensable to it, are held together by some external force. The movement of the parts and the conclusion disclose no logical necessity. The author, not the subject matter, is the arbiter.

In reading a novel, even one written by an expert craftsman, one may get a feeling early in the story that hero or heroine is doomed, doomed not by anything inherent in situations and character but by the intent of the author who makes the character a puppet to set forth his own cherished idea. The painful feeling that results is resented not because it is painful but because it is foisted upon us by something that we feel comes from outside the movement of the subject matter. A work may be much more tragic and yet leave us with an emotion of fulfillment instead of irritation. We are reconciled to the conclusion because we feel it is inherent in the movement of the subject matter portrayed. The incident is tragic but the world in which such fateful things happen is not an arbitrary and imposed world. The emotion of the author and that aroused in us are occasioned by scenes in that world and they blend with subject matter. It is for similar reasons that we are repelled by the intrusion of a moral design in literature while we esthetically accept any amount of moral content if it is held together by a sincere emotion that controls the material. A white flame of pity or indignation may find material that feeds it and it may fuse everything assembled into a vital whole.

Just because emotion is essential to that act of expression which produces a work of art, it is easy for inaccurate analysis to

misconceive its mode of operation and conclude that the work of art has emotion for its significant content. One may cry out with joy or even weep upon seeing a friend from whom one has been long separated. The outcome is not an expressive object—save to the onlooker. But if the emotion leads one to gather material that is affiliated to the mood which is aroused, a poem may result. In the direct outburst, an objective situation is the stimulus, the cause, of the emotion. In the poem, objective material becomes the content and matter of the emotion, not just its evocative occasion.

In the development of an expressive act, the emotion operates like a magnet drawing to itself appropriate material: appropriate because it has an experienced emotional affinity for the state of mind already moving. Selection and organization of material are at once a function and a test of the quality of the emotion experienced. In seeing a drama, beholding a picture, or reading a novel, we may feel that the parts do not hang together. Either the maker had no experience that was emotionally toned, or, although having at the outset a felt emotion, it was not sustained, and a succession of unrelated emotions dictated the work. In the latter case, attention wavered and shifted, and an assemblage of incongruous parts ensued. The sensitive observer or reader is aware of junctions and seams, of holes arbitrarily filled in. Yes, emotion must operate. But it works to effect continuity of movement, singleness of effect amid variety. It is selective of material and directive of its order and arrangement. But it is not *what* is expressed. Without emotion, there may be craftsmanship, but not art; it may be present and be intense, but if it is directly manifested the result is also not art.

There are other works that are overloaded with emotion. On the theory that manifestation of an emotion is its expression, there could be no overloading; the more intense the emotion, the more effective the "expression." In fact, a person overwhelmed by an emotion is thereby incapacitated for expressing it. There is at least that element of truth in Wordsworth's formula of "emotion recollected in tranquillity." There is, when one is mastered by an emotion, too much undergoing (in the language by which having an experience has been described) and too little active response to

permit a balanced relationship to be struck. There is too much "nature" to allow of the development of art. Many of the paintings of Van Gogh, for example, have an intensity that arouses an answering chord. But with the intensity, there is an explosiveness due to absence of assertion of control. In extreme cases of emotion, it works to disorder instead of ordering material. Insufficient emotion shows itself in a coldly "correct" product. Excessive emotion obstructs the necessary elaboration and definition of parts.

The determination of the *mot juste,* of the right incident in the right place, of exquisiteness of proportion, of the precise tone, hue, and shade that helps unify the whole while it defines a part, is accomplished by emotion. Not every emotion, however, can do this work, but only one informed by material that is grasped and gathered. Emotion is informed and carried forward when it is spent indirectly in search for material and in giving it order, not when it is directly expended.

Works of art often present to us an air of spontaneity, a lyric quality, as if they were the unpremeditated song of a bird. But man, whether fortunately or unfortunately, is not a bird. His most spontaneous outbursts, if expressive, are not overflows of momentary internal pressures. The spontaneous in art is complete absorption in subject matter that is fresh, the freshness of which holds and sustains emotion. Staleness of matter and obtrusion of calculation are the two enemies of spontaneity of expression. Reflection, even long and arduous reflection, may have been concerned in the generation of material. But an expression will, nevertheless, manifest spontaneity if that matter has been vitally taken up into a present experience. The inevitable self-movement of a poem or drama is compatible with any amount of prior labor provided the results of that labor emerge in complete fusion with an emotion that is fresh. Keats speaks poetically of the way in which artistic expression is reached when he tells of the "innumerable compositions and decompositions which take place between the intellect and its thousand materials before it

arrives at that trembling, delicate and snail-horn perception of beauty."

Each of us assimilates into himself something of the values and meanings contained in past experiences. But we do so in differing degrees and at differing levels of selfhood. Some things sink deep, others stay on the surface and are easily displaced. The old poets traditionally invoked the muse of Memory as something wholly outside themselves—outside their present conscious selves. The invocation is a tribute to the power of what is most deep-lying and therefore the furthest below consciousness, in determination of the present self and of what it has to say. It is not true that we "forget" or drop into unconsciousness only alien and disagreeable things. It is even more true that the things which we have most completely made a part of ourselves, that we have assimilated to compose our personality and not merely retained as incidents, cease to have a separate conscious existence. Some occasion, be it what it may, stirs the personality that has been thus formed. Then comes the need for expression. What is expressed will be neither the past events that have exercised their shaping influence nor yet the literal existing occasion. It will be, in the degree of its spontaneity, an intimate union of the features of present existence with the values that past experience have incorporated in personality. Immediacy and individuality, the traits that mark concrete existence, come from the present occasion; meaning, substance, content, from what is embedded in the self from the past.

I do not think that the dancing and singing of even little children can be explained wholly on the basis of unlearned and unformed responses to then existing objective occasions. Clearly there must be something in the present to evoke happiness. But the act is expressive only as there is in it a unison of something stored from past experience, something therefore generalized, with present conditions. In the case of the expressions of happy children the marriage of past values and present incidents takes place easily; there are few obstructions to be overcome, few wounds to heal, few conflicts to resolve. With maturer persons, the reverse is the case. Accordingly the achievement of complete unison is rare; but when it occurs it is so on a deeper level and with a fuller content of

meaning. And then, even though after long incubation and after precedent pangs of labor, the final expression may issue with the spontaneity of the cadenced speech or rhythmic movement of happy childhood.

In one of his letters to his brother Van Gogh says that "emotions are sometimes so strong that one works without knowing that one works, and the strokes come with a sequence and coherence like that of words in a speech or letter." Such fullness of emotion and spontaneity of utterance come, however, only to those who have steeped themselves in experiences of objective situations; to those who have long been absorbed in observation of related material and whose imaginations have long been occupied with reconstructing what they see and hear. Otherwise the state is more like one of frenzy in which the sense of orderly production is subjective and hallucinatory. Even the volcano's outburst presupposes a long period of prior compression, and, if the eruption sends forth molten lava and not merely separate rocks and ashes, it implies a transformation of original raw materials. "Spontaneity" is the result of long periods of activity, or else it is so empty as not to be an act of expression.

What William James wrote about religious experience might well have been written about the antecedents of acts of expression. "A man's conscious wit and will are aiming at something only dimly and inaccurately imagined. Yet all the while the forces of mere organic ripening within him are going on to their own prefigured result, and his conscious strainings are letting loose subconscious allies behind the scenes which in their way work toward rearrangement, and the rearrangement toward which all these deeper forces tend is pretty surely definite, and definitely different from what he consciously conceives and determines. It may consequently be actually interfered with (jammed as it were) by his voluntary efforts slanting toward the true direction." Hence, as he adds, "When the new center of energy has been subconsciously incubated so long as to be just ready to burst into flower, 'hands off' is the only word for us; it must burst forth unaided."

It would be difficult to find or give a better description of the nature of spontaneous expression. Pressure precedes the gushing

forth of juice from the wine press. New ideas come leisurely yet promptly to consciousness only when work has previously been done in forming the right doors by which they may gain entrance. Subconscious maturation precedes creative production in every line of human endeavor. The direct effort of "wit and will" of itself never gave birth to anything that is not mechanical; their function is necessary, but it is to let loose allies that exist outside their scope. At different times we brood over different things; we entertain purposes that, as far as consciousness is concerned, are independent, being each appropriate to its own occasion; we perform different acts, each with its own particular result. Yet as they all proceed from one living creature they are somehow bound together below the level of intention. They work together, and finally something is born almost in spite of conscious personality, and certainly not because of its deliberate will. When patience has done its perfect work, the man is taken possession of by the appropriate muse and speaks and sings as some god dictates.

Persons who are conventionally set off from artists, "thinkers," scientists, do not operate by conscious wit and will to anything like the extent popularly supposed. They, too, press forward toward some end dimly and imprecisely prefigured, groping their way as they are lured on by the identity of an aura in which their observations and reflections swim. Only the psychology that has separated things which in reality belong together holds that scientists and philosophers think while poets and painters follow their feelings. In both, and to the same extent in the degree in which they are of comparable rank, there is emotionalized thinking, and there are feelings whose substance consists of appreciated meanings or ideas. As I have already said, the only significant distinction concerns the kind of material to which emotionalized imagination adheres. Those who are called artists have for their subject-matter the qualities of things of direct experience; "intellectual" inquirers deal with these qualities at one remove, through the medium of symbols that stand for qualities but are not significant in their immediate presence. The ultimate difference is enormous as far as the technique of thought and emotion are concerned. But there is no difference as far as dependence on emo-

tionalized ideas and subconscious maturing are concerned. Thinking directly in terms of colors, tones, images, is a different operation technically from thinking in words. But only superstition will hold that, because the meaning of paintings and symphonies cannot be translated into words, or that of poetry into prose, therefore thought is monopolized by the latter. If all meanings could be adequately expressed by words, the arts of painting and music would not exist. There are values and meanings that can be expressed only by immediately visible and audible qualities, and to ask what they mean in the sense of something that can be put into words is to deny their distinctive existence.

Different persons differ in the relative amount of participation of conscious wit and will which go into their acts of expression. Edgar Allan Poe left an account of the process of expression as it is engaged in by those of the more deliberate cast of mind. He is telling about what went on when he wrote "The Raven," and says: "The public is rarely permitted to take a peep behind the scenes at the vacillating crudities, of the true purpose seized at the last moment, at the wheels and pinions, the tackle for scene shifting, the step ladders and demon traps, the red paint and black patches, which, in ninety-nine cases out of a hundred, constitute the properties of the literary *histrio.*"

It is not necessary to take the numerical ration stated by Poe too seriously. But the substance of what he says is a picturesque presentation of a sober fact. The primitive and raw material of experience needs to be reworked in order to secure artistic expression. Oftentimes, this need is greater in cases of "inspiration" than in other cases. In this process the emotion called out by the original material is modified as it comes to be attached to the new material. This fact gives us the clue to the nature of esthetic emotion.

With respect to the physical materials that enter into the formation of a work of art, every one knows that they must undergo change. Marble must be chipped; pigments must be laid on canvas; words must be put together. It is not so generally recognized that a similar transformation takes place on the side of "inner" materials, images, observations, memories and emotions. They are also progressively re-formed; they, too, must be administered.

This modification is the building up of a truly expressive act. The impulsion that seethes as a commotion demanding utterance must undergo as much and as careful management in order to receive eloquent manifestation as marble or pigment, as colors and sounds. Nor are there in fact two operations, one performed upon the outer material and the other upon the inner and mental stuff.

The work is artistic in the degree in which the two functions of transformation are effected by a single operation. As the painter places pigment upon the canvas, or imagines it placed there, his ideas and feeling are also ordered. As the writer composes in his medium of words what he wants to say, his idea takes on for himself perceptible form.

The sculptor conceives his statue, not just in mental terms but in those of clay, marble or bronze. Whether a musician, painter, or architect works out his original emotional idea in terms of auditory or visual imagery or in the actual medium as he works is of relatively minor importance. For the imagery is of the objective medium undergoing development. The physical media may be ordered in imagination or in concrete material. In any case, the physical process develops imagination, while imagination is conceived in terms of concrete material. Only by progressive organization of "inner" and "outer" material in organic connection with each other can anything be produced that is not a learned document or an illustration of something familiar.

Suddenness of emergence belongs to appearance of material above the threshold of consciousness, not to the process of its generation. Could we trace any such manifestation to its roots and follow it through its history, we should find at the beginning an emotion comparatively gross and undefined. We should find that it assumed definite shape only as it worked itself through a series of changes in imagined material. What most of us lack in order to be artists is not the inceptive emotion, nor yet merely technical skill in execution. It is capacity to work a vague idea and emotion over into terms of some definite medium. Were expression but a kind of decalcomania, or a conjuring of a rabbit out of the place where it lies hid, artistic expression would be a comparatively simple matter. But between conception and bringing to birth there lies a

long period of gestation. During this period the inner material of emotion and idea is as much transformed through acting and being acted upon by objective material as the latter undergoes modification when it becomes a medium of expression.

It is precisely this transformation that changes the character of the original emotion, altering its quality so that it becomes distinctively esthetic in nature. In formal definition, emotion is esthetic when it adheres to an object formed by an expressive act, in the sense in which the act of expression has been defined.

In its beginning an emotion flies straight to its object. Love tends to cherish the loved object as hate tends to destroy the thing hated. Either emotion may be turned aside from its direct end. The emotion of love may seek and find material that is other than the directly loved one, but that is congenial and cognate through the emotion that draws things into affinity. This other material may be anything as long as it feeds the emotion. Consult the poets, and we find that love finds its expression in rushing torrents, still pools, in the suspense that awaits a storm, a bird poised in flight, a remote star or the fickle moon. Nor is this material metaphorical in character, if by "metaphor" is understood the result of any act of conscious comparison. Deliberate metaphor in poetry is the recourse of mind when emotion does not saturate material. Verbal expression may take the form of metaphor, but behind the words lies an act of emotional identification, not an intellectual comparison.

In all such cases, some object emotionally akin to the direct object of emotion takes the place of the latter. It acts in place of a direct caress, of hesitating approach, of trying to carry by storm. There is truth in Hulme's statement that "beauty is the marking time, the stationary vibration, the feigned ecstasy, of an arrested impulse unable to reach its natural end."* If there is anything wrong with the statement, it is the veiled intimation that the impulsion *ought* to have reached "its natural end." If the emotion of love between the sexes had not been celebrated by means of diversion into material emotionally cognate but practically irrelevant to

*Speculations, p. 266.

its direct object and end, there is every reason to suppose it would still remain on the animal plane. The impulse arrested in its direct movement toward its physiologically normal end is not, in the case of poetry, arrested in an absolute sense. It is turned into indirect channels where it finds other material than that which is "naturally" appropriate to it, and as it fuses with this material it takes on new color and has new consequences. This is what happens when any natural impulse is idealized or spiritualized. That which elevates the embrace of lovers above the animal plane is just the fact that when it occurs it has taken into itself, as its own meaning, the consequences of these indirect excursions that are imagination in action.

Expression is the clarification of turbid emotion; our appetites know themselves when they are reflected in the mirror of art, and as they know themselves they are transfigured. Emotion that is distinctively esthetic then occurs. It is not a form of sentiment that exists independently from the outset. It is an emotion induced by material that is expressive, and because it is evoked by and attached to this material it consists of natural emotions that have been transformed. Natural objects, landscapes, for example, induce it. But they do so only because when they are matter of an experience they, too, have undergone a change similar to that which the painter or poet effects in converting the immediate scene into the matter of an act that expresses the value of what is seen.

An irritated person is moved to do something. He cannot suppress his irritation by any direct act of will; at most he can only drive it by this attempt into a subterranean channel where it will work the more insidiously and destructively. He must act to get rid of it. But he can act in different ways, one direct, the other indirect, in manifestations of his state. He cannot suppress it any more than he can destroy the action of electricity by a fiat of will. But he can harness one or the other to the accomplishment of new ends that will do away with the destructive force of the natural agency. The irritable person does not have to take it out on neighbors or members of his family to get relief. He may remember that a certain amount of regulated physical activity is good medicine. He sets to work tidying his room, straightening pictures that are

askew, sorting papers, clearing out drawers, putting things in order generally. He *uses* his emotion, switching it into indirect channels prepared by prior occupations and interests. But since there is something in the utilization of these channels that is emotionally akin to the means by which his irritation would find direct discharge, as he puts objects in order his emotion is ordered.

This transformation is of the very essence of the change that takes place in any and every natural or original emotional impulsion when it takes the indirect road of expression instead of the direct road of discharge. Irritation may be let go like an arrow directed at a target and produce some change in the outer world. But having an outer effect is something very different from ordered use of objective conditions in order to give objective fulfillment to the emotion. The latter alone is expression and the emotion that attaches itself to, or is interpenetrated by, the resulting object is esthetic. If the person in question puts his room to rights as a matter of routine he is anesthetic. But if his original emotion of impatient irritation has been ordered and tranquillized by what he has done, the orderly room reflects back to him the change that has taken place in himself. He feels not that he has accomplished a needed chore but has done something emotionally fulfilling. His emotion as thus "objectified" is esthetic.

Esthetic emotion is thus something distinctive and yet not cut off by a chasm from other and natural emotional experiences, as some theorists in contending for its existence have made it to be. One familiar with recent literature on esthetics will be aware of a tendency to go to one extreme or the other. On one hand, it is assumed that there is in existence, at least in some gifted persons, an emotion that is aboriginally esthetic, and that artistic production and appreciation are the manifestations of this emotion. Such a conception is the inevitable logical counterpart of all attitudes that make art something esoteric and that relegate fine art to a realm separated by a gulf from everyday experiences. On the other hand, a reaction wholesome in intent against this view goes to the extreme of holding that there is no such thing as distinctively es-

thetic emotion. The emotion of affection that operates not through an overt act of caress but by searching out the observation or image of a soaring bird, the emotion of irritating energy that does not destroy or injure but that puts objects in satisfying order, is not numerically identical with its original and natural estate. Yet it stands in genetic continuity with it. The emotion that was finally wrought out by Tennyson in the composition of "In Memoriam" was not identical with the emotion of grief that manifests itself in weeping and a downcast frame: the first is an act of expression, the second of discharge. Yet the continuity of the two emotions, the fact that the esthetic emotion is native emotion transformed through the objective material to which it has committed its development and consummation, is evident.

Samuel Johnson with the Philistine's sturdy preference for reproduction of the familiar, criticized Milton's "Lycidas" in the following way: "It is not to be considered as the effusion of real passion, for passion runs not after remote allusions and obscure opinions. Passion plucks not berries from the myrtle and ivy, nor calls upon Arethusa and Mincius, nor tells of rough satyrs and fauns with cloven heel. Where there is leisure for fiction there is little grief." Of course the underlying principle of Johnson's criticism would prevent the appearance of any work of art. It would, in strict logic, confine the "expression" of grief to weeping and tearing the hair. Thus, while the particular subject matter of Milton's poem would not be used today in an elegy, it, and any other work of art, is bound to deal with the remote in one of its aspects—namely, that remote from immediate effusion of emotion and from material that is worn out. Grief that has matured beyond the need of weeping and wailing for relief will resort to something of the sort that Johnson calls fiction—that is, imaginative material, although it be different matter from literature, classic and ancient myth. In all primitive peoples wailing soon assumes a ceremonial form that is "remote" from its native manifestation.

In other words, art is not nature, but is nature transformed by entering into new relationships where it evokes a new emotional response. Many actors remain outside the particular emotion they

portray. This fact is known as Diderot's paradox since he first developed the theme. In fact, it is paradox only from the standpoint implied in the quotation from Samuel Johnson. More recent inquiries have shown, indeed, that there are two types of actors. There are those who report that they are at their best when they "lose" themselves emotionally in their rôles. Yet this fact is no exception to the principle that has been stated. For, after all, it is a rôle, a "part" with which actors identify themselves. As a part, it is conceived and treated as part of a whole; if there is art in acting, the rôle is subordinated so as to occupy the position of a part in the whole. It is thereby qualified by esthetic form. Even those who feel most poignantly the emotions of the character represented do not lose consciousness that they are on a stage where there are other actors taking part; that they are before an audience, and that they must, therefore, coöperate with other players in creating a certain effect. These facts demand and signify a definite transformation of the primitive emotion. Portrayal of intoxication is a common device of the comic stage. But a man actually drunken would have to use art to conceal his condition if he is not to disgust his audience, or at least to excite a laughter that differs radically from that excited by intoxication when acted. The difference between the two types of actors is not a difference between expression of an emotion controlled by the relations of the situation into which it enters and a manifestation of raw emotion. It is a difference in methods of bringing about the desired effect, a difference doubtless connected with personal temperament.

Finally, what has been said locates, even if it does not solve, the vexed problem of the relation of esthetic or fine art to other modes of production also called art. The difference that exists in fact cannot be leveled, as we have already seen, by defining both in terms of technique and skill. But neither can it be erected into a barrier that is insuperable by referring the creation of fine art to an impulse that is unique, separated from impulsions which work in modes of expression not usually brought under the caption of fine art. Conduct can be sublime and manners gracious. If impulsion toward organization of material so as to present the latter in a form directly fulfilling in experience had no existence outside the

arts of painting, poetry, music, and sculpture, it would not exist anywhere; there would be no fine art.

The problem of conferring esthetic quality upon all modes of production is a serious problem. But it is a human problem for human solution; not a problem incapable of solution because it is set by some unpassable gulf in human nature or in the nature of things. In an imperfect society—and no society will ever be perfect—fine art will be to some extent an escape from, or an adventitious decoration of, the main activities of living. But in a better-ordered society than that in which we live, an infinitely greater happiness than is now the case would attend all modes of production. We live in a world in which there is an immense amount of organization, but it is an external organization, not one of the ordering of a growing experience, one that involves, moreover, the whole of the live creature, toward a fulfilling conclusion. Works of art that are not remote from common life, that are widely enjoyed in a community, are signs of a unified collective life. But they are also marvelous aids in the creation of such a life. The remaking of the material of experience in the act of expression is not an isolated event confined to the artist and to a person here and there who happens to enjoy the work. In the degree in which art exercises its office, it is also a remaking of the experience of the community in the direction of greater order and unity.

EXPRESSION, like construction, signifies both an action and its result. The last chapter considered it as an act. We are now concerned with the product, the object that is expressive, that says something to us. If the two meanings are separated, the object is viewed in isolation from the operation which produced it, and therefore apart from individuality of vision, since the act proceeds from an individual live creature. Theories which seize upon "expression," as if it denoted simply the object, always insist to the uttermost that the object of art is purely representative of other objects already in existence. They ignore the individual contribution which makes the object something new. They dwell upon its "universal" character, and upon its meaning—an ambiguous term, as we shall see. On the other hand, isolation of the act of expressing from the expressiveness possessed by the object leads to

the notion that expression is merely a process of discharging personal emotion—the conception criticized in the last chapter.

The juice expressed by the wine press is what it is because of a prior act, and it is something new and distinctive. It does not merely represent other things. Yet it has something in common with other objects and it is made to appeal to other persons than the one who produced it. A poem and picture present material passed through the alembic of personal experience. They have no precedents in existence or in universal being. But, nonetheless, their material came from the public world and so has qualities in common with the material of other experiences, while the product awakens in other persons new perceptions of the meanings of the common world. The oppositions of individual and universal, of subjective and objective, of freedom and order, in which philosophers have reveled, have no place in the work of art. Expression as personal act and as objective result are organically connected with each other.

It is not necessary, therefore, to go into these metaphysical questions. We may approach the matter directly. What does it mean to say that a work of art is representative, since it must be representative in some sense if it is expressive? To say in general that a work of art is or is not representative is meaningless. For the word has many meanings. An affirmation of representative quality may be false in one sense and true in another. If literal reproduction is signified by "representative" then the work of art is not of that nature, for such a view ignores the uniqueness of the work due to the personal medium through which scenes and events have passed. Matisse said that the camera was a great boon to painters, since it relieved them from any apparent necessity of copying objects. But representation may also mean that the work of art tells something to those who enjoy it about the nature of their own experience of the world: that it presents the world in a new experience which they undergo.

A similar ambiguity attends the question of meaning in a work of art. Words are symbols which represent objects and actions in the sense of standing for them; in that sense they have meaning. A signboard has meaning when it says so many miles to

such and such a place, with an arrow pointing the direction. But meaning in these two cases has a purely external reference; it stands for something by pointing to it. Meaning does not belong to the word and signboard of its own intrinsic right. They have meaning in the sense in which an algebraic formula or a cipher code has it. But there are other meanings that present themselves directly as possessions of objects which are experienced. Here there is no need for a code or convention of interpretation; the meaning is as inherent in immediate experience as is that of a flower garden. Denial of meaning to a work of art thus has two radically different significations. It may signify that a work of art has not the kind of meaning that belongs to signs and symbols in mathematics—a contention that is just. Or it may signify that the work of art is without meaning as nonsense is without it. The work of art certainly does not have that which is had by flags when used to signal another ship. But it does have that possessed by flags when they are used to decorate the deck of a ship for a dance.

Since there are presumably none who intend to assert that works of art are without meaning in the sense of being senseless, it might seem as if they simply intended to exclude external meaning, meaning that resides outside the work of art itself. Unfortunately, however, the case is not so simple. The denial of meaning to art usually rests upon the assumption that the kind of value (and meaning) that a work of art possesses is so unique that it is without community or connection with the contents of other modes of experience than the esthetic. It is, in short, another way of upholding what I have called the esoteric idea of fine art. The conception implied in the treatment of esthetic experience set forth in the previous chapters is, indeed, that the work of art has a unique *quality,* but that it is that of clarifying and concentrating meanings contained in scattered and weakened ways in the material of other experiences.

The problem in hand may be approached by drawing a distinction between expression and statement. Science states meanings; art expresses them. It is possible that this remark will itself illustrate the difference I have in mind better than will any amount

of explanatory comment. Yet I venture upon some degree of amplification. The instance of a signboard may help. It directs one's course to a place, say a city. It does not in any way supply experience of that city even in a vicarious way. What it does do is to set forth some of the conditions that must be fulfilled in order to procure that experience. What holds in this instance may be generalized. Statement sets forth the conditions under which an experience of an object or situation may be had. It is a good, that is, effective, statement in the degree in which these conditions are stated in such a way that they can be used as *directions* by which one may arrive at the experience. It is a bad statement, confused and false, if it sets forth these conditions in such a way that when they are used as directions, they mislead or take one to the object in a wasteful way.

"Science" signifies just that mode of statement that is most helpful as direction. To take the old standard case—which science today seems bent upon modifying—the statement that water is H_2O is primarily a statement of the conditions under which water comes into existence. But it is also for those who understand it a direction for producing pure water and for testing anything that is likely to be taken for water. It is a "better" statement than popular and pre-scientific ones just because in stating the conditions for the existence of water comprehensively and exactly, it sets them forth in a way that gives direction concerning generation of water. Such, however, is the newness of scientific statement and its present prestige (due ultimately to its directive efficacy) that scientific statement is often thought to possess more than a signboard function and to disclose or be "expressive" of the inner nature of things. If it did, it would come into competition with art, and we should have to take sides and decide which of the two promulgates the more genuine revelation.

The poetic as distinct from the prosaic, esthetic art as distinct from scientific, expression as distinct from statement, does something different from leading to an experience. It constitutes one. A traveler who follows the statement or direction of a signboard finds himself in the city that has been pointed towards. He then may *have* in his own experience some of the meaning which the

city possesses. We may have it to such an extent that the city has expressed itself to him—as Tintern Abbey expressed itself to Wordsworth in and through his poem. The city might, indeed, be trying to express itself in a celebration attended with pageantry and all other resources that would render its history and spirit perceptible. Then there is, if the visitor has himself the experience that permits him to participate, an expressive object, as different from the statements of a gazetteer, however full and correct they might be, as Wordsworth's poem is different from the account of Tintern Abbey given by an antiquarian. The poem, or painting, does not operate in the dimension of correct descriptive statement but in that of experience itself. Poetry and prose, literal photograph and painting, operate in different media to distinct ends. Prose is set forth in propositions. The logic of poetry is super-propositional even when it uses what are, grammatically speaking, propositions. The latter have intent; art is an immediate realization of intent.

Van Gogh's letters to his brother are filled with accounts of things he has observed and many of which he painted. I cite one of many instances. "I have a view of the Rhone—the iron bridge at Trinquetaille, in which sky and river are the color of absinthe, the quays a shade of lilac, the figures leaning on the parapet, blackish, the iron bridge an intense blue, with a note of vivid orange in the background, and a note of intense malachite." Here is statement of a sort calculated to lead his brother to a like "view." But who, from the words alone—"I am trying to get something utterly heart-broken"—could infer the transition that Vincent himself makes to the particular *expressiveness* he desired to achieve in his picture? These words taken by themselves are not the expression; they only hint at it. The expressiveness, the esthetic meaning, is the picture itself. But the difference between the description of the scene and what he was striving for may remind us of the difference between statement and expression.

There may have been something accidental in the physical scene itself which left Van Gogh with the impression of utter desolation. Yet the meaning is there; it is there as something beyond the occasion of the painter's private experience, something that he takes to be there potentially for others. Its incorporation is the pic-

ture. Words cannot duplicate the expressiveness of the object. But words *can* point out that the picture is *not* "representative" of just a particular bridge over the Rhone River, nor yet of a broken heart, not even of Van Gogh's own emotion of desolation that happened somehow to be first excited and then absorbed by (and into) the scene. He aimed, through pictorial presentation of material that anyone on the spot might "observe," that thousands had observed, to present a *new* object experienced as having its own unique meaning. Emotional turmoil and an external episode fused in an object which was "expressive" of neither of them separately nor yet of a mechanical junction of the two, but of just the meaning of the "utterly heart-broken." He did not pour forth the emotion of desolation; that was impossible. He selected and organized an external subject matter with a view to something quite different—an expression. And in the degree in which he succeeded the picture is, of necessity, expressive.

Roger Fry, in commenting upon the characteristic features of modern painting, has generalized as follows: "Almost any turn of the kaleidoscope of nature may set up in the artist a detached and esthetic vision, and, as he contemplates the particular field of vision, the (esthetically) chaotic and accidental contemplation of forms and colours begins to crystallize into a harmony; and, as this harmony becomes clear to the artist, his actual vision becomes distorted by the emphasis of the rhythm that is set up within him. Certain relations of line become for him full of meaning; he apprehends them no longer curiously but passionately, and these lines begin to be so stressed and stand out so clearly from the rest that he sees them more distinctly than he did at first. Similarly, colours which in nature have almost always a certain vagueness and elusiveness, become so definite and clear to him, owing to their now so necessary relation to other colours, that, if he chooses to paint his vision, he can state it positively and definitely. In such a creative vision, the objects as such tend to disappear, to lose their separate unities and to take their place as so many bits in the whole mosaic of vision."

The passage seems to me an excellent account of the sort of thing that takes place in artistic perception and construction. It

makes clear two things: Representation is not, if the vision has been artistic or constructive (creative), of "objects as such," that is of items in the natural scene as they literally occur or are recalled. It is *not* the *kind* of representation that a camera would report if a detective, say, were preserving the scene for his own purpose. Moreover, the reason for this fact is clearly set forth. Certain relations of lines and colors become important, "full of meaning," and everything else is subordinated to the evocation of what is implied in these relations, omitted, distorted, added to, transformed, to convey the relationships. One thing may be added to what is said. The painter did not approach the scene with an empty mind, but with a background of experiences long ago funded into capacities and likes, or with a commotion due to more recent experiences. He comes with a mind waiting, patient, willing to be impressed and yet not without bias and tendency in vision. Hence lines and color crystallize in this harmony rather than in that. This especial mode of harmonization is not the exclusive result of the lines and colors. It is a function of what is in the actual scene in its interaction with what the beholder brings with him. Some subtle affinity with the current of his own experience as a live creature causes lines and colors to arrange themselves in one pattern and rhythm rather than in another. The passionateness that marks observation goes with the development of the new form—it is the distinctly esthetic emotion that has been spoken of. But it is not independent of some prior emotion that has stirred in the artist's experience; the latter is renewed and re-created through fusion with an emotion belonging to vision of esthetically qualified material.

If these considerations are borne in mind, a certain ambiguity that attaches to the passage quoted will be cleared up. He speaks of lines and their relations being full of meaning. But for anything explicitly stated, the meaning to which he refers might be *exclusively* of lines in their relations to one another. Then the meanings of lines and colors would completely replace all meanings that attach to this and any other experience of natural scene. In that case, the meaning of the esthetic object is unique in the sense of separation from meanings of everything else experienced. The work of art is then expressive only in the sense that it expresses something

which belongs exclusively to art. That something of this kind is intended may be inferred from another statement of Mr. Fry's that is often quoted, to the effect that "subject matter" in a work of art is always irrelevant, if not actually detrimental.

Thus the passages quoted bring to a focus the problem of the nature of "representation" in art. The emphasis of the first passage upon emergence of new lines and colors in new relations is needed. It saves those who heed it from the assumption, usual in practice if not in theory especially in connection with painting, that representation signifies either imitation or agreeable reminiscence. But the statement that subject-matter is irrelevant commits those who accept it to a completely esoteric theory of art. Mr. Fry goes on to say: "In so far as the artist looks at objects only as parts of a whole field of vision which is his own potential theory, he can give no account of their esthetic value." And he adds: ". . . the artist is of all men the most constantly observant of his surroundings, and the least affected by their intrinsic esthetic value." Otherwise, how explain the tendency of the painter to turn away from scenes and objects that possess obvious esthetic value to things that stir him because of some oddity and form? Why is he more likely to paint Soho than St. Paul's?

The tendency to which Mr. Fry refers is an actual one, just as is the tendency of critics to condemn a picture on the ground that its subject matter is "sordid," or eccentric. But it is equally true, that any authentic artist will avoid material that has previously been esthetically exploited to the full and will seek out material in which his capacity for individual vision and rendering can have free play. He leaves it to lesser men to go on saying with slight variations what has already been said. Before we decide that such considerations as these do not explain the tendency to which Mr. Fry refers, before we draw the particular inference he draws, we must return to the force of a consideration already noted.

Mr. Fry is intent upon establishing a radical difference between esthetic values that are intrinsic to things of ordinary experience and the esthetic value with which the artist is concerned. His implication is that the former is directly connected with subject matter, the latter with form that is separated from any subject

matter, save what is, esthetically, an accident. Were it possible for an artist to approach a scene with no interests and attitudes, no background of values, drawn from his prior experience, he might, theoretically, see lines and colors exclusively in terms of their relationships as lines and colors. But this is a condition impossible to fulfill. Moreover, in such a case there would be nothing for him to become passionate about. Before an artist can develop his reconstruction of the scene before him in terms of the relations of colors and lines characteristic of his picture, he observes the scene with meanings and values brought to his perception by prior experiences. These are indeed remade, transformed, as his new esthetic vision takes shape. But they cannot vanish and yet the artist continue to see an object. No matter how ardently the artist might desire it, he cannot divest himself, in his new perception, of meanings funded from his past intercourse with his surroundings, nor can he free himself from the influence they exert upon the substance and manner of his present seeing. If he could and did, there would be nothing left in the way of an object for him to see.

Aspects and states of his prior experience of varied subject-matters have been wrought into his being; they are the organs with which he perceives. Creative vision modifies these materials. They take their place in an unprecedented object of a new experience. Memories, not necessarily conscious but retentions that have been organically incorporated in the very structure of the self, feed present observation. They are the nutriment that gives body to what is seen. As they are rewrought into the matter of the new experience, they give the newly created object expressiveness.

Suppose the artist wishes to portray by means of his medium the emotional state or the enduring character of some person. By the compelling force of his medium, he will, if an artist—that is, if a painter, with disciplined respect for his medium—modify the object present to him. He will resee the object in terms of lines, colors, light, space—relations that form a pictorial whole, that is, that create an object immediately enjoyed in perception. In denying that the artist attempts to represent in the sense of literal reproduction of colors, lines, etc., as they already exist in the object, Mr. Fry is admirably right. But the inference that there is no rep-

resentation of any meanings of any subject matter whatever, no presentation that is of a subject matter having a meaning of its own which clarifies and concentrates the diffused and dulled meanings of other experiences does not follow. Generalize Mr. Fry's contention regarding painting by extension to drama or poetry and the latter cease to be.

The difference between the two kinds of representation may be indicated by reference to drawing. A person with a knack can easily jot down lines that suggest fear, rage, amusement, and so on. He indicates elation by lines curved in one direction, sorrow by curves in the opposite direction. But the result is not an object of *perception*. What is seen passes at once over into the thing suggested. The drawing is similar in kind though not in its constituents to a signboard. The object indicates rather than contains meaning. Its value is like that of the signboard to the motorist in the direction it gives to further activity. The arrangement of lines and spaces is not enjoyed in perception because of its own experienced quality but because of what it reminds us of.

There is another great difference between expression and statement. The latter is generalized. An intellectual statement is valuable in the degree in which it conducts the mind to many things all of the same kind. It is effective in the extent to which, like an even pavement, it transports us easily to many places. The meaning of an expressive object, on the contrary, is individualized. The diagrammatic drawing that suggests grief does not convey the grief of an individual person; it exhibits the *kind* of facial "expression" persons in general manifest when suffering grief. The esthetic portrayal of grief manifests the grief of a particular individual in connection with a particular event. It is *that* state of sorrow which is depicted, not depression unattached. It has a *local* habitation.

A state of beatitude is a common theme in religious paintings. Saints are presented as enjoying a condition of blissful happiness. But in most of the earlier religious paintings, this state is indicated rather than expressed. The lines that set it forth for identification are like prepositional signs. They are almost as much of a set and generalized nature as the halo that surrounds the heads of saints.

Information is conveyed of an edifying character by symbols as conventional as those which are brought in to distinguish various St. Catherines or to mark the different Marys at the foot of the cross. There is no necessary relation, but only an association culti- vated in ecclesiastical circles between the generic state of bliss and the particular figure in question. It may arouse a similar emotion in persons who still cherish the same associations. But instead of being esthetic, it will be of the kind described by William James: "I remember seeing an English couple sit for more than an hour on a piercing February day in the Academy in Venice before the cele- brated 'Assumption' by Titian; and when I, after being chased from room to room by the cold, concluded to get into the sunshine as fast as possible and let the pictures go, but before leaving drew reverently near to them to learn with what superior forms of sus- ceptibility they might be endowed, all I overheard was the woman's voice murmuring: 'What a *deprecatory* expression her face wears! What self-abne*gation!* How *unworthy* she feels of the honor she is receiving.'"

The sentimental religiosity of Murillo's paintings affords a good example of what happens when a painter of undoubted tal- ent subordinates his artistic sense to associated "meanings" that are artistically irrelevant. Before his paintings, the type of remark that was wholly out of place in the case of Titian would be perti- nent. But it would carry with it a lack of esthetic fulfillment.

Giotto painted saints. But their faces are less conventional; they are more individual and hence more naturalistically por- trayed. At the same time they are more esthetically presented. The artist now uses light, space, color and line, the media, to present an object that belongs of itself in an enjoyed perceptual experi- ence. The distinctive human religious meaning and the distinctive esthetic value interpenetrate and fuse; the object is truly expres- sive. This part of the picture is as unmistakably a Giotto as the saints of Masaccio are Masaccio's. Bliss is not a stencil transferable from one painter's work to that of another, but bears the marks of its individual creator, for it expresses *his* experience as well as that presumed to belong to a saint in general. Meaning is more fully expressed, even in its essential nature, in an individualized form

than in a diagrammatic representation or in a literal copy. The latter contains too much that is irrelevant; the former is too indefinite. An artistic relationship between color, light, and space in a portrait is not only more enjoyable than is an outline stencil but it says more. In a portrait by Titian, Tintoretto, Rembrandt, or Goya, we seem to be in the presence of essential character. But the result is accomplished by strictly plastic means, while the very way in which backgrounds are handled gives us something more than personality. Distortion of lines and departures from actual color may not only add to esthetic effect but result in increased expressiveness. For then material is not subordinated to some particular and antecedent meaning entertained about the person in question (and a literal reproduction can give only a cross-section exhibited at a particular moment), but it is reconstructed and reorganized to express the artist's imaginative vision of the whole being of the person.

There is no more common misunderstanding of painting than attends the nature of drawing. The observer, who has learned to recognize but not to perceive esthetically, will stand before a Botticelli, an El Greco, or Cezanne and say "What a pity the painter has never learned to draw." Yet drawing may be the artist's forte. Dr. Barnes has pointed out the real function of drawing in pictures. It is not a means for securing expressiveness in general but a very special value of expression. It is not a means of assisting recognition by means of exact outline and definite shading. Drawing is drawing *out;* it is extraction of what the subject matter has to say in particular to the painter in his integrated experience. Because the painting is a unity of interrelated parts, every designation of a particular figure has, more over, to be drawn *into* a relation of mutual reënforcement with all other plastic means—color, light, the spatial planes and the placing of other parts. This integration may, and in fact does, involve what is, from the standpoint of the shape of the real thing, a physical distortion.*

*Barnes, *The Art in Painting*, pp. 86 and 126, and *The Art of Matisse*, the chapter on Drawing, especially pp. 81–82.

Linear outlines that are used to reproduce with accuracy a particular shape are of necessity limited in expressiveness. They express either just one thing, "realistically" as it is sometimes said, or they express a generalized kind of thing by which we recognize the species—being a man, a tree, a saint, or whatever. Lines esthetically "drawn" fulfill many functions with corresponding increase of expressiveness. They embody the meaning of volume, of room and position; solidity and movement; they enter into the force of all other parts of the picture, and they serve to relate all parts together so that the value of the whole is energetically expressed. No mere skill in draughtsmanship can make lines that will fulfill all these functions. On the contrary, isolated skill in this respect is practically sure to end in a construction wherein linear outlines stand out by themselves, thus marring the expressiveness of the work as a whole. In the historical development of painting, the determination of shapes by drawing has steadily progressed from giving a pleasing indication of a particular object to become a relationship of planes and a harmonious merging of colors.

"Abstract" art may seem to be an exception to what has been said about expressiveness and meaning. Works of abstract art are asserted by some not to be works of art at all, and by others to be the very acme of art. The latter estimate them by their remoteness from representation in its literal sense; the former deny they have any expressiveness. The solution of the matter is found, I think, in the following statement of Dr. Barnes. "Reference to the real world does not disappear from art as forms cease to be those of actually existing things, any more than objectivity disappears from science when it ceases to talk in terms of earth, fire, air and water, and substitutes for these things the less easily recognizable 'hydrogen,' 'oxygen,' 'nitrogen,' and 'carbon.' . . . When we cannot find in a picture representation of any particular object, what it represents may be the qualities which *all* particular objects share, such as color, extensity, solidity, movement, rhythm, etc. All particular things have these qualities; hence what serves, so to speak, as a paradigm of the visible essence of all things may hold

in solution the emotions which individualized things provoke in a more specialized way."*

Art does not, in short, cease to be expressive because it renders in visible form relations of things, without any more indication of the particulars that have the relations than is necessary to compose a whole. Every work of art "abstracts" in some degree from the particular traits of objects expressed. Otherwise, it would only, by means of exact imitation, create an illusion of the presence of the things themselves. The ultimate subject matter of still life painting is highly "realistic"—napery, pans, apples, bowls. But a still life by Chardin or Cezanne presents these materials in terms of relations of lines, planes and colors inherently enjoyed in perception. This re-ordering could not occur without some measure of "abstraction" from physical existence. Indeed, the very attempt to present three-dimensional objects on a two-dimensional plane demands abstraction from the usual conditions in which they exist. There is no *a priori* rule to decide how far abstraction may be carried. In a work of art the proof of the pudding is decidedly in the eating. There are still-lifes of Cezanne in which one of the objects is actually levitated. Yet the expressiveness of the whole to an observer with esthetic vision is enhanced not lowered. It carries further a trait which every one takes for granted in looking at a picture; namely, that no object in the picture is *physically* supported by any other. The support they give to one another lies in their respective contributions to the perceptual experience. Expression of the readiness of objects to move, although temporarily sustained in equilibrium, is intensified by abstraction from conditions that are physically and externally possible. "Abstraction" is usually associated with distinctively intellectual undertakings. Actually it is found in every work of art. The difference is the interest in which and purpose for which abstraction takes place in science and art respectively. In science it occurs for the sake of effective statement, as that has been defined; in art, for the sake of expressiveness of the object, and the artist's own

*The Art in Painting, p. 52. The origin of the idea is referred to Dr. Buermeyer.

being and experience determine *what* shall be expressed and there-
fore the nature and extent of the abstraction that occurs.

It is everywhere accepted that art involves selection. Lack of
selection or undirected attention results in unorganized miscel-
lany. The directive source of selection is interest; an unconscious
but organic bias toward certain aspects and values of the complex
and variegated universe in which we live. In no case can a work of
art rival the infinite concreteness of nature. An artist is ruthless,
when he selects, in following the logic of his interest while he adds
to his selective bent an efflorescence or "abounding" in the sense
or direction in which he is drawn. The one limit that must not be
overpassed is that some reference to the qualities and structure of
things in environment remain. Otherwise, the artist works in a
purely private frame of reference and the outcome is without
sense, even if vivid colors or loud sounds are present. The distance
between scientific forms and concrete objects shows the extent to
which different arts may carry their selective transformations
without losing reference to the objective frame of reference.

The nudes of Renoir give delight with no pornographic sug-
gestion. The voluptuous qualities of flesh are retained, even accen-
tuated. But conditions of the physical existence of nude bodies
have been abstracted from. Through abstraction and by means of
the medium of color, ordinary associations with bare bodies are
transferred into a new realm, for these associations are practical
stimuli which disappear in the work of art. The esthetic expels the
physical, and the heightening of qualities common to flesh with
flowers ejects the erotic. The conception that objects have fixed
and unalterable values is precisely the prejudice from which art
emancipates us. The intrinsic qualities of things come out with
startling vigor and freshness just because conventional associa-
tions are removed.

The moot problem of the place of the ugly in works of art
seems to me to receive its solution when its terms are seen in this
context. That to which the word "ugly" is applied is the object in
its customary associations, those which have come to appear an
inherent part of some object. It does not apply to what is present
in the picture or drama. There is transformation because of emer-

gence in an object having its own expressiveness: exactly as in the case of Renoir's nudes. Something which was ugly under other conditions, the usual ones, is extracted from the conditions in which it was repulsive and is transfigured in quality as it becomes a part of an expressive whole. In its new setting, the very contrast with a former ugliness adds piquancy, animation, and, in serious matters, increases depth of meaning in an almost incredible way.

The peculiar power of tragedy to leave us at the end with a sense of reconciliation rather than with one of horror forms the theme of one of the oldest discussions of literary art.* I quote one theory which is relevant to the present discussion. Samuel Johnson said: "The delight of tragedy proceeds from our consciousness of fiction; if we thought murders and treasons real they would please us no more." This explanation seems to be constructed on the model of the small boy's statement that pins had saved many persons' lives "on account of their not swallowing them." The absence of reality in the dramatic event is, indeed, a negative condition of the effect of tragedy. But fictitious killing is not therefore pleasant. The positive fact is that a particular subject matter in being removed from its practical context has entered into a new whole as an integral part of it. In its new relationships, it acquires a new expression. It becomes a qualitative part of a new qualitative design. Mr. Colvin after quoting from Johnson the passage just cited, adds: "So does our peculiar consciousness of pleasure in watching the fencing match in 'As You Like It,' depend on our consciousness of fiction." Here, too, a negative condition is treated as a positive force. "Consciousness of fiction" is a backhanded way of expressing something that in itself is intensely pos-

*I cannot but think that the amount of thought which has been devoted to finding ingenious explanations for the Aristotelian idea of catharsis is due rather to the fascination of the topic than to any subtlety on Aristotle's part. The sixty or more meanings that have been given to it seem unnecessary in view of his own literal statement that persons are given to excessive emotion, and that as religious music cures people in religious frenzy "like persons cured by a drug," so the excessively timid and compassionate, and all suffering from over-intense emotions, are purged by melodies, and the relief is agreeable.

itive: the consciousness of an integral whole in which an incident gets a new qualitative value.

In discussing the act of expression, we saw that the conversion of an act of immediate discharge into one of expression depends upon existence of conditions that impede direct manifestation and that switch it into a channel where it is coördinated with other impulsions. The inhibition of the original raw emotion is not a suppression of it; restraint is not, in art, identical with constraint. The impulsion is modified by collateral tendencies; the modification gives it added meaning—the meaning of the whole of which it is henceforth a constituent part. In esthetic perception, there are two modes of collateral and coöperative response which are involved in the change of direct discharge into an act of expression. These two ways of subordination and reënforcement explain the expressiveness of the perceived object. By their means, a particular incident ceases to be a stimulus to direct action and becomes a value of a perceived object.

The first of these collateral factors is the existence of motor dispositions previously formed. A surgeon, golfer, ball player, as well as a dancer, painter, or violin-player has at hand and under command certain motor sets of the body. Without them, no complex skilled act can be performed. An inexpert huntsman has buck fever when he suddenly comes upon the game he has been pursuing. He does not have effective lines of motor response ready and waiting. His tendencies to action therefore conflict and get in the way of one another, and the result is confusion, a whirl and blur. The old hand at the game may be emotionally stirred also. But he works off his emotion by directing his response along channels prepared in advance: steady holding of eye and hand, sighting of rifle, etc. If we substitute a painter or a poet in the circumstances of suddenly coming upon a graceful deer in a green and sun-specked forest, there is also diversion of immediate response into collateral channels. He does not get ready to shoot, but neither does he permit his response to diffuse itself at random through his whole body. The motor coördinations that are ready because of

prior experience at once render his perception of the situation more acute and intense and incorporate into it meanings that give it depth, while they also cause what is seen to fall into fitting rhythms.

I have been speaking from the standpoint of the one who acts. But precisely similar considerations hold from the side of the perceiver. There must be indirect and collateral channels of response prepared in advance in the case of one who really sees the picture or hears the music. This motor preparation is a large part of esthetic education in any particular line. To know what to look for and how to see it is an affair of readiness on the part of motor equipment. A skilled surgeon is the one who appreciates the artistry of another surgeon's performance; he follows it sympathetically, though not overtly, in his own body. The one who knows something about the relation of the movements of the piano-player to the production of music from the piano will hear something the mere layman does not perceive—just as the expert performer "fingers" music while engaged in reading a score. One does not have to know much about mixing paints on a palette or about the brush-strokes that transfer pigments to canvas to see the picture in the painting. But it is necessary that there be ready defined channels of motor response, due in part to native constitution and in part to education through experience. Emotion may be stirred and yet be as irrelevant to the act of perception as it is to the action of the hunter seized by buck-fever. It is not too much to say that emotion that lacks proper motor lines of operation will be so undirected as to confuse and distort perception.

But something is needed to coöperate with defined motor lines of response. An unprepared person at the theater may be so ready to take an active part in what is going on—in helping the hero and foiling the villain as he would like to do in real life—as not to see the play. But a blasé critic may permit his trained modes of technical response—ultimately always motor—to control him to such an extent that, while he skillfully apprehends *how* things are done, he does not care for *what* is expressed. The other factor that is required in order that a work may be expressive to a percipient is meanings and values extracted from prior experiences and funded

in such a way that they fuse with the qualities directly presented in the work of art. Technical responses, if not held in balance with such secondary supplied material, are so purely technical that the expressiveness of the object is narrowly limited. But if the allied material of former experiences does not directly blend with the qualities of the poem or painting, they remain extraneous suggestions, not part of the expressiveness of the object itself.

I have avoided the use of the word "association" because traditional psychology supposes that associated material and the immediate color or sound that evokes it remain separate from one another. It does not admit of the possibility of a fusion so complete as to incorporate both members in a single whole. This psychology holds that direct sensuous quality is one thing, and an idea or image which it calls out or suggests is another distinct mental item. The esthetic theory based on this psychology cannot admit that the suggesting and the suggested may interpenetrate and form a unity in which present sense quality confers vividness of realization while the material evoked supplies content and depth.

The issue that is involved has a much greater import for the philosophy of esthetics than appears at first sight. The question of the relation that exists between direct sensuous matter and that which is incorporated with it because of prior experiences, goes to the heart of the expressiveness of an object. Failure to see that what takes place is not external "association" but is internal and intrinsic integration has led to two opposed and equally false conceptions of the nature of expression. According to one theory, *esthetic* expressiveness belongs to the direct sensuous qualities, what is added by suggestion only rendering the object more interesting but not becoming a part of its esthetic being. The other theory takes the opposite tack, and imputes expressiveness wholly to associated material.

The expressiveness of lines as mere lines is offered as proof that esthetic value belongs to sense qualities in and of themselves; their status may serve as a test of the theory. Different kinds of lines, straight and curved, and among the straight the horizontal and vertical, and among curves those that are closed and those

that droop and rise, have different immediate esthetic qualities. Of this fact there is no doubt. But the theory under consideration holds that their peculiar expressiveness can be explained without any reference beyond the immediate sensory apparatus directly involved. It is held that the dry stiffness of a straight line is due to the fact that the eye in seeing tends to change direction, to move in tangents, so that it acts under coercion when compelled to move straight on, so that, in consequence, the experienced result is unpleasant. Curved lines, on the other hand, are agreeable because they conform to the natural tendencies of the eye's own movements.

It is admitted that this factor probably does have something to do with the mere pleasantness or unpleasantness of the experience. But the problem of expressiveness is not touched. While the optical apparatus may be isolated in anatomical dissection, it never *functions* in isolation. It operates in connection with the hand in reaching for things and in exploring their surface, in guiding manipulation of things, in directing locomotion. This fact has for its consequence the other fact that the sense-qualities coming to us by means of the optical apparatus are simultaneously bound up with those that come to us from objects through collateral activities. The roundness seen is that of balls; angles perceived are the result not just of switches in the eye-movements but are properties of books and boxes handled; curves are the arch of the sky, the dome of a building; horizontal lines are seen as the spread of the ground, the edges of things around us. This factor is so continually and so unfailingly involved in every use of the eyes that the visually experienced qualities of lines cannot possibly be referred to the action of the eyes alone.

Nature, in other words, does not present us with lines in isolation. As experienced, they are the lines of objects; boundaries of *things*. They define the shapes by which we ordinarily recognize objects about us. Hence lines, even when we try to ignore everything else and gaze upon them in isolation, carry over the meaning of the objects of which they have been constituent parts. They are expressive of the natural scenes they have defined for us. While lines demarcate and define objects, they also assemble and con-

nect. One who has run into a sharply projecting corner will appreciate the aptness of the term "acute" angle. Objects with widely spreading lines often have that gaping quality so stupid that we call it "obtuse." That is to say, lines express the ways in which things act upon one another and upon us; the ways in which, when objects act together, they reënforce and interfere. For *this* reason, lines are wavering, upright, oblique, crooked, majestic; for this reason they seem in direct perception to have even moral expressiveness. They are earthbound and aspiring; intimate and coldly aloof; enticing and repellent. They carry with them the properties of objects.

The habitual properties of lines cannot be got rid of even in an experiment that endeavors to isolate the experience of lines from everything else. The properties of objects that lines define and of movements they relate are too deeply embedded. These properties are resonances of a multitude of experiences in which, in our concern with objects, we are not even aware of lines as such. Different lines and different relations of lines have become subconsciously charged with all the values that result from what they have done in our experience in our every contact with the world about us. The expressiveness of lines and space relations in painting cannot be understood upon any other basis.

The other theory denies that immediate sense qualities have *any* expressiveness; it holds that sense serves merely as an external vehicle by which other meanings are conveyed to us. Vernon Lee, herself an artist of undoubted sensitiveness, has developed this theory most consistently, and in a way, which, while it has something in common with the German theory of *Einfuehling* or empathy, avoids the idea that our esthetic perception is a projection into objects of an internal mimicry of their properties, one which we dramatically enact when we look at them—a theory that, in turn, is hardly more than an animistic version of the classic theory of representation.

According to Vernon Lee, as well as to some other theorists in the field of esthetics, "art" signifies a group of activities that are, respectively, recording, constructive, logical and communicative. There is nothing esthetic about art itself. The products of these

arts become esthetic "in response to a totally different desire having its own reasons, standard, imperative." This "totally different" desire is the desire for *shapes,* and this desire arises because of the need for satisfaction of congruous relations among our modes of *motor* imagery. Hence direct sensuous qualities like those of color and tone are irrelevant. The demand for shapes is satisfied when our motor imagery reënacts the *relations* embodied in an object—as, for example, "the fan-like arrangement of sharply convergent lines and exquisitely phrased skyline of hills, picked up at intervals into sharp crests and dropping down merely to rush up again in long rapid concave curves."

Sensory qualities are said to be non-esthetic because, unlike the relations we actively enact, they are forced upon us and tend to overwhelm us. What counts is what we *do,* not what we receive. The essential thing esthetically is our own mental activity of starting, traveling, returning to a starting point, holding on to the past, carrying it along; the movement of attention backwards and forwards, as these acts are executed by the mechanism of motor imagery. The resulting relations define *shape* and shape is *wholly* a matter of relations. They "transform what would otherwise be meaningless juxtapositions or sequences of sensations into the significant entities which can be remembered and cognized even when their constituent sensations are completely altered, namely, into shapes." The outcome is empathy in its true meaning. It deals not "directly with mood and emotion but with dynamic conditions which enter into moods and emotions and take their names from them. . . . The various and variously combined dramas enacted by lines and curves and angles take place not in the marble or pigment embodying the contemplated shapes, but *solely in ourselves.* . . . And since we are their only real actors, these empathic dramas of lines are bound to affect us, whether as corroborating or as thwarting our vital needs and habits." (Italics not in the original text.)

The theory is significant in the thoroughness with which it separates sense and relations, matter and form, the active and the receptive, phases of experience, and in its logical statement of what happens when they are separated. The recognition of the

rôles of relations and of activity on our part (the latter being physiologically mediated in all probability by our motor mechanisms) is welcome in contrast with theories that recognize only sense-qualities as they are passively received and undergone. But a theory that regards color in painting as esthetically irrelevant, that holds that tones in music are merely something upon which esthetic relations are superimposed, hardly seems to need refutation.

The two theories that have been criticized complement each other. But the truth of esthetic theory cannot be arrived at by a mechanical addition of one theory to the other. The expressiveness of the object of art is due to the fact that it presents a thorough and complete interpenetration of the materials of undergoing and of action, the latter including a reorganization of matter brought with us from past experience. For, in the interpenetration, the latter is material not added by way of external association nor yet by way of superimposition upon sense qualities. The expressiveness of the object is the report and celebration of the complete fusion of what we undergo and what our activity of attentive perception brings into what we receive by means of the senses.

The reference to corroboration of our vital needs and habits deserves notice. Are these vital needs and habits purely formal? Can they be satisfied through relations alone, or do they demand to be fed by the matter of color and sound? That the latter is the case seems to be implicitly admitted when Vernon Lee goes on to say that "art so far from delivering us from the sense of really living, intensifies and amplifies those states of serenity of which we are given the sample, too rare, too small and too alloyed in the course of our normal practical life." Exactly so. But the experiences that art intensifies and amplifies neither exist solely inside ourselves, nor do they consist of relations apart from matter. The moments when the creature is both most alive and most composed and concentrated are those of fullest intercourse with the environment, in which sensuous material and relations are most completely merged. Art would not amplify experience if it withdrew the self into the self nor would the experience that results from such retirement be expressive.

* * *

Both of the theories considered separate the live creature from the world in which it lives; lives by interaction through a series of related doings and undergoings, which when they are schematized by psychology, are motor and sensory. The first theory finds in organic activity isolated from the events and scenes of the world a sufficient cause of the expressive nature of certain sensations. The other theory locates the esthetic element "solely in ourselves," through enacting of motor relations in "shapes." But the process of living is continuous; it possesses continuity because it is an everlastingly renewed process of acting upon the environment and being acted upon by it together with institution of relations between what is done and what is undergone. Hence experience is necessarily cumulative and its subject matter gains expressiveness because of cumulative continuity. The world we have experienced becomes an integral part of the self that acts and is acted upon in further experience. In their physical occurrence, things and events experienced pass and are gone. But something of their meaning and value is retained as an integral part of the self. Through habits formed in intercourse with the world, we also in-habit the world. It becomes a home and the home is part of our every experience.

How, then, can objects of experience avoid becoming expressive? Yet apathy and torpor conceal this expressiveness by building a shell about objects. Familiarity induces indifference, prejudice blinds us; conceit looks through the wrong end of a telescope and minimizes the significance possessed by objects in favor of the alleged importance of the self. Art throws off the covers that hide the expressiveness of experienced things; it quickens us from the slackness of routine and enables us to forget ourselves by finding ourselves in the delight of experiencing the world about us in its varied qualities and forms. It intercepts every shade of expressiveness found in objects and orders them in a new experience of life.

Because the objects of art are expressive, they communicate. I do not say that communication to others is the intent of an artist. But it is the consequence of his work—which indeed lives only in communication when it operates in the experience of others. If the

artist desires to communicate a *special* message, he thereby tends to limit the expressiveness of his work to others—whether he wishes to communicate a moral lesson or a sense of his own cleverness. Indifference to response of the immediate audience is a necessary trait of all artists that have something new to say. But they are animated by a deep conviction that since they can only say what they have to say, the trouble is not with their work but those who, having eyes, see not, and having ears, hear not. Communicability has nothing to do with popularity.

I can but think that much of what Tolstoi says about immediate contagion as a test of artistic quality is false, and what he says about the kind of material which can alone be communicated is narrow. But if the time span be extended, it is true that no man is eloquent save when someone is moved as he listens. Those who are moved feel, as Tolstoi says, that what the work expresses is as if it were something one had oneself been longing to express. Meantime, the artist works to create an audience to which he does communicate. In the end, works of art are the only media of complete and unhindered communication between man and man that can occur in a world full of gulfs and walls that limit community of experience.

BECAUSE objects of art are expressive, they are a language. Rather they are many languages. For each art has its own medium and that medium is especially fitted for one kind of communication. Each medium says something that cannot be uttered as well or as completely in any other tongue. The needs of daily life have given superior practical importance to one mode of communication, that of speech. This fact has unfortunately given rise to a popular impression that the meanings expressed in architecture, sculpture, painting, and music can be translated into words with little if any loss. In fact, each art speaks an idiom that conveys what cannot be said in another language and yet remains the same.

Language exists only when it is listened to as well as spoken. The hearer is an indispensable partner. The work of art is complete only as it works in the experience of others than the one who created it. Thus language involves what logicians call a triadic rela-

tion. There is the speaker, the thing said, and the one spoken to. The external object, the product of art, is the connecting link between artist and audience. Even when the artist works in solitude all three terms are present. The work is there in progress, and the artist has to become vicariously the receiving audience. He can speak only as his work appeals to him as one spoken to through what he perceives. He observes and understands as a third person might note and interpret. Matisse is reported to have said: "When a painting is finished, it is like a new-born child. The artist himself must have time for understanding it." It must be lived with as a child is lived with, if we are to grasp the meaning of his being.

All language, whatever its medium, involves *what* is said and *how* it is said, or substance and form. The great question concerning substance and form is: Does matter come first ready-made, and search for a discovery of form in which to embody it come afterwards? Or is the whole creative effort of the artist an endeavor to form material so that it will be in actuality the authentic substance of a work of art? The question goes far and deep. The answer given it determines the issue of many other controverted points in esthetic criticism. Is there one esthetic value belonging to sense materials and another to a form that renders them expressive? Are all subjects fit for esthetic treatment or only a few which are set aside for that end by their intrinsically superior character? Is "beauty" another name for form descending from without, as a transcendent essence, upon material, or is it a name for the esthetic quality that appears whenever *material is formed* in a way that renders it adequately expressive? Is form, in its esthetic sense, something that uniquely marks off as esthetic from the beginning a certain realm of objects, or is it the abstract name for what emerges whenever an experience attains complete development?

All of these questions have been implicit in the discussions of the three previous chapters, and by implication have been answered. If an art product is taken to be one of *self*-expression and the self is regarded as something complete and self-contained in isolation, then of course substance and form fall apart. That in which a self-revelation is clothed, is, by the underlying assumption, external to the things expressed. The externality persists no matter

which of the two is regarded as form and which as substance. It is also clear that if there be *no* self-expression, no free play of individuality, the product will of necessity be but an instance of a species; it will lack the freshness and originality found only in things that are individual on their own account. Here is a point from which the relation of form and substance may be approached.

The *material* out of which a work of art is composed belongs to the common world rather than to the self, and yet there is self-expression in art because the self assimilates that material in a distinctive way to reissue it into the public world in a form that builds a new object. This new object may have as its consequence similar reconstructions, recreations, of old and common material on the part of those who perceive it, and thus in time come to be established as part of the acknowledged world—as "universal." The material expressed cannot be private; that is the state of the madhouse. But the *manner* of saying it is individual, and, if the product is to be a work of art, induplicable. Identity of mode of production defines the work of a machine, the esthetic counterpart of which is the academic. The quality of a work of *art* is *sui generis* because the manner in which general material is rendered transforms it into a substance that is fresh and vital.

What is true of the producer is true of the perceiver. He may perceive academically, looking for identities with which he already is familiar; or learnedly, pedantically, looking for material to fit into a history or article he wishes to write, or sentimentally for illustrations of some theme emotionally dear. But if he perceives esthetically, he will create an experience of which the intrinsic subject matter, the substance, is new. An English critic, Mr. A. C. Bradley, has said that "poetry being poems, we are to think of a poem as it actually exists; and an actual poem is a succession of experiences—sounds, images, thought—through which we pass when we read a poem. . . . A poem exists in unnumberable degrees." And it is also true that it exists in unnumberable qualities or kinds, no two readers having exactly the same experience, according to the "forms," or manners of response brought to it. A new poem is created by everyone who reads poetically—not that its *raw* material is original for, after all, we live in the same old

world, but that every individual brings with him, when he exercises his individuality, a way of seeing and feeling that in its interaction with old material creates something new, something previously not existing in experience.

A work of art no matter how old and classic is actually, not just potentially, a work of art only when it lives in some individualized experience. As a piece of parchment, of marble, of canvas, it remains (subject to the ravages of time) self-identical throughout the ages. But as a work of art, it is recreated every time it is esthetically experienced. No one doubts this fact in the rendering of a musical score; no one supposes that the lines and dots on paper are more than the recorded means of evoking the work of art. But what is true of it is equally true of the Parthenon as a building. It is absurd to ask what an artist "really" meant by his product: he himself would find different meanings in it at different days and hours and in different stages of his own development. If he could be articulate, he would say "I meant just *that*, and *that* means whatever you or any one can honestly, that is in virtue of your own vital experience, get out of it." Any other idea makes the boasted "universality" of the work of art a synonym for monotonous identity. The Parthenon, or whatever, is universal because it can continuously inspire new personal realizations in experience.

It is simply an impossibility that anyone today should experience the Parthenon as the devout Athenian contemporary citizen experienced it, any more than the religious statuary of the twelfth century can mean, esthetically, even to a good Catholic today just what it meant to the worshipers of the old period. The "works" that fail to become *new* are not those which are universal but those which are "dated." The enduring art-product may have been, and probably was, called forth by something occasional, something having its own date and place. But *what* was evoked is a substance so formed that it can enter into the experiences of others and enable them to have more intense and more fully rounded out experiences of their own.

This is what it is to have form. It marks a way of envisaging, of feeling, and of presenting experienced matter so that it most readily and effectively becomes material for the construction of

adequate experience on the part of those less gifted than the original creator. Hence there can be no distinction drawn, save in reflection, between form and substance. The work itself *is* matter formed into esthetic substance. The critic, the theorist, as a reflective student of the art product, however, not only may but must draw a distinction between them. Any skilled observer of a pugilist or a golf-player will, I suppose, institute distinctions between *what* is done and *how* it is done—between the knockout and the manner of the delivery of a blow; between the ball driven so many yards to such and such a line and the way the drive was executed. The artist, the one engaged in doing, will effect a similar distinction when he is interested in correcting an habitual error, or learning how better to secure a given effect. Yet the act itself is exactly *what* it is because of *how* it is done. In the act there is no distinction, but perfect integration of manner and content, form and substance.

The author just quoted, Mr. Bradley, in an essay on *Poetry for Poetry's Sake,* draws a distinction between subject and substance which may well form the start of our further discussion of this matter. The distinction may, I think, be paraphrased as that between matter *for* and matter *in* artistic production. The subject or "matter for" is capable of being indicated and described in other fashion than that of the art-product itself. The "matter in," the actual substance, *is* the art object itself and hence cannot be expressed in any other way. The subject for Milton's "Paradise Lost" is, as Bradley says, the fall of man in connection with the revolt of the angels—a theme already current in Christian circles and readily identifiable by anyone familiar with the Christian tradition. The substance of the poem, the esthetic *matter,* is the poem itself; what became of the subject as it underwent Milton's imaginative treatment. Similarly, one can tell another in words the subject of the "Ancient Mariner." But to convey to him its substance one would have to expose him to the poem and let the latter have its way with him.

The distinction that Bradley draws with respect to poems is equally applicable to every art, even architecture. The "subject" of the Parthenon is Pallas Athene, the Virgin Goddess, the presiding

divinity of the city of Athens. If one will take a multitude of art products of all kinds and sorts and keep them in mind long enough to assign a subject to each, one will see that the substance of works of art dealing with the same "subject" is infinitely varied. How many poems are there in all languages having flowers, or even the rose, for their "subject"? Hence changes in art products are not arbitrary; they do not proceed, even when quite revolutionary, (as one school of critics always assumes) from the unregulated wish of undisciplined men to produce something new and startling. They are inevitable as the common things of the world are experienced in different cultures and different personalities. The subject that meant so much to the Athenian citizen of the fourth century B.C. is hardly more than a historic incident today. An English Protestant of the seventeenth century who savored to the full the theme of Milton's epic may have been so out of sympathy with the topic and setting of Dante's *Divine Comedy* as to be unable to appreciate the latter's artistic quality. Today an "unbeliever" may be the one who is most sensitive esthetically to such poems, just because of indifference to their antecedent subject-matter. On the other hand, many an observer of pictures is now unable to do full justice to the painting of Poussin in its intrinsic plastic qualities because its classical themes are so alien.

The subject, as Bradley says, is outside the poem; the substance is within *it;* rather, *it is* the poem. "Subject," however, itself varies over a wide range. It may be hardly more than a label; it may be the occasion that called out the work; or it may be the subject-matter which as raw material entered into the new experience of the artist and found transformation. The poems of Keats and Shelley on the sky-lark and nightingale probably did not have the songs of these birds alone for an occasioning stimulus. It is well, then, for the sake of clarity to discriminate not only substance from theme or topic, but both of them from antecedent subject-matter. The "subject" of the "Ancient Mariner" is the killing of an albatross by a sailor and what happened in consequence thereof. Its matter is the poem itself. Its subject-matter is all the experiences a reader brings with him of cruelty and pity in connection with a living creature. The artist himself can hardly

begin with a subject alone. If he did, his work would almost surely suffer from artificiality. First comes subject-matter, then the substance or matter of the work; finally the determination of topic or theme.

Antecedent subject-matter is not instantaneously changed into the matter of a work of art in the mind of an artist. It is a developing process. As we have already seen, the artist finds where he is going because of what he has previously done; that is, the original excitation and stir of some contact with the world undergo successive transformation. That state of the matter he has arrived at sets up demands to be fulfilled and it institutes a framework that limits further operations. As the experience of transforming subject-matter into the very substance of the work of art proceeds, incidents and scenes that figured at first may drop out and others take their place, being drawn in by the suction of the qualitative material that aroused the original excitement.

The theme or subject, on the other hand, may be of no significance at all save for purposes of practical identification. I once saw a lecturer on painting obtain a cheap laugh from his audience by showing a cubistic picture and asking the audience to guess what it was about. He then told them its title—as if that were either its subject-matter or its substance. The artist had labeled his picture for some reason best known to himself, whether *pour epater les bourgeois* or because of its occasion, or because of some subtle affinity of quality, by the name of a historic personage. The implication of the lecturer and of the audience's laugh was that the obvious disparity between the title and the visible picture was somehow a reflection on the esthetic qualities of the latter. No one would allow his perception of the Parthenon to be influenced by the fact that he did not happen to know the signification of the word by which the building is called. Yet the fallacy exists, especially in connection with pictures, in many ways much more subtle than that illustrated by the incident of the lecture.

Titles are, so to say, social matters. They identify objects for easy reference, so that one knows what is meant when a symphony of Beethoven's is called the "Fifth" or when Titian's "Entombment" is mentioned. A poem of Wordsworth's may be specified by

name, but it might be identified as the poem found on a certain page of a given edition, as well as by being called "Lucy Gray." Rembrandt's painting can be named the "Jewish Wedding," or that which hangs on a certain wall of a particular room in the Amsterdam gallery. Musicians usually call their works by number with perhaps an indication of the key. Painters prefer vague titles. Thus artists, perhaps unconsciously, strive to escape from the general tendency to link an object of art with some scene or course of events that listeners and spectators recognize from their prior experience. A picture may be catalogued merely "River at Twilight." Even then, many persons will suppose they must carry into their experience of it some remembered river once seen at that particular hour. But in such treatment the picture in so far ceases to be a picture and becomes an inventory or document, as if it were a colored photograph taken for historical or geological purposes or to serve the business of a detective.

The distinctions made are elementary; but they are basic in esthetic theory. When there is an end of confusion of subject and substance, there will also be an end, for example, of the ambiguities regarding representation such as have been discussed. Mr. Bradley calls attention to the common tendency to treat a work of art as a mere reminder of something, by the illustration of the sight-seer in a picture-gallery who remarks as he moves along, "This picture is so like my cousin," or that picture "the image of my birthplace," and who, after satisfying himself that one painting is about Elijah, passes on rejoicing to discover the subject and nothing but the subject of the next one. Unless the radical difference between subject and substance is appreciated, not only does the casual visitor go wrong, but critics and theorists judge objects of art in terms of their preconceptions as to what the subject-matter of art ought to be. The time is not far remote when the proper thing to say about the dramas of Ibsen was that they are "sordid"; and paintings that modify subject-matter in accordance with requirements of esthetic form in ways that involve distortion of physical shape are condemned as arbitrary and capricious. The painter's just retort to such a misunderstanding is found in a remark of Matisse. When someone complained to him that she had

never seen a woman who looked like the one in his painting, he replied: "Madam, that is not a woman; that is a picture." The critics who drag in extraneous subject-matter—historical, moral, sentimental, or in the guise of established canons that prescribe proper themes—may be vastly superior in learning to the guide in the gallery who says nothing about paintings as pictures and a great deal about the occasions which produced them and the sentimental associations they arouse, the majesty of Mount Blanc or the tragedy of Anne Boleyn; but esthetically they stand on the same level.

The city man who lived in the country when he was a boy is given to purchasing pictures of green meadows with grazing cattle or purling brooks—especially if there is also a swimming hole. He obtains from such pictures a revival of certain values of his childhood minus attendant back-breaking experiences, plus, indeed, an added emotional value because of contrast with a present well-to-do estate. In all such cases the picture is not seen. The painting is used as a springboard for arriving at sentiments that are, because of extraneous subject-matter, agreeable. The subject-matter of experiences of childhood and youth is nevertheless a subconscious background of much great art. But to be the substance of art, it must be made into a new object by means of the medium employed, not merely suggested in a reminiscent way.

The fact that form and matter are connected in a work of art does not mean they are identical. It signifies that in the work of art they do not offer themselves as two distinct things: the work is formed matter. But they are legitimately distinguished when reflection sets in, as it does in criticism and in theory. We are then compelled to inquire as to the formal structure of the work, and in order to carry on this inquiry intelligently, we must have a conception of what form is generically. We may get a key to this idea by starting from the fact that one idiomatic use of the word makes it equivalent with shape or figure. Especially in connection with pictures is form frequently identified simply with the patterns defined by linear outlines of shapes. Now shape is only an element in esthetic

form; it does not constitute it. In ordinary perception we recognize and identify things by their shapes; even words and sentences have shapes, when heard as well as when seen. Consider how a misplaced accent disturbs recognition more than does any other kind of mispronunciation.

For shape in relation to recognition is not limited to geometric or spatial properties. The latter play a part only as they are subordinated to *adaptation to an end*. Shapes that are not in our minds associated with any function are hard to grasp and retain. The shapes of spoons, knives, forks, household articles, pieces of furniture, are means of identification because of their association with purpose. Up to a certain point, then, shape is allied with form in its artistic sense. In both there is organization of constituent parts. In some sense the typical shape of even a utensil and tool indicates that the meaning of the whole has entered into the parts to qualify them. This is the fact that has led some theorists, like Herbert Spencer, to identify the source of "beauty" with efficient and economical adaptation of parts to the function of a whole. In some cases fitness is indeed so exquisite as to constitute visible grace independent of the thought of any utility. But this special case indicates the way in which shape and form differ generically. For there is more to grace than just lack of clumsiness, in the sense in which "clumsy" means inefficiency of adaptation to an end. In shape as such adaptation is intrinsically limited to a particular end—like that of a spoon for carrying liquids to the mouth. The spoon that in addition has that esthetic form called grace bears no such limitation.

A good deal of intellectual effort has been expended in trying to identify efficiency for a particular end with "beauty" or esthetic quality. But these attempts are bound to fail, fortunate as it is that in some cases the two coincide and humanly desirable as it is that they should always meet. For adaptation to a particular end is often (always in the case of complicated affairs) something perceived by thought, while esthetic effect is found directly in sense-perception. A chair may serve the purpose of affording a comfortable and hygienically efficient seat, without serving at the same time the needs of the eye. If, on the contrary, it blocks rather than

promotes the rôle of vision in an experience, it will be ugly no matter how well adapted to use as a seat. There is no preëstablished harmony that guarantees that what satisfies the need of one set of organs will fulfill that of all the other structures and needs that have a part in the experience, so as to bring it to completion as a complex of all elements. All we can say is that in the absence of disturbing contexts, such as production of objects for a maximum of private profit, a balance tends to be struck so that objects will be satisfactory—"useful" in the strict sense—to the self as a whole, even though some specific efficiency be sacrificed in the process. In so far there is a tendency for dynamic shape (as distinguished from bare geometric figure) to blend with artistic form.

Early in the history of philosophic thought the value of shape in making possible the definition and classification of objects was noted and was seized upon as a basis for a metaphysical theory of the nature of forms. The empirical fact of the relationship, effected by arrangement of parts to a definite end and use—like that of spoon or table or cup—was wholly neglected and even repudiated. Form was treated as something intrinsic, as the very essence of a thing in virtue of the metaphysical structure of the universe. It is easy to follow the course of reasoning that led to this result provided the relation of shape to use is once ignored. It is by form—in the sense of adapted shape—that we both identify and distinguish things in perception: chairs from tables, a maple from an oak. Since we note—or "know" them—in this way, and, since knowledge was believed to be a revelation of the true nature of things, it was concluded that things are what they are in virtue of having, intrinsically, certain forms.

Moreover, since things are rendered knowable by these forms, it was concluded that form is the rational, the intelligible, element in the objects and events of the world. Then it was set over against "matter," the latter being the irrational, the inherently chaptic and fluctuating, stuff upon which form was impressed. It was as eternal as the latter was shifting. This metaphysical distinction of matter and form was embodied in the philosophy that ruled European thought for centuries. Because of this fact it still affects the esthetic philosophy of form in relation to matter. It is the source of

the bias in favor of their separation, especially when that takes the shape of assuming that form has a dignity and stability lacking to matter. Indeed, were it not for this background of tradition, it may be doubted whether it would occur to anyone that there is a problem in their relation, so clear would it be that the only distinction important in art is that between matter inadequately formed and material completely and coherently formed.

Objects of industrial arts have form—that adapted to their special uses. These objects take on esthetic form, whether they are rugs, urns, or baskets, when the material is so arranged and adapted that it serves immediately the enrichment of the immediate experience of the one whose attentive perception is directed to it. No material can be adapted to an end, be it that of use as spoon or carpet, until raw material has undergone a change that shapes the parts and that arranges these parts with reference to one another with a view to the purpose of the whole. Hence the object has form in a definitive sense. When this form is liberated from limitation to a specialized end and serves also the purposes of an immediate and vital experience, the form is esthetic and not merely useful.

It is significant that the word "design" has a double meaning. It signifies purpose and it signifies arrangement, mode of composition. The design of a house is the plan upon which it is constructed to serve the purposes of those who live in it. The design of a painting or novel is the arrangement of its elements by means of which it becomes an expressive unity in direct perception. In both cases, there is an ordered relation of many constituent elements. The characteristic of artistic design is the intimacy of the relations that hold the parts together. In a house we have rooms *and* their arrangement with respect to one another. In the work of art, the relations cannot be told apart from *what* they relate except in later reflection. A work of art is poor in the degree in which they exist in separation, as in a novel wherein plot—the design—is felt to be superimposed upon incidents and characters instead of being their dynamic relations to one another. To understand the design of a complicated piece of machinery we have to know the purpose the machine is intended to serve, and how the various parts fit in to the

accomplishment of that purpose. Design is, as it were, superimposed upon materials that do not actually share in it, as privates engage in a battle while they have only a passive share in the general's "design" for the battle.

Only when the constituent parts of a whole have the unique end of contributing to the consummation of a conscious experience, do design and shape lose superimposed character and become form. They cannot do this so long as they serve a specialized purpose; while they can serve the inclusive purpose of having *an* experience only when they do not stand out by themselves but are fused with all other properties of the work of art. In dealing with the significance of form in painting, Dr. Barnes has brought out the necessity for this completeness of blending, the interpenetration of "shape" and pattern with color, space, and light. Form is, as he says, "the synthesis or fusion of *all* plastic means . . . their harmonious merging." On the other hand, pattern in its limited sense, or plan and design, "is merely the skeleton upon which plastic units . . . are engrafted."*

This interfusion of all properties of the medium is necessary if the object in question is to serve the whole creature in his unified vitality. It therefore defines the nature of form in all the arts. With respect to a specialized utility, we can characterize design as being related to this and that end. One chair has a design fitted to give comfort; another, to hygiene; a third, to regal splendor. Only when all means are diffused through one another does the whole suffuse the parts so as to constitute an experience that is unified through inclusion instead of by exclusion. This fact confirms the position of the previous chapter as regards the union of qualities of direct sensuous vividness with other expressive qualities. As long as "meaning" is a matter of association and suggestion, it falls apart from the qualities of the sensuous medium and form is disturbed. Sense qualities are the carriers of meanings, not as vehicles carry goods but as a mother carries a baby when the baby is part of her

The Art in Painting, pp. 85 and 87. Chapter I of Book II should be consulted. Form in the sense defined is, as is shown there, "the criterion of value."

own organism. Works of art, like words, are literally pregnant with meaning. Meanings, having their source in past experience, are means by which the particular organization that marks a given picture is effected. They are not added on by "association" but are either, and equally, the soul of which colors are the body or the body of which colors are the soul—according as we happen to be concerned with the picture.

Dr. Barnes has pointed out that not only are intellectual meanings carried over from past experiences to add expressiveness, but so are qualities that add emotional excitation, whether the excitation be of serenity or poignancy. "There are," as he says, "in our minds in solution a vast number of emotional attitudes, feelings ready to be reëxcited when the proper stimulus arrives, and more than anything else it is these forms, this residue of experience, which, fuller and richer than in the mind of the ordinary man, constitute the artist's capital. What is called the magic of the artist resides in his ability to transfer these values from one field of experience to another, to attach them to the objects of our common life, and by his imaginative insight make these objects poignant and momentous."* Not colors, not sense qualities as such, are either matter or form, but these qualities as thoroughly imbued, impregnated, with transferred value. And then they are either matter or form according to the direction of our interest.

While some theorists make a distinction between sensuous and borrowed value because of the metaphysical dualism just mentioned, others make it from fear lest the work of art be unduly intellectualized. They are concerned to emphasize something which is in fact an esthetic necessity: the immediacy of esthetic experience. It cannot be asserted too strongly that what is not immediate is not esthetic. The mistake lies in supposing that only certain *special* things—those attached just to eye, ear, etc.—can be

*See the chapter on Transferred Values, in the volume on *The Art of Henri Matisse*; the quotation is from p. 31. In the chapter, Dr. Barnes shows how much of the immediate emotional effect of the pictures of Matisse is unconsciously transferred from emotional values first connected with tapestry, posters, rosettes (including flower-patterns), tiles, stripes and bands, as of banners and many other objects.

qualitatively and immediately experienced. Were it true that only qualities coming to us through sense-organs in *isolation* are directly experienced, then, of course, all relational material would be superadded by an association that is extraneous—or, according to some theorists, by a "synthetic" action of thought. From this point of view the strictly *esthetic* value of say a painting consists simply of certain relations and orders of relation that colors *sustain to one another* apart from relation to objects. The expressiveness they gain by being present as colors of water, rocks, clouds, etc., is due to art. On this basis, there is always a gap between the esthetic and the artistic. They are of two radically different kinds.

The psychology underlying this bifurcation was exploded in advance by William James when he pointed out that there are direct feelings of such relations as "if," "then," "and," "but," "from," "with." For he showed that there is no relation so comprehensive that it may not become a matter of immediate experience. Every work of art that ever existed had indeed already contradicted the theory in question. It is quite true that certain things, namely ideas, exercise a mediating function. But only a twisted and aborted logic can hold that because something is mediated, it cannot, therefore, be immediately experienced. The reverse is the case. We cannot grasp any idea, any organ of mediation, we cannot possess it in its full force, until we have felt and sensed it, as much so as if it were an odor or a color.

Those who are especially addicted to thinking as an occupation, are aware when they observe the processes of thought, instead of determining by dialectic what they must be, that immediate feeling is not limited in its scope. Different ideas have their different "feels," their immediate qualitative aspects, just as much as anything else. One who is thinking his way through a complicated problem finds direction on his way by means of this property of ideas. Their qualities stop him when he enters the wrong path and send him ahead when he hits the right one. They are signs of an intellectual "Stop and Go." If a thinker had to work out the meaning of each idea discursively, he would be lost in a labyrinth that had no end and no center. Whenever an idea loses its immediate felt quality, it ceases to be an idea and be-

comes, like an algebraic symbol, a mere stimulus to execute an operation without the need of thinking. For this reason certain trains of ideas leading to their appropriate consummation (or conclusion) are beautiful or elegant. They have esthetic character. In reflection it is often necessary to make a distinction between matters of sense and matters of thought. But the distinction does not exist in all modes of experience. When there is genuine artistry in scientific inquiry and philosophic speculation, a thinker proceeds neither by rule nor yet blindly, but by means of meanings that exist immediately as feelings having qualitative color.*

Qualities of sense, those of touch and taste as well as of sight and hearing, have esthetic quality. But they have it not in isolation but in their connections; as interacting, not as simple and separate entities. Nor are connections limited to their own kind, colors with colors, sounds with sounds. Even the utmost in the way of scientific control never succeeds in getting either a "pure" color or a pure spectrum of colors. A ray of light produced under scientific control does not end sharply and with uniformity. It has vague edges and so internal complexity. Moreover, it is projected on a background and only thus does it enter perception. And the background is not merely one of other hues and shades. It has its own qualities. No shadow cast by even the thinnest line is ever homogeneous. It is impossible to isolate a color from light so that no refraction occurs. Even under the most uniform laboratory conditions, a "simple" color will be complex to the extent of having a bluish edge. And the colors used in paintings are not pure spectral colors but are pigments, not projected on the void but applied on a canvas.

These elementary observations are made with reference to attempts to carry over alleged scientific findings about sense material into esthetics. They show that even on so-called scientific ground there are no experiences of "pure" or "simple" qualities, nor of

*In connection with this matter, which bears not only on this particular topic, but on all questions connected with the intelligence that is characteristic of any artist, I refer to the essay on Qualitative Thought, contained in the volume *Philosophy and Civilization*.

qualities limited to the range of a single sense. But in any case there is an unbridgeable gap between science in the laboratory and the work of art. In a painting, colors are presented as those of sky, cloud, river, rock, turf, jewel, silk, and so on. Even the eye that is artificially trained to see color as color, apart from things that colors qualify, cannot shut out the resonances and transfers of value due to these objects. Of color qualities it is peculiarly true that they are in perception what they are in relations of contrast and harmony with other qualities. Those who measure a picture by its linear draughtsmanship have attacked colorists on this very ground, pointing out that in contrast with the stable constancy of line, color is never twice alike, varying with every change of light and other conditions.

In contrast with the attempt to carry over misplaced abstractions of anatomy and psychology into esthetic theory, we may well listen to painters. For example, Cézanne says: "Design and color are not distinct. In the degree in which color is really *painted,* design exists. The more colors harmonize with one another, the more defined is design. When color is at its richest, form is most complete. The secret of design, of everything marked by pattern, is contrast and relation of tones." He quotes with approval the saying of another painter, Delacroix: "Give me the mud of the streets and if you will leave me also with power to surround it to my taste I will make of it a woman's flesh of delicious tint." The opposition of quality as immediate and sensuous to relation as purely mediate and intellectual is false in general theory, psychological and philosophical. In fine art it is absurd, since the force of an art product depends upon complete interpenetration of the two.

The action of any one sense includes attitudes and dispositions that are due to the whole organism. The energies belonging to the sense-organs themselves enter causally into the perceived thing. When some painters introduced the "pointillist" technique, relying upon the capacity of the visual apparatus to fuse dots of color physically separate on the canvas, they exemplified but they did not originate an organic activity that transforms physical existence into a perceived object. But this sort of modification is elementary. It is not just the visual apparatus but the whole organism

that interacts with the environment in all but routine action. The eye, ear, or whatever, is only the channel *through* which the total response takes place. A color as seen is always qualified by implicit reactions of many organs, those of the sympathetic system as well as of touch. It is a funnel for the total energy put forth, not its wellspring. Colors are sumptuous and rich just because a total organic resonance is deeply implicated in them.

Even more important is the fact that the organism which responds in production of the experienced object is one whose tendencies of observation, desire and emotion, are shaped by prior experiences. It carries past experiences in itself not by conscious memory but by direct charge. This fact accounts for the existence of some degree of expressiveness in the object of every conscious experience. That fact has already been brought out. What is pertinent to the topic of esthetic substance turns upon the *way* in which the material of past experience, which loads present attitudes, operates in connection with material provided by means of the senses. In sheer recollection, for example, it is essential to keep the two apart; otherwise remembering is distorted. In purely acquired automatic action, past material is subordinated to the extent of not appearing at all in consciousness. In other cases, material of the past comes to consciousness but is consciously employed as an instrument to deal with some present problem and difficulty. It is kept down so as to serve some special end. If the experience is predominatingly one of investigation, it has the status of offering evidence or of suggesting hypotheses; if "practical," of furnishing cues to present action.

In esthetic experience, on the contrary, the material of the past neither fills attention, as in recollection, nor is subordinated to a special purpose. There is, indeed, a restriction imposed upon what comes. But it is that of contribution to the immediate matter of an experience now had. The material is not employed as a bridge to some further experience, but as an increase and individualization of *present* experience. The scope of a work of art is measured by the number and variety of elements coming from past experiences that are organically absorbed into the perception had here and now. They give it its body and its suggestiveness. They often come

from sources too obscure to be identified in any conscious memorial way, and thus they create the aura and penumbra in which a work of art swims.

We see a painting *through* the eyes, and hear music *through* the ears. Upon reflection, we are then only too much given to supposing that in the experience itself visual or auditory qualities as such, are central if not exclusive. This carrying into the primary experience as part of its immediate nature whatever subsequent analysis finds in it, is a fallacy—one which James called *the* psychological fallacy. In seeing a picture, it is not true that visual qualities are as such, or consciously, central, and other qualities arranged about them in an accessory or associated fashion. Nothing could be further from the truth. It is no more true of seeing a picture than it is of reading a poem or a treatise on philosophy, in which we are not aware in any distinct way of the visual forms of letters and words. These are stimuli to which we respond with emotional, imaginative, and intellectual values drawn from ourselves, which then are ordered by interaction with those presented through the medium of words. The colors seen in a picture are referred to objects, *not* to the eye. For this reason alone are they emotionally qualified, up to the point sometimes of hypnotic force, and are significant or expressive. The organ that investigation, using anatomical and physiological lore to help it out, shows to be causally primary in conditioning the experience, may in the experience itself be as unobtrusive as are the brain tracts that are involved just as much as the eye is, but which only the trained neurologist knows anything about—and which even he is not aware of when he is absorbed in seeing something. When we perceive, by means of the eyes as causal aids, the liquidity of water, the coldness of ice, the solidity of rocks, the bareness of trees in winter, it is certain that other qualities than those of the eye are conspicuous and controlling in perception. And it is as certain as anything can be that optical qualities do not stand out by themselves with tactual and emotive qualities clinging to their skirts.

The point just made is not one of remote technical theory. It bears directly upon our main problem, the relation of substance and form. This bearing has many aspects. One of them is the in-

herent tendency of sense to expand, to come into intimate rela-
tions with other things than itself, and thus to take on form be-
cause of its own movement—instead of passively waiting to have
form imposed on it. Any sensuous quality tends, because of its or-
ganic connections, to spread and fuse. When a sense quality re-
mains on the relatively isolated plane on which it first emerges, it
does so because of some special reaction, because it is cultivated
for special reasons. It ceases to be sensuous and becomes sensual.
This isolation of sense is not characteristic of esthetic objects, but
of such things as narcotics, sexual orgasms, and gambling in-
dulged in for the sake of the immediate excitement of sensation. In
normal experience, a sensory quality is related to other qualities in
such ways as to define an object. The organ of reception, which is
focal, adds energy and freshness to meanings otherwise merely
reminiscent, stale, or abstract. No poet is more directly sensuous
than Keats. But no one has written poetry in which sensuous qual-
ities are more intimately pervaded by objective events and scenes.
Milton was seemingly inspired by what to most persons today is a
dry and repellent theology. But he was sufficiently in the Shake-
spearean tradition so that his substance is that of direct drama
composed on a majestic scale. If we hear a rich and haunting
voice, we feel it immediately as the voice *of* a certain kind of per-
sonality. If we discover later that the person is, in fact, of a meager
and thin nature, we feel as if we had been cheated. So we are al-
ways esthetically disappointed when the sensuous qualities and the
intellectual properties of an object of art do not coalesce.

The moot problem of the relation of the decorative and the ex-
pressive is solved when it is viewed in the context of the integration
of matter and form. The expressive inclines to the side of meaning,
the decorative to that of sense. There is a hunger of the eyes for
light and color; there is distinctive satisfaction when this hunger is
fed. Wallpaper, rugs, tapestries, the marvelous play of changing
tints in sky and flowers, fulfill the need. Arabesques, gay colors,
have a like office in paintings. Some of the charm of architectural
structures—for they have charm as well as dignity—derives from
the fact that, in their exquisite adaptations of lines and spaces, they
meet a similar organic need of the sensorimotor system.

Yet in all this, there is no isolated operation of particular senses. The conclusion to be drawn is that the distinctively decorative quality is due to unusual energy of a sensory tract that lends vividness and appeal to the other activities with which it is associated. Hudson was a person of extraordinary sensitiveness to the sensuous surface of the world. Speaking of his childhood when he was, as he says, "just a little wild animal running around on its hind legs, amazingly interested in the world in which it found itself," he goes on to say: "I rejoiced in colors, scents, in taste and touch: the blue of the sky, the verdure of earth, the sparkle of light on water, the taste of milk, of fruit, of honey, the smell of dry or moist soil, of wind and rain, of herbs and flowers; the mere feel of a blade of grass made me happy; and there were certain sounds and perfumes, and above all certain colors in flowers, and in the plumage and eggs of birds, such as the purple polished shell of the tinamou's egg, which intoxicated me with delight. When riding on the plain I discovered a patch of scarlet verbenas in full bloom, the creeping plants covering an area of several yards, with a moist greensward sprinkled abundantly with the shining flower bosses, I would throw myself from the pony with a cry of joy to lie on the turf among them and feast my sight on their brilliant color."

No one can complain of a lack of recognition of immediate sensuous effect in such an experience. It is the more noteworthy because not affecting that superior attitude toward qualities of smell, taste, and touch adopted by some writers since Kant. But it will be noted that "colors, scents, taste and touch" are not isolated. The enjoyment is of the color, feel, and scent of *objects:* blades of grass, sky, sunlight and water, birds. The sight, smell, and touch immediately appealed to are means through which the boy's entire being reveled in acute perception of the qualities of the world in which he lived—qualities of things experienced not of sensation. The active agency of a particular sense-organ is involved in the production of the quality, but the organ is not for this reason the focus of the conscious experience. The connection of qualities with objects is intrinsic in all experience having significance. Eliminate this connection and nothing remains but a senseless and unidentifiable succession of transitory thrills. When we

have "pure" sensational experiences they come to us in moments of abrupt and coerced attention; they are shocks, and even shocks serve normally to incite curiosity to inquire into the nature of the situation that has suddenly interrupted our previous occupation. If the condition persists unchanged without ability to sink what is felt into a property of the object, the result is sheer exasperation— a thing far removed from esthetic enjoyment. To make the pathology of sensation the basis of esthetic enjoyment is not a promising undertaking.

Translate the enjoyment of the verbena creeping over the grass, sunlight sparkling on water, the shining polish of the bird's egg, into experiences of the live creature, and what we find is the very opposite of a single sense functioning alone, or of a number of senses merely adding their separate qualities together. The latter are coördinated into a whole of vitality by their common relations to objects. It is the objects that live an impassioned life. Art, like that of Hudson himself in recreating the experience of childhood, but carries further, through selection and concentration, the reference to an object, to organization and order beyond mere sense, implicit in the experience of the child. The native experience in its continuous and cumulative character (properties that exist because "sensations" are of *objects* ordered in a common world and are not mere transient excitations), thus affords a frame of reference for the work of art. If the theory that primary esthetic experience is of isolated sense qualities were correct, it would be impossible for art to superimpose connection and order upon them.

The situation just described gives the key to understanding the relation in a work of art between decorative and expressive. Were enjoyment simply of qualities by themselves, the decorative and the expressive would have no connection with each other, one coming from immediate sense experience and the other from relations and meanings introduced by art. Since sense itself blends with relations, the difference between the decorative and the expressive is one of emphasis. *Joie de vivre*—the abandon that takes no thought for the morrow, the sumptuousness of fabrics, the gayety of flowers, the matured richness of fruits—is *expressed* through the decorative quality that springs directly out of the full

play of sensuous qualities. If the range of expression in the arts is to be comprehensive, there are objects with values that must be rendered decoratively and others that must be rendered without it. A gay Pierrot at a funeral would clash with the others. When a court fool is introduced in a picture of the obsequies of his lord, his semblance must at least fit the requirements of the context. An excess of decorative quality in a particular setting has an expressiveness of its own—as Goya carries its exaggeration in some portraits of the court folk of his day to a point where their pomposity is made ridiculous. To demand that all art be decorative is as much a limitation of the material of art in its exclusion of expression of the somber as is a Puritanic demand that all art be grave.

The special bearing of the expressiveness of decoration on the problem of substance and form is that it proves the wrongness of the theories that isolate sense qualities. For in the degree in which decorative effect is achieved by isolation, it becomes empty embellishment, factitious ornamentation—like sugar figures on a cake—and external bedecking. There is no need for me to go out of my way to condemn the insincerity of using adornment to conceal weakness and cover up structural defects. But it is necessary to note that upon the basis of esthetic theories which separate sense and meaning, there is no artistic ground for such condemnation. Insincerity in art has an esthetic not just a moral source; it is found wherever substance and form fall apart. This statement does not signify that all structurally necessary elements should be evident to perception, as some extreme "functionalists" in architecture have insisted they should be. Such a contention confuses a rather bald conception of morals with art.* For, in architecture as in painting and poetry, raw materials are reordered through interaction with the self to make experience delightful.

Flowers in a room add to its expressiveness, when they harmonize with its furnishing and use without adding a note of

*Geoffrey Scott in his *Architecture of Humanism* has well exposed and explained this fallacy.

insincerity—even though they cover up something structurally necessary.

The truth of the matter is that what is form in one connection is matter in another and vice-versa. Color that is matter with respect to expressiveness of some qualities and values is form when it is used to convey delicacy, brilliance, gayety. And this statement does not signify that some colors have one function and other colors another function. Take, for example, Velasquez's painting of the child Maria Theresa, the one with a vase of flowers at her right. Its grace and delicacy is unsurpassable; the delicacy pervades every aspect and part—dress, jewels, face, hair, hands, flowers; but exactly the same colors express not only the stuff of fabrics, but as always with Velasquez when he succeeds, the inherent dignity of a human being, a dignity that even in a royal personage is so intrinsic that it is not a trapping of royalty.

It does not follow, of course, that all works of art, even those of the highest quality, must possess such a complete interpenetration of the decorative and the expressive as is often exhibited in Titian, Velasquez and Renoir. Artists may be great in one direction or the other, and still be great. French painting, almost from its beginning, has been marked by a lively sense of the decorative. Lancret, Fragonard, Watteau may be delicate to the point at times of fragility, but they almost never exhibit the split between expressiveness and extraneous ornamentation that almost always marks Boucher. They prefer *subjects* that require delicacy and intimate subtlety to render them fully expressive. Renoir has more of the substance of common life in his paintings than they. But he uses every plastic means—color, light, line, and planes, in themselves and in their interrelations—to convey a sense of abounding joy in intercourse with common things. Friends who knew the models he used, sometimes complained, according to report, that he made them much more beautiful than they really were. But no one who looks at the paintings gets any sense of their being "fixed up" or prettified. What is expressed is the experience Renoir himself had of the joy of perceiving the world. Matisse is unrivaled among the decorative colorists of the present. At first he may give to the beholder a shock because of juxtaposition of colors that in them-

selves are garish and because at first physical blanks seem to be unesthetic. But when one has learned to see, one finds a marvelous rendering of a quality that is characteristically French—clearness, clarté. If the attempt to express it does not succeed—and, of course, it does not always—then the decorative quality stands out by itself and is oppressive—like too much sugar.

Hence, one important faculty in learning to perceive a work of art—a faculty that many critics do not possess—is power to grasp the phases of objects that specially interest a particular artist. Still-life painting would be as empty as is most genre painting if it did not, under the hand of a master, become expressive through its very decorative quality of significant structural factors, as Chardin renders volume and spacial positions in ways that caress the eye; while Cézanne achieves monumental quality with fruits, just as, on the opposite side, Guardi suffuses the monumental in buildings with a decorative glow.

As objects are transported from one culture-medium to another, decorative quality takes on a new value. Rugs and bowls of the Orient have patterns whose original value was usually religious or political—as tribal emblems—expressed in decorative semi-geometrical figures. The western observer does not get the former any more than he grasps the religious expressiveness in Chinese paintings of original Buddhist and Taoist connections. The plastic elements remain and sometimes give a false sense of the separation of decorative from expressive. Local elements were a kind of medium by which entrance fee was paid. The intrinsic value remains after local elements have been stripped away.

Beauty, conventionally assumed to be the especial theme of esthetics, has hardly been mentioned in what precedes. It is properly an emotional term, though one denoting a characteristic emotion. In the presence of a landscape, a poem or a picture that lays hold of us with immediate poignancy, we are moved to murmur or to exclaim "How beautiful." The ejaculation is a just tribute to the capacity of the object to arouse admiration that approaches worship. Beauty is at the furthest remove from an analytic term, and hence from a conception that can figure in theory as a means of

explanation or classification. Unfortunately, it has been hardened into a peculiar object; emotional rapture has been subjected to what philosophy calls hypostatization, and the concept of beauty as an essence of intuition has resulted. For purposes of theory, it then becomes an obstructive term. In case the term is used in theory to designate the total esthetic quality of an experience, it is surely better to deal with the experience itself and show whence and how the quality proceeds. In that case, beauty is the response to that which to reflection is the consummated movement of matter integrated through its inner relations into a single qualitative whole.

There is another and more limited use of the term in which beauty is set off against other modes of esthetic quality—against the sublime, the comic, grotesque. Judging from results, the distinction is not a happy one. It tends to involve those who engage in it in dialectical manipulation of concepts and a compartmental pigeonholing that obstructs rather than aids direct perception. Instead of favoring surrender to the object, ready-made divisions lead one to approach an esthetic object with an intent to compare and thus to restrict the experience to a partial grasp of the unified whole. An examination of the cases in which the word is commonly used, apart from its immediate emotional sense mentioned above, reveals that one significance of the term is the striking presence of decorative quality, of immediate charm for sense. The other meaning indicates the marked presence of relations of fitness and reciprocal adaptation among the members of the whole, whether it be object, situation, or deed.

Demonstrations in mathematics, operations in surgery, are thus said to be beautiful—even a case of disease may be so typical in its exhibition of characteristic relations as to be called beautiful. Both meanings, that of sensuous charm and of manifestation of a harmonious proportion of parts, mark the human form in its best exemplars. The efforts that have been made by theorists to reduce one meaning to the other illustrate the futility of approaching the subject-matter through fixed concepts. The facts throw light upon the immediate fusion of form and matter, and upon the rela-

tivity of what is taken as form or as substance in a particular case to the purpose animating reflective analysis.

The sum of the whole discussion is that theories which separate matter and form, theories that strive to find a special locus in experience for each, are, in spite of their oppositions to one another, cases of the same fundamental fallacy. They rest upon separation of the live creature from the environment in which it lives. One school, one which becomes the "idealistic" school in philosophy when its implications are formulated, makes the separation in the interest of meanings or relations. The other school, the sensational-empiricist, makes the separation in behalf of the primacy of sense qualities. Esthetic experience has not been trusted to generate its own concepts for interpretation of art. These have been superimposed through being carried over, ready-made, from systems of thought framed without reference to art.

Nowhere has the result been more disastrous than with respect to the problem of matter and form. It would have been easy to fill the pages of this chapter with quotations from writers on esthetics asserting an original dualism of matter and form. I shall quote only one instance: "We call the facade of a Greek temple beautiful with special reference to its admirable form; whereas, in predicating beauty of a Norman castle, we refer rather to what the castle means—to the effect of imagination of its past proud strength and slow vanquishment by the unrelenting strokes of time."

This particular writer refers "form" directly to sense, and matter or "substance" to associated meaning. It would be just as easy to reverse the process. Ruins are picturesque; that is, their immediate pattern and color with overgrowing ivy, make a decorative appeal to sense; while, it might be argued, the effect of the Greek facade is due to a perception of relations of proportion, etc., which involve rational rather than sensuous considerations. Indeed, at first view, it seems more natural to ascribe matter to sense and form to mediating thought than vice versa. The fact is that distinctions in both directions are equally arbitrary. What is form in one context is matter in another and vice versa. Moreover,

they change places in the same work of art with a shift in our interest and attention. Take the following stanzas of "Lucy Gray":

> "Yet some maintain that to this day
> She is a living child;
> That you may see sweet Lucy Gray
> Upon the lonesome wild.
> O'er rough and smooth she trips along
> And never looks behind;
> And sings a solitary song
> That whistles in the wind."

Did anybody who felt the poem esthetically make—at the same time—a conscious distinction of sense and thought, of matter and form? If so, they did not read or hear esthetically, for the esthetic value of the stanzas lies in the integration of the two. Nevertheless, after an absorbed enjoyment of the poem, one may reflect and analyze. One may consider how the choice of words, the meter and rhyme, the movement of the phrases, contribute to the esthetic effect. Not only this, but such an analysis, performed with reference to a more definite apprehension of form, may enrich further direct experience. Upon another occasion, these same traits taken in connection with the development of Wordsworth, his experience and theories, may be treated as matter rather than as form. Then the episode, the "story of the child faithful unto death" serves as a form in which Wordsworth embodied the material of his personal experience.

Since the ultimate cause of the union of form and matter in experience is the intimate relation of undergoing and doing in interaction of a live creature with the world of nature and man, the theories, which separate matter and form, have their ultimate source in neglect of this relation. Qualities are then treated as impressions made by things, and relations that supply meaning as either associations among impressions, or as something introduced by thought. There *are* enemies of the union of form and matter. But they proceed from our own limitations; they are not intrinsic.

They spring from apathy, conceit, self-pity, tepidity, fear, convention, routine, from the factors that obstruct, deflect and prevent vital interaction of the life creature with the environment in which he exists. Only the being who is ordinarily apathetic finds merely transient excitement in a work of art; only one who is depressed, unable to face the situations about him, goes to it merely for medicinal solace through values he cannot find in his world. But art itself is more than a stir of energy in the doldrums of the dispirited, or a calm in the storms of the troubled.

Through art, meanings of objects that are otherwise dumb, inchoate, restricted, and resisted are clarified and concentrated, and not by thought working laboriously upon them, nor by escape into a world of mere sense, but by creation of a new experience. Sometimes the expansion and intensification is effected by means of

> "... some philosophic song
> Of Truth that cherishes our daily life";

sometimes it is brought about by a journey to far places, a venture to

> "casements opening on the foam
> Of perilous seas in faëry lands forlorn."

But whatever path the work of art pursues, it, just because it is a full and intense experience, keeps alive the power to experience the common world in its fullness. It does so by reducing the raw materials of that experience to matter ordered through form.

FORM as something that organizes material into the matter of art has been considered in the previous chapter. The definition that was given tells what form is when it is achieved, when it is there in a work of art. It does not tell how it comes to be, the conditions of its generation. Form was defined in terms of relations and esthetic form in terms of completeness of relations within a chosen medium. But "relation" is an ambiguous word. In philosophic discourse it is used to designate a connection instituted in thought. It then signifies something indirect, something purely intellectual, even logical. But "relation" in its idiomatic usage denotes something direct and active, something dynamic and energetic. It fixes attention upon the way things bear upon one another, their clashes and unitings, the way they fulfill and frustrate, promote and retard, excite and inhibit one another.

Intellectual relations subsist in propositions; they state the

connection of terms with one another. In art, as in nature and in life, relations are modes of interaction. They are pushes and pulls; they are contractions and expansions; they determine lightness and weight, rising and falling, harmony and discord. The relations of friendship, of husband and wife, of parent and child, of citizen and nation, like those of body to body in gravitation and chemical action, may be symbolized by terms or conceptions and then be stated in propositions. But they *exist* as actions and reactions in which things are modified. Art expresses, it does not state; it is concerned with existences in their perceived qualities, not with conceptions symbolized in terms. A social relation is an affair of affections and obligations, of intercourse, of generation, influence and mutual modification. It is in this sense that "relation" is to be understood when used to define form in art.

Mutual adaptation of parts to one another in constituting a whole is the relation which, formally speaking, characterizes a work of art. Every machine, every utensil, has, within limits, a similar reciprocal adaptation. In each case, an end is fulfilled. That which is merely a utility satisfies, however, a particular and limited end. The work of esthetic art satisfies many ends, none of which is laid down in advance. It serves life rather than prescribing a defined and limited mode of living. This service would be impossible were not parts bound together in the esthetic object in distinctive ways. How is it that each part is a dynamic part, that is, *plays an active part,* in constituting this kind of a whole? This is the question which confronts us.

In his *Enjoyment of Poetry*, Max Eastman uses the apt illustration of a man crossing the river, we will say coming into New York City on a ferry boat, to bring out the nature of an esthetic experience. Some men regard it as simply a journey to get them where they want to be—a means to be endured. So, perhaps, they read a newspaper. One who is idle may glance at this and that building identifying it as the Metropolitan Tower, the Chrysler Building, the Empire State Building, and so on. Another, impatient to arrive, may be on the lookout for landmarks by which to judge progress toward his destination. Still another, who is taking the journey for the first time, looks eagerly but is bewildered by the

multiplicity of objects spread out to view. He *sees* neither the whole nor the parts; he is like a layman who goes into an unfamiliar factory where many machines are plying. Another person, interested in real estate, may see, in looking at the skyline, evidence in the height of buildings, of the value of land. Or he may let his thoughts roam to the congestion of a great industrial and commercial center. He may go on to think of the planlessness of arrangement as evidence of the chaos of a society organized on the basis of conflict rather than coöperation. Finally the scene formed by the buildings may be looked at as colored and lighted volumes in relation to one another, to the sky and to the river. He is now seeing esthetically, as a painter might see.

Now the characteristic of the last-named vision in contrast with the others mentioned is that it is concerned with a *perceptual* whole, constituted by related parts. No one single figure, aspect, or quality is picked out as a means to some further external result which is desired, nor as a sign of an inference that may be drawn. The Empire State Building may be *recognized* by itself. But when it is seen pictorially it is seen as a related part of a perceptually organized whole. Its values, its qualities as seen, are modified by the other parts of the whole scene, and in turn these modify the value, as perceived, of every other part of the whole. There is now form in the artistic sense.

Matisse has described the actual process of painting in the following way: "If, on a clean canvas, I put at intervals patches of blue, green and red, with every touch that I put on, each of those previously laid on loses in importance. Say I have to paint an interior; I see before me a wardrobe. It gives me a vivid sensation of red; I put on the canvas the particular red that satisfies me. A relation is now established between this red and the paleness of the canvas. When I put on besides a green, and also a yellow to represent the floor, between this green and the yellow and the color of the canvas there will be still further relations. But these different tones diminish one another. It is necessary that the different tones I use be balanced in such a way that they do not destroy one another. To secure that, I have to put my ideas in order; the relationships between tones must be instituted in such a way that they are

built up instead of being knocked down. A new *combination* of colors will succeed to the first one and will give the wholeness of my conception."*

Now there is nothing different in principle here from what is done in the furnishing of a room, when the householder sees to it that tables, chairs, rugs, lamps, color of walls, and spacing of the pictures on them are so selected and arranged that they do not clash but form an ensemble. Otherwise there is confusion— confusion, that is, *in perception*. Vision cannot then complete it- self. It is broken up into a succession of disconnected acts, now seeing this, now that, and no mere succession is a series. When masses are balanced, colors harmonized, and lines and planes meet and intersect fittingly, perception will be serial in order to grasp the whole and each sequential act builds up and reënforces what went before. Even at first glance there is the sense of qualitative unity. There is form.

In a word, form is not found exclusively in objects labeled works of art. Wherever perception has not been blunted and per- verted, there is an inevitable tendency to arrange events and ob- jects with reference to the demands of complete and unified perception. Form is a character of every experience that is *an* ex- perience. Art in its specific sense enacts more deliberately and fully the conditions that effect this unity. *Form may then be defined as the operation of forces that carry the experience of an event, ob- ject, scene, and situation to its own integral fulfillment.* The con- nection of form with substance is thus inherent, not imposed from without. It marks the matter of an experience that is carried to consummation. If the matter is of a jolly sort, the form that would be fitting to pathetic matter is impossible. If expressed in a poem, then meter, rate of movement, words chosen, the whole structure, will be different, and in a picture so will the whole scheme of color and volume relationships. In comedy, a man at work laying bricks while dressed in evening clothes is appropriate; the form fits

*From *Notes d'un Peintre*, published in 1908. In another connection one might dwell upon the implications of the phrase concerning the necessity for "putting ideas in order."

the matter. The same subject-matter would bring the movement of another experience to disaster.

The problem of discovering the nature of form is thus identical with that of discovering the means by which are effected the carrying forward of an experience to fulfillment. When we know these means, we know what form is. While it is true that every matter has its own form, or is intimately individual, yet there are general conditions involved in the orderly development of any subject-matter to its completion, since only when these conditions are met does a unified perception take place.

Some of the conditions of form have been mentioned in passing. There can be no movement toward a consummating close unless there is a progressive massing of values, a cumulative effect. This result cannot exist without conservation of the import of what has gone before. Moreover, to secure the needed continuity, the accumulated experience must be such as to create suspense and anticipation of resolution. Accumulation is at the same time preparation, as with each phase of the growth of a living embryo. Only that is carried on which is led up to; otherwise there is arrest and a break. For this reason consummation is relative; instead of occurring once for all at a given point, it is recurrent. The final end is anticipated by rhythmic pauses, while that end is final only in an external way. For as we turn from reading a poem or novel or seeing a picture the effect presses forward in further experiences, even if only subconsciously.

Such characteristics as continuity, cumulation, conservation, tension and anticipation are thus formal conditions of esthetic form. The factor of resistance is worth especial notice at this point. Without internal tension there would be a fluid rush to a straightaway mark; there would be nothing that could be called development and fulfillment. The existence of resistance defines the place of intelligence in the production of an object of fine art. The difficulties to be overcome in bringing about the proper reciprocal adaptation of parts constitute what in intellectual work are problems. As in activity dealing with predominatingly intellectual matters, the material that constitutes a problem has to be converted into a means for its solution. It cannot be sidestepped. But

in art the resistance encountered enters into the work in a more immediate way than in science. The perceiver as well as artist has to perceive, meet, and overcome problems; otherwise, appreciation is transient and overweighted with sentiment. For, in order to perceive esthetically, he must remake his past experiences so that they can enter integrally into a new pattern. He cannot dismiss his past experiences nor can he dwell among them as they have been in the past.

A rigid predetermination of an end-product whether by artist or beholder leads to the turning out of a mechanical or academic product. The processes by which the final object and perception are reached are not, in such cases, means that move forward in the construction of a consummating experience. The latter is rather of the nature of a stencil, even though the copy from which the stencil is made exists in mind and not as a physical thing. A statement that an artist does not care how his work eventuates would not be literally true. But it is true that he cares about the end-result as a completion of what goes before and not because of its conformity or lack of conformity with a ready-made antecedent scheme. He is willing to leave the outcome to the adequacy of the means from which it issues and which it sums up. Like the scientific inquirer, he permits the subject-matter of his perception in connection with the problems it presents to determine the issue, instead of insisting upon its agreement with a conclusion decided upon in advance.

The consummatory phase of experience—which is intervening as well as final—always presents something new. Admiration always includes an element of wonder. As a Renaissance writer said: "There is no excellent beauty that hath not some strangeness in the proportion." The unexpected turn, something which the artist himself does not definitely foresee, is a condition of the felicitous quality of a work of art; it saves it from being mechanical. It gives the spontaneity of the unpremeditated to what would otherwise be a fruit of calculation. The painter and poet like the scientific inquirer know the delights of discovery. Those who carry on their work as a demonstration of a preconceived thesis may have the joys of egotistic success but not that of fulfillment of an experience for its own sake. In the latter they learn by their work, as they pro-

ceed, to see and feel what had not been part of their original plan and purpose.

The consummatory phase is recurrent throughout a work of art, and in the experience of a great work of art the points of its incidence shift in successive observations of it. This fact sets the insuperable barrier between mechanical production and use and esthetic creation and perception. In the former there are no ends until the final end is reached. Then work tends to be labor and production to be drudgery. But there is no final term in appreciation of a work of art. It carries on and is, therefore, instrumental as well as final. Those who deny this fact confine the significance of "instrumental" to the process of contributing to some narrow, if not base, office of efficacy. When the fact is not given a name, they acknowledge it. Santayana speaks of being "carried by contemplation of nature to a vivid faith in the ideal." This statement applies to art as to nature, and it indicates an instrumental function exercised by a work of art. We are carried to a refreshed attitude toward the circumstances and exigencies of ordinary experience. The work, in the sense of working, of an object of art does not cease when the direct act of perception stops. It continues to operate in indirect channels. Indeed, persons who draw back at the mention of "instrumental" in connection with art often glorify art for precisely the enduring serenity, refreshment, or re-education of vision that are induced by it. The real trouble is verbal. Such persons are accustomed to associate the word with instrumentalities for narrow ends—as an umbrella is instrumental to protection from rain or a mowing machine to cutting grain.

Some features, that at first sight seem extraneous, belong in fact to expressiveness. For they further the development of an experience so as to give the satisfaction peculiar to striking fulfillment. This is true, for example, of evidence of unusual skill and of economy in use of means, when these traits are integrated with the actual work. Skill is then admired not as part of the external equipment of the artist, but as an enhanced expression belonging to the object. For it facilitates the carrying on a continuous process to its own precise and definite conclusion. It belongs to the product and not merely to the producer, because it is a constituent

of form; just as the grace of a greyhound marks the movements he performs rather than is a trait possessed by the animal as something outside the movements.

Costliness is, also, as Santayana has pointed out, an element in expression, a costliness that has nothing in common with vulgar display of purchasing power. Rarity counts to intensify expression whether the rarity is that of infrequent occurrence of patient labor, or because it has the glamor of a distant clime and initiates us into hardly known modes of living. Such instances of costliness are part of form because they operate as do all factors of the new and unexpected in promoting the building up of a unique experience. The familiar may also have this effect. There are others beside Charles Lamb who are peculiarly sensitive to the charm of the domestic. But they *celebrate* the familiar instead of reproducing its forms in waxy puppets. The old takes on a new guise in which the sense of the familiar is rescued from the oblivion that custom usually effects. Elegance is also a part of form for it marks a work whenever subject-matter moves to its conclusion with inevitable logic.

Some of the traits mentioned are more often referred to technique than to form. The attribution is correct whenever the qualities in question are referred to the artist rather than to his work. There is a technique that obtrudes, like the flourishes of a writing master. If skill and economy suggest their author, they take us away from the work itself. The traits of the work which suggest the skill of its producer are then *in* the work but they are not *of* it. And the reason they are not of it is precisely the negative side of the point which I am emphasizing. They do not take us anywhere in the institution of unified developing experience; they do not act as inherent forces to carry the object of which they are a professed part to consummation. Such traits are like any other superfluous or excrescent element. Technique is neither identical with form nor yet wholly independent of it. It is, properly, the skill with which the elements constituting form are managed. Otherwise it is show-off or a virtuosity separated from expression.

Significant advances in technique occur, therefore, in connection with efforts to solve problems that are not technical but that

grow out of the need for new modes of experience. This statement is as true of esthetic arts as of the technological. There are improvements in technique that have to do merely with the bettering of an old-style vehicle. But they are insignificant in comparison with the change in technique from the wagon to the automobile when social needs called for a rapid transportation under personal control that was not possible even with the railway locomotive. If we take developments in the major techniques of painting during and since the Renaissance we find that they were connected with efforts to solve problems that grew out of the experience expressed in painting and not out of the craftsmanship of painting itself.

There was first the problem of transition from depiction of contours in flat-like mosaics to "three-dimensional" presentations. Until experience expanded to demand expression of something more than decorative renderings of religious themes determined by ecclesiastic fiat there was nothing to motivate this change. In its own place, the convention of "flat" painting is just as good as any other convention, as Chinese rendering of perspective is as perfect in one way as that of Western painting in another. The force that brought about the change in technique was the growth of naturalism in experience outside of art. Something of the same sort applies to the next great change, mastery of means for rendering aërial perspective and light. The third great technical change was the use by the Venetians of color to effect what other schools, especially the Florentine, had accomplished by means of the sculpturesque line—a change indicative of a vast secularization of values with its demand for the glorification of the sumptuous and suave in experience.

I am not concerned, however, with the history of an art, but with indicating how technique functions in respect to expressive form. The dependence of significant technique upon the need for expressing certain distinctive modes of experience is testified to by the three stages that usually attend the appearance of a new technique. At first there is experimentation on the side of artists, with considerable exaggeration of the factor to which the new technique is adapted. This was true of the use of line to define recognition of the value of the round, as with Mantegna; it is true of the

typical impressionists in respect to light-effects. On the side of the public there is general condemnation of the intent and subject-matter of these adventures in art. In the next stage, the fruits of the new procedure are absorbed; they are naturalized and effect certain modifications of the old tradition. This period establishes the new aims and hence the new technique as having "classic" validity, and is accompanied with a prestige that holds over into subsequent periods. Thirdly, there is a period when special features of the technique of the masters of the balanced period are adopted for imitation and made ends in themselves. Thus in the later seventeenth century, the treatment of dramatic movement characteristic of Titian and still more of Tintoretto, by means chiefly of light and shade, is exaggerated to the point of the theatrical. In Guercino, Caravaggio, Feti, Carracci, Ribera, the attempt to depict movement dramatically results in posed tableaux and defeats itself. In this third stage (which dogs creative work after the latter has received general recognition), technique is borrowed without relation to the urgent experience that at first evoked it. The academic and eclectic result.

I have previously stated that craftsmanship alone is not art. What is now added is the often ignored point of the thorough relativity of technique to form in art. It was not lack of dexterity that gives early Gothic sculpture its special form nor that gives Chinese paintings their special kind of perspective. The artists said what they had to say better with the techniques they used than they could have done with another. What to us is a charming naïveté was to them the simple and direct method of expressing a felt subject-matter. For this reason, while there is not continuity of repetition in any esthetic art, neither is there, of necessity, advance. Greek sculpture will never be equaled in its own terms. Thorwaldsen is no Pheidias. That which Venetian painters achieved will stand unrivaled. The modern reproduction of the architecture of the Gothic cathedral always lacks the quality of the original. What happens in the movement of art is emergence of new materials of experience demanding expression, and therefore involving in their expression new forms and techniques. Manet went back in time to

achieve his brushwork, but his return involved no mere copying of an old technique.

The relativity of technique to form is nowhere better exemplified than in Shakespeare. After his reputation was established as the universal literary artist, critics thought it necessary to assume that greatness adhered to all his work. They built up theories of literary form on the basis of special techniques. They were shocked when a more accurate scholarship showed that many much lauded things were borrowed from the conventions of the Elizabethan stage. To those who have identified technique with form, the effect is to deflate Shakespeare's greatness. But his substantial form remains just what it always has been and is unaffected by his local adaptations. Allowance for some aspects of his technique should indeed but concentrate attention upon what is significant in his art.

It is hardly possible to overstate the relativity of technique. It varies with all sorts of circumstances having little relation to the work of art—perhaps a new discovery in chemistry that affects pigments. The significant changes are those which affect form itself in its esthetic sense. The relativity of technique to instruments is often overlooked. It becomes important when the new instrument is a sign of a change in culture—that is, in material to be expressed. Early pottery is largely determined by the potters' wheel. Rugs and blankets owe much of their geometric design to the nature of the instrument of weaving. Such things by themselves are like the physical constitution of an artist—as Cezanne wished he had Manet's muscles. Such things become of more than antiquarian interest only when they relate to a change in culture and experience. The technique of those who painted long ago on walls of caves and who carved bone served the purpose that conditions offered or imposed. Artists always have used and always will use all kinds of techniques.

There is, on the other side, a tendency among lay critics to confine experimentation to scientists in the laboratory. Yet one of the essential traits of the artist is that he is born an experimenter. Without this trait he becomes a poor or a good academician. The

artist is compelled to be an experimenter because he has to express an intensely individualized experience through means and materials that belong to the common and public world. This problem cannot be solved once for all. It is met in every new work undertaken. Otherwise an artist repeats himself and becomes esthetically dead. Only because the artist operates experimentally does he open new fields of experience and disclose new aspects and qualities in familiar scenes and objects.

If, instead of saying "experimental" one were to say "adventurous," one would probably win general assent—so great is the power of words. Because the artist is a lover of unalloyed experience, he shuns objects that are already saturated, and he is therefore always on the growing edge of things. By the nature of the case, he is as unsatisfied with what is established as is a geographic explorer or a scientific inquirer. The "classic" when it was produced bore the marks of adventure. This fact is ignored by classicists in their protest against romantics who undertake the development of new values, often without possessing means for their creation. That which is now classic is so because of completion of adventure, not because of its absence. The one who perceives and enjoys esthetically always has the sense of adventure in reading any classic that Keats had in reading Chapman's *Homer*.

Form in the concrete can be discussed only with respect to actual works of art. These cannot be presented in a book on the theory of esthetics. But absorption in a work of art so complete as to exclude analysis cannot be long sustained. There is a rhythm of surrender and reflection. We interrupt our yielding to the object to ask where it is leading and how it is leading there. We then become occupied in some degree with the formal conditions of a concrete form. We have, indeed, already mentioned these conditions of form in speaking of cumulation, tension, conservation, anticipation, and fulfillment as formal characteristics of an esthetic experience. The one who withdraws far enough from the work of art to escape the hypnotic effect of its total qualitative impression will

not use these words nor be explicitly conscious of the things for which they stand. But the traits he distinguishes as those which gave the work its power over him are reducible to such conditions of form as have been stated.

The total overwhelming impression comes first, perhaps in seizure by a sudden glory of the landscape, or by the effect upon us of entrance into a cathedral when dim light, incense, stained glass and majestic proportions fuse in one indistinguishable whole. We say with truth that a painting strikes us. There is an impact that precedes all definite recognition of what it is about. As the painter Delacroix said about this first and pre-analytic phase, "before knowing what the picture represents you are seized by its magical accord." This effect is particularly conspicuous for most persons in music. The impression directly made by an harmonious ensemble in any art is often described as the musical quality of that art.

Not only, however, is it impossible to prolong this stage of esthetic experience indefinitely, but it is not desirable to do so. There is only one guarantee that this direct seizure be at a high level, and that is the degree of cultivation of the one experiencing it. In itself it may be, and often is, the result of cheap means employed upon meretricious stuff. And the only way in which to rise from that level to one where there is intrinsic assurance of worth is through intervening periods of discrimination. Distinction in product is intimately connected with the process of distinguishing.

While both original seizure and subsequent critical discrimination have equal claims, each to its own complete development, it must not be forgotten that direct and unreasoned impression comes first. There is about such occasions something of the quality of the wind that bloweth where it listeth. Sometimes it comes and sometimes it does not, even in the presence of the same object. It cannot be forced, and, when it does not arrive, it is not wise to seek to recover by direct action the first fine rapture. The beginning of esthetic understanding is the retention of these personal experiences and their cultivation. For, in the end, nourishing of them will pass into discrimination. The outcome of discrimination will often be to convince us that the particular thing in question

was not worthy of calling out the rapt seizure; that in fact the latter was caused by factors adventitious to the object itself. But this outcome is itself a definite contribution to esthetic education and lifts the next direct impression to a higher level. In the interest of discrimination, as well as that of direct capture by the object, the one sure means is refusal to simulate and pretend when that which, when it was intense, seemed to the ancients to be a kind of divine madness, does not arrive.

The phase of reflection in the rhythm of esthetic appreciation is criticism in germ and the most elaborate and conscious criticism is but its reasoned expansion. The development of that particular theme belongs elsewhere.* But one topic belonging within that general theme must at least be touched upon here. Many tangled problems, multifarious ambiguities, and historic controversies are involved in the question of the subjective and objective in art. Yet if the position that has been taken regarding form and substance is correct, there is at least one important sense in which form must be as objective as the material which it qualifies. If form emerges when raw materials are selectively arranged with reference to rendering an experience unified in movement to its intrinsic fulfillment, then surely objective conditions are controlling forces in the production of a work of art. A work of fine art, a statue, building, drama, poem, novel, when done, is as much a part of the objective world as is a locomotive or a dynamo. And, as much as the latter, its existence is causally conditioned by the coördination of materials and energies of the external world. I do not mean that this is the whole of the work of art; even the product of industrial art was made to serve a purpose and is actually, instead of potentially, a locomotive as it operates in conditions where it produces consequences beyond its bare physical being; as, namely, it transports human beings and goods. But I do mean that there can be no esthetic experience apart from an *object,* and that for an object to be the content of esthetic appreciation it must satisfy those *objective* conditions without which cumulation, conservation, reënforce-

*See Chapter XIII.

ment, transition into something more complete, are impossible. The general conditions of esthetic form, of which I spoke a few paragraphs ago, are objective in the sense of belonging to the world of physical materials and energies: while the latter do not suffice for an esthetic experience, they are a *sine qua non* of its existence. And the immediate artistic evidence for the truth of this statement is the interest that obsesses every artist in observing the world about him and his devoted care for the physical media with which he works.

What, then, are those formal conditions of artistic form that are rooted deep in the world itself? The implications of the question involve no material not already considered. Interaction of environment with organism is the source, direct or indirect, of all experience and from the environment come those checks, resistances, furtherances, equilibria, which, when they meet with the energies of the organism in appropriate ways, constitute form. The first characteristic of the environing world that makes possible the existence of artistic form is rhythm. There is rhythm in nature before poetry, painting, architecture and music exist. Were it not so, rhythm as an essential property of form would be merely superimposed upon material, not an operation through which material effects its own culmination in experience.

The larger rhythms of nature are so bound up with the conditions of even elementary human subsistence, that they cannot have escaped the notice of man as soon as he became conscious of his occupations and the conditions that rendered them effective. Dawn and sunset, day and night, rain and sunshine, are in their alternation factors that directly concern human beings.

The circular course of the seasons affects almost every human interest. When man became agricultural, the rhythmic march of the seasons was of necessity identified with the destiny of the community. The cycle of irregular regularities in the shape and behavior of the moon seemed fraught with mysterious import for the welfare of man, beast, and crops, and inextricably bound up with the mystery of generation. With these larger rhythms were bound up those of the ever-recurring cycles of growth from seed to a maturity that reproduced the seed; the reproduction of animals, the

relation of male and female, the never-ceasing round of births and deaths.

Man's own life is affected by the rhythm of waking and sleeping, hungering and satiety, work and rest. The long rhythms of agrarian pursuits were broken into minuter and more directly perceptible cycles with the development of the crafts. With the working of wood, metal, fibers, clay, the change of raw material into consummated result, through technically controlled means, is objectively manifest. In working the matter, there are the recurrent beats of patting, chipping, molding, cutting, pounding, that mark off the work into measures. But more significant were those times of preparation for war and planting, those times of celebrating victory and harvest, when movements and speech took on cadenced form.

Thus, sooner or later, the participation of man in nature's rhythms, a partnership much more intimate than is any observation of them for purposes of knowledge, induced him to impose rhythm on changes where they did not appear. The apportioned reed, the stretched string and taut skin rendered the measures of action conscious through song and dance. Experiences of war, of hunt, of sowing and reaping, of the death and resurrection of vegetation, of stars circling over watchful shepherds, of constant return of the inconstant moon, were undergone to be reproduced in pantomime and generated the sense of life as drama. The mysterious movements of serpent, elk, boar, fell into rhythms that brought the very essence of the lives of these animals to realization as they were enacted in dance, chiseled in stone, wrought in silver, or limned on the walls of caves. The formative arts that shaped things of use were wedded to the rhythms of voice and the self-contained movements of the body, and out of the union technical arts gained the quality of fine art. Then the apprehended rhythms of nature were employed to introduce evident order into some phase of the confused observations and images of mankind. Man no longer conformed his activities of necessity to the rhythmic changes of nature's cycles, but used those which necessity forced upon him to celebrate his relations to nature as if she had conferred upon him the freedom of her realm.

The reproduction of the order of natural changes and the perception of that order were at first close together, so close that no distinction existed between art and science. They were both called techné. Philosophy was written in verse and, under the influence of imaginative endeavor, the world became a cosmos. Early Greek philosophy told the story of nature, and since a story has beginning, movement, and climax, the substance of the story demanded esthetic form. Within the story, minor rhythms became parts of the great rhythm of generation and destruction, of coming into being and passing out of being; of remission and concentration; of aggregation and dispersion; of consolidation and dissolution. The idea of law emerged with the idea of harmony, and conceptions that are now prosaic commonplaces emerged as parts of the art of nature as that was construed in the art of language.

The existence of a multitude of *illustrations* of rhythm in nature is a familiar fact. Oft cited are the ebb and flow of tides, the cycle of lunar changes, the pulses in the flow of blood, the anabolism and katabolism of all living processes. What is not so generally perceived is that every uniformity and regularity of change in nature is a rhythm. The terms "natural law" and "natural rhythm" are synonymous. As far as nature is to us more than a flux lacking order in its mutable changes, as far as it is more than a whirlpool of confusions, it is marked by rhythms. Formulæa for these rhythms constitute the canons of science. Astronomy, geology, dynamics, and kinematics record various rhythms that are the orders of different kinds of change. The very conceptions of molecule, atom, and electron arise out of the need of formulating lesser and subtler rhythms that are discovered. Mathematics are the most generalized statements conceivable corresponding to the most universally obtaining rhythms. The one, two, three, four, of counting, the construction of lines and angles into geometric patterns, the highest flights of vector analysis, are means of recording or of imposing rhythm.

The history of the progress of natural science is the record of operations that refine and that render more comprehensive our grasp of the gross and limited rhythms that first engaged the attention of archaic man. The development reached a point where

the scientific and artistic parted ways. Today the rhythms which physical science celebrates are obvious only to thought, not to perception in immediate experience. They are presented in symbols which signify nothing in sense-perception. They make natural rhythms manifest only to those who have undergone long and severe discipline. Yet a common interest in rhythm is still the tie which holds science and art in kinship. Because of this kinship, it is possible that there may come a day in which subject-matter that now exists only for laborious reflection, that appeals only to those who are trained to interpret that which to sense are only hieroglyphics, will become the substance of poetry, and thereby be the matter of enjoyed perception.

Because rhythm is a universal scheme of existence, underlying all realization of order in change, it pervades all the arts, literary, musical, plastic and architectural, as well as the dance. Since man succeeds only as he adapts his behavior to the order of nature, his achievements and victories, as they ensue upon resistance and struggle, become the matrix of all esthetic subject-matter; in some sense they constitute the common pattern of art, the ultimate conditions of form. Their cumulative orders of succession become without express intent the means by which man commemorates and celebrates the most intense and full moments of his experience. Underneath the rhythm of every art and of every work of art there lies, as a substratum in the depths of the subconsciousness, the basic pattern of the relations of the live creature to his environment.

It is not, therefore, just because of the systole and diastole in the coursing of the blood, or alternate inspiration and exhalation in breathing, the swing of the legs and arms in locomotion, nor because of any combination of specific exemplifications of natural rhythm, that man delights in rhythmic portrayals and presentations. The importance of such considerations is great. But ultimately the delight springs from the fact that such things are instances of the relationships that determine the course of life, natural and achieved. The supposition that the interest in rhythm which dominates the fine arts can be explained simply on the basis of rhythmic processes in the living body is but another case of the

separation of organism from environment. Man attended to the environment long before he gave much observation or thought to his own organic processes and certainly long before he developed attentive interest to his own mental states.

Naturalism is a word of many meanings in philosophy as well as in art. Like most 'isms—classicism and romanticism, idealism and realism in art—it has become an emotional term, a war cry of partisans. In respect to art, even more than in respect to philosophy, formal definitions leave us cold; by the time we arrive at them, the elements that stirred the blood and aroused admiration in the concrete have vanished. In poetry, "nature" is often associated with an interest that is distinct from, if not opposed to, matter derived from the life of men in association. As with Wordsworth, nature is, then, that to which one turns in communion for the sake of consolation and peace

> *". . . when the fretful stir*
> *Unprofitable, and the fever of the world*
> *Have hung upon the beatings of the heart."*

In painting, "naturalism" suggests turning to the more incidental and, as it were, informal, the more immediately evident aspects of earth, sky, and water in distinction from those pictures that attend to structural relationships. But naturalism in the broadest and deepest sense of nature is a necessity of all great art, even of the most religiously conventional and of abstract painting, and of the drama that deals with human action in an urban setting. Discrimination can be made only with reference to the particular aspect and phase of nature in which the rhythms that mark all relationships of life and its setting are displayed.

Natural and objective conditions must be used in any case to carry through to completion the expression of the values that belong to an integrated experience in its immediate quality. But naturalism in art means something more than the necessity all arts are under of employing natural and sensuous media. It means that all which can be expressed is some aspect of the relation of man and his environment, and that this subject-matter attains its most per-

fect wedding with form when the basic rhythms that characterize the interaction of the two are depended upon and trusted with abandon. "Naturalism" is often alleged to signify disregard of all values that cannot be reduced to the physical and animal. But so to conceive nature is to isolate environing conditions as the whole of nature and to exclude man from the scheme of things. The very existence of art as an objective phenomenon using natural materials and media is proof that nature signifies nothing less than the whole complex of the results of the interaction of man, with his memories and hopes, understanding and desire, with that world to which one-sided philosophy confines "nature." The true antithesis of nature is not art but arbitrary conceit, fantasy, and stereotyped convention.

Not but that there exist conventions which are vital and natural. The arts in certain times and places are controlled by conventions of rite and ceremony. Yet they do not then of necessity become barren and unesthetic, for the conventions themselves live in the life of the community. Even when they assume prescribed hieratic and liturgical shapes, they may express what is active in the experience of the group. When Hegel asserted that the first stage in art is always "symbolic" he hinted, in terms of his philosophy, at the fact that certain arts were once free to express only that aspect of experience that had a priestly or royal sanction. Yet it was still an aspect of experience that was expressed. Moreover, as a generalization, the characterization is false. For in all times and places, there have been popular arts of song, dance, storytelling, and picture-making, outside of officially sanctioned and directed arts. The secular arts were, however, more directly naturalistic, and, whenever secularism invaded experience, their qualities remade the official arts in a naturalistic direction. As far as this did not occur, that which was once vital degenerated. Witness, for example, the degenerate baroque that is found in public squares in southwestern Europe. It is trivial to the point of frivolity, with cupids masquerading for cherubs, as a typical example.

Genuine naturalism is as different from imitation of things and traits as it is from imitation of the procedures of artists upon

whom time has conferred specious authority—specious because not arising from experience of the things which they experienced and expressed. It is a term of contrast and signifies a deeper and wider sensitivity to some aspect of the rhythms of existence than had previously existed. It is a term of contrast, because it signifies that in some particular a personal perception has been substituted for a convention. Let me recur to what was previously said about the expression of beatification in paintings. The assumption that certain definite lines stand for a given emotion is a convention that does not arise from observation; it stands in the way of acute sensitivity of response. Genuine naturalism supervened when the *unfixity* of human features under the influence of emotions was perceived; when their own variety of rhythm was reacted to. I do not mean to restrict limiting conventions to ecclesiastic influence. More hampering ones arise within artists themselves when they become academic, like the later eclectic painting in Italy and most of English poetry in the eighteenth century. What for convenience I call "realistic" art (the word is arbitrary but the thing exists), in distinction from naturalistic, reproduces details but misses their moving and organizing rhythm. Like a photograph it wears out, save for the recording purposes of prose. It wears out because the object can be approached only from one fixed point of view. The relations that form a subtle rhythm promote approach from changing points of view. How many individualized varieties of personal experience utilize a rhythm that is formally the same, though it is actually differentiated by the material which it forms into the substance of a work of art!

In opposition to the so-called poetic diction that flourished in England after the death of Milton, Wordsworth's poetry was a naturalistic revolt. The assumption (due to misunderstanding of something that Wordsworth wrote) that its essence was a use of words of the common idiom makes nonsense of his actual work. For it assumes that he continued the separation of form and substance characteristic of earlier poetry, only turning it face-about. In fact, its significance is illustrated in an early couplet of the poet when that is taken in connection with a comment of his own.

> *"And, fronting the bright west, yon oak entwines*
> *Its darkening boughs and leaves in stronger lines."*

This is verse rather than poetry. It is stark description untouched by emotion. As Wordsworth himself said of it: "This is feebly and imperfectly exprest." But he goes on to add, "I recollect distinctly the very spot where this first struck me. It was on the way between Hawkshead and Ambleside and gave me extreme pleasure. The moment was important in my poetic history; for I date from it my consciousness of *the infinite variety of natural appearances* which had been unnoticed by the poets of any age or country, so far as I was acquainted with them; and I made a resolution to supply in some degree the deficiency. I could not at this time have been above fourteen years of age."

Here is a definite instance of transition from the conventional, from something abstractly generalized that both sprang from and conduced to incomplete perception, to the naturalistic—to an experience that corresponded more subtly and sensitively to the rhythm of natural change. For it was not mere variety, mere flux, he wished to express, but that of ordered relationships—the relation of accent of leaves and boughs to variations of sunshine. The details of place and time, of the particular oak, disappear; the relation remains and yet not in the abstract but definitely, though, in this particular case, rather prosaically embodied.

The discussion involves no diversion from the theme of rhythm as a condition of form. Other persons may prefer some other word than "naturalistic" to express escape from convention to perception. But whatever word is used, it must, if it is to be true to refreshment of esthetic form, emphasize sensitivity to natural rhythm. And this fact brings me to a short definition of rhythm. It is ordered variation of changes. When there is a uniformly even flow, with no variations of intensity or speed, there is no rhythm. There is stagnation even though it be the stagnation of unvarying motion. Equally there is no rhythm when variations are not placed. There is a wealth of suggestion in the phrase *"takes place."* The change not only comes but it belongs; it has its definite place in a larger whole. The most obvious instances of rhythm concern varia-

tions in intensity as, in the verses quoted from Wordsworth, certain forms grow strong against the weaker forms of other boughs and leaves. There is no rhythm of any kind, no matter how delicate and no matter how extensive, where variation of pulse and rest do not occur. But these variations of intensity are not, in any complex rhythm, the whole of the matter. They serve to define variations in number, in extent, in velocity, and in intrinsic qualitative differences, as of hue, tone, etc. That is, variations of intensity are relative to the subject-matter directly experienced. Each beat, in differentiating a part within the whole, adds to the force of what went before while creating a suspense that is a demand for something to come. It is not a variation in a single feature but a modulation of the entire pervasive and unifying qualitative substratum.

A gas that evenly saturates a container, a torrential flood sweeping away all resistance, a stagnant pond, an unbroken waste of sand, and a monotonous roar are wholes without rhythm. A pond moving in ripples, forked lightning, the waving of branches in the wind, the beating of a bird's wing, the whorl of sepals and petals, changing shadows of clouds on a meadow, are simple natural rhythms.* There must be energies resisting each other. Each gains intensity for a certain period, but thereby compresses some opposed energy until the latter can overcome the other which has been relaxing itself as it extends. Then the operation is reversed, not necessarily in equal periods of time but in some ratio that is felt as orderly. Resistance accumulates energy; it institutes conservation until release and expansion ensue. There is, at the moment of reversal, an interval, a pause, a rest, by which the interaction of opposed energies is defined and rendered perceptible. The pause is a balance or symmetry of antagonistic forces. Such is the generic schema of rhythmic change save that the statement fails to take account of minor coincident changes of expansion and contraction that are going on in every phase and aspect of an organized whole, and of the fact that the successive waves and pulses are themselves cumulative with respect to final consummation.

*The fact that we designate it a "whorl" indicates that we are subconsciously aware of the tension of energies involved.

With respect to human emotion, an immediate discharge that is fatal to expression is detrimental to rhythm. There is not enough resistance to create tension, and thereby a periodic accumulation and release. Energy is not conserved so as to contribute to an ordered development. We get a sob or shriek, a grimace, a scowl, a contortion, a fist striking out wildly. Darwin's book entitled *Expression of Emotions*—more accurately their discharge—is full of examples of what happens when an emotion is simply an organic state let loose on the environment in direct overt action. When complete release is postponed and is arrived at finally through a succession of ordered periods of accumulation and conservation, marked off into intervals by the recurrent pauses of balance, the manifestation of emotion becomes true expression, acquiring esthetic quality—and only then.

Emotional energy continues to work but now does real work; it accomplishes something. It evokes, assembles, accepts, and rejects memories, images, observations, and works them into a whole toned throughout by the same immediate emotional feeling. Thereby is presented an object that is unified and distinguished throughout. The resistance offered to immediate expression of emotion is precisely that which compels it to assume rhythmic form. This, indeed, is Coleridge's explanation of meter in verse. Its origin, he says, he "would trace to the balance in the mind effected by that spontaneous effort which strives to hold in check the workings of passion. . . . This salutary antagonism is assisted by the very state which it counteracts, and this balance of antagonists becomes organized into meter by a supervening act of will or judgment, consciously and for the foreseen purpose of pleasure." There is "an interpenetration of passion and of will, of spontaneous impulse and voluntary purpose." Meter thus "tends to increase the vivacity and susceptibility of both the general feelings and the attention. This effect it produces by the continued excitement of surprise and the quick reciprocations of curiosity gratified and re-excited, which are too slight indeed to be at any one moment objects of distinct consciousness, yet become considerable in their aggregate influence." Music complicates and intensifies the process of genial reciprocating antagonism, suspense and reën-

forcement, where the various "voices" at once oppose and answer one another.

Santayana has truly remarked: "Perceptions do not remain in the mind, as would be suggested by the trite simile of the seal and the wax, passive and changeless, until time wears off their rough edges and makes them fade. No, perceptions fall into the brain rather as seeds into a furrowed field or even as sparks into a keg of gunpowder. Each image breeds a hundred more, sometimes slowly and subterraneously, sometimes (as when a passionate train is started) with a sudden burst of fancy." Even in abstract processes of thought, connection with the primary motor apparatus is not entirely severed, and the motor mechanism is linked up with reservoirs of energy in the sympathetic and endocrine system. An observation, an idea flashing into the mind, starts something. The result may be a too direct discharge to be rhythmic. There may be a display of rude undisciplined force. There may be a feebleness that allows energy to dissipate itself in idle day-dreaming. There may be too great openness of certain channels due to habits having become blind routines—when activity takes the form sometimes identified exclusively with "practical" doing. Unconscious fears of a world unfriendly to dominating desires breed inhibition of all action or confine it within familiar channels. There are multitudes of ways, varying between poles of tepid apathy and rough impatience, in which energy once aroused, fails to move in an ordered relation of accumulation, opposition, suspense and pause, toward final consummation of an experience. The latter is then inchoate, mechanical, or loose and diffuse. Such cases define, by contrast, the nature of rhythm and expression.

Physically, if you turn a faucet only a little, resistance to the flow compels a conservation of energy until resistance is overcome. Then water comes in individual drops and at regular intervals. If a stream of water falls a sufficient distance, as in a cataract, surface tension causes the stream to reach the bottom in single globules. Polarity, or opposition of energies, is everywhere necessary to the definition, the delimitation, that resolves an otherwise uniform mass and expanse into individual forms. At the same time the balanced distribution of opposite energies provides the measure or

order which prevents variation from becoming a disordered heterogeneity. Paintings as well as music, drama, and the novel are characterized by tension. In its obvious forms it is seen in the use of complementary colors, the contrast of foreground and background, of central and peripheral objects. In modern paintings, the necessary contrast and relation of light and dark is not attained by using shading, umbers and browns, but by pure colors each of which in itself is bright. Curves similar to one another are used in defining contours but with opposed direction, up and down, forward and back. Single lines also exhibit tension. As Leo Stein has remarked, "Tension in line can be observed if one will follow the outline of a vase and notice the force it takes to bend the line of a contour. This will depend upon the inherent elasticity of the line, the direction and energy imparted by the previous portion, and so on." The universality of use of intervals in works of art is significant. They are not breaks, since they bring about both individualized delimitation and proportionate distribution. They specify and they relate at the same time.

The medium through which energy operates determines the resulting work. The resistance to be overcome in song, dance, and dramatic presentation is partly within the organism itself, embarrassment, fear, awkwardness, self-consciousness, lack of vitality, and partly in the audience addressed. Lyrical utterance and dance, the sounds emitted by musical instruments stir the atmosphere or the ground. They do not have to meet the opposition that is found in reshaping external material. Resistance is personal and consequences are directly personal on the side of both producer and consumer. Yet eloquent utterance is not writ in water. The organisms, the persons concerned are in some measure remade. Composer, writer, painter, sculptor, work in a medium that is more external and at a greater remove from the audience than do actor, dancer, and musical performer. They reshape an external material that offers resistance and sets up tensions within, while they are relieved of the pressure exercised by an immediate audience. The difference goes deep. It appeals to difference in temperament and talent and different moods in the audience. Painting and architecture cannot receive the direct excited simultaneous acclaim evoked

by the theater, the dance, and the musical performance. The direct personal contact established by eloquence, music, and enacted drama is *sui generis*.

The immediate effect of the plastic and architectural arts is not organic but in the enduring environing world. It is at once more indirect and more lasting. Song and drama recorded in letters, music that is written, take their place among the formative arts. The effect of the objective modifications brought about in the formative arts is dual. On the one hand, there is a direct lowering of tension between man and the world. Man finds himself more at home, since he is in a world that he has participated in making. He becomes habituated and relatively at ease. In some cases and within certain limits, the resulting greater accommodation of man and the environment to each other is unfavorable to further esthetic creation. Things are now too smooth; there is not enough irregularity to create demand for a new manifestation and opportunity for a new rhythm. Art becomes stereotyped, and contented with playing minor variations upon old themes in styles and manners that are agreeable because they are the channels of pleasant reminiscence. The environment is, in so far, exhausted, worn out, esthetically speaking. The recurrence of the academic and eclectic in the arts is a phenomenon that cannot be ignored. And if we usually associate the academic with painting and sculpture rather than with, say, poetry or the novel, it is none the less true that the reliance of the latter upon stock scenes, variations of familiar situations and dressings-up of readily recognized types of character have all the traits that make us call a picture academic.

But in time, this very familiarity sets up resistance in some minds. Familiar things are absorbed and become a deposit in which the seeds or sparks of new conditions set up a turmoil. When the old has not been incorporated, the outcome is merely eccentricity. But great original artists take a tradition into themselves. They have not shunned but digested it. Then the very conflict set up between it and what is new in themselves and in their environment creates the tension that demands a new mode of expression. Shakespeare may have had "little Latin and less Greek" but he was such an insatiable devourer of accessible mate-

rial that he would have been a plagiarist if the material had not at once antagonized and coöperated with his personal vision by means of an equally insatiable curiosity concerning the life surrounding him. The great innovators in modern painting were more assiduous students of the pictures of the past than were the imitators who set the contemporary fashion. But the materials of their personal vision operated to oppose the old traditions and out of the reciprocal conflict and reënforcement came new rhythms.

In the facts indicated are the foundations of an esthetic theory based on art and not on extraneous preconceptions. Theory can be based *only* upon an understanding of the central rôle of energy within and without, and of that interaction of energies which institutes opposition in company with accumulation, conservation, suspense and interval, and coöperative movement toward fulfillment in an ordered, or rhythmical experience. Then the inward energy finds release in expression and the outward embodiment of energy in matter takes on form. Here we have a fuller and more explicit case of that relation between doing and undergoing of organism and environment whose product is an experience. The rhythm peculiar to different relations between doing and undergoing is the source of the distribution and apportionment of elements that conduces to directness and unity of perception. Lack of proper relationship and distribution produces a confusion that blocks singleness of perception. Just relationship produces the experience by virtue of which a work of art both excites and composes. The doing stirs while undergone consequences bring a phase of tranquillity. A thorough and related undergoing effects an accumulation of energy that is the source of further discharge in activity. The resulting perception is ordered and clear and at the same time emotionally toned.

It is possible to exaggerate the quality of serenity in art. There is no art without the composure that corresponds to design and composition in the object. But there is also none without resistance, tension, and excitement; otherwise the calm induced is not one of fulfillment. In conception, things are distinguished that in perception and emotion belong together. The distinctions, which become antitheses in philosophic reflection, of sensuous and ideal,

surface and content or meaning, of excitement and calm, do not exist in works of art; and they are not there merely because conceptual oppositions have been overcome but because the work of art exists at a level of experience in which these distinctions of reflective thought have not arisen. From variety excitement may occur, but in mere variety there are no resistances to be overcome and brought to a pause. There is nothing more diverse than furniture scattered about a sidewalk waiting for the moving van. Yet order and serenity do not emerge when these things are forced together in the van. They must be distributed in relation to one another as in the furnishing of a room to compose a whole. Coöperation of distribution and unification bring about that movement of change which excites and the fulfillment which calms.

There is an old formula for beauty in nature and art: Unity in variety. Everything depends upon how the preposition "in" is understood. There may be many articles in a box, many figures in a single painting, many coins in one pocket, and many documents in a safe. The unity is extraneous and the many are unrelated. The significant point is that unity and manyness are always of this sort or approximate it when the unity of the object or scene is morphological and static. The formula has meaning only when its terms are understood to concern a relation of energies. There is no fullness, no many parts, without distinctive differentiations. But they have esthetic quality, as in the richness of a musical phrase, only when distinctions depend upon reciprocal resistances. There is unity only when the resistances create a suspense that is resolved through coöperative interaction of the opposed energies. The "one" of the formula is the realization through interacting parts of their respective energies. The "many" is the manifestation of the defined individualizations due to opposed forces that finally sustain a balance. Thus the next theme is the organization of energies in a work of art. For the unity in variety that characterizes a work of art is dynamic.

IT has been repeatedly intimated that there is a difference between the art product (statue, painting or whatever), and the *work* of art. The first is physical and potential; the latter is active and experienced. It is what the product does, its working. For nothing enters experience bald and unaccompanied, whether it be a seemingly formless happening, a theme intellectually systematized, or an object elaborated with every loving care of united thought and emotion. Its very entrance is the beginning of a complex interaction; upon the nature of this interaction depends the character of the thing as finally experienced. When the structure of the object is such that its force interacts happily (but not easily) with the energies that issue from the experience itself; when their mutual affinities and antagonisms work together to bring about a substance that develops cumulatively and surely (but not too steadily) toward

a fulfilling of impulsions and tensions, then indeed there is a work of art.

In the previous chapter, I emphasized the dependence of this final work upon the existence of rhythms in nature; as I pointed out, they are the conditions of form in experience and hence of expression. But an esthetic experience, the work of art in its actuality, is *perception*. Only as these rhythms, even if embodied in an outer object that is itself a product of art, become a rhythm in experience itself are they esthetic. And this rhythm in what is experienced is something quite different from intellectual recognition that there is rhythm in the external thing: as different as is the perceptual enjoyment of glowing harmonious colors from the mathematical equations that define them for a scientific inquirer.

I begin by applying this consideration to get rid of a false notion of rhythm that has, somehow, seriously infected esthetic theory. For the misconception springs from failure to take into account the fact that esthetic rhythm is a matter of perception and therefore includes whatever is contributed by the self in the active process of perceiving. And strangely enough the misconception in question exists side by side with statements that esthetic experience is an affair of immediacy of perception. The notion I refer to identifies rhythm with regularity of recurrence amid changing elements.

Before dealing directly with this conception, I want to point out its effect upon understanding art. The order of the elements of spatial objects *as* spatial and physical, that is apart from their entrance into that interaction which causes an experience, is, comparatively at least, fixed. Aside from a slow process of weathering, the lines and planes of a statue stay the same, and so do the configurations and intervals of a building. From this fact is derived the conclusion that there are two kinds of fine arts, the spatial and the temporal, and that only the latter are marked by rhythm: the counterpart of this error being that only buildings and statues possess symmetry. The mistake would be serious if it affected only theory. In fact denial of rhythm to pictures and buildings obstructs perception of qualities that are absolutely indispensable in their esthetic effect.

The identification of rhythm with literal recurrence, with reg-
ular return of identical elements, conceives of recurrence statically
or anatomically instead of functionally; for the latter interprets re-
currence on the basis of furtherance, through the energy of the el-
ements, of a complete and consummatory experience. Since a
favorite illustration of those who hold the theory is the ticking of
a clock, it may be called the tick-tock theory. Although it should
be evident upon a moment's reflection that if it were possible to
experience a uniform series of tick-tocks, the effect would be ei-
ther to put us to sleep or goad us to exasperation, yet the concep-
tion of such regularity is taken as furnishing the ground-plan,
which is then supposed to be complicated by the superimposition
of a number of other rhythms, each equally regular in itself. Of
course, it may be possible to analyze mathematically an actually
experienced rhythm into a combination of a basic regularity over-
laid with a number of minor uniform repetitions. But the result is
only a mechanical approximation to any vital or expressive
rhythm. It is similar to the outcome of attempts to construct es-
thetically satisfactory curved lines (like those of a Greek vase) out
of the combination of a number of curves, each of which is con-
structed according to rigid mathematical calculation.

An investigator undertook with the aid of a recording instru-
ment an inquiry into the voices of singers. It was found that the
voices of accomplished artists, those rated as superior, were regis-
tered in lines slightly above or slightly below the lines which stood
for exact pitch, while singers still in training were much more
likely to produce sounds that coincided exactly with the registers
of exact intervals. The investigator remarked that the artists al-
ways "took liberties" with music. In fact these "liberties" mark
the difference between mechanical or purely objective construc-
tion and artistic production. For rhythm involves constant varia-
tion. In the definition that was given of rhythm as ordered
variation of manifestation of energy, variation is not only as im-
portant as order, but it is an indispensable coefficient of esthetic
order. The greater the variation, the more interesting the effect,
provided order is maintained—a fact that proves that the order in
question is not to be stated in terms of objective regularities but

requires another principle for its interpretation. This principle, once more, is that of cumulative progression toward the fulfillment of an experience in terms of the integrity of the experience itself—something not to be measured in external terms, though not attainable without the use of external materials, observed or imagined.

I may illustrate by a somewhat arbitrarily selected portion of verse, purposely taking that which, although interesting, is not of the highest order. Some lines from Wordsworth's "Prelude" will serve the purpose:

> "... the wind and sleety rain,
> And all the business of the elements,
> The single sheep, and the one blasted tree,
> And the bleak music from that old stone wall,
> The noise of wood and water, and the mist
> That on the line of each of these two roads
> Advanced in such indisputable shapes."

There is always something stupid about turning poetry into a prose that is supposed to explain the meaning of the poetry. But my purpose here in giving a prosaic analysis is not to explain the lines but to enforce a point of theory. So we notice that, in the first place, there is not a word that repeats the kind of fixed significance that might be set forth in a dictionary. The meaning of "wind, rain, sheep, tree, stone wall, mist" is a function of the whole situation expressed, and hence is a variable of *that* situation and not an external constant. The same thing is true of the adjectives: sleety, single, blasted, bleak, indisputable. Their sense is determined by the individual experience of desolation that is building; each contributes a furtherance of its realization, while each in turn is qualified by the experience into the construction of which it enters as an energizing factor. Then there is the variation in objects, some relatively motionless set over against those in motion; things seen and things heard, rain and wind; wall and music; tree and noise. Then there is the relatively slow pace as long as *objects* dominate, changing to an accelerated pace with *events,* with "the

noise of wood and water," culminating in the push of the relentlessly advancing mist. It is this variation affecting every detail that makes the difference between such verses and a seesaw couplet. Yet "order" is maintained, not that indeed of repetition in substance or in form, but actively, since each element carries forward the building up of an integrally experienced situation, building it up without waste, and without incongruities that clash and destroy. Order, for esthetic purposes, is defined and measured by functional and operative traits.

Contrast these lines with, say, some gospel hymn from whose lilt and swing thousands have obtained a rudimentary esthetic satisfaction. The relatively external and physical character of the latter is manifest in the tendency to respond with a physical keeping of time; the poverty of the sentiment is due to the comparative uniformity of both matter and its treatment. Even in a ballad, refrains do not have in experience the uniformity they have in isolation. For as they enter into changing contexts they have a varying effect that carries on a *cumulative* conservation. It is possible for an artist to employ something that is externally sheer repetition to convey a sense of inexorable fate. But the effect depends upon a summation that is more than quantitative addition. Thus in music a repeated phrase, perhaps the one thrown at us at the beginning of a symphony, gains force because the new contexts in which it is found, color it and give it a new value, even if only that of a more insistent, precise and cumulative enunciation of a theme.

There is, of course, no rhythm without recurrence. But the reflective analysis of physical science is substituted for the experience of art when recurrence is interpreted as literal repetition, whether of material or exact interval. Mechanical recurrence is that of material units. Esthetic recurrence is that of *relationships* that sum up and carry forward. Recurring units as such call attention to themselves as isolated parts, and thus away from the whole. Hence they lessen esthetic effect. Recurring *relationships* serve to define and delimit parts, giving them individuality of their own. But they also connect; the individual entities they mark off demand, *because* of the relations, association and interaction with

other individuals. Thus the parts vitally serve in the construction of an expanded whole.

The beat of the drum of the savage has also been held up as the model of rhythm, so that the "tick-tock" theory becomes the "tom-tom" theory. Here, too, it is held that a simple, rather monotonous, repetition of beats is the standard, and that it is varied by the addition of other rhythms each of which is itself uniform, while piquancy is introduced by the use of arythmic change. Unfortunately for the supposed objective basis of the theory, tom-tom beats do not occur alone, but as factors in a much more complex whole of varied singing and dancing. And instead of repetition there is a development, a working up to greater pitches of excitement, perhaps a frenzy, that has begun with relative slow and calm movements. What is even more important, the history of music shows that in fact the primitive rhythms, like those of the African negro, are more subtly varied, less uniform, than those of the music of civilized folk, just as those of northern negroes in the United States are usually more conventionalized than those of the south. The exigencies of part-music and the potentialities of harmony have operated to reduce to greater uniformity that phase of rhythm that consists in direct variations of intensity, while the theory in question demands a reverse movement.

The live creature demands order in his living but he also demands novelty. Confusion is displeasing but so is ennui. The "touch of disorder" that lends charm to a regular scene is disorderly only from some external standard. From the standpoint of actual experience it adds emphasis, distinction, as long as it does not prevent a cumulative carrying forward from one part to another. If it were experienced *as* disorder it would produce an unresolved clash and be displeasing. A temporary clash, on the other hand, may be the factor of resistance that summons up energy to proceed the more actively and triumphantly. Only persons who have been spoiled in early life like things always soft; persons of vigor who prefer to live and who are not contented with subsisting find the too easy repulsive. The difficult becomes objectionable only when instead of challenging energy it overwhelms and blocks

it. Some esthetic products have an immediate vogue; they are the "best sellers" of their day. They are "easy" and thus make a quick appeal; their popularity calls out imitators, and they set the fashion in plays or novels or songs for a time. But their very ready assimilation into experience exhausts them quickly; no new stimulus is derived from them. They have their day—and only a day.

Compare a picture by, say, Whistler with one by Renoir. In the former—in most cases—there will be found considerable stretches of color as nearly uniform as may be. Rhythms, with their necessary factors of contrast, are constituted only by the opposition of large blocks. On only a square inch of a painting by Renoir there will be found no two contiguous lines of exactly the same quality. We may not be conscious of this fact as we look at the picture, but we are conscious of its effect. It contributes to the immediate richness of the whole, and it provides the conditions for new stimulation of new responses upon every subsequent approach. This element of continual variation—provided dynamic relations of reënforcement, and conservation are met—is what makes a picture or any work of art wear.

What is true in the large is true in the small. Repetition of uniform units at uniform intervals is not only not rhythmic but is opposed to the experience of rhythm. A checkerboard effect is more pleasing than a large blank space or than one filled with lines that wander at random and that instead of defining figures interfere with the carrying forward of vision. For experience of the checkered arrangement is not so regular as is the object taken physically and geometrically. As the eye moves it takes in new and reënforcing surfaces, and careful observation will show that new patterns are almost automatically constructed. The squares run now vertically, now horizontally, now in one diagonal, now in the other; and the smaller squares construct not only larger squares but also rectangles and figures having stair-like outlines. The organic demand for variety is such that it is enforced in experience, even without much external occasion. Even the tick-tock of the clock as it is heard varies, because what is *heard* is an interaction of the physical event with changing pulsations of organic response. The often made comparison of music and architecture rests upon the fact

that these arts, more directly than others, exemplify organic recurrences effected by cumulative relationships rather than by repetition of units. The esthetic vulgarity of many of our edifices, especially of those that line American city streets, is due to the monotony caused by regular repetition of forms, uniformly spaced, the architect depending only upon adventitious ornamentation for variety. An even more striking example is found in our terrible civil-war monuments and much of our municipal statuary.

I have said that the organism craves variety as well as order. The statement, however, is too weak for it sets forth a secondary property rather than the primary fact. The process of organic life *is* variation. In words which William James often quoted, it marks an instance of "ever, not quite." Craving as such arises only when this natural tendency is blocked by untoward circumstance, by the monotony of excess poverty or excess luxury. Every movement of experience in completing itself recurs to its beginning, since it is a satisfaction of the prompting initial need. But the recurrence is with a difference; it is charged with all the differences the journey out and away from the beginning has made. For random samples, take the return after many years to childhood's home; the proposition that is proved through a course of reasoning and the proposition as first enunciated; the meeting with an old friend after separation; the recurrence of a phrase in music; of a refrain in poetry.

Demand for variety is the manifestation of the fact that being alive we seek to live, until we are cowed by fear or dulled by routine. The need of life itself pushes us out into the unknown. This is the abiding truth of romance. It may degenerate into formless indulgence in motion and excitement for its own sake, and be expressed in pseudo-romanticism. But vocal classicism, that which preaches rather than enacts as does that which genuinely *becomes* classic, is always based on fear of life and retraction from its exigencies and challenges. The romantic when ordered by appropriate rhythm becomes classic, whenever the adventure undertaken is of scope sufficient to test as well as evoke the energies of men: The *Iliad* and *Odyssey* are perennial witnesses. Rhythm is rationality among qualities. The hold of the lowest order of rhythm upon the uncultivated shows that some order is desired in the stir of exis-

tence. And even the equations of mathematicians are evidence that variation is desired in the midst of maximum repetition, since they express equivalences, not exact identities.

Esthetic recurrence in short is vital, physiological, functional. Relationships rather than elements recur, and they recur in differing contexts and with different consequences so that each recurrence is novel as well as a reminder. In satisfying an aroused expectancy, it also institutes a new longing, incites a fresh curiosity, establishes a changed suspense. The completeness of the integration of these two offices, opposed as they are in abstract conception, by the *same* means instead of by using one device to arouse energy and another to bring it to rest, measures artistry of production and perception. A well-conducted scientific inquiry discovers as it tests, and proves as it explores; it does so in virtue of a method which combines both functions. And conversation, drama, novel, and architectural construction, if there is an ordered experience, reach a stage that at once records and sums up the value of what precedes, and evokes and prophesies what is to come. Every closure is an awakening, and every awakening settles something. This state of affairs defines organization of energy.

Insistence upon variation in rhythm may seem to be a laboring of the obvious. My excuse is not only that influential theories have slighted this property, but that there is a tendency to limit rhythm to some one phase of an art product: for instance, to tempo in music, lines in painting, meter in poetry; to flattened or smooth curves in sculpture. Such limitation always tends in the direction of what Bosanquet called "easy beauty," and when carried through logically, whether in theory or practice, results in some matter being left without form and some form being arbitrarily imposed upon matter.

In the "Spring" and "Birth of Venus" of Botticelli, the charm of arabesques and line in rhythmic patterns is easily felt. Its charm may easily seduce a spectator into making this phase of rhythm, more unconsciously than explicitly, a standard of judgment for experience of other paintings. It will then result in an overestimation of Botticelli in comparison with other painters. This in itself is a minor matter, since it is better to be sensitive to one aspect of form

than to judge pictures merely as illustrations. What is more important is that it tends to create insensitiveness to ways of achieving rhythms that are at once more solid and more subtle: such as relations of planes, of masses, of colors not sharply delineated. Again, the adequacy of Greek sculpture as a means of expressing the human figure through the use of flattened or rounded planes is worth the admiration called forth by the statues of Pheidias. But it is not well when this particular rhythmic mode is set up as the sole standard. Then perception is obscured of what is characteristic of the best in Egyptian sculpture, obtained by relation of larger masses, of negro sculpture with its sharp angularities, of works like Epstein's that depend so largely upon rhythms of light obtained by continually broken surfaces.

The same instances exemplify the separation of substance and form that results when rhythm is limited to variation and recurrence in a single feature. Familiar ideas, standardized moral counsels, themes of conventional romance like the love of a Darby for some Joan, the established charm of objects such as rose and lily, are made more pleasing when clothed in rhyme and punctuated with metrical swing. But in such cases we are, at the end, only reminded in an agreeable way, occasioning a temporary titillation of pleasure, of what we have already experienced. When all materials are interpenetrated by rhythm, the theme or "subject" is transformed into a new subject-matter. There is that sudden magic which gives us the sense of an inner revelation brought to us about something we had supposed to be known through and through. In short, the reciprocal interpretation of parts and whole, which we have seen to constitute an object a work of art, is effected when all the constituents of the work, whether picture, drama, poem or building, stand in rhythmic connection with all other members of the same kind—line with line, color with color, space with space, illumination with light and shade in a painting—and all of these distinctive factors reenforce one another as variations that build up an integrated complex experience. It would be pedantic as well as ungenerous to deny all esthetic quality to an object that is marked in some one respect by rhythms that consolidate and organize the energies involved in having an experience. But the objective mea-

sure of greatness is precisely the variety and scope of factors which, in being rhythmic each to each, still cumulatively conserve and promote one another in building up the actual experience.

An attempt has been made to support the distinction between substance and form in works of art by contrasting "fineness" with "greatness." Art is fine, it is said, when form is perfected; but it is great because of the intrinsic scope and weight of the subject-matter dealt with, even though the manner of dealing with it is less fine. The novels of Jane Austen and of Sir Walter Scott have been used to illustrate the alleged distinction. I cannot find that it is valid. *If* the novels of Scott are greater in scope and amplitude than those of Miss Austen, although less fine, it is because, while no one phase of the means employed is carried through as perfectly as in the one medium in which Jane Austen excels, there is a wider range of subject-matter in which some degree of form is attained. It is not a question of form versus subject-matter but of the number of kinds of co-working formal relationships. A clear pool, a gem, a miniature, an illuminated manuscript, a short story have their own perfection, each after its kind. The single quality that dominates in each may be carried through more adequately than is any single system of relations in objects of greater scope and complexity. But the multiplication of effects in the latter, when they conduce to an unified experience, makes the latter "greater."

When it is a matter of technology, domestic economy, or social polity, we do not have to be told that rationality, intelligibility, is measured by orderly co-adaptation of means moving toward a common end. Absurdity is mutual nullification carried to *its* completion, becoming esthetic or "funny" when successfully executed. We are aware, in a corresponding way, that a man's practical ability is determined by his capacity to mobilize a variety of means and measures to accomplish a large result with the maximum of economy; and that economy becomes esthetically unpleasant when it is forced upon attention as a separate factor, while scope of means is magnificent, not silly display, when there is a corresponding extensive result. So too, we are aware that thinking consists in ordering a variety of meanings so that they move to a conclusion that all support and in which all are summed up and

conserved. What we perhaps are less cognizant of is that this organization of energies to move cumulatively to a terminal whole in which the values of all means and media are incorporated is the essence of fine art.

In the practice and reasoning of ordinary life, organization is less direct, and the sense of the conclusion or consummation comes, comparatively at least, only at the end, instead of being carried at every stage. This postponement of the sense of completion, this lack of the presence of continuous perfecting, reacts, of course, to reduce means used to the state of *mere* means. They are indispensable antecedent conditions, but they are not intrinsic constituents of the end. In such cases, in other words, organization of energies is piecemeal, one replacing another, while in the artistic process it is cumulating and conserving. And thus we are brought again to rhythm. For whenever each step forward is at the same time a summing up and fulfillment of what precedes, and every consummation carries expectation tensely forward, there is rhythm.

In ordinary life, much of our pressing forward is impelled by outside necessities, instead of an onward motion like that of waves of the sea. Similarly, much of our resting is recuperation from exhaustion; it, too, is compelled by something external. In rhythmic ordering, every close and pause, like the rest in music, connects as well as delimits and individualizes. A pause in music is not a blank, but is a rhythmic silence that punctuates what is done while at the same time it conveys an impulsion forward, instead of arresting at the point which it defines. In looking at a picture or reading a poem or drama, we sometimes take the same feature in its defining and closing quality, sometimes in its transitive office. Normally, the way we take it depends upon the direction of our interest at that particular point in our experience. But there are art-products in which an element insists upon being taken in only one way. Then there is the kind of restriction that is found in painting by the exaggeration of line in the Florentine school; of light in Leonardo, and in Raphael under the influence of Leonardo; of atmosphere in the thoroughgoing impressionists. To achieve an exact balance of mergings that carry forward and

pauses that accentuate and define is extremely difficult, and we can derive genuine esthetic satisfaction from objects in which it is not accomplished. But organization of energy is none the less partial in such cases.

The active as distinct from morphological character of the rhythm of acts and undergoings, of defining rests and forward impulsions, is made clear in art by the fact that the artist uses that which is usually found ugly to get esthetic effect; colors that clash, sounds that are discordant, cacophonies in poetry, seemingly dark and obscure places or even sheer blanks—as in Matisse—in painting. It is the way the thing is related that counts. The familiar instance of Shakespeare's employing the comic in the midst of tragedy is in point. It does more than relieve strain on the part of the spectator. It has a more intrinsic office in that it punctuates tragic quality. Any product whose quality is not of the very "easy" sort exhibits dislocations and dissociations of what is usually connected. The distortion found in paintings serves the need of some particular rhythm. But it does more. It brings to definite perception values that are concealed in ordinary experience because of habituation. Ordinary prepossession must be broken through if the degree of energy required for an esthetic experience is to be evoked.

Unfortunately, in writing upon esthetic theory one is compelled to speak in generalized terms because it is impossible to present the work in which the material exists in its individualized form. But I shall engage in a schematic illustration drawn from an actual painting.* In looking at this particular object I have in mind, attention is first caught by the objects in which masses point upward: the first impression is that of movement from below to above. This statement does not mean that the spectator is explicitly conscious of vertically direct rhythms, but that, if he stops to analyze, he finds that the first and dominant impression is determined by patterns so constituted by rhythms. Meantime the eye is also

*Barnes' *The Art in Painting, French Primitives and Their Forms*, and *The Art of Henri Matisse*, give many detailed analyses of pictures.

moving across the picture though the interest remains in patterns that rise. Then there is a halt, an arrest, a punctuating pause as vision comes in the opposite lower corner upon a definite mass that instead of fitting into the vertical patterns transfers attention to the weight of horizontally disposed masses. Were the picture badly composed, the variation would operate as a disturbing interruption, a break in experience instead of as a re-direction of interest and attention, thus expanding the significance of the object. As it is, the close of one phase of order gives a new set to expectancy and this is fulfilled as vision travels back, by a series of colored areas dominantly horizontal in character. Then, as that phase of perception completes itself, attention is drawn to the ordered variation in color characteristic of these masses. Then as attention is redirected to the vertical patterns—at the point from which we set out—we miss the design constituted by color variation and find attention directed toward spatial intervals determined by a series of receding and intertwined planes. The impression of depth, implicit of course, in perception from the first is made explicit by this particular rhythmic order.

In the building up of this pictorial perception, four kinds of organic energy, merged in the original total impression, have been called into special intensity of action, and yet there has been no break in experience. Nor does the story cease at this point. As one becomes more aware of the factors that constitute depth in space, a scene in the far distance stands out. This scene, considering its indicated distance, is characterized by marked luminosity. Then vision is set to perceiving more definitely the rhythms of luminosity that give enhanced value to the picture as a whole. Here are some five systems of rhythm. Each of these, if further examined, would disclose minor rhythms within it. Each rhythm, major or minor, interacts with all the others to engage different systems of organic energy. But they also have to interact with one another in such ways that energy is consistently organized as well as called forth. Sometimes in an object of a new kind, one meets with a surprise that is disconcerting. This happens in objects so eccentric as to be of little worth; it also happens, upon their first appearance, with works of high esthetic value. It takes time to discern whether

the shock is caused by inherent breaks in the organization of the object, or by lack of preparation in the perceiver.

What has been said may seem to exaggerate the temporal aspect of perception. I have, without doubt, stretched out elements that are usually more or less telescoped. But in no case can there be *perception of an object* except in a process developing in time. Mere excitations, yes; but not an object as perceived, instead of just recognized as one of a familiar kind. If our view of the world consisted of a succession of momentary glimpses, it would be no view of the *world* nor of anything in it. If the roar and the rushing stream of Niagara were limited to an instantaneous noise and peep, there would not be perceived the sound or sight of any *object,* much less of the particular object called Niagara Falls. It would not be grasped even as a noise. Nor would mere isolated continuation of the external noise beating on the ear effect anything except increased confusion. Nothing is perceived except when different senses work in relation with one another except when the energy of one "center" is communicated to others, and then new modes of motor responses are incited which in turn stir up new sensory activities. Unless these various sensory-motor energies are coördinated with one another there is no perceived scene or object. But equally there is none when—by a condition impossible to fulfill in fact—a single sense alone is operative. If the eye is the organ primarily active, then the color quality is affected by qualities of other senses overtly active in earlier experiences. In this way it is affected with a history; there is an object with a past. And the impulsion of the motor elements which are involved effects an extension into the future, since it gets ready for what is to come and in a way predicts what is to happen.

The denial of rhythm to pictures, edifices, and statues, or the assertion that it is found in them only metaphorically, rests upon ignorance of the inherent nature of every perception. Of course there are recognitions that are virtually instantaneous. But these occur only when, through a sequence of past experiences, the self has become expert in certain directions, be it simply in seeing at a glance that a certain object is a table or that a painting is by a particular artist, say Manet. Because present perception utilizes an or-

ganization of energies worked out serially in the past is no reason for eliminating temporal quality from perception. And in any case, if the perception is esthetic, an instantaneous identification is only its beginning. There is no inherent esthetic value in identifying a picture as such and such. The identification may arouse attention and lead to dwelling upon the painting in such a way that parts and relations are called out to compose a whole.

We are hardly conscious of anything metaphorical when we say of one picture or of a story that it is dead, and of another that it has life. To explain just what we mean when we say this, is not easy. Yet the consciousness that one thing is limp, that another has the heavy inertness of inanimate things, while another seems to move from within, arises spontaneously. There must be something in the object that instigates it. Now that which marks off the living from the dead is not bustle and ado, nor does a picture literally move. The living being is characterized by having a past and a present; having them as possessions of the present, not just externally. And I suggest that it is precisely when we get from an art product the feeling of dealing with a *career,* a history, perceived at a particular point of its development, that we have the impression of life. That which is dead does not extend into the past nor arouse any interest in what is to come.

The common element in all the arts, technological and useful, is organization of energy as means for producing a result. In products that strike us as merely useful, our only concern is with something beyond the thing, and if we are not interested in that ulterior product then we are indifferent to the object itself. It may be passed over without our really seeing it or may be idly inspected as we look casually at any curiosity we are told is remarkable. In the esthetic object the object operates—as of course one having an external use may also do—to pull together energies that have been separately occupied in dealing with many different things on different occasions, and to give them that particular rhythmic organization that we have called (when thinking of the effect and not of the mode of its effectuation), clarification, intensification, concentration. Energies that remain in a potential state with respect to one another, however actual of themselves, evoke

and reënforce one another directly for the sake of the experience that results.

What is true of original production is true of appreciative perception. We speak of perception *and* its object. But perception and *its* object are built up and completed in one and the same continuing operation. What is called *the* object, *the* cloud, river, garment, has imputed to it an existence independent of an actual experience; still more is this true of *the* carbon molecule, *the* hydrogen ion, the entities of science generally. But the object of—or better *in*—perception is not one of a kind in general, a sample of a cloud or river, but is *this* individual thing existing here and now with all the unrepeatable particularities that accompany and mark such existences. In its capacity of object-of-perception, it exists in exactly the same interaction with a living creature that constitutes the activity of perceiving. Now under the pressure of external circumstances or because of internal laxity, objects of most of our *ordinary* perception lack completeness. They are cut short when there is recognition; that is to say when the object is identified as one of a kind, or of a species within the kind. For such recognition suffices to enable us to employ the object for customary purposes. It is enough to know that those objects are rain-clouds to induce us to carry an umbrella. The full perceptual realization of just the *individual* clouds they are might even get in the way of utilizing them as an index of a specific, a limited, kind of conduct. Esthetic perception, on the other hand, is a name for a full perception and its correlative, an object or event. Such a perception is accompanied by, or rather consists in, a release of energy in its purest form; which, as we have seen, is one that is organized and so rhythmic.

We do not need to feel, therefore, that we are speaking metaphorically nor apologize for animism when we speak of a painting as alive, and its figures, as well as architectural and sculptural forms, as manifesting movement. The "Entombment" of Titian does more than suggest the carrying of depressed weight; it conveys or expresses it. The ballet girls of Degas are actually on tiptoe to dance; the children in Renoir's paintings are intent upon their reading or sewing. In Constable, verdure is moist; and in Courbet a glen drips and rocks shine with cool wetness. When fishes are

not darting or lazily balancing themselves, when clouds are not floating or scudding, when trees are not reflecting light, they do not evoke the energy appropriate to realization of the full energy of the object. If the perception is then eked out by reminiscences or by sentimental associations derived from literature—as is usually the case in paintings popularly regarded as poetic—a simulated esthetic experience occurs.

Paintings that seem dead in whole or part are those in which intervals merely arrest, instead of also carrying forward. They are "holes," blanks. What we call dead spots are, from the side of the percipient, the things that enforce a partial or frustrated organization of outgoing energy. There are works of art that merely excite, in which activity is aroused without the composure of satisfaction, without fulfillment within the terms of the medium. Energy is left without organization. Dramas are then melodramatic; paintings of nudes are pornographic; the fiction that is read leaves us discontented with the world in which we are, alas, compelled to live without the opportunity for the romantic adventure and high heroism suggested by the story-book. In those novels, in which characters are the puppets of their authors, our revulsion comes from the fact that life is pretended, not enacted. The simulation of life by a show of animation and vivacity leaves us with the same irritation of incompletion that follows continued idle chatter.

I have probably seemed to some to have exaggerated the importance of rhythm at the expense of symmetry. As far as explicit words are concerned, I have done so. But only with respect to words. For the idea of organized energy means that rhythm and balance cannot be separated, although they may be distinguished by thought. Putting it briefly and schematically, when attention dwells especially upon the traits and aspects in which completed organization is displayed, we are especially aware of symmetry, the measuring of one thing in relation to another. Symmetry and rhythm are the same thing felt with the difference of emphasis that is due to attentive interest. When intervals that define rest and relative fulfillment are the traits that especially characterize perception, we are aware of symmetry. When we are concerned with movement, with comings and goings rather than arrivals, rhythm

stands out. But in every case, symmetry, since it is the equilibrium of counteracting energies, involves rhythm, while rhythm occurs only when movement is spaced by places of rest, and hence involves measure.

Of course at times, the two fall apart in an art product. But this fact signifies that it is not esthetically complete, that on the one hand there are holes, dead spots, and, on the other, unmotivated and unresolved excitations. In reflective experience as such, in investigation called forth by problematic situations, there is a rhythm of seeking and finding, of reaching out for a tenable conclusion and coming to what is at least a tentative one. But, as a rule, these phases are too incidental to affect the process with conspicuous esthetic quality. When they become emphatic and are unified with subject-matter, there is the same kind of consciousness that there is in the presence of any artistic construction. In merely simulated and academic art, on the other hand, balance does not coincide with subject-matter but is an arbitrary pose, which in its isolation from movement becomes in time highly wearisome.

The connection of intensity and extensity and of both with tension is not a verbal matter. There is no rhythm save where there is alternation of compressions and releases. Resistance prevents immediate discharge and accumulates tension that renders energy intense. Its release from this state of detention takes necessarily the form of a sequential spreading out. In a picture, cold and warm colors, complementary colors, light and shade, up and down, back and forwards, right and left are, schematically speaking, the means by which the kind of opposition is brought about in a picture that results in balance. In early paintings, this symmetry is effected mainly by means of oppositions in positions to right and left, or by an obvious diagonal arrangement. Now there is energy of position and, hence, in even these pictures, symmetry is not merely spatial. But it is weak, as in the silhouette pictures of the thirteenth and fourteenth centuries when the important figure is placed in the exact center, and figures almost identical with one another are placed in nearly exact lateral correspondence. Later, pyramidal forms are depended upon. Such arrangements owe

much of their force to factors outside the picture. Stability of objects is accomplished by reminding us of familiar modes securing equilibrium. Thus the effect of symmetry in the picture is associational rather than intrinsic. The tendency in painting has been to the development of relations such that balance cannot be topographically indicated by selection of particular figures but is a function of the whole picture. The "center" of the picture is not spatial but is the focus of interacting forces.

The definition of symmetry in static terms is the exact correspondent of the error by which rhythm is conceived to be recurrence of elements. Balance is balancing, a matter of distribution of weights with respect to the way they act upon one another. The two pans of the scales balance when their push and pull on each other is adjusted. And scales exist in actuality (instead of potentially) only when their pans are operating antagonistically to each other with reference to reaching an equilibrium. Since esthetic objects depend upon a progressively enacted experience, the final measure of balance or symmetry is the capacity of the whole to hold together within itself the greatest variety and scope of opposed elements.

The connection of balance with stress of weights is inherent. Work in any sphere is performed only by the interworking of opposed forces—as by the antagonistic systems of the muscular frame. Hence everything depends in a work of art upon the scale attempted—that is the reason it is but a step from the sublime to the ridiculous. There is no such thing as a force strong or weak, great or petty, in itself. Miniatures and quatrains have their own perfection, and mere bigness is offensive in its empty pretentiousness. To say that one part of a painting, drama, or novel is too weak, means that some related part is too strong—and vice-versa. Absolutely speaking, nothing is strong or weak; it is the way it works and is worked on. It is sometimes surprising in an architectural vista to see how a low building *rightly placed* will pull together surrounding high buildings instead of being annihilated by them.

The commonest fault in works having some claim to be called works of art is the effort to get strength by exaggeration of some one element. At first, as with temporary best-sellers in any line,

there is an immediate response. But such works do not wear. As time passes it becomes every day more evident that what had been taken to be strength signifies weakness on the part of counterbalancing factors. No sensuous charm, however great in amount, is cloying if it is counteracted in relation to other factors. But in isolation sugariness is one of the most quickly exhausted qualities. The "he-man" style in literature soon wearies because it is evident (even if only subconsciously) that, in spite of violent movement, no real strength is displayed, the counteracting energies being only pasteboard and plaster figures. The seeming strength of one element is at the expense of weakness in other elements. Even the sensationalism of a novel or stage-play refers only to a lack of relations which affects the quality of the whole, not any one incident in itself. A critic has observed of O'Neill's plays that they suffer from lack of retardations; everything moves too quickly and hence too easily, and the result is an overcrowding. Painters at work are obliged to work here and there, not all over the picture at once. And they are aware of the necessity of "keeping down" the part they are at work upon at any particular time. Every writer has to solve the same problem. Unless it is solved, other parts are not "kept up." In most cases the esthetic objection to doses of morals and of economic or political propaganda in works of art will be found upon analysis to reside in the overweighing of certain values at the expense of others until, except for those in a similar state of one-sided enthusiasm, weariness rather than refreshment sets in.

The manifestation of a single form of energy in isolation results in uncoördinated movements, the human organism being, in fact, complex, and hence requiring adjustment of many varied factors. There is a great difference between violence and intensity of action. Watch young children who have the intention of acting in a play, and a succession of unrelated movements will be observed. They gesticulate, tumble and roll, each pretty much on his own account, with little reference to what others are doing. The acts of even the same child have little sequence. Such a case exemplifies, by way of contrast, the artistic relation between intensity and extension. Because energy is not restrained by other elements that are at once antagonistic and coöperative, action proceeds by jerks

and spasms. There is discontinuity. Where energy is rendered tense by reciprocal oppositions, it unfolds in ordered extension. The contrast that is extreme in the case of a well-constructed and well-executed play set over against a childish scramble is found in lesser measure in all cases of contrasting esthetic value. Paintings, buildings, poems, novels, all have different degrees of volume—not to be confused with bulk. They are esthetically thick and thin, solid and crumbling, well-knit and loose-jointed. This property of extension, of related variety, is the kinetic phase which marks the release of energies that are restrained in ordered intervals of rest. But once more the order of these intervals (that constitute the symmetry of the work) is not regulated on the basis of units of time or space. When it is so determined, the effect is mechanical, like the seesaw of a jingling rhyme. In an art product, intervals are regular whenever they are determined by mutual reënforcement of parts with respect to the effect of unity and totality. This is what is meant by calling symmetry dynamic and functional.

In seeing a picture or an edifice, there is the same compression from accumulation in time that there is in hearing music, reading a poem or novel, and seeing a drama enacted. No work of art can be instantaneously perceived because there is then no opportunity for conservation and increase of tension, and hence none for that release and unfolding which give volume to a work of art. In most intellectual work, in all save those flashes that are distinctly esthetic, we have to go backwards; we have consciously to retrace previous steps and to recall distinctly particular facts and ideas. Getting ahead in thought is dependent upon these conscious excursions of memory into the past. But only when esthetic perception is interrupted (whether by lapse on the part of artist or perceiver) are we compelled to turn back, say in seeing a play on the stage, to ask ourselves what went before in order to get the thread of movement. What is retained from the past is embedded within what is now perceived and so embedded that, by its compression there, it forces the mind to stretch forward to what is coming. The more there is compressed from the continuous series of prior perceptions, the richer the present perception and the more intense the forward impulsion. Because of the depth of con-

centration, the release of contained materials as it unrolls gives subsequent experiences a wider span consisting of a larger number of defined particularities: what I have called the extension and volume corresponding to the intension of energy due to multiplied resistances.

It follows that the separation of rhythm and symmetry from each other and the division of the arts into temporal and spatial is more than a misapplied ingenuity. It is based on a principle that is destructive, so far as it is heeded, of esthetic understanding. Moreover, it has now lost the support from the scientific side it was once supposed to have. For physicists have been forced in virtue of the character of their own subject-matter to see that their units are not those of space *and* time, but of space-time. The artist made in action if not in conscious thought this belated scientific discovery from the very beginning. For he has always dealt perforce with perceptual instead of conceptual material, and, in what is perceived, the spatial and temporal always go together. It is interesting to note that the discovery was made in science when it was found that the process of conceptual abstraction could not be carried to the point of excluding the act of observation without destroying the possibility of verification.

When, therefore, the scientific inquirer was obliged to take the consequences of the act of perception into account in connection with his subject-matter, he passed from space *and* time to a unity which he could describe only as space-time. He thus came upon a fact that is exemplified in every ordinary perception. For the extension and volume of an object, its spatial properties cannot be *directly* experienced—or perceived—in a mathematical instant, nor can temporal properties of events be experienced save as some energy displays itself in an extensive way. Thus the artist only does with respect to the temporal and spatial qualities of the material of perception what he does with respect to all the content of ordinary perception. He selects, intensifies, and concentrates by means of form: rhythm and symmetry being of necessity the form that material takes when it undergoes the clarifying and ordering operations of art.

Apart from loss of supposed scientific sanction, the separation

of temporal and spatial in the fine arts was always inept. As Croce has said, we are *specifically* (or separately) conscious of temporal sequence in music and poetry, and of spatial co-existence in architecture and painting, only when we pass from perception to analytic reflection. The supposition that we directly hear musical tones to *be* in time and directly see colors as *being* in space, reads into an immediate experience a later interpretation of it due to reflection. We *see* intervals and directions in pictures and we *hear* distances and volumes in music. If movement alone were perceived in music and rest alone in painting, music would be wholly without structure and pictures nothing but dry bones.

Nevertheless, though the distinction between spatial and temporal arts is wrongly drawn, since all objects of art are matters of perception and perception is not instantaneous, music in its evident temporal emphasis illustrates perhaps better than any other art the sense in which form is the moving integration of an experience. In music, form, for which even the musical have to find spatial language and which even the musical often see as a structure, the form develops with the hearing of the music. Any point in the musical development, that is to say, any tone, is what it is in that musical object—or perception—by virtue of what has gone before and what is musically impinging or prophesied. A melody is set by the tonic note, to which an expectancy of return is set up as a tension of attention. The "form" of the music becomes form in the career of the listening. Moreover, any section of the music and any cross-section of it has precisely the balance and symmetry, in chords and harmonies, as a painting, statue, or building. A melody is a chord deployed in time.

The term "energy" has been used many times in this discussion. Perhaps insistence upon the idea of energy in connection with fine art seems to some minds out of place. Yet there are certain commonplaces that it is proper to utter in connection with art that cannot be intelligible unless the fact of energy be made central: its power to move and stir, to calm and tranquillize. And surely either rhythm and balance are either characters foreign to art or else art,

because of their basic rôle, is only definable as organization of energies. With respect to what the work of art does to us and for us, I see but two alternatives. Either it operates because some transcendent essence (usually called "beauty") descends upon experience from without, or esthetic effect is due to art's unique transcript of the energy of the things of the world. As between these two alternatives, I do not know how mere argument can determine the choice. But it is something to know what is involved in making the choice.

Taking my stand, then, upon the connection of esthetic effect with qualities of all experience as far as any experience is unified, I would ask how art can be expressive and yet not be imitative or slavishly representative, save by selecting and ordering the energies in virtue of which things act upon us and interest us? If art is in any sense reproductive, and yet reproduces neither details nor generic features, it necessarily follows that art operates by selecting those potencies in things by which an experience—any experience—has significance and value. Elimination gets rid of forces that confuse, distract, and deaden. Order, rhythm and balance, simply means that energies significant for experience are acting at their best.

The terms "ideal" has been cheapened by sentimental popular use, and by use in philosophic discourse for apologetic purposes to disguise discords and cruelties in existence. But there is a definite sense in which art is ideal—namely, the sense just indicated. Through selection and organization those features that make any experience worth having as an experience are prepared by art for commensurate perception. There must be, in spite of all indifference and hostility of nature to human interests, some congruity of nature with man or life could not exist. In art the forces that are congenial, that sustain not this or that special aim but the processes of enjoyed experience itself, are set free. That release gives them ideal quality. For what ideal can man honestly entertain save the idea of an environment in which all things conspire to the perfecting and sustaining of the values occasionally and partially experienced?

An English writer, Galsworthy I think, has somewhere defined

art "as the imaginative expression of energy which, through technical concretion of feeling and perception, tends to reconcile the individual with the universal by exciting in him impersonal emotion." Energies that constitute the objects and events of the world and hence determine our experience are the "universal." "Reconciliation" is the attaining, in immediate unargumentative form, of periods of harmonious coöperation of man and the world in experiences that are complete. The resultant emotion is "impersonal" because it is attached not to personal fortune but to the object to the construction of which the self has surrendered itself in devotion. Appreciation is equally impersonal in its emotional quality because it also involves construction and organization of objective energies.

WHAT subject-matter is appropriate for art? Are there materials inherently fit and others unfit? Or are there none which are common and unclean with respect to artistic treatment? The answer of the arts themselves has been steadily and progressively in the direction of an affirmative answer to the last question. Yet there is an enduring tradition that insists art should make invidious distinctions. A brief survey of the theme may accordingly serve as an introduction to the special topic of this chapter, namely, the aspects of the matter of art that are common to all the arts.

I had occasion in another connection to refer to the difference between the popular arts of a period and the official arts. Even when favored arts came out from under patronage and control of priest and ruler, the distinction of kinds remained even though the name "official" is no longer a fitting designation. Philosophic theory concerned itself only with those arts that had the stamp and

seal of recognition by the class having social standing and authority. Popular arts must have flourished, but they obtained no literary attention. They were not worthy of mention in theoretical discussion. Probably they were not even thought of as arts.

Instead, however, of dealing with the early formulation of an invidious distinction among the arts, I shall select a modern representative, and then indicate briefly some aspects of the revolt that has broken down the barriers once set up. Sir Joshua Reynolds presents us with the statement that since the only subjects fit for treatment in painting are those "*generally* interesting," they should be "some eminent instance of heroic action or heroic suffering," such as "the great events of Greek and Roman fable and history. Such, too, are the capital events of Scripture." All the great paintings of the past, according to him, belong to this "historical school," and he goes on to say that "upon this principle, the Roman, the Florentine, the Bolognese schools have formed their practice and by it they have deservedly obtained the highest praise"—the omission of the Venetian and Flemish schools, side by side with the commendation of the eclectic school, being a sufficient comment from the strictly artistic side. What would he have said if he had been able to anticipate the ballet girls of Degas, the railway-coaches of Daumier—actually third class—or the apples, napkins, and plates of Cézanne?

In literature the dominant tradition in theory was similar. It was constantly asserted that Aristotle had once for all delimited the scope of tragedy, the highest literary mode, by declaring that the misfortunes of the noble and those in high place were its proper material, while those of the common people were intrinsically fit for the lesser mode of comedy. Diderot virtually announced a historic revolution in theory when he said there was need for bourgeois tragedies, and that, instead of putting on the stage only kings and princes, private persons are subject to terrible reverses which inspire pity and terror. And again he asserts that domestic tragedies, although having another tone and action than classic drama, can have their own sublimity—a prediction assuredly fulfilled by Ibsen.

At the beginning of the nineteenth century, following the pe-

riod that Housman calls one of sham or counterfeit poetry, verse masquerading as poetry, "The Lyrical Ballads" of Wordsworth and Coleridge ushered in a revolution. One of the principles that animated its authors was stated by Coleridge as follows: "One of the two cardinal points in poetry consists of faithful adherence to such characters and incidents as will be found in every village and its vicinity when there is a meditative and feeling mind to seek after them, or to notice them when they present themselves." I hardly need point out that long before Reynolds' day a similar revolution was well along in painting. It took a long stride when the Venetians in addition to celebrating the sumptuousness of the lives about them gave nominally religious themes a distinctly secular treatment. Flemish painters, in addition to Dutch genre painters, Breughel the elder, for example, and French painters like Chardin, turned frankly to ordinary themes. Painting of portraits was extended from nobility to wealthy merchants with the growth of commerce, and then to men less conspicuous. Toward the end of the nineteenth century all lines were swept away as far as plastic arts are concerned.

The novel has been the great instrument of effecting change in prose literature. It shifted the center of attention from the court to the bourgeoisie, then to the "poor" and the laborer, and then to the common person irrespective of station. Rousseau owes most of his permanent enormous influence in the field of literature to his imaginative excitement about "*le peuple*"; certainly more to that cause than to his formal theories. The part played by folk-music, especially in Poland, Bohemia, and Germany, in the expansion and renewal of music is too well known to require more than notice. Even architecture, the most conservative of all the arts, has felt the influence of a transformation similar to that the other arts have undergone. Railway stations, bank buildings and post-offices, even churches, are no longer exclusively built as imitations of Greek temples and medieval cathedrals. The art of established "orders" has been influenced as much by revolt against fixation in social classes as by technological developments in cement and steel.

This brief sketch has only one purpose: to indicate that, in spite of formal theory and canons of criticism, there has taken

place one of those revolutions that do not go backward. Impulsion beyond all limits that are externally set inheres in the very nature of the artist's work. It belongs to the very character of the creative mind to reach out and seize any material that stirs it so that ths value of that material may be pressed out and become the matter of a new experience. Refusal to acknowledge the boundaries set by convention is the source of frequent denunciations of objects of art as immoral. But one of the functions of art is precisely to sap the moralistic timidity that causes the mind to shy away from some materials and refuse to admit them into the clear and purifying light of perceptive consciousness.

The interest of an artist is the only limitation placed upon use of material, and this limitation is not restrictive. It but states a trait inherent in the work of the arist, the necessity of sincerity; the necessity that he shall not fake and compromise. The universality of art is so far away from denial of the principle of selection by means of vital interest that it depends upon interest. Other artists have other interests, and by their collective work, unembarrassed by fixed and antecedent rule, all aspects and phases of experience are covered. Interest becomes one-sided and morbid only when it ceases to be frank, and becomes sly and furtive—as it doubtless does in much contemporary exploitation of sex. Tolstoi's identification of sincerity as the essence of originality compensates for much that is eccentric in his tractate on art. In his attack upon the merely conventional in poetry, he declares that much of its material is borrowed, artists feeding like cannibals upon one another. Stock material consists, he says, of "all sorts of legends, sagas and ancient traditions; maidens, warriors, shepherds, hermits, angels, devils of all sorts; moonlight, thunder, mountains, the sea, precipices, flowers, long hair; lions, lambs, doves, nightingales—because they have often been used by former artists in their productions."

In his desire to restrict the material of art to themes drawn from the life of the common man, factory worker and especially peasant, Tolstoi paints a picture of the conventional restrictions that is out of perspective. But there is truth enough in it to serve as illustration of one all-important characteristic of art: Whatever

narrows the boundaries of the material fit to be used in art hems in also the artistic sincerity of the individual artist. It does not give fair play and outlet to his vital interest. It forces his perceptions into channels previously worn into ruts and clips the wings of his imagination. I think the idea that there is a moral obligation on an artist to deal with "proletarian" material, or with any material on the basis of its bearing on proletarian fortune and destiny is an effort to return to a position that art has historically outgrown. But as far as proletarian interest marks a new direction of attention and involves observation of materials previously passed over, it will certainly call into activity persons who were not moved to expression by former materials, and will disclose and thus help break down boundaries of which they were not previously aware. I am somewhat skeptical about Shakespeare's alleged personal aristocratic bias. I fancy that his limitation was conventional, familiar, and therefore congenial to pit as well as to stalls. But whatever its source, it limited his "universality."

Evidence that the historic movement of the art has abolished restrictions of its subject-matter that once were justified on alleged rational grounds does not prove that there is something common in the matter of all the arts. But it suggests that with the vast extension of its scope to take in (potentially) anything and everything, art would have lost its unity, dispersed into connected arts, till we could not see the woods for the trees nor a single tree for its branches, were there not a core of common substance. The obvious reply to this suggested inference is that the unity of the arts resides in their common form. Acceptance of this reply commits us, however, to the idea that form and matter are separate, and leads us therefore to return to the assertion that an art product is formed substance, and that what appears upon reflection as form when one interest is uppermost appears as matter when change of interest gives another turn to direction.

Apart from some special interest, every product of art is matter and matter only, so that the contrast is not between matter and form but between matter relatively unformed and matter adequately formed. The fact that reflection finds distinctive form in pictures cannot be set against the fact that a painting consists sim-

ply of pigments placed on canvas, since any arrangement and design they have is, after all, a property of the substance and of nothing else. Similarly, literature as it exists is just so many words, spoken and written. "Stuff" is everything, and form a name for certain aspects of the matter when attention goes primarily to just these aspects. The fact that a work of art is an organization of energies and that the nature of the organization is all important, cannot militate against the fact that it is energies which are organized and that organization has no existence outside of them.

The acknowledged community of form in different arts carries with it by implication a corresponding community of substance. It is this implication which I now propose to explore and develop. I have previously noted that artist and perceiver alike begin with what may be called a total seizure, an inclusive qualitative whole not yet articulated, not distinguished into members. Speaking of the origin of his poems, Schiller said: "With me the perception is at first without a clear and definite object. This takes shape later. What precedes is a peculiar musical mood of mind. Afterwards comes the poetical *idea*." I interpret this saying to mean something of the kind just stated. Moreover, not only does the "mood" come first, but it persists as the substratum after distinctions emerge; in fact they emerge as *its* distinctions.

Even at the outset, the total and massive quality has its uniqueness; even when vague and undefined, it is just that which it is and not anything else. If the perception continues, discrimination inevitably sets in. Attention must move, and, as it moves, parts, members, emerge from the background. And if attention moves in a unified direction instead of wandering, it is controlled by the pervading qualitative unity; attention is controlled *by* it because it operates within it. That verses *are* the poem, are its substance, is so truistic that it says nothing. But the fact which the truism records could not exist unless matter, poetically felt, came first, and came in such a unified and massive way as to determine its own development, that is its specification into distinctive parts. If the percipient is aware of seams and mechanical junctions in a

work of art, it is because the substance is not controlled by a permeating quality.

Not only must this quality be in all "parts," but it can only be felt, that is, immediately experienced. I am not trying to describe it, for it cannot be described nor even be *specifically* pointed at—since whatever is specified in a work of art is one of *its* differentiations. I am only trying to call attention to something that everyone can realize is present in his experience of a work of art, but that is *so* thoroughly and pervasively present that it is taken for granted. "Intuition" has been used by philosophers to designate many things—some of which are suspicious characters. But the penetrating quality that runs through all the parts of a work of art and binds them into an individualized whole can only be emotionally "intuited." The different elements and specific qualities of a work of art blend and fuse in a way which physical things cannot emulate. This fusion is the felt presence of the same qualitative unity in all of them. "Parts" are discriminated, not intuited. But without the intuited enveloping quality, parts are external to one another and mechanically related. Yet the organism which is the work of art is nothing different from its parts or members. It *is* the parts as members—a fact that again brings us to the one pervasive quality that remains the same quality in being differentiated. The resulting sense of totality is commemorative, expectant, insinuating, premonitory.*

There is no name to be given it. As it enlivens and animates, it is the spirit of the work of art. It is its reality, when we feel the work of art to be real on its own account and not as a realistic exhibition. It is the idiom in which the particular work is composed and expressed, that which stamps it with individuality. It is the background which is more than spatial because it enters into and qualifies everything in the focus, everything distinguished as a part and member. We are accustomed to think of physical objects as having bounded edges; things like rocks, chairs, books, houses,

*I take this opportunity to mention again the essay on *Qualitative Thought,* previously referred to (p. 125).

trade, and science, with its efforts at precise measurement, have confirmed the belief. Then we unconsciously carry over this belief in the bounded character of all *objects* of experience (a belief founded ultimately in the practical exigencies of our dealings with things) into our conception of experience itself. We suppose the experience has the same definite limits as the things with which it is concerned. But any experience the most ordinary, has an indefinite total setting. Things, objects, are only focal points of a here and now in a whole that stretches out indefinitely. This is the qualitative "background" which is defined and made definitely conscious in particular objects and specified properties and qualities. There is something mystical associated with the word intuition, and any experience becomes mystical in the degree in which the sense, the feeling, of the unlimited envelope becomes intense—as it may do in experience of an object of art. As Tennyson said:

> *"Experience is an arch wherethro'*
> *Gleams that untravell'd world, whose margin fades*
> *Forever and forever when I move."*

For although there is a bounding horizon, it moves as we move. We are never wholly free from the sense of something that lies beyond. Within the limited world directly seen, there is a tree with a rock at its foot; we fasten our sight upon the rock, and then upon the moss on the rock, perhaps we then take a microscope to view some tiny lichen. But whether the scope of vision be vast or minute, we experience it as a part of a larger whole and inclusive whole, a part that now focuses our experience. We might expand the field from the narrower to the wider. But however broad the field, it is still felt as not the whole; the margins shade into that indefinite expanse beyond which imagination calls the universe. This sense of the including whole implicit in ordinary experiences is rendered intense within the frame of a painting or poem. It, rather than any special purgation, is that which reconciles us to the events of tragedy. The symbolists have exploited this indefinite phase of art; Poe spoke of "a suggestive indefiniteness of vague and therefore spiritual effect," while Coleridge said that every

work of art must have about it something not *understood* to obtain its full effect.

About every explicit and focal object there is a recession into the implicit which is not intellectually grasped. In reflection we call it dim and vague. But in the original experience it is not identified as the vague. It is a function of the whole situation, and not an element in it, as it would have to be in order to be apprehended *as* vague. At twilight, dusk is a delightful quality of the whole world. It is its appropriate manifestation. It becomes a specialized and obnoxious trait only when it prevents distinct perception of some particular thing we desire to discern.

The undefined pervasive quality of an experience is that which binds together all the defined elements, the objects of which we are focally aware, making them a whole. The best evidence that such is the case is our constant sense of things as belonging or not belonging, of relevancy, a sense which is immediate. It cannot be a product of reflection, even though it requires reflection to find out whether some particular consideration is pertinent to what we are doing or thinking. For unless the sense were immediate, we should have no guide to our reflection. The sense of an extensive and underlying whole is the context of every experience and it is the essence of sanity. For the mad, the insane, thing to us is that which is torn from the common context and which stands alone and isolated, as anything must which occurs in a world totally different from ours. Without an indeterminate and undetermined setting, the material of any experience is incoherent.

A work of art elicits and accentuates this quality of being a whole and of belonging to the larger, all-inclusive, whole which is the universe in which we live. This fact, I think, is the explanation of that feeling of exquisite intelligibility and clarity we have in the presence of an object that is experienced with esthetic intensity. It explains also the religious feeling that accompanies intense esthetic perception. We are, as it were, introduced into a world beyond this world which is nevertheless the deeper reality of the world in which we live in our ordinary experiences. We are carried out beyond ourselves to find ourselves. I can see no psychological ground for such properties of an experience save that, somehow,

the work of art operates to deepen and to raise to great clarity that sense of an enveloping undefined whole that accompanies every normal experience. This whole is then felt as an expansion of ourselves. For only one frustrated in a particular object of desire upon which he had staked himself, like Macbeth, finds that life is a tale told by an idiot, full of sound and fury, signifying nothing. Where egotism is not made the measure of reality and value, we are citizens of this vast world beyond ourselves, and any intense realization of its presence with and in us brings a peculiarly satisfying sense of unity in itself and with ourselves.

Every work of art has a particular medium by which, among other things, the qualitative pervasive whole is carried. In every experience we touch the world through some particular tentacle; we carry on our intercourse with it, it comes home to us, through a specialized organ. The entire organism with all its charge of the past and varied resources operates, but it operates through a particular medium, that of eye, as it interacts with eye, ear, and touch. The fine arts lay hold of this fact and push it to its maximum of significance. In any ordinary visual perception, we see by means of light; we distinguish by means of reflected and refracted colors: that is a truism. But in ordinary perceptions, this medium of color is mixed, adulterated. While we see, we also hear; we feel pressures, and heat or cold. In a painting, color renders the scene without these alloys and impurities. They are part of the dross that is squeezed out and left behind in an act of intensified expression. The medium becomes color alone, and since color alone must now carry the qualities of movement, touch, sound, etc., that are present physically on their own account in ordinary vision, the expressiveness and energy of color are enhanced.

Photographs to primitive folk have, so it is said, a fearful magical quality. It is uncanny that solid and living things should be thus presented. There is evidence that when pictures of any kind first made their appearance, magical power was imputed to them. Their power of representation could come only from a supernatural source. To one who is not rendered callous by common contact

with pictorial representations there is still something miraculous in the power of a contracted, flat, uniform thing to depict the wide and diversified universe of animate and inanimate things: it is possibly for this reason that popularly "art" tends to denote painting, and "artist" one who paints. Primitive man also imputed to sounds when used as words the power to control supernaturally the acts and secrets of men and to command, provided the right word was there, the forces of nature. The power of mere sounds to express in literature all events and objects is equally marvelous.

Such facts as these seem to me to suggest the rôle and significance of media for art. At first sight, it seems a fact not worth recording that every art has a medium of its own. Why put it down in black and white that painting cannot exist without color, music without sound, architecture without stone and wood, statuary without marble and bronze, literature without words, dancing without the living body? The answer has, I believe, been indicated. In every experience, there is the pervading underlying qualitative whole that corresponds to and manifests the whole organization of activities which constitute the mysterious human frame. But in every experience, this complex, this differentiated and recording, mechanism operates through special structures that take the lead, not in dispersed diffusion through all organs at once—save in panic when, as we truly say, one has lost one's *head*. "Medium" in fine art denotes the fact that this specialization and individualization of a particular organ of experience is carried to the point wherein all its possibilities are exploited. The eye or ear that is centrally active does not lose its specific character and its special fitness as the bearer of an experience that it uniquely makes possible. In art, the seeing or hearing that is dispersed and mixed in ordinary perceptions is concentrated until the peculiar office of the special medium operates with full energy, free from distraction.

"Medium" signifies first of all an intermediary. The import of the word "means" is the same. They are the middle, the intervening, things through which something now remote is brought to pass. Yet not all means are media. There are two kinds of means. One kind is external to that which is accomplished; the other kind is taken up into the consequences produced and remains imma-

nent in them. There are ends which are merely welcome cessations and there are ends that are fulfillments of what went before. The toil of a laborer is too often only an antecedent to the wage he receives, as consumption of gasoline is merely a means to transportation. The means cease to act when the "end" is reached; one would be glad, as a rule, to get the result without having to employ the means. They are but a scaffolding.

Such external or *mere* means, as we properly term them, are usually of such a sort that others can be substituted for them; the particular ones employed are determined by some extraneous consideration, like cheapness. But the moment we say "media," we refer to means that are incorporated in the outcome. Even bricks and mortar become a part of the house they are employed to build; they are not mere means to its erection. Colors *are* the painting; tones are the music. A picture painted with water colors has a quality different from that painted with oil. Esthetic effects belong intrinsically to their medium; when another medium is substituted, we have a stunt rather than an object of art. Even when substitution is practiced with the utmost virtuosity or for any reason outside the kind of end desired, the product is mechanical or a tawdry sham—like boards painted to resemble stone in the construction of a cathedral, for stone is integral not just physically, but to the esthetic effect.

The difference between external and intrinsic operations runs through all the affairs of life. One student studies to pass an examination, to get promotion. To another, the means, the activity of learning, is completely one with what results from it. The consequence, instruction, illumination, is one with the process. Sometimes we journey to get somewhere else because we have business at the latter point and would gladly, were it possible, cut out the traveling. At other times we journey for the delight of moving about and seeing what we see. Means and end coalesce. If we run over in mind a number of such cases we quickly see that all the cases in which means and ends are external to one another are non-esthetic. This externality may even be regarded as a definition of the non-esthetic.

Being "good" for the sake of avoiding penalty, whether it be

going to jail or to hell, makes conduct unlovely. It is as anesthetic as is going to the dentist's chair so as to avoid a lasting injury. When the Greeks identified the good and beautiful in actions, they revealed, in their feeling of grace and proportion in right conduct, a perception of fusion of means and ends. The adventures of a pirate have at least a romantic attraction lacking in the painful acquisitions of him who stays within the law merely because he thinks it pays better in the end to do so. A large part of popular revulsion against utilitarianism in moral theory is because of its exaggeration of sheer calculation. "Decorum" and "propriety" which once had a favorable, because esthetic, meaning are taking on a disparaging signification because they are understood to denote a primness or smugness assumed because of desire for an external end. In all ranges of experience, externality of means defines the mechanical. Much of what is termed spiritual is also unesthetic. But the unesthetic quality is because the things denoted by the word also exemplify separation of means and end; the "ideal" is so cut off from the realities, by which alone it can be striven for, that it is vapid. The "spiritual" gets a local habitation and achieves the solidity of form required for esthetic quality only when it is embodied in a sense of actual things. Even angels have to be provided in imagination with bodies and wings.

I have referred more than once to the esthetic quality that may inhere in scientific work. To the layman the material of the scientist is usually forbidding. To the inquirer there exists a fulfilling and consummatory quality, for conclusions sum up and perfect the conditions that lead up to them. Moreover, they have at times an elegant and even austere form. It is said that Clark-Maxwell once introduced a symbol in order to make a physical equation symmetrical, and that it was only later that experimental results gave the symbol its meaning. I suppose that it is also true that if businessmen were the mere money-grubbers they are often supposed to be by the unsympathetic outsider, business would be much less attractive than it is. In practice, it may take on the properties of a game, and even when it is socially harmful it must have an esthetic quality to those whom it captivates.

Means are, then, media when they are not just preparatory or

preliminary. As a medium, color is a go-between for the values weak and dispersed in ordinary experiences and the new concentrated perception occasioned by a painting. A phonographic disk is a vehicle of an effect and nothing more. The music which issues from it is also a vehicle but is something more; it is a vehicle which becomes one with what it carries; it coalesces with what it conveys. Physically, a brush and the movement of the hand in applying color to canvas are external to a painting. Not so artistically. Brushstrokes are an integral part of the esthetic effect of a painting when it is perceived. Some philosophers have put forth the idea that esthetic effect or beauty is a kind of ethereal essence which, in accommodation to flesh, is compelled to use external sensuous material as a vehicle. The doctrine implies that were not the soul imprisoned in the body, pictures would exist without colors, music without sounds, and literature without words. Except, however, for critics who tell us how they feel without telling or knowing in terms of media used *why* they feel as they do, and except for persons who identify gush with appreciation, media and esthetic effect are completely fused.

Sensitivity to a medium as a medium is the very heart of all artistic creation and esthetic perception. Such sensitiveness does not lug in extraneous material. When, for example, paintings are looked at as illustrations of historical scenes, of literature, of familiar scenes, they are not perceived in terms of their media. Or, when they are looked at simply with reference to the technique employed in making them what they are, they are not esthetically perceived. For here, too, means are separated from ends. Analysis of the former becomes a substitute for enjoyment of the latter. It is true that artists seem themselves often to approach a work of art from an exclusively technical standpoint—and the outcome is at least refreshing after having had a dose of what is regarded as "appreciation." But in reality, for the most part, they so feel the whole that it is not necessary to dwell upon the end, the whole, in words, and so they are freed to consider how the latter is produced.

The medium is a mediator. It is a go-between of artist and perceiver. Tolstoi in the midst of his moral preconceptions often speaks as an artist. He is celebrating this function of an artist

when he makes the remarks already quoted about art as that which unites. The important thing for the theory of art is that this union is effected through the use of special material as a medium. By temperament, perhaps by inclination and aspiration, we are all artists—up to a certain point. What is lacking is that which marks the artist in execution. For the artist has the power to seize upon a special kind of material and convert it into an authentic medium of expression. The rest of us require many channels and a mass of material to give expression to what we should like to say. Then the variety of agencies employed get in the way of one another and render expression turbid, while the sheer bulk of material employed makes it confused and awkward. The artist sticks to his chosen organ and its corresponding material, and thus the idea singly and concentratedly felt in terms of the medium comes through pure and clear. He plays the game intensely, because strictly.

Something which Delacroix said of painters of his day applies to inferior artists generally. He said they used coloration rather than color. The statement signified that they applied color *to* their represented objects instead of making them out of color. This procedure signifies that colors as means and objects and scenes depicted were kept apart. They did not use color as medium with complete devotion. Their minds and experience were divided. Means and end did not coalesce. The greatest esthetic revolution in the history of painting took place when color was used structurally; then pictures ceased to be colored drawings. The true artist sees and feels in terms of his medium and the one who has learned to perceive esthetically emulates the operation. Others carry into their seeing of pictures and hearing of music preconceptions drawn from sources that obstruct and confuse perception.

Fine art is sometimes defined as power to create illusions. As far as I can see this statement is a decidedly unintelligent and misleading way of stating a truth—namely, that artists create effects by command of single medium. In ordinary perception we depend upon contribution from a variety of sources for our understanding of the meaning of what we are undergoing. The artistic use of a medium signifies that irrelevant aids are excluded and one sense

quality is concentratedly and intensely used to do the work usually done loosely with the aid of many. But to call the result an illusion is to mix matters that should be distinguished. If measure of artistic merit were ability to paint a fly on a peach so that we are moved to brush it off or grapes on a canvas so that birds come to peck at them, a scarecrow would be a work of consummate fine-art when it succeeds at keeping away the crows.

The confusion of which I have just spoken can be cleared up. There *is* something physical, in its ordinary sense of real existence. There is the color or sound that constitutes the medium. And there is an experience having a sense of reality, quite likely a heightened one. This sense would be illusory, if it were like that which appertains to the sense of the real existence of the medium. But it is very different. On the stage the media, the actors and their voices and gestures, are really there; they exist. And the cultivated auditor has as a consequence a heightened sense (supposing the play to be genuinely artistic) of the reality of things of *ordinary* experience. Only the uncultivated theatergoer has such an illusion of the reality of what is enacted that he identifies what is done with the kind of reality manifested in the psychical presence of the actors, so that he tries to join in the action. A painting of trees or rocks may make the characteristic reality of tree or rock more poignant than it had ever been before. But that does not imply that the spectator takes a part of the picture to be an actual rock of the kind he could hammer or sit on. What makes a material a medium is that it is used to express a meaning which is other than that which it is in virtue of its bare physical existence: the meaning not of what it physically is, but of what it expresses.

In the discussion of the qualitative background of experience and of the special medium through which distinct meanings and values are projected upon it, we are in the presence of something common in the substance of the arts. Media are different in the different arts. But possession of a medium belongs to them all. Otherwise they would not be expressive, nor without this common substance could they possess form. I referred earlier to Dr. Barnes' definition of form as the integration, through relations, of color, light, line and space. Color is evidently the medium. But the

other arts not only have something corresponding to color as medium but they have as a property of their substance something which exercises the same function that line and space perform in a picture. In the latter, line demarcates, delimits, and the result is presentation of distinct objects, figure or shape being the means by which an otherwise indiscriminate mass is defined into identifiable objects, persons, mountains, grass. Every art has individualized, defined members. Every art so uses its substantial medium as to give complexity of parts to the unity of its creations.

The function we are likely to assign to line, upon first thinking of it, is that of form. A line relates, connects. It is an integral means of determining rhythm. Reflection shows, however, that what gives the just relationship in one direction constitutes individuality of parts in the other direction. Suppose we are looking at an ordinary "natural" landscape, consisting of trees, undergrowth, a patch of grassy field, and a few hills in the background. The scene consists of these parts. But they do not compose well as far as the entire scene is concerned. The hills and some of the trees are not placed right; we want to rearrange them. Some of the branches do not fit; and, while some of the underbrush makes a good setting, other parts of it are confusingly in the way.

Physically the things mentioned are parts of the scene. But they are not parts of it if we take it as an esthetic whole. Now our first tendency, looking at the matter esthetically, would probably be to assign the defects to the form, to the side of inadequate and disturbing relationship of contour, mass, and placing. And we should not be wrong in feeling that jar and interference arise from this source. But if we carry analysis further, we see that defect in relationship on one side is defect in individual structure and definiteness on the other side. We should find that the changes we make in order to get a better composition also serve to give *parts* an individualization, a definiteness, in perception they did not have before.

The same sort of thing holds when accent and interval are in question. They are determined by the necessity of maintaining the relations that bind parts into a whole. But also without these elements, parts would be a jumble, running aimlessly into one an-

other; they would lack the demarcation that individualizes. In music or verse there would be meaningless lapses. If a painting is to be a picture, there must be not only rhythm, but mass—the common substratum of color—must be defined into figures; otherwise there are smears, blotches, and blurs.

There are pictures in which colors are subdued and yet the painting gives us a sense of glow and splendor, while the colors in other paintings are bright to the point of loudness, and yet the total effect is of something drab. Vividly bright color, except at the hands of an artist, is reasonably sure to suggest a chromo. But with an artist, a color garish in itself or even muddy may enhance energy. The explanation of such facts as these is that an artist uses color to define an *object,* and accomplishes this individualization so completely that color and object fuse. The color is of the object and the object in *all* its qualities is expressed through color. For it is *objects* that glow—gems and sunlight; and it is *objects* that are splendid—crowns, robes, sunlight. Except as they express objects, through being the significant color-quality of materials of ordinary experience, colors effect only transient excitations—as red arouses while another color soothes. Take any art one pleases, and it will appear that the medium is expressive because it is used to individualize and define, and this not just in the sense of physical outline but in the sense of expressing that quality which is one with the character of an object; it renders character distinct by emphasis.

What would a novel or drama be without different persons, situations, actions, ideas, movements, events? These are marked off technically by acts and scenes in the drama, by various entrances and exits and all the devices of stagecraft. But the latter are just means of throwing elements into such relief that they complete objects and episodes on their own account—as rests in music are not blanks, but, while they continue a rhythm, punctuate and institute individuality. What would an architectural structure be without differentiation of masses, and a differentiation that is not just physical and spatial, but one that defines parts, windows, doors, cornices, supports, roof, and so on? But by dwelling unduly on a fact that is always present in any complex significant whole, I may appear to make a mystery out of a thing

that is our most familiar experience—that no whole is significant to us except as it is constituted by parts that are themselves significant apart from the whole to which they belong—that, in short, no significant community can exist save as it is composed of individuals who are significant.

The American watercolorist, John Marin, has said of a work of art: "Identity looms up as the great sheet anchor. And as nature in the fashioning of man has adhered strictly to Identity, Head, Body, Limbs and their separate contents, identities in themselves, working every part within itself and through and with the other parts, its neighbors, at its best approaching a beautiful balance, so this art product is made up of neighbor identities. And if an identity in this make-up doesn't take its place and part it's a bad neighbor. And if the chords connecting the neighbors do not take their places and parts, it's a bad service, a bad contact. So this Art product is a village in itself." These identities are the parts that are themselves individual wholes in the substance of the work of art.

In great art, there is no limit set to the individualization of parts within parts. Leibniz taught that the universe is infinitely organic because every organic thing is constituted ad infinitum of other organisms. One may be skeptical of the truth of this proposition as regards the universe, but, as a measure of artistic achievement, it is true that every part of a work of art is potentially at least so constituted, since it is susceptible of indefinite perceptual differentiation. We see buildings in which there is little or nothing in the parts to arrest attention—unless from sheer ugliness.* Our eyes literally glance over and by. In trivial music, parts are simply means of passing on; they do not hold us as parts, nor as the succession goes on do we hold what precedes as parts; as with the esthetically cheap novel, we may get a "kick" from the excitation of movement, but there is nothing to *dwell* upon unless there is an individualized object or event. On the other hand, prose may have a symphonic effect when articulation is carried down into every par-

*The explanation of the fact that things ugly in themselves may contribute to the esthetic effect of a whole is doubtless often due to the fact that they are so used as to contribute to individualization of parts within a whole.

ticular. The more definition of parts contributes to the whole, the more it is important in itself.

To look at a work of art in order to see how well certain rules are observed and canons conformed to impoverishes perception. But to strive to note the ways in which certain conditions are fulfilled, such as the organic means by which the media is made to express and carry definite parts, or how the problem of adequate individualization is solved, sharpens esthetic perception and enriches its content. For every artist accomplishes the operation in his own way and never exactly repeats himself in any two of his works. He is entitled to every and any technical means by which he can effect the result, while to apprehend his characteristic method of doing so is to get an initiation into esthetic comprehension. One painter gives individuality in detail by fluid lines, by mergings, more than another artist does with the most sharply outlined profile. One does with chiaroscuro what another brings about by highlights. It is not uncommon to find in Rembrandt's drawings, lines within a figure that are stronger than those which bound it externally—and yet there is gain rather than sacrifice of individuality. In a general way there are two opposite methods; that of contrast, of the staccato, the abrupt, and that of the fluid, the merging, the subtle gradation. From that we can proceed to discovery of ever-increasing refinements. As instances of the two methods in the large, we may take instances cited by Leo Stein. "Compare," he says, "the line of Shakespeare 'in cradle of rude imperious surge' with the line 'When icicles hang by the wall.'" In the first, there are contrasts like cradle-surge, imperious-rude, contrasts of vowels and also of pace. In the other, he says: "Each line is like a loop in a lightly hung chain, or even like a cantilever, easily in touch with its fellows." The fact that the method of abruptness lends itself most directly to definition and that of continuity to establishing of relations is perhaps a reason why artists have liked to reverse the process and thus increase the amount of energy elicited.

It is possible for both perceiver and artist to carry their predilection for a particular method of attaining individualization to such a point that they confuse the method with the end, and

deny the latter exists when they are repelled by the means used to achieve it. From the side of the audience, this fact is illustrated on a large scale by the reception given to paintings when artists ceased to employ obvious shading to delimit figures, using a relation of colors instead. It is peculiarly evident from the side of art, in one who is significant in painting (but especially in drawing) and preëminently great in poetry, Blake. He denied esthetic merit to Rubens, Rembrandt, and the Venetian and Flemish schools generally because they worked with "broken lines, broken masses and broken colors"—the very factors that characterize the great revival of painting toward the end of the nineteenth century. He added: "The great and golden rule of art, as well as of life, is this: That the more distinct, sharp and wiry the bounding line, the more perfect the work of art, and the less keen and sharp, the greater is the evidence of weak imagination, plagiarism and bungling. . . . The want of this determinate and bounding form evidences the want of idea in the artist's mind, and the pretense of plagiary in all its branches." The passage deserves quotation for its emphatic recognition of the necessity of determinateness of individualization of the members of a work of art. But it also indicates the limitation that may accompany a particular mode of vision when it is intense.

There is another matter that is common to the substance of all works of art. Space and time—or rather space-time—are found in the matter of every art product. In the arts, they are neither the empty containers nor the formal relations that schools of philosophy have sometimes represented them to be. They are substantial; they are properties of every kind of material employed in artistic expression and esthetic realization. Imagine in reading *Macbeth* an attempt to separate the witches from the heath, or in the matter of Keats' "Ode on the Grecian Urn," a separation of the bodily figures of priest, maidens, and heifer from something called soul or spirit. In painting, space certainly relates; it helps constitute form. But it is directly felt, sensed, as quality also. If it were not, a picture would be so full of holes as to disorganize perceptual experience. Psychologists, until William James taught better, were accustomed to find only temporal quality in sounds, and some of

them made even this a matter of intellectual relationship instead of a quality as distinctive as any other trait of sound. James showed that sounds were spatially voluminous as well—a fact which every musician had practically employed and exhibited whether he had theoretically formulated it or not. As with the other properties of substance of which we have spoken, the fine arts seek out and elicit this quality of all the things we experience and express it more energetically and clearly than do the things from which they extract it. As science takes qualitative space and time and reduces them to relations that enter into equations, so art makes them abound in their own sense as significant values of the very substance of all things.

Movement in direct experience is alteration in the *qualities* of objects, and space as experienced is an aspect of this qualitative change. Up and down, back and front, to and fro, this side and that—or right and left—here and there, *feel* differently. The reason they do is that they are not static points in something itself static, but are objects in movement, qualitative changes of value. For "back" is short for back*wards* and front for for*wards*. So with velocity. Mathematically there are no such things as fast and slow. They mark simply greater and less on a number scale. As experienced they are qualitatively as unlike as are noise and silence, heat and cold, black and white. To be forced to wait a long time for an important event to happen is a length very different from that measured by the movements of the hands of a clock. It is something qualitative.

There is another significant involution of time and movement in space. It is constituted not only by directional tendencies—up and down, for example—but by mutual approaches and retreatings. Near and far, close and distant, are qualities of pregnant, often tragic, import—that is, as they are experienced, not just stated by measurement in science. They signify loosening and tightening, expanding and contracting, separating and compacting, soaring and drooping, rising and falling; the dispersive, scattering, and the hovering and brooding, unsubstantial lightness and massive blow. Such actions and reaction are the very stuff out of which the objects and events we experience are made. They can be described in

science because they are there reduced to relations that differ only mathematically, as science is concerned about the remote and identical or repeated things that are *conditions* of actual experience and not with experience in its own right. But in experience they are infinitely diversified and cannot be described, while in works of art they are *expressed*. For art is a selection of what is significant, with rejection by the very same impulse of what is irrelevant, and thereby the significant is compressed and intensified.

Music, for example, gives us the very essence of the dropping down and the exalted rising, the surging and retreating, the acceleration and retardation, the tightening and loosening, the sudden thrust and the gradual insinuation of things. The expression is abstract in that it is freed from attachment to this and that, while at the same time it is intensely direct and concrete. It would be possible, I think, to make out a plausible case for the assertion that, without the arts, the experience of volumes, masses, figures, distances and directions of qualitative change would have remained rudimentary, something dimly apprehended and hardly capable of articulate communication.

While the emphasis of the plastic arts is upon the spatial aspects of change and that of music and the literary arts upon the temporal, the difference is only one of emphasis within a common substance. Each possesses what the other actively exploits, and its possession is a background without which the properties brought to the front by emphasis would explode into the void, evaporate into imperceptible homogeneity. An almost point for point correspondence can be instituted between, say, the opening bars of Beethoven's fifth symphony and the serial order of weights, of ponderous volumes, in Cézanne's "Card Players." In consequence of the voluminous quality belonging to them both, both the symphony and the painting have power, strength, and solidity—like a massive, well-constructed bridge of stone. They both express the enduring, that which is structurally resistant. Two artists by different media put the essential quality of a rock into things as unlike as a picture and a series of complex sounds. One does his work by color plus space, the other by a sound plus time, which in this case has the massive volume of space.

For space and time as experienced are not only qualitative but infinitely diversified in qualities. We can reduce the diversification to three general themes: Room, Extent, Position—Spaciousness, Spatiality, Spacing—or in terms of time—transition, endurance and date. In experience, these traits qualify one another in a single effect. One usually predominates over the others, however, and while they have no separate existence they can be distinguished in thought.

Space is room, *Raum,* and room is roominess, a chance to be, live and move. The very word "breathing-space" suggests the choking, the oppression that results when things are constricted. Anger appears to be a reaction in protest against fixed limitation of movement. Lack of room is denial of life, and openness of space is affirmation of its potentiality. Overcrowding, even when it does not impede life, is irritating. What is true of space is true of time. We need a "space of time" in which to accomplish anything significant. Undue haste forced upon us by pressure of circumstances is hateful. Our constant cry when pushed from without is Give us time! The master, it is true, shows himself within limitations, and a literally infinite room within which to act would signify complete dispersion. But the limitations must bear a definite ratio to power; they involve coöperative choice; they cannot be imposed.

Works of art express space as opportunity for movement and action. It is a matter of proportions qualitatively felt. A lyric ode may have it when a would-be epic misses it. Small pictures manifest it when acres of paint leave us with a sense of being cribbed and cabined. Emphasis upon spaciousness is a characteristic of Chinese paintings. Instead of being centralized so as to require frames, they move outwards, while panoramic scroll paintings present a world in which ordinary boundaries are transformed into invitations to proceed. Yet by different means, western paintings that are highly centralized create the sense of the extensive whole that encloses a scene that is carefully defined. Even an interior, like Van Eyck's "Jean Arnolfini and Wife," may convey within a defined compass the explicit sense of the outdoors beyond the walls. Titian paints the background in the portrait of an individual so that infinite space, not just the canvas, is behind the figure.

Mere room, opportunity and possibility wholly indeterminate, would be, however, blank and empty. Space and time in experience are also occupancy, filling—not merely something externally filled. Spatiality is mass and volume, as temporality is endurance, not just abstract duration. Sounds as well as colors shrink and expand and colors like sounds rise and fall. As I have noted before, William James made evident the voluminous quality of sounds, and it is no metaphor when tones are denominated high and low, long and short, thin and massive. In music, sounds return as well as proceed; they display intervals as well as progression. The reason is like that already noted regarding the splendor or dinginess of colors in painting. They belong to objects; they are not floating and isolated, and the objects to which they belong exist in a world possessed of extent and volume.

Murmuring is of brooks, whispering, and rustling of leaves, rippling of waves, roar of surf and thunder, moaning and whistling of wind . . . and so on indefinitely. By this statement I do not mean that the thinness of the flute's note and the massive peal of the organ are directly associated by us with particular natural objects. But I do mean that these tones express qualities of extension because only intellectual abstraction can separate an event in time from an extended object that initiates or undergoes change. Time as empty does not exist; time as an entity does not exist. What exists are things acting and changing, and a constant quality of their behavior is temporal.

Volume, like roominess, is a quality independent of mere size and bulk. There are small landscapes that convey the abundance of nature. A still life of Cézanne's, with a composition of pears and apples, conveys the very essence of volume in dynamic equilibrium both to another and to surrounding space as well. The frail, the fragile, need not be examples of esthetic weakness; they, too, may be embodiments of volume. Novels, poems, dramas, statues, buildings, characters, social movements, arguments, as well as pictures and sonatas, are marked by solidity, massiveness, and the reverse.

Without the third property, spacing, occupancy would be a jumble. Place, position, determined by distribution of intervals

through spacing, is a great factor in effecting the individualization of parts already spoken of. But a position taken has an immediate qualitative value and as such is an inherent part of substance. The feeling of energy and especially not just of energy in general but of this or that power in the concrete is closely connected with rightness in placing. For there is an energy of position as well as of motion. And while the former is sometimes called potential energy in physics in distinction from kinetic energy, as directly felt it is as actual as is the latter. Indeed in the plastic arts, it is the means by which movement is expressed. Some intervals (determined in all directions, not merely laterally) are favorable to the manifestation of energy; others frustrate its operation—boxing and wrestling are obvious examples.

Things may be too far apart, too near together, or disposed at the wrong angle in relation to one another, to allow of energy of action. Awkwardness of composition whether a human being or in architecture, prose, or painting is the result. Meter in poetry owes its more subtle effects to what it does in securing a just position for various elements—an obvious instance being its frequent inversion of the order of prose. There are ideas that would be destroyed if they were spaced by means of spondees instead of trochees. Too much distance or too undefined an interval in novel and drama sets attention wandering or puts it to sleep, while incidents and characters treading on one another's heels detract from the force of them all. Certain effects that distinguish some painters depend upon their fine feeling for spacing—a matter quite distinct from use of planes to convey volumes and backgrounds. As Cézanne is a master of the latter, Corot has unerring tact for the former—especially in portraits and so-called Italian paintings as compared with his popular but relatively weak silvery landscapes. We think of transposition particularly in connection with music, but in terms of media it characterizes equally painting and architecture. The recurrence of relations—not of elements—in different contexts, which constitutes transposition is qualitative and hence is directly experienced in perception.

The progress—which is not necessarily an advance and, practically never an advance in all respects—of the arts display a tran-

sition from more obvious to subtler means of expressing position. In earlier literature position was in accord (as we have already noted in another connection) with social convention and economic and political class. It was position in the sense of social status that fixed the force of place in the older tragedy. Distance was already determined outside the drama. In modern drama, with Ibsen as the outstanding example, relations of husband and wife, politician and democratic citizenship, old age and encroaching youth (whether by way of competition or of seductive attraction), contrasts of external convention and personal impulse, forcibly express energy of position.

The bustle and ado of modern life render nicety of placing the feature most difficult for artists to achieve. Tempo is too rapid and incidents too crowded to permit of decisiveness—a defect found in architecture, drama, and fiction alike. The very profusion of materials and the mechanical force of activities get in the way of effective distribution. There is more of vehemence than of the intensity that is constituted by emphasis. When attention lacks the remission that is indispensable to its operations, it becomes numb as protection against its recurrent overstimulation. Only occasionally do we find the problem solved—as it is in fiction in Mann's *Magic Mountain* and in architecture in the Bush Building in New York City.

I have said that the three qualities of space and time reciprocally affect and qualify one another in experience. Space is inane save as occupied with active volumes. Pauses are holes when they do not accentuate masses and define figures as individuals. Extension sprawls and finally benumbs if it does not interact with place so as to assume intelligible distribution. Mass is nothing fixed. It contracts and expands, asserts itself and yields, according to its relations to other spatial and enduring things. While we may view these traits from the standpoint of form, of rhythm, balance and organization, the relations which thought grasps as ideas are present as *qualities* in perception and they inhere in the very substance of art.

There are then common properties of the matter of arts because there are general conditions without which an experience is

not possible. As we saw earlier, the basic condition is felt relationship between doing and undergoing as the organism and environment interact. Position expresses the poised readiness of the live creature to meet the impact of surrounding forces, to meet so as to endure and to persist, to extend or expand through undergoing the very forces that, apart from its response, are indifferent and hostile. Through going out into the environment, position unfolds into volume; through the pressure of environment, mass is retracted into energy of position, and space remains, when matter is contracted, as an opportunity for further action. Distinction of elements and consistency of members in a whole are the functions that define intelligence; the intelligibility of a work of art depends upon the presence to the meaning that renders individuality of parts and their relationship in the whole directly present to the eye and ear trained in perception.

ART is a quality of doing and of what is done. Only outwardly, then, can it be designated by a noun substantive. Since it adheres to the manner and content of doing, it is adjectival in nature. When we say that tennis-playing, singing, acting, and a multitude of other activities are arts, we engage in an elliptical way of saying that there is art *in* the conduct of these activities, and that this art so qualifies what is done and made as to induce activities in those who perceive them in which there is also art. The *product* of art—temple, painting, statue, poem—is not the *work* of art. The work takes place when a human being coöperates with the product so that the outcome is an experience that is enjoyed because of its liberating and ordered properties. Esthetically at least:

". . . we receive but what we give,
 And in our life alone does nature live;
 Ours is her wedding garment; ours her shroud."

If "art" denoted objects, if it were genuinely a noun, art objects could be marked off into different classes. Art would then be divided into genera and these subdivided into species. This sort of division was applied to animals as long as they were believed to be things fixed in themselves. But the system of classification had to change when they were discovered to be differentiation in a stream of vital activity. Classifications became genetic, designating as accurately as may be the special place of particular forms in the continuity of life on earth. If art is an intrinsic quality of activity, we cannot divide and subdivide it. We can only follow the differentiation of the activity into different modes as it impinges on different materials and employs different media.

Qualities as qualities do not lend themselves to division. It would be impossible to name the subordinate sorts of even sweet and sour. In the end such an attempt would be compelled to enumerate every *thing* in the world that is sweet or sour, so that the alleged classification would be merely a catalogue that idly reduplicates in the form of "qualities" what was previously known in the form of things. For quality is concrete and existential, and hence varies with individuals since it is impregnated with their uniqueness. We may indeed speak of red, and then of the red of rose or sunset. But these terms are practical in nature, giving a certain amount of direction as to where to turn. In existence no two sunsets have exactly the same red. They could not have it unless one sunset repeated the other in absolutely complete detail. For the red is always the red of the material of *that* experience.

Logicians for certain purposes regard qualities like red, sweet, beautiful, etc., as universals. As formal logicians, they are not concerned with existential matters which are precisely what artists *are* concerned with. A painter knows, therefore, that there are no two reds in a picture exactly like each other, each being affected by the

infinite detail of its context in the individual whole in which it appears. "Red" when used to signify "redness" in general is a handle, a mode of approach, a delimitation of action within a given region, such as buying red paint for a barn where any red within limits will do, or for matching a sample in buying goods.

Language comes infinitely short of paralleling the variegated surface of nature. Yet words as practical devices are the agencies by which the ineffable diversity of natural existence as it operates in human experience is reduced to orders, ranks, and classes that can be managed. Not only is it impossible that language should duplicate the infinite variety of individualized qualities that exist, but it is wholly undesirable and unneeded that it should do so. The unique quality of a quality is found in experience itself; it is there and sufficiently there not to need reduplication in language. The latter serves its scientific or its intellectual purpose as it gives directions as to how to come upon these qualities in experience. The more generalized and simple the direction the better. The more uselessly detailed they are, the more they confuse instead of guiding. But words serve their poetic purpose in the degree in which they summon and evoke into active operation the vital responses that are present whenever we experience qualities.

A poet has recently said that poetry seemed to him "more physical than intellectual," and he goes on to say that he recognizes poetry by physical symptoms such as bristling of the skin, shivers in the spine, constriction of the throat, and a feeling in the pit of the stomach like Keats' "spear going through me." I do not suppose that Mr. Housman means that these feelings *are* the poetical effect. To be a thing and to be a sign of its presence are different modes of being. But just such feelings, and what other writers have called organic "clicks," are the gross indication of complete organic participation, while it is the fullness and immediacy of this participation that constitutes the esthetic quality of an experience, just as it is that which transcends the intellectual. For this reason, I should question the literal truth of the saying that poetry is *more* physical than intellectual. But that it is more than intellectual, because it absorbs the intellectual into immediate qualities that are experienced through senses that belong to the vital body, seems to

me so indubitable as to justify the exaggeration contained in the saying as against the idea that qualities are universals intuited through the intellect.

The fallacy of definition is the other side of the fallacy of rigid classification, and of abstraction when it is made an end in itself instead of being used as an instrument for the sake of experience. A definition is good when it is sagacious, and it is that when it so points the direction in which we can move expeditiously toward having an experience. Physics and chemistry have learned by the inward necessity of their tasks that a definition is that which indicates to us *how* things are made, and in so far enables to predict their occurrence, to test for their presence and, sometimes, to make them ourselves. Theorists and literary critics have lagged far behind. They are still largely in thralls to the ancient metaphysics of essence according to which a definition, if it is "correct," discloses to us some inward reality that causes the thing to be what it is as a member of a species that is eternally fixed. Then the species is declared to be more real than an individual, or rather to be itself the true individual.

For practical purposes we *think* in terms of classes, as we concretely experience in terms of individuals. Thus a layman would probably suppose that it is a simple matter to define a vowel. But a phonetician is compelled by intimate contact with actual subject-matter to recognize that a strict definition, strict in the sense of marking off one class of things from others in every respect, is an illusion. There are only a number of more or less useful definitions; useful, because directing attention to significant *tendencies* in the continuous process of vocalization—tendencies that if carried to a limit of discreteness would yield this or that "exact" definition.

William James remarked on the tediousness of elaborate classification of things that merge and vary as do human emotions. Attempts at precise and systematic classification of fine arts seem to me to share this tediousness. An enumerative classification is convenient and for purposes of easy reference indispensable. But a cataloguing like painting, statuary, poetry, drama, dancing, landscape gardening, architecture, singing, musical instrumentation,

etc., etc., makes no pretense to throwing any light on the intrinsic nature of things listed. It leaves that illumination to come from the only place it can come from—individual works of art.

Rigid classifications are inept (if they are taken seriously) because they distract attention from that which is esthetically basic—the qualitatively unique and integral character of experience of an art product. But for a student of esthetic theory they are also misleading. There are two important points of intellectual understanding in which they are confusing. They inevitably neglect transitional and connecting links; and in consequence they put insuperable obstacles in the way of an intelligent following of the historical development of any art.

One classification which has had some vogue is according to sense-organs. We shall see later what element of truth may reside in this mode of division. But taken literally and rigidly, it cannot possibly yield a coherent result. Recent writers have dealt adequately with Kant's effort to limit the material of the arts to the "higher" intellectual senses, eye and ear, and I shall not repeat their convincing arguments. But, when the range of senses is extended in the most catholic manner, it still remains true that a particular sense is simply the outpost of a total organic activity in which all organs, including the functioning of the autonomic system, participate. Eye, ear, touch, take the lead in a particular organic enterprise, but they are no more the exclusive or even always the most important agent than a sentinel is a whole army.

A particular example of the confusion worked by division into arts of the eye and ear is found in the case of poetry. Poems were once the work of bards. Poetry as far as we know had no existence outside the spoken voice appealing to the ear. It was something sung or chanted. It is hardly necessary to say how far away the great mass of poetry has got from song since the invention of writing and of printing. There are even attempts at present to use the device of figures made by printed forms to intensify the sense of a poem as it strikes the eye—like the tail of the mouse in *Alice in Wonderland*. But apart from any exaggeration, while the heard "music" of silently read poetry is still a factor (illustrating the point made in the last paragraph), poetry as a mode

of literature is now outwardly and sensibly visual. Has it then migrated from one "class" to another in the last two thousand years?

Then there is the classification into arts of space and time that has already been mentioned. Now even if this division were correct, it is one made after the event and from the outside, and throws no light upon the esthetic *content* of any work of art. It does not aid perception; it does not tell what to look for, nor how to see, hear, and enjoy. It has, moreover, a positive serious defect. As was previously pointed out, it denies rhythm to architectural structures, statues and paintings, and symmetry to song, poetry, and eloquence. And the implication of the denials is refusal to acknowledge the thing most fundamental to esthetic experience—that it is perceptual. The division is made on the basis of traits of art products as external and physical existences.

A writer on the fine arts in one edition of the *Encyclopedia Britannica* illustrates this fallacy so beautifully as to make it pertinent to quote a passage. In justifying the division of the arts into spatial and temporal, he says, in speaking of a statue and building: "What the eye sees from any point of view it sees all at once; in other words, the parts of anything we see fill or occupy not time but space, and reach us from various points in space at a single instantaneous perception." And it is added: "Their products (that is, of the arts of sculpture and architecture) are in themselves solid, stationary, and permanent."

A number of ambiguities and resulting misconceptions are crowded into these few sentences. First, as to the "all-at-once." Any object in space (and all objects are spatial) sends out vibrations all at once, and the physical parts of the object occupy space all at once. But these traits of the object have nothing to say or do in distinguishing one kind of perception from another. Space occupancy is a general condition of the existence of anything—even of a ghost if there be one. It is a *causal* condition for having any and every "sensation." Similarly vibrations sent out from an object are causal conditions of every kind of perception; accordingly they do not mark out one kind of perception from others.

Thus at most what "reaches us simultaneously" is the physical

conditions of a perception, not the constituents of the object as perceived. Inference is made to the latter only through confusion of "simultaneous" with "single." Of course, all the impressions that reach us from any object or event must be integrated into one perception. The only alternative to singleness of perception, whether the object be one in space or time, is a disconnected succession of snapshots that do not even form cross-sections of anything. The difference between that elusive and fragmentary thing psychologists call a sensation and a perception is the singleness, the integrated unity, of the latter. Simultaneity of both physical existence and physiological reception have nothing to do with this singleness. As was just indicated, they can be taken to be identical only when the causal conditions of a perception are confused with the actual content of the perception.

But the fundamental mistake is the confusion of the physical product with the esthetic object, which is that which is perceived. Physically, a statue is a block of marble, nothing more. It is stationary, and, as far as the ravages of time permit, permanent. But to identify the physical lump with the statue that is a work of art and to identify pigments on a canvas with a picture is absurd. What about the play of light on a building with the constant change of shadows, intensities, and colors, and shifting reflections? If the building or statue were as "stationary" in perception as it is in physical existence, they would be so dead that the eye would not rest on it, but glance by. For an object is perceived by a cumulative series of interactions. The eye as the master organ of the whole being produces an undergoing, a return effect; this calls out another act of seeing with new allied supplementations with another increment of meaning and value, and so on, in a continuous building-up of the esthetic object. What is called the inexhaustibility of a work of art is a function of this continuity of the total act of perceiving. "Simultaneous vision" is an excellent definition of a perception so little esthetic that it is not even a perception.

Architectural structures provide, I should imagine, the perfect *reductio ad absurdum* of the separation of space and time in works of art. If anything exists in the mode of "space-occupancy," it is a building. But even a small hut cannot be the matter of es-

thetic perception save as temporal qualities enter in. A cathedral, no matter how large, makes an instantaneous impression. A total qualitative impression emanates from it as soon as it interacts with the organism through the visual apparatus. But this is only the substratum and framework within which a continuous process of interactions introduces enriching and defining elements. The hasty sightseer no more has an esthetic vision of Saint Sophia or the Cathedral of Rouen than the motorist traveling at sixty miles an hour *sees* the flitting landscape. One must move about, within and without, and through repeated visits let the structure gradually yield itself to him in various lights and in connection with changing moods.

I may appear to have dwelt at unnecessary length upon a not very important statement. But the implication of the passage quoted affects the whole problem of art as experience. An instantaneous experience is an impossibility, biologically and psychologically. An experience is a product, one might almost say a by-product, of continuous and cumulative interaction of an organic self with the world. There is no other foundation upon which esthetic theory and criticism can build. When an individual does not permit this process to work itself out fully, he begins at the point of arrest to supplant experience of the work of art with unrelated private notions. What ails much esthetic theory and criticism is accurately described in the following: "When the continuously unfolding process of cumulative interaction and its result are neglected, an object is seen in only a part of its totality, and the rest of theory becomes subjective reverie, instead of a growth. It is arrested after the first perception of partial detail; the rest of the process is exclusively cerebral—a one-sided affair that acquires momentum only from within. It does not include that stimulation from environment that would displace revery by interaction with the self."*

In any case, the division of the arts into spatial and temporal has to be eked out by another classification, that into representative and non-representative, a division within which architecture

*From a personal letter of Dr. Barnes to the author.

and music are now assigned to the latter genus. Aristotle, who gave the conception that art is representative its classic formation, at least avoided the dualism of this division. He took the concept of imitation more generously and more intelligently. Thus he declares that music is the *most* representative of all the arts—this being the very one that some modern theorists refer to the wholly non-representative class. Nor did he mean anything so silly as that music represents the twittering of birds, lowing of cows and gurgling of brooks. He meant that music reproduces by means of sounds the affections, the emotional impressions, that are produced by martial, sad, triumphant, sexually orgasmic, objects and scenes. Representation in the sense of expression covers all the qualities and values of any possible esthetic experience.

Architecture is not representative if we understand by that term reproduction of natural forms for the sake of their reproduction—as some have supposed that cathedrals "represent" high trees in a forest. But architecture does more than merely utilize natural forms, arches, pillars, cylinders, rectangles, portions of spheres. It expresses their characteristic effect upon the observer. Just what a building would be which did not use and represent the natural energies of gravity, stress, thrust, and so on, must be left to those to explain who regard architecture as nonrepresentative. But architecture does not combine representation to these qualities of matter and energy. It expresses also enduring values of collective human life. It "represents" the memories, hopes, fears, purposes, and sacred values of those who build in order to shelter a family; provide an altar for the gods, establish a place in which to make laws, or set up a stronghold against attack. Just why buildings are called palaces, castles, homes, city-halls, forums, is a mystery if architecture is not supremely expressive of human interests and values. Apart from cerebral reveries, it is self-evident that every important structure is a treasury of storied memories and a monumental registering of cherished expectancies for the future.

Moreover, the separation of architecture (music, too, for that matter) from such arts as painting and sculpture makes a mess of the historical developments of the arts. Sculpture (which is acknowledged to be representative) was for ages an organic part of

architecture: witness the frieze of the Parthenon, the carvings of the cathedrals of Lincoln and Chartres. Nor can it be said that its growing independence of architecture—with statues scattered in parks and public squares and busts placed on pedestals in rooms already overcrowded—has coincided with any advance in the art of sculpture. Painting was first adherent to the walls of caves. It long continued to be a decorative effect of temples and palaces, without and on inner walls. Frescoes were meant to inspire faith, revive piety and instruct the worshiper concerning the saints, heroes, and martyrs of his religion. When Gothic buildings left little wall space for murals, stained glass and later panel paintings took their place—still as much parts of an architectural whole as were carvings on altar and reredos. When nobles and merchant princes began the collection of paintings on canvas, they were used to decorate walls—so much so that they were frequently cut and trimmed to make them fit better the purpose of wall ornamentation. Music was associated with song, and its differentiated modes were adapted to the needs of great crises and important events—death, marriage, war, worship, feasting. With the passage of time, both painting and music have ceased to be subservient to special ends. Since all the arts have tended to exploit their own media to the point of independence, the fact can be better used to prove that none of the arts is literally imitative than to furnish a reason for drawing hard and fast lines between them.

Moreover, as soon as lines have been drawn, the theorists who institute them find it necessary to make exceptions and introduce transitional forms and even to say that some arts are mixed—dancing, for example, being both spatial and temporal. Since it is the nature of any art object to be itself, single and unified, this notion of a "mixed" art may be safely regarded as a *reductio ad absurdum* of the whole rigid classificatory business. What can such classifications make out of sculpture in relief, high and low, of marble figures on tombs, carved on wooden doors and cast in bronze doors? What about carvings of capitals, friezes, cornices, canopies, brackets? How do the minor arts fit in, workings in ivory, alabaster, plaster of paris, terra-cotta, silver and gold, ornamental iron work in brackets, signs, hinges, screens and grills? Is

the same music nonrepresentative when played in a concert hall and representative when it is part of a sacramental service in a church?

The attempt at rigid classification and definition is not confined to the arts. A like method has been applied to esthetic effects. Much ingenious effort has been spent in enumerating the different species of beauty after beauty itself has had its "essence" set forth: the sublime, grotesque, tragic, comic, poetic, and so on. Now there are undoubtedly realities to which such terms apply—as proper names are used in connection with different members of a family. It is possible for a qualified person to say things about the sublime, eloquent, poetic, humorous, that enhance and clarify perception of objects in the concrete. It may help in seeing a Giorgione to possess in advance a definite sense of what it is to be lyric; and in listening to Beethoven's major theme in the "Fifth Symphony" to come to it with a clear conception of what force is and is not in the arts. But, unfortunately, esthetic theory has not been content with clarifying qualities as matter of emphasis in individual wholes. It erected adjectives into nouns substantive, and then played dialectical tunes upon the fixed concepts which emerge. Since rigid conceptualization is compelled to take place on the basis of principles and ideas that are framed outside of direct esthetic experience, all such performances afford good samples of "cerebral revery."

If, however, we regard such terms as picturesque, sublime, poetic, ugly, tragic, as marking *tendencies,* and hence as adjectival as are the terms, pretty, sugary, convincing, we shall be led back to the fact that art is a quality of activity. Like any mode of activity, it is marked by *movement* in this direction and that. These movements may be discriminated in such fashion that our relation to the activity in question is rendered more intelligent. A tendency, a movement, occurs within certain limits which define its direction. But tendencies of experience do not have limits that are exactly fixed or that are mathematical lines without breadth and thickness. Experience is too rich and complex to permit such precise limita-

tion. The termini of tendencies are bands not lines, and the qualities that characterize them form a spectrum instead of being capable of distribution in separate pigeonholes.

Thus anyone can select passages of literature and say without hesitation this is poetic, that is prosaic. But this assigning of qualities does not imply that there is one entity called poetry and another called prose. It implies, once more, a felt quality of a movement toward a limit. Hence the quality exists in many degrees and forms. Some of its lesser degrees manifest themselves in unexpected places. Dr. Helen Parkhurst quotes the following from a weather report: "Low pressure prevails west of the Rocky Mountains, in Idaho and south of the Columbia River as far as Nevada. Hurricane conditions continue along the Mississippi Valley and into the Gulf of Mexico. Blizzards are reported in North Dakota and Wyoming, snow and hail in Oregon and zero temperature in Missouri. High winds are blowing southeastward from the West Indies and shipping along the coast of Brazil has received a warning."

No one would say that the passage is poetry. But only pedantic definition will deny that there is something poetic about it, due in part to the euphony of the geographical terms, and more to "transferred values"; to accumulation of allusions that create a sense for the wide spaciousness of the earth, the romance of distant and strange countries, and above all the mystery of the varied turmoil of the forces of nature in hurricane, blizzard, hail, snow, cold, and tempest. The intention is a prosaic statement of weather conditions. But the words are charged with a load that gives them an impulsion toward the poetic. I suppose that even equations composed of chemical symbols may under certain circumstances of an extension of insight into nature have for some persons a poetic value, though in such cases the effect is limited and idiosyncratic. But that experiences having different materials and different movements toward different kinds of conclusions will have differences that at the poles are as far apart as the baldly prosaic and the excitedly poetic, is guaranteed in advance to happen. For in some cases the tendency is in the direction of fulfillment of an experience as an experience, while in other cases the result moved toward is but a deposit for use in another experience.

Examination of the literature regarding the comic and humorous will show, I think, the same two facts. On one hand, incidental and side remarks make clearer some particular tendency and make the reader more alive and discriminating in actual situations. These instances will be identical with cases where an adjectival quality, a tendency, is under survey. But there are elaborate and painful efforts to establish a rigid definition illustrated by a collection of cases. How can any classification of genus and species reduce to conceptual unity such a variety of tendencies as are indicated by even a few of the terms in use: Laughable, ridiculous, ribald, amusing, funny, mirthful, farcical, diverting, witty, hilarious; joking, fooling, making fun of, making sport of, mocking, letting-down? Of course with sufficient ingenuity one may start from a definition, like incongruity, or from a sense of logic and proportion working in reverse, and then find a specific differentia for each variety. But it should be evident that we are then attending a dialectical game.

If we confine ourselves to one aspect alone, the ridiculous, *le rire,* the comic is what we laugh at. But we also laugh with; we laugh from elation, sheer high spirits, geniality, conviviality, from scorn and from embarrassment. Why confine all these variations of tendency in a single hard and fast concept? Not that conceptions are not the heart of thinking, but that their real office is as instruments of approach to the changing play of concrete material, not to tie that material down into rigid immobility. Since it is the incidental material rather than the formal definitions that acts as reënforcements of perception in particular experience, the side remarks exercise the real office of conception.

Finally, on this point, the notion of fixed classes and that of fixed rules inevitably accompany each other. If there are, for example, so many separate genres in literature, then there is some immutable principle which marks off each kind and which defines an inherent essence that makes each species what it is. This principle must then be conformed to; otherwise the "nature" that belongs to the art will be violated and "bad" art will be the result. Instead of being free to do what he can with the material at hand and the media under his control, the artist is bound, under penalty of rebuke

from the critic who knows the rules, to follow the precepts that flow from the basic principle. Instead of observing subject-matter, he observes rules. Thus classification sets limits to perception. If the theory that underlies it is influential, it restricts creative work. For new works, in the degree in which they are new, do not fit into pigeon-holes already provided. They are in the arts what heresies are in theology. There are obstructions enough in any case in the way of genuine expression. The rules that attend classification add one more handicap. The philosophy of fixed classification as far as it has vogue among critics (who whether they know it or not are subjects of one or other of the positions that philosophers have formulated more definitely) encourages all artists, save those of unusual vigor and courage, to make "safety first" their guiding principle.

The tenor of the foregoing is not so negative as might seem at first sight. For it calls attention in an indirect way to the importance of media and to their inexhaustible variety. We may safely start any discussion of the varied matter of the arts with this fact of the decisive importance of the medium: with the fact that different media have different potencies and are adapted to different ends. We do not make bridges with putty nor use the most opaque things we can find to serve as windowpanes to transmit sunlight. This negative fact alone compels differentiation in works of art. On the positive side, it suggests that color does something characteristic in experience and sound something else; sounds of instruments something different from the sound of the human voice and so on. At the same time it reminds us that the exact limits of the efficacy of any medium cannot be determined by any *à priori* rule, and that every great initiator in art breaks down some barrier that had previously been supposed to be inherent. If, moreover, we establish the discussion on the basis of media, we recognize that they form a continuum, a spectrum, and that while we may distinguish arts as we distinguish the seven so-called primary colors, there is no attempt to tell exactly where one begins and the other ends; and also that if we take one color out of its context, say a particular band of red, it is no longer the same color it was before.

When we view the arts from the standpoint of media of expression, the broad distinction that confronts us is between the arts that have the human organism, the mind-body, of the artist as their medium and those which depend to a much greater extent upon materials external to the body: automatic and shaping arts so-called.* Dancing, singing, yarn-spinning—the prototype of the literary arts in connection with song—are examples of "automatic" arts, and so are bodily scarifications, tattooings, etc., and the cultivation of the body by the Greeks in games and gymnasia. Cultivation of voice, posture, and gesture that adds grace to social intercourse is another.

Since the shaping arts must at first have been identified with technological arts, they were associated with work and with some degree, even if slight, of external pressure in contrast with automatic arts as spontaneous, free accompaniments of leisure. Therefore, the Greek thinkers ranked them as higher than those which subordinated the use of the body to deal with external materials by the intermediation of instruments. Aristotle reckons the sculptor and the architect—even if of the Parthenon—as craftsmen rather than as artists in the liberal sense. Modern taste tends to reckon as higher the fine arts that reshape material, where the product is enduring instead of fugitive, and is capable of appealing to a wide circle, including the unborn, in contrast with the limitation of singing, dancing, and oral storytelling to an immediate audience.

But all rankings of higher and lower are, ultimately, out of place and stupid. Each medium has its own efficacy and value. What we can say is that the products of the technological arts become fine in the degree in which they carry over into themselves something of the spontaneity of the automatic arts. Except in the case of work done by machines, mechanically tended by an operator, the movements of the individual body enter into all reshapings of material. When these movements carry over in dealings with

*Santayana, in his *Reason in Art*, was the first, I think, to make clear the importance of this distinction.

physically external matters the organic push from within of an automatic art, they become, in so far, "fine." Something of the rhythm of vital natural expression, something as it were of dancing and pantomime, must go into carving, painting, and making statues, planning buildings, and writing stories; which is one more reason for the subordination of technique to form.

Even in the case of this broad distinction of the arts, we are in the presence of a spectrum rather than of separate classes. Cadenced speech would not have developed far in the direction of music without the assistance of reed, string and drum, and the assistance is not external, since it modified the matter of song itself. The history of musical forms is on one side the history of the invention of instruments and the practice of instrumentation. That instruments are not mere vehicles, like a phonographic disc, but all media are, is evident in the way in which the piano, for example, operated in fixing the scale now in general use. Similarly print has acted—or reacted—to profoundly modify the substance of literature; modifying, by way of a single illustration, the very words that form the medium of literature. The change is indicated on the unfavorable side by the growing tendency to use "literary" as a term of disparagement. Spoken language was never "literary" till print and reading came into general use. But, on the other side, even if it be admitted that no single work of literature excels, say, the *Iliad* (though even that doubtless is the product of an organization of previously scattered materials necessitated by writing and wider publication), yet print has made for an enormous extension not merely in bulk but in qualitative variety and subtlety, aside from compelling an organization that did not previously exist.

However, I have no desire to go into this matter further than to indicate that even in this broad differentiation of different arts into automatic and shaping, we are in the presence also of intermediate forms, transitions, and mutual influences, rather than of the compartments of a filing-case. The important thing is that a work of art exploit *its* medium to the uttermost—bearing in mind that material is not medium save when used as an organ of expression. The materials of nature and human association are multifarious to the point of infinity. Whenever any material finds a

medium that expresses its value in experience—that is, its imaginative and emotional value—it becomes the substance of a work of art. The abiding struggle of art is thus to convert materials that are stammering or dumb in ordinary experience into eloquent media. Remembering that art itself denotes a quality of action and of things done, every authentic new work of art is in some degree itself the birth of a new art.

I should say, then, there are two fallacies of interpretation in connection with the matter under discussion. One is to keep the arts wholly separate. The other is to run them altogether into one. The latter fallacy is found in the interpretation often given by critics who content themselves with the tag in quotation of Pater's saying that all "arts constantly aspire to the condition of music." I say interpretations rather than Pater himself, because the complete passage shows that he did not mean that every art is developing to the point where it will give the same effect that music gives. He thought that music "most perfectly realizes the artistic ideal of complete union of form and matter." *This* union is the "condition" to which other arts aspire. Whether he is correct or not in holding that music does most perfectly realize this interfusion of substance and form, there should not be imputed to him the other idea. For, among other things, it is plainly false. Since he wrote, both painting and music itself have moved in the direction of the architectonic and away from the "musical" in its limited sense: so, to a considerable extent, has poetry as well as painting. And it is worth noting that Pater speaks of every art passing into the condition of some other, music having figures, "curves, geometrical forms, weaving."

In short what I should like to bring out is that such words as poetic, architectural, dramatic, sculptural, pictorial, literary—in the sense of designating the quality best effected by literature—designate *tendencies* that belong in some degree to every art, because they qualify any complete experience, while, however, a particular medium is best adapted to making that strain emphatic. When the effect appropriate to one medium becomes too marked in the use of another medium, there is esthetic defect. When, therefore, I use the names of arts as nouns in what follows, it will

be understood that I have in mind a range of objects that express a certain quality emphatically but not exclusively.

The trait that characterizes architecture in an emphatic sense is that its media are the (relatively) raw materials of nature and of the fundamental modes of natural energy. Its effects are dependent upon features that belong in dominant measure to just these materials. All of the "shaping" arts bend natural materials and forms of energy to serve some human desire. There is nothing distinctive in architecture with respect to this general fact. But it is singularly marked off with respect to the scope and directness of its use of natural forces. Compare buildings with other artistic products and you are at once struck by the indefinitely wide range of materials it adopts to its ends—wood, stone, steel, cement, burnt clay, glass, rushes, cement, as compared with the relatively restricted number of materials available in painting, sculpture, poetry. But equally important is the fact that it takes these materials, so to speak, neat. It employs materials not only on a grand scale but at first hand— not that steel and bricks are furnished directly by nature but that they are closer to nature than are pigments and musical instruments. If there is any doubt about this fact, there is none about its use of the energies of nature. No other products exhibit stresses and strains, thrusts and counterthrusts, gravity, light, cohesion, on a scale at all comparable to the architectural, and it takes these forces more directly, less mediately and vicariously, than does any other art. It expresses the structural constitution of nature itself. Its connection with engineering is inevitable.

For this reason, buildings, among all art objects, come the nearest to expressing the stability and endurance of existence. They are to mountains what music is to the sea. Because of its inherent power to endure, architecture records and celebrates more than any other art the generic features of our common human life. There are those who, under the influence of theoretical preconceptions, regard the human values expressed in architecture esthetically irrelevant, a mere unavoidable concession to utility. That buildings are esthetically the worse because they express the pomp of power, the majesty of government, the sweet pieties of domestic relations, the busy traffic of cities, and the adoration of worshipers

is not apparent. That these ends enter organically into the structure of buildings seems too evident to permit of discussion. That degradation to some special use often occurs and is artistically detrimental is equally clear. But the reason is the baseness of the end, or the fact that materials are not so handled express in a balanced way adaptation both to natural and human conditions.

The complete elimination of human use (as by Schopenhauer) illustrates the limitation of "use" to narrow ends and it depends upon ignoring the fact that fine art is always the product in experience of an interaction of human beings with their environment. Architecture is a notable instance of the reciprocity of the results of this interaction. Materials are transformed so as to become media of the purposes of human defense, habitation, and worship. But human life itself is also made different, and this in ways far beyond the intent or capacity of foresight of those who constructed the buildings. The reshaping of subsequent experience by architectural works is more direct and more extensive than in the case of any other art save perhaps literature. They not only influence the future, but they record and convey the past. Temples, colleges, palaces, homes, as well as ruins, tell what men have hoped and struggled for, what they have achieved and suffered. The desire of man to live on through his deeds, characteristic of the erection of pyramids, is found in less massive way in every architectural work. The quality is not confined to buildings. For something architectural is found in every work of art in which there is manifest on a broad scale the harmonious mutual adaptation of enduring forces of nature with human need and purpose. The sense of structure cannot be dissociated from the architectonic, and the architectural exists in any work whether of music, literature, painting, or architecture, in its specific meaning, wherein structural properties are strongly manifest. But in order to be esthetic, structure has to be more than physical and mathematical. It has to be used with the support, reënforcement, and extension, through enduring time, of human values. The appropriateness of clinging ivy to some buildings illustrates that intrinsic unity of architectural effect with nature which is seen on a larger scale in the necessity that buildings fit naturally into their surroundings to secure full esthetic effect.

But this unconscious vital union must be paralleled by an equal absorption of human values into the complete experienced effect of the building. The ugliness, for example, of most factory buildings and the hideousness of the ordinary bank building, while it depends upon structural defects on the technically physical side, reflects as well a distortion of human values, one incorporated in the experience connected with the buildings. No mere technical skill can render such buildings beautiful as temples once were. First there must occur a humane transformation so that these structures will spontaneously express a harmony of desires and needs that does not now exist.

Sculpture, as we have already noted, is closely allied with architecture. I think it is open to doubt whether the sculptural dissociated from the architectural ever will reach great esthetic heights. It is difficult not to feel something incongruous in the single and isolated statue in the public square or park. Surely statues are most successful when they are massive, monumental, and have something approaching an architectural context, even though it be but an expansive bench. Sculpture may include a number, a great number of different figures, as in the Elgin marbles. But imagine these figures intended collectively to represent a single action and yet physically detached from one another, and you summon up an image that evokes a smile. Yet there are differences that mark off the sculptural effect from the architectural.

Sculpture selects for emphasis the recording and monumental aspect of architecture. It specializes, so to say, upon the memorial. Buildings enter into and help shape and direct life directly; statues and monuments, as they remind us of the heroism, devotion, and achievement of the past. The granite column, the pyramid, the obelisk, are sculptural; they are witnesses to the past, not, however, of subjection to the vicissitudes of time but of power to endure and rise above time—noble or pathetic manifestations of such immortality as belongs to mortals. The other distinction marks a more decisive difference. Both sculpture and architecture must possess and must express unity. But the unity of an architectural whole is that of the convergence of a vast multitude of elements. The unity of sculpture is more single and defined—it is

forced to be so if only by space. Only Negro sculpture has attempted, through sacrifice of all directly associated values, to give within a narrow compass the character of design that is inherent in an effective building, accomplishing it by means of rhythm of lines, masses, and shapes. But even Negro sculpture has been compelled to observe the principle of singleness—the design is built out of the connected parts of the human body: head, arms and legs, trunk.

This singleness of material and of purpose (for even a specialized structure like a temple serves a complex of aims) makes it necessary for sculpture to limit itself to expression of materials that have a significant and readily perceived unity of their own. Living things only fulfill this condition—animals and man, or, when directly adherent to buildings, flowers, fruits, vines and other forms of vegetation. Architecture expresses the collective life of man—the hermit, the lone soul, does not build but seeks a cave. Sculpture expresses life in its individualized forms. The respective emotional effects of the two arts correspond with this principle. Architecture is said to be "frozen music," but emotionally this holds only of its dynamic structure, not of the effect of its substance. Upon the whole, its emotional effect is dependent upon or closely allied to human affairs in which the building participates. The Greek temple is too remote for us to experience much more than the effects of exquisite balance of natural forces. But it is impossible upon entering a medieval cathedral not to feel as part of it the uses to which it is historically put; even a westerner feels something of the same sort in entering a Buddhist temple. I would not use the word "borrowed" of the like effects that belong to experience of homes and public buildings, because the values are too completely incorporated to make that word applicable. But esthetic values in architecture are peculiarly dependent upon absorption of meanings drawn from collective human life.

The emotions aroused by sculpture are of necessity those belonging to what is defined and enduring—except when sculpture is used for illustrative purposes, a use congenial to the medium. For, while music and lyric poetry are intrinsically suited to express especial throbs and crises (like the occasions which evoke them),

sculpture is anything but "occasional" in character, as little so as architecture. Sentiments of the vague, transient, and uncertain do not go well with the medium. Akin to the architectural in this respect, it differs from it as, once more, the singular differs from the collective. What is said about art as union of the universal and individual is peculiarly true of sculpture; so much so that the idea that this union provides a formula for all works of art probably had its source in Greek statuary. Michelangelo's "Moses" is highly individualized, but it is no more generic than it is episodic, for the "universal" is something quite different from the general. The attitude of the sculptured figure with its energetic but restrained forward impulsion expresses the leader who sees from afar the promised land he knows he will not enter. But it conveys, in a highly individualized value and feeling, the eternal disparity of aspiration and achievement.

Sculpture communicates the sense of movement with extraordinarily delicate energy—witness Greek dancing figures and the "Winged Victory." But it is movement arrested in a single and enduring poise—as celebrated in the verses of Keats—not the vicissitudes of motion for which music is the incomparable medium. A sense of time is an inalienable part of the nature of sculptural effect in its own or formal right. But it is sense of time suspended, not in succession and lapse. In short, the emotions to which the medium is best suited are finish, gravity, repose, balance, peace. Greek sculpture owes much of its effect to the fact that it expresses the idealized human form—so much so that its influence upon subsequent sculpture has not been altogether happy, since it has overweighted European statues and busts, till very recently, with a tendency to expression of idealizations, which, except at the hands of masters in well-adjusted conditions (like those of Greece), tend to the pretty, trivial, and the illustration of wish fulfillments. To portray the human form in the guise of gods and semi-divine heroes is not an enterprise to be lightly undertaken.

Even a child soon learns that it is through light that the world becomes visible. He learns it as soon as he connects the blotting out of scenes before him with the shutting of his eyes. Yet this truism, when its force is apprehended, says more about the peculiar

effect of color as the medium of painting than would volumes of verbal expatiation. For painting expresses nature and the human scene as a *spectacle*, and spectacles exist because of the interaction of the live being, centered through the eyes, with light, pure, reflected, and refracted into colors. The pictorial (in this sense) exists in the works of many arts. The play of light and shade is a vital factor in architecture, of sculpture that has not been too much enslaved to Greek models—and the coloring of their statues by the Greeks was perhaps a compensation. Prose and drama often attain the picturesque, and poetry the genuinely pictorial, that is the communication of the visible scene of things. But in these arts, it is subdued and secondary. The effort to make it primary, as in "imagism," doubtless taught poets something new, but it was such a forcing of the medium that it could endure only as an emphasis, not as a dominant value. The obverse truth is the fact that, when paintings go beyond the scene and spectacle to tell a story, they become "literary."

Because painting deals directly with the world as a "view," a directly seen world, it is even less possible to discuss the products of this art than of any other in the absence of objects. Pictures can express every object and situation capable of presentation as a scene. They can express the meaning of events when the latter provide a scene in which a past is summed up and a future indicated, provided the scene is sufficiently simple and coherent. Otherwise—as, for example, in Abbey's pictures in the Public Library in Boston—it becomes a document. To say that it can present objects and situations is, however, so far short of its power as to be misleading, if we do not include the unrivaled ability of paint to convey through the eye the qualities by which objects are distinguished and the aspects by which their very nature and constitution is established in perception—the fluidity of water, the solidity of rocks, the combined frailty and resistance of trees, the texture of clouds, and so through all the varied aspects by which we enjoy nature as a spectacle and an expression. Because of the very reach of painting, an attempt to set forth the range of materials with which it deals would be to get involved in an endless cataloguing. It is enough that the aspects of the spectacle of nature are

inexhaustible, and that every significant new movement in painting is the discovery and exploitation of some possibility of vision not previously developed—as Dutch painters grasped the intimate quality of interiors, forming a design in furnishings and perspectives; as Rousseau Douanier elicited the spatial rhythm of homely as well as exotic scenes; as Cézanne re-saw the volume of natural forces in their dynamic relations, the stability of wholes composed by just adaptations to one another of unstable parts.

The ear and eye complement one another. The eye gives the *scene* in which things *go on* and on which changes are projected—leaving it still a scene even amid tumult and turmoil. The ear, taking for granted the background furnished by cooperative action of vision and touch, brings home to us changes as changes. For sounds are always effects; effects of the clash, the impact and resistance, of the forces of nature. They express these forces in terms of what they do to one another when they meet; the way they change one another, and change the things that are the theater of their endless conflicts. The lapping of water, the murmur of brooks, the rushing and whistling of wind, the creaking of doors, the rustling of leaves, the swishing and cracking of branches, the thud of fallen objects, the sobs of depression and the shouts of victory—what are these, together with all noises and sounds, but immediate manifestation of changes brought about by the struggle of forces? Every stir of nature is effected by means of vibrations, but an even uninterrupted vibration makes no sound; there must be interruption, impact, and resistance.

Music, having sound as its medium, thus necessarily expresses in a concentrated way the shocks and instabilities, the conflicts and resolutions, that are the dramatic changes enacted upon the more enduring background of nature and human life. The tension and the struggle has its gatherings of energy, its discharges, its attacks and defenses, its mighty warrings and its peaceful meetings, its resistances and resolutions, and out of these things music weaves its web. It is thus at the opposite pole from the sculptural. As one expresses the enduring, the stable and universal, so the other expresses stir, agitation, movement, the particulars and contingencies of existences—which, nevertheless, are as ingrained in

nature and as typical in experience as are its structural perma-
nences. With only a background there would be monotony and
death; with only change and movement there would be chaos, not
even recognized as disturbed or disturbing. The structure of things
yields and alters, but it does so in rhythms that are secular, while
the things that catch the ear are the sudden, abrupt, and speedy in
change.

The connections of cerebral tissues with the ear constitute a
larger part of the brain than those of any other sense. Recur to the
live animal and the savage, and the import of this fact is not far to
seek. It is a truism that the visible scene is evident; the idea of be-
ing clear, plain, is all one with being in view—in plain sight as we
say. Things in plain view are not of themselves disturbing; the
plain is the ex-plained. It connotes assurance, confidence; it pro-
vides the conditions favorable to formation and execution of
plans. The eye is the sense of distance—not just that light comes
from afar, but that through vision we are connected with what is
distant and thus forewarned of what is to come. Vision gives the
spread-out scene—that *in* and *on* which, as I have said, change
takes place. The animal is watchful, wary, in visual perception,
but it is ready, prepared. Only in a panic is what is seen deeply
perturbing.

The material to which the ear relates us through sound is op-
posite at every point. Sounds *come* from outside the body, but
sound itself is near, intimate; it is an excitation of the organism;
we feel the clash of vibrations throughout our whole body. Sound
stimulates directly to immediate change because it reports a
change. A footfall, the breaking of a twig, the rustling of under-
brush may signify attack or even death from hostile animal or
man. Its import is measured by the care animal and savage take to
make no noise as they move. Sound is the conveyor of what im-
pends, of what is happening as an indication of what is likely to
happen. It is fraught much more than vision with the sense of is-
sues; about the impending there is always an aura of indetermi-
nateness and uncertainty—all conditions favorable to intense
emotional stir. Vision arouses emotion in the form of interest—
curiosity solicits further examination, but it attracts; or it insti-

tutes a balance between withdrawal and forward exploring action It is sounds that make us jump.

Generically speaking, what is *seen* stirs emotion indirectly, through interpretation and allied idea. Sound agitates directly, as a commotion of the organism itself. Hearing and sight are often classed together as the two "intellectual" senses. In reality the intellectual range of hearing although enormous is acquired; in itself the ear is the emotional sense. Its intellectual scope and depth come from connection with speech; they are a secondary and so to speak artificial achievement, due to the institution of language and conventional means of communication. Vision receives its direct extension of meaning from connection with other senses, especially with touch. The difference works both ways. What is true of hearing on the intellectual side is true of seeing on the emotional. Architecture, sculpture, painting can stir emotion profoundly. The "right" farmhouse come upon in a certain mood may constrict the throat and make the eyes water as does a poetical passage. But the effect is because of a spirit and atmosphere due to association with human life. Apart from the emotional effect of formal relations, the plastic arts arouse emotion through *what* they express. Sounds have the power of direct emotional expression. A sound is itself threatening, whining, soothing, depressing, fierce, tender, soporific, in its own quality.

Because of this immediacy of emotional effect, music has been classed as both the lowest and the highest of the arts. To some its direct organic dependence and resonances have seemed evidence that it is close to the life of animals; they can cite the fact that music of a considerable degree of complexity has been successfully performed by persons of subnormal intelligence. The appeal of music—of certain grades—is much more widespread, much more independent of special cultivation, than that of any other art. And one has only to observe some musical enthusiasts of a certain kind at a concert to see that they are enjoying an emotional debauch, a release from ordinary inhibitions and an entrance into a realm where excitations are given unrestricted rein—Havelock Ellis noting that musical performances are resorted to by some for obtaining sexual orgasms. On the other side, there are types of music,

those most prized by connoisseurs, that demand special training to be perceived and enjoyed, and its devotees form a cult, so that *their* art is the most esoteric of all arts.

Because of the connections of hearing with all parts of the organism, sound has more reverberations and resonances than any other sense. It is quite likely that the organic causes that render persons unmusical are due to breaks in these connections rather than to inherent defects in the auditory apparatus itself. What has been said in general about the power of an art to take a natural, raw material and convert it, through selection and organization, into an intensified and concentrated medium of building up an experience, applies with particular force to music. Through the use of instruments, sound is freed from the definiteness it has acquired through association with speech. It thus reverts to its primitive passional quality. It achieves generality, detachment from particular objects and events. At the same time, the organization of sound effected through the multitude of means at the command of the artists—a wider range technically, perhaps, than of any other art save architecture—deprives sound of its usual immediate tendency to stimulate a particular overt action. Responses become internal and implicit, thus enriching the content of perception instead of being dispersed in overt discharge. "It is we ourselves who are tortured by the strings," as Schopenhauer says.

It is the peculiarity of music, and indeed its glory, that it can take the quality of sense that is the most immediately and intensely practical of all the bodily organs (since it incites most strongly to impulsive action) and by use of formal relationships transform the material into the art that is most remote from practical preoccupations. It retains the primitive power of sound to denote the clash of attacking and resisting forces and all accompanying phases of emotional movement. But by the use of harmony and melody of tone, it introduces incredibly varied complexities of question, uncertainty, and suspense wherein every tone is ordered in reference to others so that each is a summation of what precedes and a forecast of what is to come.

In contrast with the arts so far mentioned, literature exhibits one unique trait. Sounds, which are directly or as symbolized in

print, their medium, are not sounds as such, as in music, but sounds that have been subjected to transforming art before literature deals with them. For words exist before the art of letters and words have been formed out of raw sounds by the art of communication. It would be useless to try to sum up the ends that speech serves before literature as such exists—command, guidance, exhortation, instruction, warning. Only exclamation and interjections retain their native aspect as sounds. The art of literature thus works with loaded dice; its material is charged with meanings they have absorbed through immemorial time. Its material thus has an intellectual force superior to that of any other art, while it equals the capacity of architecture to present the values of collective life.

There is not the gap between raw material and material as medium in letters that there is in other arts. Molière's character did not know he had been talking prose all his life. So men in general are not aware that they have been exercising an art as long as they have engaged in spoken intercourse with others. One reason for the difficulty in drawing a line between prose and poetry is doubtless the fact that the matter of both has already undergone the transforming influence of art. Use of "literary" as a term of disparagement signifies that the more formal art has departed too far from the idiom of the prior art from which it draws its sustenance. All the "fine" arts in order not to become merely refined have to be renewed from time to time by closer contact with materials outside the esthetic tradition. But literature in particular is the one most in need of constant refreshment from this source, since it has at command material already eloquent, pregnant, picturesque, and general in its appeal, and yet most subject to convention and stereotype.

Continuity of meaning and value is the essence of language. For it sustains a continuing culture. For this reason words carry an almost infinite charge of overtones and resonances. "Transferred values" of emotions experienced from a childhood that cannot be consciously recovered belong to them. Speech is indeed the mother tongue. It is informed with the temperament and the ways of viewing and interpreting life that are characteristic of the culture of a continuing social group. Since science aims to speak a tongue

from which these traits are eliminated, only scientific literature is completely translatable. All of us share to some extent in the privilege of the poets who

> ". . . *speak the tongue*
> *That Shakespeare spake; the faith and morals hold*
> *Which Milton held.*"

For this continuity is not confined to letters in its written and printed form. The grandam telling stories of "once upon a time" to children at her knee passes on and colors the past; she prepares material for literature and may be herself an artist. The capacity of sounds to preserve and report the values of all the varied experiences of the past, and to follow with accuracy every changing shade of feeling and idea, confers upon their combinations and permutations the power to create a new experience, oftentimes an experience more poignantly felt than that which comes from things themselves. Contacts with the latter would remain on a merely physical plane of shock were it not that things have absorbed into themselves meanings developed in the art of communication. Intense and vivid realization of the meanings of the events and situations of the universe can be achieved only through a medium already instinct with meaning. The architectural, pictorial, and sculptural are always unconsciously surrounded and enriched by values that proceed from speech. It is impossible because of the nature of our organic constitution to exclude this effect.

While there is no difference that may be exactly defined between prose and poetry, there is a gulf between the prosaic and poetic as extreme limiting terms of tendencies in experience. One of them realizes the power of words to express what is in heaven and earth and under the seas by means of extension; the other by intension. The prosaic is an affair of description and narration, of details accumulated and relations elaborated. It spreads as it goes like a legal document or catalogue. The poetic reverses the process. It condenses and abbreviates, thus giving words an energy of expansion that is almost explosive. A poem presents material so

that it becomes a universe in itself, one, which, even when it is a miniature whole, is not embryonic any more than it is labored through argumentation. There is something self-enclosed and self-limiting in a poem, and this self-sufficiency is the reason, as well as the harmony and rhythm of sounds, why poetry is, next to music, the most hypnotic of the arts.

Every word in poetry is imaginative, as indeed it was in prose until words were rubbed down by attrition in use to be mere counters. For a word, when it is not purely emotional, refers to something absent for which it stands. When things are present, it is enough to ignore them, or to use them and point to them. Probably even purely emotional words are not exceptions; the emotion they give vent to may be that toward absent objects so massed that they have lost their individuality. The imaginative force of literature is an intensification of the idealizing office performed by words in ordinary speech. The most realistic presentation of a scene by words puts before us, after all, things that, for direct contact, are but possibilities. Every idea is by its nature indicative of a possibility not of present actuality. The meaning it conveys may be actual at some time and place. But as entertained in idea, the meaning is for that experience a possibility; it is ideal in the strict sense of the word: strict sense, because "ideal" is also used to denote the fanciful and utopian, the possibility that is impossible.

If the ideal is really present to us, its presence must be effected through the medium of sense. In poetry the medium and the meaning seem to fuse as by a preëstablished harmony, which is the "music" and euphony of words. Music in the strict sense there cannot be, since pitch is wanting. But the musical there is, since words themselves are harsh and solemn, swift and languorous, solemn and romantic, brooding and flighty, in accord with meaning. The chapter on sound of words in Lascelles Abercrombie's *The Theory of Poetry* renders detail superfluous, though I would call especial attention to his demonstration that cacophony is as genuine a factor as is euphony. For I think it fair to interpret its force as evidence that fluidity must be balanced with structural factors that in themselves are harsh, or else it will in the end be sugary.

There are critics who hold that music outrivals poetry in its power to convey a sense of life and phases of life as we should desire them to be. I cannot, however, but think that by the very nature of its medium music is brutally organic: not, of course, in the sense in which "brutal" signifies "beastly," but as we speak of brute facts, of that which is undeniable and unescapable, because so inevitably there. Nor is this view disparaging to music. Its value is precisely that it can take material which is organically assertive and apparently intractable, and make melody and harmony out of it. As for pictures, when they are dominated by ideal qualities, they become weak from excess of poetic quality; they cross the borderline and, when critically examined, they manifest a lack of sense of the medium—paint. But in the epic, lyric, the dramatic— comedy as well as tragedy—ideality in contrast with actuality plays an intrinsic and essential part. What might be or might have been stands always in contrast with what is and has been in a way only words are capable of conveying. If animals are strict realists, it is because they lack the signs that language confers on humans.

Words as media are not exhausted in their power to convey possibility. Nouns, verbs, adjectives express generalized conditions— that is to say *character*. Even a proper name can but denote character in its limitation to an individual exemplification. Words attempt to convey the *nature* of things and events. Indeed it is through language that these have a nature over and above a brute flux of existence. That they can convey character, nature, not in abstract conceptual form, but as exhibited and operating in individuals is made evident in the novel and drama, whose business it is to exploit this particular function of language. For characters are presented in situations that evoke their natures, giving particularity of existence to the generality of potentiality. At the same time situations are defined and made concrete. For all we know of any situation is what it does to and with us: *that* is *its* nature. Our conception of types of character and the manifold variations of these types is due mainly to literature. We observe, note, and judge the people about us in terms that are derived from literature, including, of course, biography and history with novel and drama. Ethical treatises in the past have been impotent in comparison in

portraying characters so that they remain in the consciousness of mankind. The correlativity of character and situation is illustrated in the fact that whenever situations are left inchoate and wavering, characters are found to be vague and indefinite—something to be guessed at, not embodied, in short are uncharactered.

In what has been said, I have touched upon themes to each of which volumes have been devoted. For I have been concerned with the various arts in but one respect. I have wished to indicate that, as we build bridges of stone, steel, or cement, so every medium has its own power, active and passive, outgoing and receptive, and that the basis for distinguishing the different traits of the arts is their exploitation of the energy that is characteristic of the material used as a medium. Most of what is written about the different arts as different seems to me to be said from the inside—by which I mean it takes the medium as an existing fact without asking why and how it is what it is.

Literature thus presents evidence, more convincing perhaps than that offered by the other arts, that art is fine when it draws upon the material of other experiences and expresses their material in a medium which intensifies and clarifies its energy through the order that supervenes. The arts accomplish this result not by self-conscious intention but in the very operation of creating, by means of new objects, new modes of experience. Every art communicates because it expresses. It enables us to share vividly and deeply in meanings to which we had been dumb, or for which we had but the ear that permits what is said to pass through in transit to overt action. For communication is not announcing things, even if they are said with the emphasis of great sonority. Communication is the process of creating participation, of making common what had been isolated and singular; and part of the miracle it achieves is that, in being communicated, the conveyance of meaning gives body and definiteness to the experience of the one who utters as well as to that of those who listen.

Men associate in many ways. But the only form of association that is truly human, and not a gregarious gathering for warmth

and protection, or a mere device for efficiency in outer action, is the participation in meanings and goods that is effected by communication. The expressions that constitute art are communication in its pure and undefiled form. Art breaks through barriers that divide human beings, which are impermeable in ordinary association. This force of art, common to all the arts, is most fully manifested in literature. Its medium is already formed by communication, something that can hardly be asserted of any other art. There may be arguments ingeniously elaborated and plausibly couched about the moral and the humane function of other arts. There can be none about the art of letters.

BY the phrase, "the human contribution," I mean those aspects and elements of esthetic experience that are usually called psychological. It is theoretically conceivable that discussion of psychological factors is not a necessary ingredient of a philosophy of art. Practically, it is indispensable. For historic theories are full of psychological terms, and these terms are not used in a neutral sense, but are charged with interpretations read into them because of psychological theories that have been current. Expunge special meanings given to such terms as sensation, intuition, contemplation, will, association, emotion, and a large part of esthetic philosophy would disappear. Moreover, each one of these terms has different meanings given to it by different schools of psychology. "Sensation," for example, has been treated in ways as far apart as the notion that it is the sole original constitutent of experience and the idea that it is a heritage from low forms of animal life, and

hence something to be minimized in human experience. Esthetic theories are filled with fossils of antiquated psychologies and are overlaid with débris of psychological controversies. Discussion of the psychological aspect of esthetics is unavoidable.

Naturally the discussion must be confined to the more generic features of the human contribution. Because of the individual interest and attitude of the artist, because of the individualized character of every concrete work of art, the specifically personal contribution must be sought in works of art themselves. But in spite of the immense disparity of these unique products, there is a constitution common to all normal individuals. They have the same hands, organs, dimensions, senses, affections, passions; they are fed with the same foods, hurt by the same weapons, subject to the same diseases, healed by the same remedies, warmed and cooled by the same variations in climate.

To understand the basic psychological factors and to protect ourselves against the errors of false psychologies that play havoc with esthetic philosophies, we recur to our basic principles: Experience is a matter of the interaction of organism with its environment, an environment that is human as well as physical, that includes the materials of tradition and institutions as well as local surroundings. The organism brings with it through its own structure, native and acquired, forces that play a part in the interaction. The self acts as well as undergoes, and its undergoings are not impressions stamped upon an inert wax but depend upon the way the organism reacts and responds. There is no experience in which the human contribution is not a factor in determining what actually happens. The organism is a force, not a transparency.

Because every experience is constituted by interaction between "subject" and "object," between a self and its world, it is not itself either merely physical nor merely mental, no matter how much one factor or the other predominates. The experiences that are emphatically called, because of the dominance of the internal contribution, "mental," have reference, direct or remote, to experiences of a more objective character; they are the products of discrimination, and hence can be understood only as we take into account the total normal experience in which both inner and outer

factors are so incorporated that each has lost its special character. In an experience, things and events belonging to the world, physical and social, are transformed through the human context they enter, while the live creature is changed and developed through its intercourse with things previously external to it.

This conception of the production and structure of an experience is, then, the criterion that will be used to interpret and judge the psychological conceptions that have played a chief rôle in esthetic theory. I say "judge," or criticize, because so many of these conceptions have their source in a separation of organism and environment; a separation that is alleged to be native and original. Experience is supposed to be something that occurs exclusively inside a self or mind or consciousness, something self-contained and sustaining only external relations to the objective scene in which it happens to be set. Then all psychological states and processes are not thought of as functions of a live creature as it lives in its natural surroundings. When the linkage of the self with its world is broken, then also the various ways in which the self interacts with the world cease to have a unitary connection with one another. They fall into separate fragments of sense, feeling, desire, purpose, knowing, volition. Intrinsic connection of the self with the world through reciprocity of undergoing and doing; and the fact that all distinctions which analysis can introduce into the psychological factor are but different aspects and phases of a continuous, though varied, interaction of self and environment, are the two main considerations that will be brought to bear in the discussion that follows.

Before setting out on any detailed discussion, I shall, however, refer to the way in which sharp psychological distinctions historically originated. They were at first formulations of differences found among the portions and classes of society. Plato provides an almost perfect example of this fact. He openly derived his three-fold division of the soul from what he observed in the communal life of his day. He did consciously what many psychologists have done in their classifications without being aware of their source, taking them from differences socially observable while they thought to arrive at them by pure introspection. From mind as it

was manifest in the large print version of the community, Plato discriminated the sensuously appetitive and acquisitive faculty, exhibited in the mercantile class; the "spirited" faculty, that of generous outgoing impulse and will, he derived from citizen-soldiers loyal to law and right belief, even at the expense of their personal existence; the rational faculty he found in those who were fit for the making of laws. He found these same differences dominant in different racial groups, the Oriental, the northern barbarians, and the Athenian Greeks.

There are no intrinsic psychological divisions between the intellectual and the sensory aspects; the emotional and ideational; the imaginative and the practical phases of human nature. But there are individuals and even classes of individuals who are dominantly executive or reflective; dreamers or "idealists" and doers; sensualists and the humanely minded; egoists and unselfish; those who engage in routine bodily activity and those who specialize in intellectual inquiry. In a badly ordered society such divisions as these are exaggerated. The well-rounded man and woman are the exception. But just as it is the office of art to be unifying, to break through conventional distinctions to the underlying common elements of the experienced world, while developing individuality as the manner of seeing and expressing these elements, so it is the office of art in the individual person, to compose differences, to do away with isolations and conflicts among the elements of our being, to utilize oppositions among them to build a richer personality. Hence the extraordinary ineptitude of a compartmentalized psychology to serve as an instrument for a theory of art.

Extreme instances of the results of separation of organism and the world are not infrequent in esthetic philosophy. Such a separation lies behind the idea that esthetic quality does not belong to objects as objects but is projected into them by mind. It is the source of the definition of beauty as "objectified pleasure" instead of as pleasure in the object, so much *in* it that the object and pleasure are one and undivided in the experience. In other fields of experience a preliminary distinction between self and object is not only legitimate but necessary. An investigator must constantly distinguish as best he can between those parts of an experience that

come from himself in the way of suggestions and hypotheses, and the influence of personal desire for a certain result, and the properties of the object inquired into. Improvements in scientific technique are devised for the express purpose of facilitating this distinction. Prejudice, preconceptions and desire influence native tendencies in judgment to such an extent that especial pains must be taken to become aware of them so that they may be eliminated.

A like obligation is imposed upon those engaged in manipulation of materials and execution of projects. They need to maintain the attitude of saying "this belongs to me while that inheres in the objects dealt with." Otherwise they will not keep their eye "upon the ball." The fuzzy sentimentalist is one who permits his own feelings and wishes to color that which he takes to be the object. An attitude that is indispensable to success in thinking and in practical planning and execution becomes a deep-seated habit. A person can hardly cross a street where traffic is swift and crowded save as he keeps in mind differences which philosophers formulate in terms of "subject" and "object." The professional thinker (and naturally he is the one who writes treatises on esthetic theory) is the one who is most perpetually haunted by the difference between self and the world. He approaches discussion of art with a reënforced bias, and one, which, most unfortunately, is just the one most fatal to esthetic understanding. For the uniquely distinguishing feature of esthetic experience is exactly the fact that no such distinction of self and object exists in it, since it is esthetic in the degree in which organism and environment coöperate to institute an experience in which the two are so fully integrated that each disappears.

When an experience is once recognized to be causally dependent upon the way in which self and objects interact, there is no mystery about what is called "projection." When a landscape is seen as yellow with yellow spectacles or by jaundiced eyes, there is no shooting of yellow, like a projectile, into the landscape from the self. The organic factor in causal interaction with the environmental produces the yellow of the landscape, in the same way in which hydrogen and oxygen when interacting produce water that is wet. A writer on psychiatry tells a story of a man who complained of

Past experiences affect
 interpretation/reaction

the discordant sound of church bells when in fact the sound was musical. Examination showed that his betrothed had jilted him to marry a clergyman. Here was "projection" with a vengeance. Not, however, because something psychical was miraculously extruded from the self and shot into the physical object, but because the *experience* of the sound of bells was dependent upon an organism that was so twisted as to *act* abnormally as a factor in certain situations. Projection in fact is a case of transferred values, "transfer" being accomplished through the organic participation of a being that has been made what it is and caused to act as it does through organic modifications due to prior experiences.

It is a familiar fact that colors of a landscape become more vivid when seen with the head upside down. The change of physical position does not cause a new psychical element to be injected, but it does signify that a somewhat different organism is acting, and difference in the cause is bound to make a difference in the effect. Instructors in drawing strive to bring about a recovery of the original innocency of the eye. Here it is a question of affecting a disassociation of elements that have, in prior experience, got so bound together that an experience is induced which works against representation upon a two-dimensional surface. The organism that is set to experience in terms of touch has to be reconditioned to experience space-relations as nearly as possible in terms of the eye. The kind of projection usually involved in esthetic vision involves an analogous relaxation of a strain built up in pursuit of special ends so that the whole personality may interact freely without deflection or restriction so as to reach a particular and preconceived outcome. First hostile reactions to a new mode in an art are usually due to unwillingness to perform some needed disassociation.

The misconception of what takes place in what is called projection is, in short, wholly dependent upon failure to see that self, organism, subject, mind—whatever term is used—denotes a factor which interacts causally with environing things to produce an experience. The same failure is found when the self is regarded as the bearer or carrier of an experience instead of a factor absorbed in what is produced, as once more in the case of the gases that pro-

duce water. When *control* of formation and development of an experience is needed, we have to treat the self as its bearer; we have to acknowledge the causal efficacy of the self in order to secure responsibility. But this emphasis upon the self is for a special purpose, and it disappears when the need for control in a specified predetermined direction no longer exists—as it assuredly does not exist in an esthetic experience, although in case of the new in art it may be a preliminary to having an esthetic experience.

As intelligent a critic as I. A. Richards falls into the fallacy. He writes: "We are accustomed to say that the picture is beautiful instead of saying that it causes an experience in us which is valuable in certain ways. . . . When what we ought to say is that they (certain objects) cause effects in us of one kind or another, the fallacy of projecting the effect and making it a part of the cause tends to recur." What is overlooked is that it is *not* the painting as a *picture* (that is, the object in esthetic experience) that causes certain effects *"in us."* The painting as a picture is *itself* a *total effect* brought about by the interaction of external and organic causes. The external causal factor is vibrations of light from pigments on canvas variously reflected and refracted. It is ultimately that which physical science discovers—atoms, electrons, protons. The *picture* is the integral outcome of their interaction with what the mind through the organism contributes. Its "beauty," which, I agree with Mr. Richards, is simply a short term for certain valued qualities, in being an intrinsic part of the total effect, belongs to the picture just as much as do the rest of its properties.

The reference to "in us" is as much an abstraction from the total experience, as on the other side it would be to resolve the picture into mere aggregations of molecules and atoms. Even anger and hate are partly caused *by* us rather than *in* us. Not that we are the sole cause, but that our own make-up is a contributing causal factor. It is true that most art, up to the time of the Renaissance, seems to us impersonal, dealing with "universal" phases of the experienced world, in comparison with the rôle of the individual's experience in modern art. Not perhaps till the nineteenth century did *consciousness* of the rightful place of the strictly personal factor play any large rôle in plastic and literary arts. The novel of the

"stream of consciousness" marks a definite date in the course of changing experience, as much so as impressionism in painting. The longer course of every art is marked by shifts of emphasis. Already we are in the presence of a reaction toward the impersonal and the abstract. These shifts in art are connected with large rhythms in human history. But even the art that allows least play to individual variations—like, say, the religious painting and sculpture of the twelfth century—is not mechanical and hence it bears the stamp of personality; and the classicist paintings of the seventeenth century reflect, like those of Nicholas Poussin, a personal predilection in substance and form, while the most "individualized" paintings never get away from some aspect or phase of the objective scene.

Variations in what we may call the *ratio* of personal and impersonal, subjective and objective, concrete and abstract factors, are perhaps the very things that lead the psychological aspect of esthetic theory and criticism astray. Writers in each period tend to take as what is uppermost in the art tendencies of their own day as the normal psychological base of all art. The consequence is that those eras and aspects of the past and of alien countries most similar and dissimilar to existing tendencies undergo waves of appreciation and depreciation. A catholic philosophy based on understanding of the constant relation of self and world amid variations in their actual contents would render enjoyment wider and more sympathetic. We could then enjoy Negro sculpture as well as Greek; Persian paintings as well as those of the sixteenth century by Italian painters.

Whenever the bond that binds the living creature to his environment is broken, there is nothing that holds together the various factors and phases of the self. Thought, emotion, sense, purpose, impulsion fall apart, and are assigned to different compartments of our being. For their unity is found in the coöperative rôles they play in active and receptive relations to the environment. When elements united in experience are separated, the resulting esthetic theory is bound to be one-sided. I may illustrate from the vogue which the concept of contemplation, understood in a narrow way, has enjoyed in esthetics. At first sight, "contemplation" appears to

be about as inept a term as could be selected to denote the excited and passionate absorption that often accompanies experience of a drama, a poem, or a painting. Attentive observation is certainly one essential factor in all genuine perception including the esthetic. But how does it happen that this factor is reduced to the bare act of contemplation?

The answer, so far as psychological theory is concerned, is to be found in Kant's *Critique of Judgment*. Kant was a past-master in first drawing distinctions and then erecting them into compartmental divisions. The effect upon subsequent theory was to give the separation of the esthetic from other modes of experience an alleged scientific basis in the constitution of human nature. Kant had referred knowledge to one division of our nature, the faculty of understanding working in conjunction with sense-materials. He had referred ordinary conduct, as prudential, to desire which has pleasure for its object, and moral conduct to the Pure Reason operating as a demand upon Pure Will.* Having disposed of Truth and the Good, it remained to find a niche for Beauty, the remaining term in the classic trio. Pure Feeling remained, being "pure" in the sense of being isolated and self-enclosed; feeling free from any taint of desire; feeling that strictly speaking is nonempirical. So he bethought himself of a faculty of Judgment which is not reflective but intuitive and yet not concerned with objects of Pure Reason. This faculty is exercised in Contemplation, and the distinctively esthetic element is the pleasure which attends such Contemplation. Thus the psychological road was opened leading to the ivory tower of "Beauty" remote from all desire, action, and stir of emotion.

Although Kant gives no evidence in his writings of any special esthetic sensitivity, it is possible that his theoretic emphasis reflects the artistic tendencies of the eighteenth century. For that century was, generally speaking, till towards its close, a century of "reason" rather than of "passion," and hence one in which objective order and regularity, the invariant element, was almost exclusively

*The effect upon German thought of Capitalization has hardly received proper attention.

the source of esthetic satisfaction—a situation that lent itself to the idea that contemplative judgment and the feeling connected with it are the peculiar differentia of esthetic experience. But if we generalize the idea and extend it to all periods of artistic endeavor, its absurdity is evident. It not only passes over, as if it were irrelevant, the doing and making involved in the production of a work of art (and the corresponding active elements in the appreciative response), but it involves an extremely one-sided idea of the nature of perception. It takes as its cue to the understanding of perception what belongs only to the act of recognition, merely broadening the latter to include the pleasure that attends it when recognition is prolonged and extensive. It is thus a theory peculiarly appropriate to a time when the "representative" nature of art is especially marked and when the subject-matter represented is of a "rational" nature—regular and recurrent elements and phases of existence.

Taken at its best, that is to say, with a liberal interpretation, contemplation designates that aspect of perception in which elements of seeking and of thinking are subordinated (although not absent) to the perfecting of the process of perception itself. To define the emotional element of esthetic perception merely as the pleasure taken in the act of contemplation, independent of what is excited by the matter contemplated, results, however, in a thoroughly anæmic conception of art. Carried to its logical conclusion, it would exclude from esthetic perception most of the subject-matter that is enjoyed in the case of architectural structures, the drama, and the novel, with all their attendant reverberations.

Not absence of desire and thought but their thorough incorporation into perceptual experience characterizes esthetic experience, in its distinction from experiences that are especially "intellectual" and "practical." The uniqueness of the object perceived is an obstacle rather than an aid to the investigator. He is interested in it as far as it leads his thought and observation to something beyond itself; to him the object is datum or evidence. Nor does the man whose perception is *dominated* by desire or appetite enjoy it for its own sake; his interest in it is because of a particular act to which as a consequence his perception may lead; it is

a stimulus, rather than an object in which perception may rest with satisfaction. The esthetic percipient is free from desire in the presence of a sunset, a cathedral, or a bouquet of flowers in the sense that his desires are fulfilled in the perception itself. He does not want the object for the sake of something else.

In reading, say, Keats' "St. Agnes Eve," thought is active but at the same time its demands are fully met. The rhythm of expectancy and satisfaction is so internally complete that the reader is not aware of thought as a separate element, certainly not of it as a labor. The experience is marked by a greater inclusiveness of all psychological factors than occurs in ordinary experiences, not by reduction of them to a single response. Such a reduction is an impoverishment. How can an experience that is rich as well as unified be reached by a process of exclusion? A man who finds himself in a field with an angry bull has but one desire and thought: to attain a place of safety. Once in security, he may enjoy the spectacle of untamed power. His satisfaction in his present act, in contrast with that of the effort to escape, may be called one of contemplation; but the latter act marks the fulfillment of many obscure active tendencies, and the pleasure taken is not in the act of contemplation but in the fulfillment of these tendencies in the subject-matter perceived. More imagery and "ideas" are included than attend the act of escape; while if emotion means something *conscious* and not the mere excited energy of escape, there is much more emotion.

One trouble with the Kantian psychology is that it supposes all "pleasure," save that of "contemplation," to consist wholly of personal and private gratification. Every experience, including the most generous and idealistic, contains an element of seeking, of pressing forward. Only when we are dulled by routine and sunk in apathy does this eagerness forsake us. Attention is built out of an organization of these factors, and a contemplation that is not an aroused and intensified form of attention to material in perception presented through the senses is an idle stare.

"Sensations" are necessarily involved, and are not mere external incidents of the act of perception. The traditional psychology that puts sensation first and impulsion second reverses the actual

state of the case. We consciously experience colors because the impulse to look is performed; we hear sounds because we are satisfied in listening. Motor and sensory structure form a single apparatus and effect a single function. Since life is activity, there is always desire whenever activity is obstructed. A painting satisfies because it meets the hunger for scenes having color and light more fully than do most of the things with which we are ordinarily surrounded. In the kingdom of art as well as of righteousness it is those who hunger and thirst who enter. The very dominance of intense sensuous qualities in esthetic objects is itself proof, psychologically speaking, that appetition is there.

Seeking, desire, need, can be fulfilled only through material external to the organism. The hibernating bear cannot live indefinitely upon its own substance. Our needs are drafts drawn upon the environment, at first blindly, then with conscious interest and attention. To be satisfied, they must intercept energy from surrounding things and absorb what they lay hold of. Surplus energy, so-called, of the organism only increases restlessness save as it can feed upon something objective. While instinctive need is impatient and hurries to its discharge (as a spider whose spinning is interfered with will spin itself to death), impulse that has become conscious of itself tarries to amass, incorporate, and digest congenial objective material.*

Perception is therefore at its lowest and its most obscure in the degree that only instinctive need operates. Instinct is in too much haste to be solicitous about its environing relations. Nevertheless instinctive demands and responses serve a double purpose after transformation into conscious demand for congenial matter has supervened. Many impulses of which we are not distinctively aware give body and breadth to the conscious focus. Even more important is the fact that primitive need is the source of attachment to objects. Perception is born when solicitude for objects and their qualities brings the organic demand for attachment to con-

*The reader will note that I am saying here, in different terms, what was found to be involved in the "Expressive Act."

sciousness. If we judge on the basis of production of works of art, instead of that of a preconceived psychology, the absurdity of supposing that need, desire, and affection are excluded together with action from esthetic experience is evident, unless the artist is the one person who has no esthetic experience. Perception that occurs for its own sake is full realization of all the elements of our psychological being.

Here, of course, is the explanation of the balance, the composure, that is characteristic of much esthetic appreciation. As long as light stimulates only the eye, experience of it is thin and poor. When the tendency to turn the eyes and head is absorbed into a multitude of other impulses and it and they become the members of a single act, all impulses are held in a state of equilibrium. Perception instead of some specialized reaction then occurs, and what is perceived is charged with value.

This state *may* be described as one of contemplation. It is not practical, *if* by "practical" is meant an action undertaken for a particular and specialized end outside the perception, or for some external consequence.* In the latter case, perception does not exist for its own sake but is limited to a recognition exercised in behalf of ulterior considerations. But this conception of "practical" is a limitation of its significance. Not only is art itself an operation of doing and making—a *poiesis* expressed in the very word poetry—but esthetic perception demands, as we have seen, an organized body of activities, including the motor elements necessary for full perception.

The chief objection to the associations usually connected with the term "contemplation" is, of course, its seeming aloofness from passionate emotion. I have spoken of a certain internal equilibrium of impulsions found in the act of perception. But even the word "equilibrium" may give rise to a false conception. It may suggest a balance so calm and sedate as to exclude rapture by an absorbing object. It signifies, in fact, only that different impul-

*Compare what was said about the difference between external means and a medium, p. 205.

sions mutually excite and reënforce one another so as to exclude the kind of overt action that leads away from emotionalized perception. Psychologically, deep-seated needs cannot be stirred to find fulfillment in perception without an emotion and affection that, in the end, constitute the unity of the experience. And, as I have noted in other connections, the emotion aroused attends the subject-matter that is perceived, thus differing from crude emotion because it is attached to the movement of the subject-matter toward consummation. To limit esthetic emotion to the pleasure attending the act of contemplation is to exclude all that is most characteristic of it.

It is worthwhile to quote from Keats a passage already cited in part: "As to the poetical character itself . . . it is not itself—it has no self. It is everything and nothing—it enjoys light and shade; it lives in gusto, be it fair or foul, high or low, rich or poor, mean or elevated. It has as much delight in conceiving an Iago as an Imogen. What shocks the virtuous philosopher delights the chameleon poet. It does not harm from its relish for the dark side of things, any more than from its taste for the bright one, because they both end in speculation [Imaginative perception]. A poet is the most unpoetical of anything in existence, because he has no identity—he is continually in and for, and filling some other body. . . . When I am in a room with people, if I am ever free from speculating on creations of my own brain, then, not myself goes home to myself, but the identity of every one in the room begins to press upon me, so that I am in a very little time annihilated—not only among men; it would be the same in a nursery of children."

The ideas of disinterestedness, detachment and "psychical distance," of which much has been made in recent esthetic theory, are to be understood in the same way as contemplation. "Disinterestedness" cannot signify uninterestedness. But it may be used as a roundabout way to denote that no specialized interest holds sway. "Detachment" is a negative name for something extremely positive. There is no severance of self, no holding of it aloof, but fullness of participation. Even "attachment" fails to convey fully the right idea, for it suggests that self and the esthetic object continue to exist separately although in close connection. Participation is so

thoroughgoing that the work of art is detached or cut off from the kind of specialized desire that operates when we are moved to consume or appropriate a thing physically.

The phrase "psychical distance" has been employed to indicate much the same fact. The illustration of the man who enjoys the spectacle of the angry bull is in point. He is not overtly engaged in the scene. He is not stirred to the performance of a particular and special act beyond the perception itself. Distance is a name for a participation so intimate and balanced that no particular impulse acts to make a person withdraw, a completeness of surrender in perception. The person who enjoys a storm at sea unites his impulses with the drama of rushing seas, roaring gale and plunging ship. "Diderot's paradox" exemplifies a similar situation. An actor on the stage is not cold and unmoved in his part, but impulses that would be dominant, were he actually in the scenes that he represents, are transformed by coördination with the interests belonging to him as an artist. Disinterestedness, detachment, psychical distance, all express ideas that apply to raw primitive desire and impulse, but that are irrelevant to the matter of experience artistically organized.

The psychological conceptions that are implied in "rationalistic" philosophies of art are all associated with a fixed separation of sense and reason. The work of art is so obviously sensuous and yet contains such wealth of meaning, that it is defined as a cancellation of the separation, and as an embodiment through sense of the logical structure of the universe. Ordinarily, and apart from fine art, according to the theory, sense conceals and distorts a rational substance that is the reality behind appearances—to which sense perception is limited. The imagination, by means of art, makes a concession to sense in employing its materials, but nevertheless uses sense to suggest underlying ideal truth. Art is thus a way of having the substantial cake of reason while also enjoying the sensuous pleasure of eating it.

But, in fact, the distinction of quality as sensuous and meaning as ideational is not primary but secondary and methodological. When a situation is construed as being or as containing a problem, we set facts that are given through perception on one

side and possible meanings for these facts on the other. The distinction is a necessary instrumentality of reflection. The distinction between some elements of subject-matter as rational and others as sensible is always intermediary and transitive. Its office is to lead in the end to a perceptual experience in which the distinction is overcome—in which what were once conceptions become the inherent meanings of material mediated through sense. Even scientific conceptions have to receive embodiment in sense-perception to be accepted as more than ideas.

All observed objects that are identified without reflection (although their recognition may give rise to further reflection) exhibit an integral union of sense quality and meaning in a single firm texture. We recognize with the eye the green of the sea as belonging to the sea, not to the eye, and as a different quality from the green of a leaf; and the gray of a rock as different in quality from that of the lichen growing upon it. In all objects perceived for what they are without need for reflective inquiry, the quality *is* what it means, namely, the object to which it belongs. Art has the faculty of enhancing and concentrating this union of quality and meaning in a way which vivifies both. Instead of canceling a separation between sense and meaning (asserted to be psychologically normal), it exemplifies in an accentuated and perfected manner the union characteristic of many other experiences through finding the exact qualitative media that fuse most completely with what is to be expressed. The remark previously made concerning differing ratios of the two factors is applicable in this connection. There are whole periods of art, as well as individual works, in which one element predominates as compared with the other. But when the result is art, integration is always effected. In impressionistic painting, an immediate quality dominates. In Cezanne, relations, meanings, with their inevitable tendency toward abstraction, dominate. But, nevertheless, when Cézanne succeeds esthetically the work is accomplished wholly in terms of the qualitative and sensuous medium.

Ordinary experience is often infected with apathy, lassitude and stereotype. We get neither the impact of quality through sense nor

the meaning of things through thought. The "world" is too much with us as burden or distraction. We are not sufficiently alive to feel the tang of sense nor yet to be moved by thought. We are oppressed by our surroundings or are callous to them. Acceptance of this sort of experience as normal is the chief cause of acceptance of the idea that art cancels separations that inhere in the structure of ordinary experience. Were it not for the oppressions and monotonies of daily experience, the realm of dream and revery would not be attractive. No complete and enduring suppression of emotion is possible. Repelled by the dreariness and indifference of things which a badly adjusted environment forces upon us, emotion withdraws and feeds upon things of fantasy. These things are built up by an impulsive energy that cannot find outlet in the usual occupations of existence. It may well be under such circumstances that multitudes have recourse to music, theater and the novel to find easy entrance into a kingdom of free floating emotions. But this fact is no ground for the assertion by philosophic theory of an inherent psychological separation of sense and reason, desire and perception.

When, however, theory frames its conception of experience from the situations that drive so many persons to find relief and excitation in the purely fanciful, it is inevitable that the idea of the "practical" should stand in opposition to the properties that belong to a work of art. Much of the current opposition of objects of beauty and use—to use the antithesis most frequently used—is due to dislocations that have their origin in the economic system. Temples have a use; the paintings in them have a use; the beautiful city halls found in many European cities are used for the conduct of public business, and it is not necessary to rehearse the multitude of things produced by peoples we call savages and peasants which charm the eye and touch as well as serve the utilities of partaking of food and of protection. The commonest cheap plate and bowl made by a Mexican potter for domestic use has its own unstereotyped charm.

It has been contended, however, that there is a psychological opposition between objects employed for practical purposes and those that contribute to direct intensity and unity of experience. It

has been urged that there is an antithesis in the very structure of our being between the fluent action of practice and the vivid consciousness of esthetic experience. It is said that production and use of goods involve the worker and the user in action that is fluent in the sense of being as mechanical and automatic as possible, while the intense and robust consciousness of a work of art demands the presence of resistances that inhibit such action.* About the latter fact there is no doubt.

It is stated that "utensils can only, through some ceremonial effort, or when imported from some far time or countries, become the source of heightened consciousness, because we flow from a utensil smoothly into the action for which it is designed." As for the producer of utensils, the fact that so many artisans in all times and places have found and taken time to make their products esthetically pleasing seems to me a sufficient answer. I do not see how there could be better proof that prevailing social conditions, under which industry is carried on, are the factors that determine the artistic or non-artistic quality of utensils, rather than anything inherent in the nature of things. As far as the one who uses the utensil is concerned, I do not see why in drinking tea from a cup he is necessarily estopped from enjoying its shape and the delicacy of its material. Not everyone gulps his food and drink in the shortest possible time in obedience to some necessary psychological law.

Just as there is many a mechanic under present industrial conditions who stops to admire the fruit of his labors, holding it off to admire its shape and texture and not merely to examine into its efficiency for practical purposes, and as there is many a milliner and dressmaker who is the more engaged in her work because of appreciation of its esthetic qualities, so those who are not crowded by economic pressure, or who have not given way completely to habits formed in working on a moving belt in a speeded-up indus-

*The division between fine and useful art has many supporters. The psychological argument to which the text refers is that of Max Eastman in his *Literary Mind*, pp. 205–206. As to the nature of the esthetic experience, I am glad to find myself in close accord with what he says.

try, have a vivid consciousness in the very process of using utensils. I suppose all of us have heard some men boast of the beauty of their cars and of the esthetic qualities of its performance, even though fewer in numbers than those who brag of the number of miles it can cover in a given time.

The compartmentalized psychology that holds to an intrinsic separation between completeness of perceptual experience is, then, itself a reflection of dominant social institutions that have deeply affected both production and consumption or use. Where the worker produces in different industrial conditions from those which prevail today, his own impulsions tend in the direction of creation of articles of use that satisfy his urge for experience as he works. It seems to me absurd to suppose that preference for mechanically effective execution by means of completely smooth running mental automatisms, and at the expense of quickened consciousness of what he is about, is ingrained in psychological structure. And if our environment, as far as it is constituted by objects of use, consisted of things that are themselves contributory to a heightened consciousness of sight and touch, I do not think anyone would suppose that the act of use is such as to be anesthetic.

A sufficient refutation of the idea in question is supplied by the action of the artist himself. If painter and sculptor have an experience in which action is not automatic, but emotionally and imaginatively dyed, there is in that one fact proof of the invalidity of the notion that action is so fluent as to exclude the elements of resistance and inhibition necessary to heightened consciousness. There may have been a time when the scientific inquirer sat still in his chair to excogitate science. Now his action occurs in a place significantly called a laboratory. If the action of a teacher is so fluent as to exclude emotional and imaginative perception of what he is doing, he may be safely set down as a wooden and perfunctory pedagogue. The same is true of any professional man, a lawyer or doctor. Not only do such actions demonstrate the falsity of the psychological principle laid down, but their experiences often become definitely esthetic in nature. The beauty of a skilled surgical operation is felt by the operator as well as by an onlooker.

*　*　*

Popular psychology and much so-called scientific psychology have been pretty thoroughly infected by the idea of the separateness of mind and body. This notion of their separation inevitably results in creating a dualism between "mind" and "practice," since the latter must operate through the body. The idea of the separation perhaps arose, in part at least, from the fact that so much of mind at a given time is aloof from action. The separation, when it is once made, certainly confirms the theory that mind, soul, and spirit can exist and go through their operations without any interaction of the organism with its environment. The traditional notion of leisure is thoroughly infected by contrast with the character of onerous labor.

It seems to me, accordingly, that the idiomatic use of the word "mind" gives a much more truly scientific, and philosophic, approach to the actual facts of the case than does the technical one. For in its non-technical use, "mind" denotes every mode and variety of interest in, and concern for, things: practical, intellectual, and emotional. It never denotes anything self-contained, isolated from the world of persons and things, but is always used with respect to situations, events, objects, persons and groups. Consider its inclusiveness. It signifies memory. We are reminded of this and that. Mind also signifies attention. We not only keep things in mind, but we bring mind to bear on our problems and perplexities. Mind also signifies purpose; we have a mind to do this and that. Nor is mind in these operations something purely intellectual. The mother minds her baby; she cares for it with affection. Mind is care in the sense of solicitude, anxiety, as well as of active looking after things that need to be tended; we mind our step, our course of action, emotionally as well as thoughtfully. From giving heed to acts and objects, mind comes also to signify, to obey—as children are told to mind their parents. In short "to mind" denotes an activity that is intellectual, to *note* something; affectional, as caring and liking, and volitional, practical, acting in a purposive way.

Mind is primarily a verb. It denotes all the ways in which we

deal consciously and expressly with the situations in which we find ourselves. Unfortunately, an influential manner of thinking has changed modes of action into an underlying substance that performs the activities in question. It has treated mind as an independent entity *which* attends, purposes, cares, notices, and remembers. This change of ways of responding to the environment into an entity from which actions proceed is unfortunate, because it removes mind from necessary connection with the objects and events, past, present and future, of the environment with which responsive activities are inherently connected. Mind that bears only an accidental relation to the environment occupies a similar relation to the body. In making mind purely immaterial (isolated from the organ of doing and undergoing), the body ceases to be living and becomes a dead lump. This conception of mind as an isolated being underlies the conception that esthetic experience is merely something "in mind," and strengthens the conception which isolates the esthetic from those modes of experience in which the body is actively engaged with the things of nature and life. It takes art out of the province of the live creature.

In the idiomatic sense of the word "substantial," as distinct from the metaphysical sense of a substance, there is something substantial about mind. Whenever anything is undergone in consequence of a doing, the self is modified. The modification extends beyond acquisition of greater facility and skill. Attitudes and interests are built up which embody in themselves some deposit of the meaning of things done and undergone. These funded and retained meanings become a part of the self. They constitute the capital with which the self notes, cares for, attends, and purposes. In this substantial sense, mind forms the background upon which every new contact with surroundings is projected; yet "background" is too passive a word, unless we remember that it is active and that, in the projection of the new upon it, there is assimilation and reconstruction of both background and of what is taken in and digested.

This active and eager background lies in wait and engages whatever comes its way so as to absorb it into its own being. Mind as background is formed out of modifications of the self that have

occurred in the process of prior interactions with environment. Its animus is toward further interactions. Since it is formed out of commerce with the world and is set toward that world nothing can be further from the truth than the idea which treats it as something self-contained and self-enclosed. When its activity is turned upon itself, as in meditation and reflective speculation, its withdrawal is only from the immediate scene of the world during the time in which it turns over and reviews material gathered from that world.

Different kinds of minds are named from the different interests that actuate the gathering and assemblage of material from the encompassing world: the scientific, the executive, the artistic, the business mind. In each there is a preferential manner of selection, retention, and organization. The native constitution of the artist is marked by peculiar sensitiveness to some aspect of the multiform universe of nature and man and by urge to the remaking of it through expression in a preferred medium. These inherent impulsions become mind when they fuse with a particular background of experience. Of this background, traditions form a large part. It is not enough to have direct contacts and observations, indispensable as these are. Even the work of an original temperament may be relatively thin, as well as tending to the bizarre, when it is not informed with a wide and varied experience of the traditions of the art in which the artist operates. The organization of the background with which immediate scenes are approached cannot otherwise be rendered solid and valid. For each great tradition is itself an organized habit of vision and of methods of ordering and conveying material. As this habit enters into native temperament and constitution it becomes an essential ingredient of the mind of an artist. Peculiar sensitiveness to certain aspects of nature is thereby developed into a power.

"Schools" of art are more marked in sculpture, architecture, and painting than in the literary arts. But there has been no great literary artist who did not feed upon the works of the masters of drama, poetry, and eloquent prose. In this dependence upon tradition there is nothing peculiar to art. The scientific inquirer, the philosopher, the technologist, also derive their substance from the

stream of culture. This dependence is an essential factor in original vision and creative expression. The trouble with the academic imitator is not that he depends upon traditions, but that the latter have not entered into his mind; into the structure of his own ways of seeing and making. They remain upon the surface as tricks of technique or as extraneous suggestions and conventions as to the proper thing to do.

Mind is more than consciousness, because it is the abiding even though changing background of which consciousness is the foreground. Mind changes slowly through the joint tuition of interest and circumstance. Consciousness is always in rapid change, for it marks the place where the formed disposition and the immediate situation touch and interact. It is the continuous readjustment of self and the world in experience. "Consciousness" is the more acute and intense in the degree of the readjustments that are demanded, approaching the nil as the contact is frictionless and interaction fluid. It is turbid when meanings are undergoing reconstruction in an undetermined direction, and becomes clear as a decisive meaning emerges.

"Intuition" is that meeting of the old and new in which the readjustment involved in every form of consciousness is effected suddenly by means of a quick and unexpected harmony which in its bright abruptness is like a flash of revelation; although in fact it is prepared for by long and slow incubation. Oftentimes the union of old and new, of foreground and background, is accomplished only by effort, prolonged perhaps to the point of pain. In any case, the background of organized meanings can alone convert the new situation from the obscure into the clear and luminous. When old and new jump together, like sparks when the poles are adjusted, there is intuition. This latter is thus neither an act of pure intellect in apprehending rational truth nor a Crocean grasp by spirit of its own images and states.

Because interest is the dynamic force in selection and assemblage of materials, products of mind are marked by individuality, just as products of mechanism are marked by uniformity. No amount of technical skill and craftsmanship can take the place of vital interest; "inspiration" without it is fleeting and futile. A triv-

ial and badly ordered mind accomplishes things like unto itself in art as well as elsewhere, for it lacks the push and centralizing energy of interest. Works of art are measured by display of virtuosity when criteria are carried over from the field of technical invention. Judgment of them on the basis of sheer inspiration overlooks the long and steady work done by an interest always at work below the surface. The perceiver, as much as the creator, needs a rich and developed background which, whether it be painting, in the field of poetry, or music, cannot be achieved except by consistent nurture of interest.

In what precedes, I have said nothing about imagination. "Imagination" shares with "beauty" the doubtful honor of being the chief theme in esthetic writings of enthusiastic ignorance. More perhaps than any other phase of the human contribution, it has been treated as a special and self-contained faculty, differing from others in possession of mysterious potencies. Yet if we judge its nature from the creation of works of art, it designates a quality that animates and pervades all processes of making and observation. It is a *way* of seeing and feeling things as they compose an integral whole. It is the large and generous blending of interests at the point where the mind comes in contact with the world. When old and familiar things are made new in experience, there is imagination. When the new is created, the far and strange become the most natural inevitable things in the world. There is always some measure of adventure in the meeting of mind and universe, and this adventure is, in its measure, imagination.

Coleridge used the term "esemplastic" to characterize the work of imagination in art. If I understand his use of the term, he meant by it to call attention to the welding together of all elements, no matter how diverse in ordinary experience, into a new and completely unified experience. "The poet," he said, "diffuses a tone and spirit of unity that (as it were) fuses each to each the faculties of the soul with the subordination of each according to relative dignity and worth, by that synthetic and magical power to which I would exclusively appropriate the name of imagination."

Coleridge used the vocabulary of his philosophic generation. He speaks of faculties that are fused and of imagination as if it were another power acting to draw them together.

But one may pass over his verbal mode, and find in what he says an intimation not that imagination is the power that does certain things, but that an imaginative experience is what happens when varied materials of sense quality, emotion, and meaning come together in a union that marks a new birth in the world. I do not profess to an exact understanding of what Coleridge meant by his distinction between imagination and fancy. But there can be no doubt of the difference between the kind of experience just indicated and that in which a person deliberately gives familiar experience a strange guise by clothing it in unusual garb, as of a supernatural apparition. In such cases, mind and material do not squarely meet and interpenetrate. Mind stays aloof for the most part and toys with material rather than boldly grasping it. The material is too slight to call forth the full energy of the dispositions in which values and meanings are embodied; it does not offer enough resistance, and so mind plays with it capriciously. At the best, the fanciful is confined to literature wherein the imaginative too easily becomes the imaginary. One has only to think of painting—to say nothing of architecture—to see how remote it is from essential art. Possibilities are embodied in works of art that are not elsewhere actualized; this *embodiment* is the best evidence that can be found of the true nature of imagination.

There is a conflict artists themselves undergo that is instructive as to the nature of imaginative experience. The conflict has been set forth in many ways. One way of stating it concerns the opposition between inner and outer vision. There is a stage in which the inner vision seems much richer and finer than any outer manifestation. It has a vast and enticing aura of implications that are lacking in the object of external vision. It seems to grasp much more than the latter conveys. Then there comes a reaction; the matter of the inner vision seems wraith-like compared with the solidity and energy of the presented scene. The object is felt to say something succinctly and forcibly that the inner vision reports vaguely, in diffuse feeling rather than organically. The artist is driven to submit

himself in humility to the discipline of the objective vision. But the inner vision is not cast out. It remains as the organ by which outer vision is controlled, and it takes on structure as the latter is absorbed within it. The interaction of the two modes of vision is imagination; as imagination takes form the work of art is born. It is the same with the philosophic thinker. There are moments when he feels that his ideas and ideals are finer than anything in existence. But he finds himself obliged to go back to objects if his speculations are to have body, weight, and perspective. Yet in surrendering himself to objective material he does not surrender his vision; the object just as an object is not his concern. It is placed in the context of ideas and, as it is thus placed, the latter acquire solidity and partake of the nature of the object.

Trains of what by courtesy are called ideas become mechanical. They are easy to follow, too easy. Observation as well as overt action is subject to inertia and moves in the line of least resistance. A public is formed that is inured to certain ways of seeing and thinking. It likes to be reminded of what is familiar. Unexpected turns then arouse irritation instead of adding poignancy to experience. Words are particularly subject to this tendency towards automatism. If their almost mechanical sequence is not too prosaic, a writer gets the reputation of being clear merely because the meanings he expresses are so familiar as not to demand thought by the reader. The academic and eclectic in any art is the outcome. The peculiar quality of the imaginative is best understood when placed in opposition to the narrowing effect of habituation. Time is the test that discriminates the imaginative from the imaginary. The latter passes because it is arbitrary. The imaginative endures because, while at first strange with respect to us, it is enduringly familiar with respect to the nature of things.

The history of science and philosophy as well as of the fine arts is a record of the fact that the imaginative product receives at first the condemnation of the public, and in proportion to its range and depth. It is not merely in religion that the prophet is at first stoned (metaphorically at least) while later generations build the commemorative monument. With respect to painting, Constable stated, with almost undue moderation, the universal fact when he

said: "In art there are two modes by which men aim at distinction. In the one by a careful application to what others have accomplished, the artist imitates their works or selects and combines their various beauties; in the other, he seeks excellence at its primitive source-nature. In the first, he forms a style upon the study of pictures, and produces either imitative or eclectic art; in the second, by a close observation of nature, he discovers qualities existing in her which have never been portrayed before, and thus forms a style which is original. The results of the one mode, as they repeat that with which the eye is already familiar, are soon recognized and estimated, while the advance of the artist in a new path must necessarily be slow, for few are able to judge of that which deviates from the usual course, or are qualified to judge original studies."* Here is the contrast between the inertia of habit and the imaginative; that is the mind that seeks and welcomes what is new in perception but is enduring in nature's possibilities. "Revelation" in art is the quickened expansion of experience. Philosophy is said to begin in wonder and end in understanding. Art departs from what has been understood and ends in wonder. In this end, the human contribution in art is also the quickened work of nature in man.

Any psychology that isolates the human being from the environment also shuts him off, save for external contacts, from his fellows. But an individual's desires take shape under the influence of the human environment. The materials of his thought and belief come to him from others with whom he lives. He would be poorer than a beast of the fields were it not for traditions that become a part of his mind, and for institutions that penetrate below his outward actions into his purposes and satisfactions. Expression of experience is public and communicating because the experiences expressed are what they are because of experiences of the living and the dead that have shaped them. It is not necessary that com-

*It may be that Constable is here using the word "nature" in a somewhat limited sense, corresponding to his interest as a landscape painter. But the contrast between first-hand experience and the second-hand and imitative remains when "nature" is broadened to include all the phases, aspects, and structures of existence.

munication should be part of the deliberate intent of an artist, although he can never escape the thought of a potential audience. But its function and consequence are to effect communication, and this not by external accident but from the nature he shares with others.

Expression strikes below the barriers that separate human beings from one another. Since art is the most universal form of language, since it is constituted, even apart from literature, by the common qualities of the public world, it is the most universal and freest form of communication. Every intense experience of friendship and affection completes itself artistically. The sense of communion generated by a work of art may take on a definitely religious quality. The union of men with one another is the source of the rites that from the time of archaic man to the present have commemorated the crises of birth, death, and marriage. Art is the extension of the power of rites and ceremonies to unite men, through a shared celebration, to all incidents and scenes of life. This office is the reward and seal of art. That art weds man and nature is a familiar fact. Art also renders men aware of their union with one another in origin and destiny.

ESTHETIC experience is imaginative. This fact, in connection with a false idea of the nature of imagination, has obscured the larger fact that all *conscious* experience has of necessity some degree of imaginative quality. For while the roots of every experience are found in the interaction of a live creature with its environment, that experience becomes conscious, a matter of perception, only when meanings enter it that are derived from prior experiences. Imagination is the only gateway through which these meanings can find their way into a present interaction; or rather, as we have just seen, the conscious adjustment of the new and the old *is* imagination. Interaction of a living being with an environment is found in vegetative and animal life. But the experience enacted is human and conscious only as that which is given here and now is extended by meanings and values

drawn from what is absent in fact and present only imagina-
tively.*

There is always a gap between the here and now of direct inter-
action and the past interactions whose funded result constitutes the
meanings with which we grasp and understand what is now occur-
ring. Because of this gap, all conscious perception involves a risk; it
is a venture into the unknown, for as it assimilates the present to the
past it also brings about some reconstruction of that past. When
past and present fit exactly into one another, when there is only re-
currence, complete uniformity, the resulting experience is routine
and mechanical; it does not come to consciousness in perception.
The inertia of habit overrides adaptation of the meaning of the here
and now with that of experiences, without which there is no con-
sciousness, the imaginative phase of experience.

Mind, that is the body of organized meanings by means of
which events of the present have significance for us, does not al-
ways enter into the activities and undergoings that are going on
here and now. Sometimes it is baffled and arrested. Then the
stream of meanings aroused into activity by the present contact
remain aloof. Then it forms the matter of reverie, of dream; ideas
are floating, not anchored to any existence as its property, its pos-
session of meanings. Emotions that are equally loose and floating
cling to these ideas. The pleasure they afford is the reason why
they are entertained and are allowed to occupy the scene; they are
attached to existence only in a way that, as long as sanity abides, is
felt to be only fanciful and unreal.

In every work of art, however, these meanings are actually em-
bodied in a material which thereby becomes the medium for their
expression. This fact constitutes the peculiarity of all experience
that is definitely esthetic. Its imaginative quality dominates, be-
cause meanings and values that are wider and deeper than the par-
ticular here and now in which they are anchored are realized by
way of *expressions* although not by way of an object that is phys-

* "Mind denotes a whole system of meanings as they are embodied in the workings
of organic life. . . . Mind is a constant luminosity; consciousness is intermittent, a se-
ries of flashes of different intensities."—*Experiences and Nature.* p. 303.

ically efficacious in relation to other objects. Not even a useful object is produced except by the intervention of imagination. Some existent material was perceived in the light of relations and possibilities not hitherto realized when the steam engine was invented. But when the imagined possibilities were embodied in a new assemblage of natural materials, the steam engine took its place in nature as an object that has the same physical effects as those belonging to any other physical object. Steam did the physical work and produced the consequences that attend any expanding gas under definite physical conditions. The sole difference is that the conditions under which it operates have been arranged by human contrivance.

The work of art, however, unlike the machine, is not only the outcome of imagination, but operates imaginatively rather than in the realm of physical existences. What it does is to concentrate and enlarge an immediate experience. The formed matter of esthetic experience directly *expresses,* in other words, the meanings that are imaginatively evoked; it does not, like the material brought into new relations in a machine, merely provide *means* by which purposes over and beyond the existence of the object may be executed. And yet the meanings imaginatively summoned, assembled, and integrated are embodied in material existence that here and now interacts with the self. The work of art is thus a challenge to the performance of a like act of evocation and organization, through imagination, on the part of the one who experiences it. It is not just a stimulus to and means of an overt course of action.

This fact constitutes the uniqueness of esthetic experience, and this uniqueness is in turn a challenge to thought. It is particularly a challenge to that systematic thought called philosophy. For esthetic experience is experience in its integrity. Had not the term "pure" been so often abused in philosophic literature, had it not been so often employed to suggest that there is something alloyed, impure, in the very nature of experience and to denote something beyond experience, we might say that esthetic experience is pure experience. For it is experience freed from the forces that impede and confuse its development as experience; freed, that is, from factors that subordinate an experience as it is directly had to some-

thing beyond itself. To esthetic experience, then, the philosopher must go to understand what experience is.

For this reason, while the theory of esthetics put forth by a philosopher is incidentally a test of the capacity of its author to have the experience that is the subject-matter of his analysis, it is also much more than that. It is a test of the capacity of the system he puts forth to grasp the nature of experience itself. There is no test that so surely reveals the one-sidedness of a philosophy as its treatment of art and esthetic experience. Imaginative vision is the power that unifies all the constituents of the matter of a work of art, making a whole out of them in all their variety. Yet all the elements of our being that are displayed in special emphases and partial realizations in other experiences are merged in esthetic experience. And they are so completely merged in the immediate wholeness of the experience that each is submerged:—it does not present itself in consciousness as a distinct element.

Yet philosophies of esthetics have often set out from one factor that plays a part in the constitution of experience, and have attempted to interpret or "explain" the esthetic experience by a single element; in terms of sense, emotion, reason, of activity; imagination itself is viewed not as that which holds all other elements in solution but as a special faculty. The philosophies of esthetics are many and diverse. It is impossible to give even a résumé of them in a chapter. But criticism has a clue that, if it is followed, furnishes a sure guide through the labyrinth. We can ask what element, in the formation of experience, each system has taken as central and characteristic. If we start from this point, we find that theories fall of themselves into certain types, and that the particular strand of experience that is offered reveals, when it is placed in contrast with esthetic experience itself, the weakness of the theory. For it is shown that the system in question has superimposed some preconceived idea upon experience instead of encouraging or even allowing esthetic experience to tell its own tale.

Since experience is rendered conscious by means of that fusion of old meanings and new situations that transfigures both (a trans-

formation that defines imagination), the theory that art is a form of make-believe suggests itself as the natural one with which to begin. The theory grows out of, and depends upon, contrast between the work of art as an experience and experience of the "real." Now there is no doubt that because of the domination of esthetic experience by imaginative quality, it exists in a medium of light that never was on land or sea. Even the most "realistic" work, if it is one of art, is not an imitative reproduction of the things that are so familiar, so regular, and so importunate that we call them real. In departure from theories of art that define it as "imitative," and that conceive the pleasure that attends it as one of sheer recognition, the make-believe theory has laid hold of a genuine strand of the esthetic.

Moreover, I do not think it can be denied that an element of reverie, of approach to a state of dream, enters into the creation of a work of art, nor that the experience of the work when it is intense often throws one into a similar state. Indeed, it is safe to say that "creative" conceptions in philosophy and science come only to persons who are relaxed to the point of reverie. The subconscious fund of meanings stored in our attitudes have no chance of release when we are practically or intellectually strained. For much the greater part of this store is then restrained, because the demands of a particular problem and particular purpose inhibit all except the elements directly relevant. Images and ideas come to us not by set purpose but in flashes, and flashes are intense and illuminating, they set us on fire, only when we are free from special preoccupations.

The error of the make-believe or illusion theory of art does not, then, proceed from the fact that esthetic experience lacks the elements upon which the theory builds. Its falsity proceeds from the fact that in isolating one constituent, it denies explicitly or implicitly other elements equally essential. No matter how imaginative the material *for* a work of art, it issues from the state of reverie to become the matter *of* a work of art only when it is ordered and organized, and this effect is produced only when *purpose* controls selection and development of material.

The characteristic of dream and reverie is absence of control by purpose. Images and ideas succeed one another according to

their own sweet will, and the sweetness of the succession to feeling is the only control that is exercised. In philosophical terminology, the material is subjective. An esthetic product results only when ideas cease to float and are embodied in an object, and the one who experiences the work of art loses himself in irrelevant reverie unless his images and emotions are also tied to the object, and are tied to it in the sense of being fused with the matter of the *object*. It is not enough that they should be occasioned by the object: in order to be an experience of the object they must be saturated with its qualities. Saturation means an immersion so complete that the qualities of the object and the emotions it arouses have no separate existence. Works of art often start an experience going that is enjoyable in itself, and this experience is sometimes worth having, not merely an indulgence in irrelevant sentimentality. But such an experience is not an enjoyed perception of the object merely because it is provoked by it.

The significance of purpose as a controlling factor in both production and appreciation is often missed because purpose is identified with pious wish and what is sometimes called a motive. A purpose exists only in terms of subject matter. The experience that gave birth to a work like the "Joie de Vivre" of Matisse is highly imaginative; no such scene ever occurred. It is an example as favorable to the dreamlike theory of art as can be found. But the imaginative material did not and could not remain dreamlike, no matter what its origin. To become the matter of a work, it had to be conceived in terms of color as a medium of expression; the floating image and feeling of a dance had to be translated into rhythms of space, line, and distributions of light and colors. The *object*, the expressed material, *is* not merely the accomplished purpose, but it is *as object* the purpose from the very beginning. Even if we were to suppose that the image first presented itself in an actual dream, it would still be true that its material had to be organized in terms of objective materials and operations that moved consistently and without a break to consummation in the picture as a public object in a common world.

At the same time, purpose implicates in the most organic way an individual self. It is in the purposes he entertains and acts upon

that an individual most completely exhibits and realizes his intimate selfhood. Control of material by a self is control by more than just "mind"; it is control by the personality that has mind incorporate within it. All interest is an identification of a self with some material aspect of the objective world, of the nature that includes man. Purpose is this identification in action. Its operation in and through objective conditions is a test of its genuineness; the capacity of the purpose to overcome and utilize resistance, to administer materials, is a disclosure of the structure and quality of the purpose. For, as I have already said, the object finally created *is* the purpose both as conscious objective and as accomplished actuality. The thoroughgoing integration of what philosophy discriminates as "subject" and "object" (in more direct language, organism and environment) is the characteristic of every work of art. The completeness of the integration is the measure of its esthetic status. For defect in a work is always traceable ultimately to an excess on one side or the other, injuring the integration of matter and form. Detailed criticism of the make-believe theory is unnecessary because it is based upon violation of the integrity of the work of art. It expressly denies or virtually ignores that identification with objective material and constructive operation that is the very essence of art.

The theory that art is play is akin to the dream theory of art. But it goes one step nearer the actuality of esthetic experience by recognizing the necessity of action, of doing something. Children are often said to make-believe when they play. But children at play are at least engaged in actions that give their imagery an outward manifestation; in their play, idea and act are completely fused. The elements of strength and of weakness in the theory may be viewed by noting an order of progression that marks forms of play. A kitten plays *with* a spool or ball. The play is not wholly random because it is controlled by the structural organization of the animal, though not, presumably, by a conscious purpose, for the kitten rehearses the kind of actions the cat employs in catching its prey. But the play of the kitten, while it has a certain order as an activity, in consonance with the structural needs of the organism, does not modify the object played with except by a change of its spatial

position, a more or less accidental matter. The spool, the object, is the stimulus and occasion, the excuse as it were, for an enjoyable free exercise of activities, but it is not, save in an external way, their matter.

The first manifestations of play by a child do not differ much from those of a kitten. But as experience matures, activities are more and more regulated by an end to be attained; purpose becomes a thread that runs through a succession of acts; it converts them into a true series, a course of activity having a definite inception and steady movement toward a goal. As the need for order is recognized, play becomes a game; it has "rules." There is also a gradual transition, such that play involves not only an ordering of *activities* toward an end but also an ordering of materials. In playing with blocks the child builds a house or a tower. He becomes conscious of the meaning of his impulsions and acts by means of the difference made by them in objective materials. Past experiences more and more give meaning to what is done. The tower or fort that is to be constructed not only regulates the selection and arrangement of acts performed but is expressive of values of experience. Play as an event is still immediate. But its content consists of a mediation of present materials by ideas drawn from past experience.

This transition effects a transformation of play into work, provided work is not identified with toil or labor. For any activity becomes work when it is directed by accomplishment of a definite material result, and it is labor only as the activities are onerous, undergone as *mere* means by which to secure a result. The product of artistic activity is significantly called the *work* of art. The truth in the play theory of art is its emphasis upon the unconstrained character of esthetic experience, not in its intimation of an objectively unregulated quality in activity. Its falsity lies in its failure to recognize that esthetic experience involves a definite reconstruction of objective materials; a reconstruction that marks the arts of dance and song as well as the shaping arts. The dance, for example, involves the use of the body and its movements in a way that transforms their "natural" state. The artist is concerned with exercise of activities having a definitely objective reference;

an effect upon material so as to convert it into a medium of expression. Play remains as an attitude of freedom from subordination to an end imposed by external necessity, as opposed, that is, to labor; but it is transformed into work in that activity is subordinated to *production* of an objective result. No one has ever watched a child intent in his play without being made aware of the complete merging of playfulness with seriousness.

The philosophical implications of the play theory are found in its opposition of freedom and necessity, of spontaneity and order. This opposition goes back to the same dualism between subject and object that infects the make-believe theory. Its underlying note is the idea that esthetic experience is a release and escape from the pressure of "reality." There is an assumption that freedom can be found only when personal activity is liberated from control by objective factors. The very existence of a work of art is evidence that there is no such opposition between the spontaneity of the self and objective order and law. In art, the *playful* attitude becomes interest in the transformation of material to serve the purpose of a developing experience. Desire and need can be fulfilled only through objective material, and therefore playfulness is also interest in an object.

One form of the theory that art is play attributes play to the existence of a surplus of energy in the organism demanding outlet. But the idea passes over a question that needs to be answered. How is excess of energy measured? With respect to what is there a surplus? The play theory assumes that energy is in excess with respect to activities that are necessary because of demands of the environment that must be met practically. But children are not conscious of any opposition between play and necessary work. The idea of the contrast is a product of the adult life in which some activities are recreative and amusing because of their contrast with work that is infected with laborious care. The spontaneity of art is not one of opposition to anything, but marks complete absorption in an orderly development. This absorption is characteristic of esthetic experience; but it is an ideal for all experience, and the ideal is realized in the activity of the scientific inquirer and the professional man when the desires and urgencies of the self are completely engaged in what is objectively done.

The contrast between free and externally enforced activity is an empirical fact. But it is largely produced by social conditions and it is something to be eliminated as far as possible, not something to be erected into a differentia by which to define art. There is a place for farce and diversion in experience; "a little nonsense now and then is relished by the best of men." Works of art outside of comedy are often diverting. But these facts are no reason for *defining* art in terms of diversion. This conception has its roots in the notion that there is such an inherent and deep-seated antagonism between the individual and the world (by means of which an individual lives and develops) that freedom can be attained only through escape.

Now there is enough conflict between the needs and desires of the self and the conditions of the world to give some point to the escape theory. Spenser said of poetry that "it is the world's sweet inn from pain and wearisome turmoil." The issue does not concern this trait, true of all the arts, but has to do with the way in which art performs liberation and release. The matter at stake is whether release comes by way of anodyne or by transfer to a radically different realm of things, or whether it is accomplished by manifesting what actual existence actually becomes when its possibilities are fully expressed. The fact that art is *production* and that production occurs only through an objective material that has to be managed and ordered in accord with its *own* possibilities seem to be conclusive in the latter sense. As Goethe said: "Art is formative long before it is beautiful. For man has within him a formative nature that displays itself in action as soon as existence is secure. . . . When formative activity operates on what lies around it from single, individual, independent feeling, careless and ignorant of all that is alien to it, then, whether born of rude savagery or cultivated sensibility, it is whole and living." The activity that is free from the standpoint of the self is ordered and disciplined from the side of objective material undergoing transformation.

As far as the delight found in contrast is concerned, it is as true that we go for satisfaction from works of art to natural things as it is that we turn from the latter to art. At times we turn gladly from fine art to industry, science, politics, and domestic life. As Browning said:

> "And that's your Venus—whence we turn
> To yonder girl that fords the burn."

Soldiers get too much of fighting; philosophers of philosophizing, and the poet goes gladly to the meal he shares with his fellows. Imaginative experience exemplifies more fully than any other kind of experience what experience itself is in its very movement and structure. But we also want the tang of overt conflict and the impact of harsh conditions. Moreover, without the latter art has no material; and this fact is more important for esthetic theory than is any contrast supposed to exist between play and work, spontaneity and necessity, freedom and law. For art is the fusion in one experience of the pressure upon the self of necessary conditions and the spontaneity and novelty of individuality.*

Individuality itself is originally a potentiality and is realized only in interaction with surrounding conditions. In this process of intercourse, native capacities, which contain an element of uniqueness, are transformed and become a self. Moreover, through resistances encountered, the nature of the self is discovered. The self is both formed and brought to consciousness through interaction with environment. The individuality of the artist is no exception. If his activities remained mere play and merely spontaneous, if free activities were not brought against the resistance offered by actual conditions, no *work* of art would ever be produced. From the first manifestation by a child of an impulse to draw up to the creations of a Rembrandt, the self is created in the creation of objects, a creation that demands active adaptation to external materials, including a modification of the self so as to utilize and thereby overcome external necessities by incorporating them in an individual vision and expression.

*The most explicit philosophic statement of what is implied in the play theory is that of Schiller in his *Letters on the Esthetic Education of Man*. Kant had limited freedom to moral action controlled by the rational (supra-empirical) conception of Duty. Schiller put forward the idea that play and art occupy an intermediate transitional place between the realms of necessary phenomena and transcendent freedom, educating man to recognition and to assumption of the responsibilities of the latter. His views represent a valiant attempt on the part of an artist to escape the rigid dualism of the Kantian philosophy, while remaining within its frame.

From the philosophic point of view, I see no way to resolve the continual strife in art theories and in criticism between the classic and the romantic save to see that they represent *tendencies* that mark every authentic work of art. What is called "classic" stands for objective order and relations embodied in a work; what is called "romantic" stands for the freshness and spontaneity that come from individuality. At different periods and by different artists, one or the other tendency is carried to an extreme. If there is a definite overbalance on one side or the other the work fails; the classic becomes dead, monotonous, and artificial; the romantic, fantastic and eccentric. But the genuinely romantic becomes in time established as a recognized constituent in experience, so that there is force in the saying that after all the classic means nothing more than that a work of art has won an established recognition.

Desire for the strange and unusual, the remote in space and time, marks romantic art. Yet escape from the familiar environment to a foreign one is often a means of enlarging subsequent experience, because the excursions of art create new sensitivities that in time absorb what was alien and naturalize it within direct experience. Delacroix as a painter who was unduly romantic was at least a precursor of the artists of two generations later who made Arabian scenes a part of the common material of painting, and who, because their form is adapted to subject-matter, more justly than was that of Delacroix, do not arouse a sense of anything so remote as to seem outside the natural scope of experience. Sir Walter Scott is classed as a romanticist in literature. Yet even in his own day, William Hazlitt, who savagely denounced Scott's reactionary political opinions, said of his novels that "by going a century or so back and laying the scene in a remote and uncultivated district, all becomes new and startling in the *present advanced period.*" The italicized words with another phrase, "all is fresh as from the hand of nature," indicate the possibility of incorporation of the romantically strange into the meaning of the present environment. Indeed, since all esthetic experience is imaginative, the pitch of intensity to which the imaginative may be raised without becoming *outre* and fantastic is determined only by the doing, not by the *à priori* rules of pseudo-classicism. Charles Lamb had, as

Hazlitt said, "distaste to new faces, to new books, to new buildings, to new customs" and was "tenacious of the obscure and remote." Lamb himself said: "I cannot make these present times real to me." Yet Pater in quoting these words said that Lamb felt the poetry of things old indeed but, "surviving as an actual part of the life of the present and as something quite different from the poetry of things gone from us and antique."

The two theories criticized (as well as that of self-expression criticized in the chapter on The Act of Expression) are discussed because they typify philosophies that isolate the individual, the "subject"; one of them selecting material that is private, like that of a dream, the other activities that are exclusively individual. These theories are comparatively modern; they correspond to the overemphasis of the individual and the subjective in modern philosophy. The theory of art that has had by far the longest historical vogue and that is still so entrenched that many critics regard individualism in art as an heretical innovation, went to the opposite extreme. It regarded the individual as a mere channel, the more transparent the better, through which objective material is conveyed. This older theory conceived of art as representation, as imitation. Adherents of this theory appeal to Aristotle as the great authority. Yet, as every student of that philosopher knows, Aristotle meant something radically different from imitation of particular incidents and scenes—from "realistic" representation in its present sense.

For to Aristotle the universal was more real, metaphysically, than the particular. The gist of his theory is at least suggested by the reason he gives for regarding poetry as more *philosophical* than history. "It is not the business of the poet to tell what has happened but the kind of thing that might happen—what is possible whether necessary or probable." . . . For poetry tells us, rather, the universals, history the particulars.

Since no one can deny that art deals with the possible, Aristotle's interpretation of it as dealing with the necessary or the probable needs to be stated in terms of his system. For according to

him, things are necessary or probable in *kinds* or *species* not simply as particulars. By their own nature some kinds are necessary and eternal, while other kinds are only probable. The former kinds are always so, the latter kinds are so usually, as a rule, generally. Both kinds are universals, since they are made what they are by an inherent metaphysical essence. Thus Aristotle completes the passage just quoted by saying "the universal is the *kind* of thing which a person of certain character would necessarily or probably do or say. And this is what poetry aims at, though it gives proper names to the persons. The particular, for example, is what Alcibiades did or underwent."

Now the term here translated "character" is likely to give the modern reader a totally wrong impression. He would agree that the deeds and sayings attributed to a character in fiction, drama, or poetry should be such as flow necessarily or with great probability from that individual's character. But he thinks of character as intimately individual, while "character" in the passage signifies a universal nature or essence. To Aristotle the esthetic significance of the portrayal of Macbeth, Pendennis, or Felix Holt consists in fidelity to the nature found in a class or species. To the modern reader, it signifies fidelity to the individual whose career is exhibited; the things done, underwent, and said belong to him in his unique individuality. The difference is radical.

The influence of Aristotle upon subsequent ideas of art may be gathered by a brief quotation from the lectures of Sir Joshua Reynolds. He said of painting that its office is "exhibition of the general forms of things," for "in each *class* of objects there is one common idea and central form, which is the abstract of the various individual forms belonging to the class." This general form, antecedently existent in nature, which indeed *is* nature when nature is true to itself, is reproduced or "imitated" in art. "The idea of beauty in each species of things is invariable."

The weakness, in a relative sense, of the paintings of Sir Joshua Reynolds is doubtless to be attributed to defects in his own artistic capacity rather than to acceptance of the theory he expounds. Many a person in both plastic and literary arts held the

same theory and rose superior to it. And up to a certain point, the theory is a just reflection of the actual state of works of art for a long period, because of their search for the typical and their avoidance of anything that might be considered accidental and contingent. Its prevalence in the eighteenth century reflects not only canons followed in the art of that century (outside of painting in France through the earlier part of the century), but also the general condemnation of the baroque and the Gothic.*

But the question raised is a general one. It cannot be disposed of merely by pointing out that modern art, in all its modes, has tended to search for and express the distinctively individual traits of objects and scenes, any more than it can be settled by an *ipse dixit* that these exhibitions of the modern spirit are willful departures from true art, to be explained by desire for mere novelty and attendant notoriety. For, as we have already seen, the more a work of art embodies what belongs to experiences common to many individuals, the more expressive it is. Indeed, failure to take account of the control exercised by objective subject-matter is the just ground for the criticism directed against the subjectivist theories lately under discussion. The problem for philosophic reflection concerns, then, not the presence or absence of such objective material but its nature and the way in which it operates in the developing movement of an esthetic experience.

The question of the nature of the objective material that enters a work of art and the way in which it operates cannot be separated. In a true sense, the way in which material of other experiences enters into esthetic experience *is* its nature for art. But it may be pointed out that the terms general and common are equivocal. The meaning they possess for Aristotle and for Sir Joshua are not, for example, the meaning that most naturally comes to mind with a contemporary reader. For the former, they refer to a species or kind of objects, and, moreover, a kind already in existence by the

*It is not without interest to note that the good Bishop Berkeley, when he wishes to condemn anything in the way of opinion and action, as well as in art, as extravagant and fantastic speaks of it as "Gothic."

very constitution of nature. For a reader innocent of the underlying metaphysics, they have a simpler, more direct and more experimental significance. The "common" is that which is found in the experience of a number of persons; anything in which a number of persons participate is by that very fact common. The more deepseated it is in the doings and undergoing that form experience, the more general or common it is. We live in the same world; that aspect of nature is common to all. There are impulsions and needs that are common to humanity. The "universal" is not something metaphysically anterior to all experience but is a *way in which things function* in experience as a bond of union among particular events and scenes. *Potentially* anything whatsoever in nature or in human associations is "common"; whether or not it is actually common depends upon diverse conditions, especially those that affect the processes of communication.

For it is by activities that are shared and by language and other means of intercourse that qualities and values become common to the experience of a group of mankind. Now art is the most effective mode of communication that exists. For this reason the presence of common or general factors in conscious experience is an *effect* of art. Anything in the world, no matter how individual in its own existence is potentially common, as I have said, because it is something that may, just because it is part of the environment, interact with any living being. But it becomes a conscious common possession, or is shared, by means of works of art more than by any other means. The idea that the general is constituted by the existence of fixed kinds of things, has, moreover, been destroyed by the advance of science, physical and biological. The idea was a product of the cultural conditions, with respect both to the state of knowledge and social organization, that subordinated the individual in politics as well as in art and philosophy.

The question of the way potential common material enters into art has been dealt with in connection with other matters, especially that of the nature of the expressive object and the medium. A medium as distinct from raw material is always a mode of language and thus of expression and communication. Pigments, marble and bronze, sounds, are not media of them-

selves. They enter into the formation of a medium only when they interact with the mind and skill of an individual. Sometimes in a painting we are conscious of the paint; the physical means obtrude; they are not so absorbed into union with what the artist contributes as to carry us transparently over to the texture of the object, drapery, human flesh, the sky or whatever it may be. Even great painters do not always achieve a complete union, Cézanne being a notable example. On the other hand, there are lesser artists in whose work we are not made aware of the material means used. But since only scant material is supplied by the human meanings that interact, the work is slight in expressiveness.

Such facts as these give convincing evidence that the medium of expression in art is neither objective nor subjective. It is the matter of a new experience in which subjective and objective have so coöperated that neither has any longer an existence by itself. The fatal defect of the representative theory is that it exclusively identifies the matter of a work of art with what is objective. It passes by the fact that objective material becomes the matter of art only as it is transformed by entering into relations of doing and being undergone by an individual person with all his characteristics of temperament, special manner of vision, and unique experience. Even did there exist (as there does not) special fixed kinds of beings to which all particulars are subordinate, it would still be true that they would not be the matter of art. They would be at best material *for,* and would become matter *of* a work of art only after they had been transfigured by fusion with material that has undergone incorporation with an individual living creature. Since the physical material used in production of a work of art is not of itself a medium, no rules can be laid *à priori* down for its proper use. The limits of its esthetic potentialities can be determined only experimentally and by what artists make out of it in practice; another evidence that the *medium* of expression is neither subjective nor objective, but is an experience in which they are integrated in a *new* object.

The philosophic basis of the representative theory is compelled to omit this qualitative novelty that characterizes every genuine work of art.

This neglect is a logical consequence of virtual denial of the inherent rôle of individuality in the matter of a work of art. The theory of reality that defines the real in terms of fixed kinds is bound to regard all elements of novelty as accidental and esthetically irrelevant, even though they are practically unavoidable. Moreover, philosophies that have been marked by bias in favor of universal natures and "characters" have always regarded only the eternal and unchanging as truly real. Yet no genuine work has ever been a repetition of anything that previously existed. There are indeed works that tend to be mere recombinations of elements selected from prior works. But they are academic—that is to say, mechanical—rather than esthetic. Not only critics but historians of art have been misled by the factitious prestige of the concept of the fixed and unchanging. They have tended to find the explanation of works of art of each period as mere recombinations of those predecessors, recognizing novelty only when a new "style" appeared, and even then acknowledging it only in a grudging way. The interpenetration of the old and new, their complete blending in a work of art, is another challenge issued by art to philosophic thought. It gives a clue to the nature of things that philosophic systems have rarely followed.

The sense of increase of understanding, of a deepened intelligibility on the part of objects of nature and man, resulting from esthetic experience, has led philosophic theorists to treat art as a mode of knowledge, and has induced artists, especially poets, to regard art as a mode of revelation of the inner nature of things that cannot be had in any other way. It has led to treating art as a mode of knowledge superior not only to that of ordinary life but to that of science itself. The notion that art is a form of knowledge (though not one superior to the scientific mode) is implicit in Aristotle's statement that poetry is more philosophical than history. The assertion has been expressly made by many philosophers. A reading of these philosophers in connection with one another suggests, however, that they either have not had an esthetic experience or have allowed preconceptions to determine

their interpretation of it. For the alleged knowledge can hardly be at the same time that of fixed species, as with Aristotle; of Platonic Ideas, as with Schopenhauer; of the rational structure of the universe, as with Hegel; and of states of mind, as with Croce; of sensations with associated images, as with the sensational school; to mention a few of the outstanding philosophic instances. The varieties of incompatible conceptions put forth prove that the philosophers in question were anxious to carry a dialectical development of conceptions framed without regard to art into esthetic experience more than they were willing to allow this experience to speak for itself.

Nevertheless, the sense of disclosure and of heightened intelligibility of the world remains to be accounted for. That knowledge enters deeply and intimately into the production of a work is proved by the works themselves. Theoretically, it follows of necessity from the part played by mind, by the meanings funded from prior experiences that are actively incorporated in esthetic production and perception. There are artists who have been definitely influenced in their work by the science of their time—as Lucretius, Dante, Milton, Shelley, and, although not to advantage of their paintings, Leonardo and Dürer in the larger compositions of the latter. But there is a great difference between the transformation of knowledge that is effected in imaginative and emotional vision, and in expression through union with sense-material and knowledge. Wordsworth declared that "poetry is the breath and finer spirit of all knowledge; it is the impassioned expression which is in the countenance of all science." Shelley said: "Poetry . . . is at once the center and circumference of all knowledge; it is that which comprehends all science and to which all science must be referred."

But these men were poets and are speaking imaginatively. "Breath and finer spirit" of knowledge are far from being knowledge in any literal sense, and Wordsworth goes on to say that poetry "carries sensation into the objects of science." And Shelley also says, "poetry awakens and enlarges the mind by rendering it the receptacle of a thousand unapprehended combinations of thought." I cannot find in such remarks as these any intention to

assert that esthetic experience is to be *defined* as a mode of knowledge. What is intimated to my mind, is, that in both production and enjoyed perception of works of art, knowledge is transformed; it becomes something more than knowledge because it is merged with non-intellectual elements to form an experience worthwhile as an experience. I have from time to time set forth a conception of knowledge as being "instrumental." Strange meanings have been imputed by critics to this conception. Its actual content is simple: Knowledge is instrumental to the enrichment of immediate experience through the control over action that it exercises. I would not emulate the philosophers I have criticized and force this interpretation into the ideas set forth by Wordsworth and Shelley. But an idea similar to that I have just stated seems to me to be the most natural translation of their intent.

Tangled scenes of life are made more intelligible in esthetic experience: not, however, as reflection and science render things more intelligible by reduction to conceptual form, but by presenting their meanings as the matter of a clarified, coherent, and intensified or "impassioned" experience. The trouble I find with the representative and cognitive theories of the esthetic is that they, like the play and illusion theories, isolate one strand in the total experience, a strand, moreover, that is what it is because of the entire pattern to which it contributes and in which it is absorbed. They take it to be the whole. Such theories either mark an arrest of esthetic experience on the part of those who hold them, an arrest eked out by induced cerebral reveries, or they are evidence of forgetfulness of the nature of the actual experience in favor of enforcement of some prior philosophical conception to which their authors have been committed.

There is a third general type of theories that combines the escape phase of the first type of theories considered with the overintellectualized conception of art characteristic of the second type. The historic origin of this third type, in western thought, goes back to Plato. He sets out from the imitation conception, but to him there is an element of sham and deceit in every imitation, and the true

function of the beauty in every object, natural or artistic, is to lead us from sense and phenomena to something beyond. Plato says, in one of his more genial reference, . . . "the rhythmic and harmonious elements of art, like a breeze blowing in a goodly place, may from earliest childhood lead us peacefully into harmony with the beauty of reasonableness; one so nurtured will, beyond others, welcome reason when its time comes and know it as his own." Upon this view, the object of art is to educate us away from art to perception of purely rational essences. There is a ladder of successive rungs leading from sense upwards. The lowest stage consists in the beauty of sensible objects; a stage that is morally dangerous because we are tempted to remain there. From thence we are invited to mount to the beauty of mind, thence to the beauty of laws and institutions, whence we should ascend to the beauty of the sciences and then we may move on to the one intuitive knowledge of beauty absolute. Plato's ladder is, moreover, a one-way ascent; there is no return from the highest beauty to perceptual experience.

The beauty of things that are in change—as are all things of experience—is to be regarded then but as a potential becoming of the soul toward apprehension of eternal patterns of beauty. Even their intuition is not final. "Recall how in that communion alone, through beholding beauty with the eye of mind, one will be able to bring forth not mere images of beauty but reality itself. In thereby bringing forth and nurturing true excellence, one will be able to become the friend of God and as divine as any mortal may be." Following Plato in a time that is well designated by Gilbert Murray a "failure of nerve," Plotinus carried further the logical implications of the last clause. Proportion, symmetry, and harmonious adaptation of parts no more constitute the beauty of natural and artistic objects than does their sensuous charm. The beauty of these things is conferred upon them by the eternal essence or character that shines through them. The Creator of all things is the supreme artist by which is "conferred upon the creatures" that which causes them to be beautiful. Plotinus thought it unworthy of absolute being to conceive it as personal. Christianity did not share this scruple, and, in its version of Neo-Platonism, beauty of

nature and art were conceived to be manifestations within the limits of the perceptible world of the Spirit who is above nature and beyond perception.

An echo of this philosophy is found in Carlyle, when he says that, in art, "the infinite is made to blend with the finite; to stand visible and as it were attainable there. Of this sort are all true works of art; in this (if we know the true work from the daub of artifice), we discern eternity looking through time, the Godlike rendered visible." It is quite definitely stated by Bosanquet, a modern idealist of the German tradition, when he asserts that the spirit of art is faith in the "life and divinity with which the external world is instinct and inspired, so that the 'idealizations' characteristic of art are not so much products of an imagination that departs from reality as they are revelations of the life and divinity that is alone ultimately real."

Contemporary metaphysicians who have abandoned the theological tradition have seen that logically essences can stand alone and do not need the support that was supposed to be given them by residence in any mind or spirit. A contemporary philosopher, Santayana, writes: "The nature of essence appears in nothing better than in the beautiful, when this is a positive presence to the spirit, and not a vague title conventionally bestowed. In a form felt to be beautiful an obvious complexity composes an obvious unity; a marked intensity and individuality are seen to belong to a reality utterly immaterial and incapable of existing otherwise than speciously. This divine beauty is evident, fugitive, impalpable, and homeless in a world of material fact; yet it is unmistakably individual and sufficient unto itself, and although perhaps soon eclipsed is never really extinguished; for it visits time, but belongs to eternity." And again: "The most material thing in as far as it is felt to be beautiful, is instantly immaterialized, raised above external personal relations, concentrated and deepened in its proper being, in a word sublimated into an essence." The implications of the view are contained in the essence that says, "Value lies in meaning, not in substance; *in the ideal which things approach,* not in the energy which they embody." (Italics not in the original.)

I think there is an empirical fact involved in even this concep-

tion of esthetic experience. I have had occasion to speak more than once of a quality of an intense esthetic experience that is so immediate as to be ineffable and mystical. An intellectualized rendering of this immediate quality of experience translates it into the terms of a dream-metaphysics. In any event, when this conception of ultimate essence is compared with concrete esthetic experience it is seen to suffer from two fatal defects. All direct experience is qualitative, and qualities are what make life-experience itself directly precious. Yet *reflection* goes behind immediate qualities, for it is interested in relations and neglects qualitative setting. Philosophic reflection has carried this indifference to qualities to the point of aversion. It has treated them as obscurations of truth, as veils cast over reality by sense. The desire to derogate from immediate sense-qualities—and all qualities are mediated through some mode of sense—is reënforced by fear of sense, moralistic in origin. Sense seems, as to Plato, to be a seduction that leads man away from the spiritual. It is tolerated only as a vehicle through which man may be brought to an intuition of immaterial and non-sensuous essence. In view of the fact that the work of art is the impregnation of sensuous material with imaginative values, I know of no way to criticize the theory save to say that it is a ghostly metaphysics irrelevant to actual esthetic experience.

The term "essence" is highly equivocal. In common speech it denotes the *gist* of a thing; we boil down a series of conversations or of complicated transactions and the result is what is essential. We eliminate irrelevancies and retain what is indispensable. All genuine expression moves, in this sense, toward "essence." Essence here denotes an organization of meanings that have been dispersed in and more or less obscured by incidents attending a variety of experiences. What is essential or indispensable is also so in reference to a purpose. For why are certain considerations indispensable rather than others? The gist of a variety of transactions is not the same for a lawyer, a scientific inquirer and a poet. A work of art may certainly convey the essence of a multitude of experiences, and sometimes in a remarkably condensed and striking way. Selection and simplification occur for the sake of expressing the essential. Courbet often conveys the essence of a liquidity that sat-

urates a landscape; Claude, that of the *genius loci* and of an arcadian scene; Constable, the essence of simple rural scenes of England; Utrillo, that of the buildings in a Paris street. Dramatists and novelists construct characters that extricate the essential from the incidental.

Since a work of art is the subject-matter of experiences heightened and intensified, the purpose that determines what is esthetically essential is precisely the formation of an experience *as* an experience. Instead of fleeing from experience to a metaphysical realm, the material of experiences is so rendered that it becomes the pregnant matter of a new experience. Moreover, the sense we now have for essential characteristics of persons and objects is very largely the *result* of art, while the theory that is under discussion holds that art depends upon and refers to essences already in being, thus reversing the actual process. If we are now aware of essential meanings, it is mainly because artists in all the various arts have extracted and expressed them in vivid and salient subject-matter of perception. The forms or Ideas which Plato thought were models and patterns of existing things actually had their source in Greek art, so that his treatment of artists is a supreme instance of intellectual ingratitude.

The term "intuition" is one of the most ambiguous in the whole range of thought. In the theories just considered, it is supposed to have essence as its proper object. Croce has combined the idea of intuition with that of expression. Their identification with each other and of both with art has given readers a good deal of trouble. It can be understood, however, on the basis of his philosophic background, and it affords an excellent instance of what happens when the theorist superimposes philosophic preconceptions upon an arrested esthetic experience. For Croce is a philosopher who believes that the only real existence is mind, that "the object does not exist unless it is known, that it is not separable from the knowing spirit." In ordinary perception, objects are taken as if they were external to mind. Therefore, awareness of objects of art and of natural beauty is not a case of perception, but of an intuition that knows objects as, themselves, states of mind. "What we admire in a work of art is the perfect imaginative form

in which a state of mind has clothed itself." "Intuitions are truly such because they represent feelings." Hence the state of mind that constitutes a work of art is expression as a manifestation of a state of mind, and is intuition as knowledge of a state of mind. I do not refer to the theory for the purpose of refutation but as indication of the extreme to which philosophy may go in superimposing a preconceived theory upon esthetic experience, resulting in arbitrary distortion.

Schopenhauer, like Croce, shows in many incidental references, more, not less, sensitiveness to works of art than most philosophers. But his version of esthetic intuition is worth referring to as another instance of complete failure of philosophy to meet the challenge that art offers to reflective thought. He wrote when Kant had set the problem of philosophy by instituting a sharp separation between sense and phenomena, reason and phenomena: and to set a problem is the most effective way of influencing subsequent thought. Schopenhauer's theory of art, in spite of many acute remarks, is but a dialectical development of his solution of the Kantian problem of the relation of knowledge to reality, and of phenomena to ultimate reality.

Kant had made the moral will, controlled by consciousness of duty that transcends sense and experience, the only gateway to assurance of ultimate reality. To Schopenhauer, an active principle he termed "Will" is the creative source of all phenomena of both nature and the moral life, while will is a form of restless and insatiable striving that is doomed to everlasting frustration. The only road to peace and enduring satisfaction is escape from will and all its works. Kant had already identified esthetic experience with contemplation. Schopenhauer declared that contemplation is the sole mode of escape, and that, in contemplating works of art, we contemplate the objectifications of will, and thereby free ourselves from the hold will has upon us in all other modes of experience. The objectification of Will are universals; they are like Plato's eternal forms and patterns. In pure contemplation of them we lose ourselves, therefore, in the universal, and obtain the "blessedness of will-less perception."

The most effective criticism of Schopenhauer's theory is found

in his own development of the theory. He rules charm out from art, because charm signifies attraction, and attraction is a mode of response by will, being indeed the positive aspect of that relation of desire to the object which is expressed in its negative aspect by disgust. More important is the fixed hierarchical arrangement he institutes. Not only are beauties of nature lower than those of art since will obtains a higher degree of objectification in man than in nature, but an order from inferior to superior runs through both nature and art. The emancipation we obtain in contemplating verdures, trees, flowers is slighter than that which we get from contemplating forms of animal life, while the beauty of human beings is the highest, since Will is freed from slavery in the latter modes of its manifestations.

In works of art, architecture ranks as the lowest. The reason given is a logical deduction from his system. The forces of Will upon which it depends are of the lowest order, namely, cohesion and gravity as manifest in solid rigidity and massive weight. Hence no building made of wood can be truly beautiful, and all human accessories must be ruled out of esthetic effect because they are bound to desire. Sculpture is higher than architecture, because though it is still bound to low forms of Will-force, it deals with them as manifested in the human figure. Painting deals with shapes and figures and thus comes nearer to metaphysical forms. In literature, especially poetry, we rise to the essential Idea of man himself, and thus reach the acme of the *results* of Will.

Music is the highest of the arts, because it gives us not merely the external objectifications of Will but also sets before us for contemplation the very *processes* of Will. Moreover, the "definite intervals of the scale are parallel to definite grades of objectification of Will, corresponding to definite species in nature." Bass notes represent the workings of the lowest forces, while higher notes represent for cognition the forces of animal life, and melody presents the intellectual life of man, the highest thing in objective existence.

For the purpose of giving information my summary is scant; and, as I have already said, many of Schopenhauer's incidental remarks are just and illuminating. But the very fact that he shows

many evidences of genuine and personal appreciation affords all the better evidence of the sort of thing that happens when the reflections of a philosophic thinker are not projections in thought of the actual subject-matter of art as an experience, but are developed without respect to art and are then forced into a substitute for it. My intention throughout this chapter has not been to criticize various philosophies of art as such, but to elicit the significance that art has for philosophy in its broadest scope. For philosophy like art moves in the medium of imaginative mind, and, since art is the most direct and complete manifestation there is of experience *as* experience, it provides a unique control for the imaginative ventures of philosophy.

In art as an experience, actuality and possibility or ideality, the new and the old, objective material and personal response, the individual and the universal, surface and depth, sense and meaning, are integrated in an experience in which they are all transfigured from the significance that belongs to them when isolated in reflection. "Nature," said Goethe, "has neither kernel nor shell." Only in esthetic experience is this statement completely true. Of art as experience it is also true that nature has neither subjective nor objective being; is neither individual nor universal, sensuous nor rational. The significance of art as experience is, therefore, incomparable for the adventure of philosophic thought.

CRITICISM is judgment, ideally as well as etymologically. Understanding of judgment is therefore the first condition for theory about the nature of criticism. Perceptions supply judgment with its material, whether the judgments pertain to physical nature, to politics or biography. The subject-matter of perception is the only thing that makes the difference in the judgments which ensue. Control of the subject-matter of perception for ensuring proper data for judgment is the key to the enormous distinction between the judgments the savage passes on natural events and that of a Newton or an Einstein. Since the matter of esthetic criticism is the perception of esthetic objects, natural and artistic criticism is always determined by the quality of first-hand perception; obtuseness in perception can never be made good by any amount of learning, however extensive, nor any command of abstract theory, however correct. Nor is it possible to exclude judgment from en-

tering into esthetic perception, or at least from supervening upon a first total unanalyzed qualitative impression.

Theoretically, it should therefore be possible to proceed at once from direct esthetic experience to what is involved in judgment, the clues being given on one side from the formed matter of works of art as they exist in perception, and, on the other side, from what is involved in judgment by the nature of its own structure. But, in fact, it is first necessary to clear the ground. For unreconciled differences as to the nature of judgment are reflected in theories of criticism, while diverse tendencies among the arts have given rise to opposed theories that are developed and asserted for the sake of justifying one movement and condemning another. Indeed, there is ground for holding that the most vital questions in esthetic theory are generally to be found in controversies regarding special movements in some art, like "functionalism" in architecture, "pure" poetry or free verse in literature, "expressionism" in the drama, the "stream of consciousness" in the novel, "proletarian art" and the relation of the artist to economic conditions and revolutionary social activities. Such controversies may be attended with heat and prejudice. But they are more likely to be conducted with an eye directed upon concrete works of art than are lucubrations upon esthetic theory in the abstract. Yet they complicate the theory of criticism with ideas and aims derived from external partisan movements.

It cannot be safely assumed at the outset that judgment is an act of intelligence performed upon the matter of direct perception in the interest of a more adequate perception. For judgment has also a legalistic meaning and import, as in Shakespeare's phrase, "a critic, nay, a night watchman." Following the signification supplied by the practice of the law, a judge, a critic, is one who pronounces an authoritative sentence. We hear constantly of the verdict of critics, and of the verdict of history pronounced upon works of art. Criticism is thought of as if its business were not explication of the content of an object as to substance and form, but a process of acquittal or condemnation on the basis of merits and demerits.

The judge—in the judicial sense—occupies a seat of social au-

thority. His sentence determines the fate of an individual, perhaps of a cause, and upon occasion it settles the legitimacy of future courses of action. Desire for authority (and desire to be looked up to) animates the human breast. Much of our existence is keyed to the note of praise and blame, exculpation and disapproval. Hence there has emerged in theory, reflecting a widespread tendency in practice, a disposition to erect criticism into something "judicial." One cannot read widely in the outgivings of this school of criticism without seeing that much of it is of the compensatory type— the fact which has given rise to the gibe that critics are those who have failed in creation. Much criticism of the legalistic sort proceeds from subconscious self-distrust and a consequent appeal to authority for protection. Perception is obstructed and cut short by memory of an influential rule, and by the substitution of precedent and prestige for direct experience. Desire for authoritative standing leads the critic to speak as if he were the attorney for established principles having unquestionable sovereignty.

Unfortunately such activities have infected the very conception of criticism. Judgment that is final, that settles a matter, is more congenial to unregenerate human nature than is the judgment that is a development in thought of a deeply realized perception. The original adequate experience is not easy to attain; its achievement is a test of native sensitiveness and of experience matured through wide contacts. A judgment as an act of controlled inquiry demands a rich background and a disciplined insight. It is much easier to "tell" people what they should believe than to discriminate and unify. And an audience that is itself habituated to being told, rather than schooled in thoughtful inquiry, likes to be told.

Judicial decision can be made only on the basis of general rules supposed to be applicable to all cases. The harm done by particular instances of judicial sentence, as particular, is much less serious than the net result in developing the notion and antecedent authoritative standards and precedents are at hand by which to judge. The so-called classicism of the eighteenth century alleged that the ancients provided models from which rules could be derived. The influence of this belief extended from literature to other branches of art. Reynolds recommended to students of art the ob-

servance of the art-forms of Umbrian and Roman painters, and, warning them against others, said of Tintoretto that his inventions are "wild, capricious, extravagant and fantastic."

A temperate view of the importance of the models furnished by the past is given by Matthew Arnold. He says that the best way to discover "what poetry belongs to the class of the truly excellent, and *can therefore do us the most good,* is to have always in one's mind lines and expressions of the great masters, and to apply them as a touchstone to other poetry." He denies that he means that other poetry should be reduced to imitation, but says that such lines are an "infallible touchstone for detecting the presence or absence of high poetic quality." Aside from the moralistic element involved in the words I have taken the liberty of italicizing, the idea of an "infallible" test is bound, if acted upon, to limit direct response in perception, to introduce self-consciousness and reliance upon extraneous factors, all harmful to vital appreciation. Moreover, there is involved the question as to whether the masterpieces of the past are accepted as such because of personal response or on the authority of tradition and convention. Matthew Arnold is really assuming an ultimate dependence upon someone's personal power of just perception.

Representatives of the school of judicial criticism do not seem to be sure whether the masters are great because they observe certain rules or whether the rules now to be observed are derived from the practice of great men. In general, it is safe to assume, I think, that reliance upon rules is a weakened, a mitigated, version of a prior, more direct, admiration, finally become servile, of the work of outstanding personalities. But whether they are set up on their own account or are derived from masterpieces, standards, prescriptions, and rules are general while objects of art are individual. The former have no locus in time, a fact naïvely stated in calling them eternal. They belong neither here nor there. In applying to everything, they apply to nothing in particular. In order to get concreteness, they have to be referred for exemplification to the work of the "masters." Thus in fact they encourage imitation. The masters themselves usually serve an apprenticeship, but as they mature they absorb what they have learned into their own in-

dividual experience, vision, and style. They are masters precisely because they do not follow either models or rules but subdue both of these things to serve enlargement of personal experience. Tolstoi spoke as an artist when he said that "nothing so contributes to the perversion of art as these authorities set up by criticism." Once an artist is pronounced great "all his works are regarded as admirable and worthy of imitation. . . . Every false work extolled is a door through which hypocrites of art creep in."

If judicial critics do not learn modesty from the past they profess to esteem, it is not from lack of material. Their history is largely the record of egregious blunders. The commemorative exhibition of paintings by Renoir in Paris in the summer of 1933 was the occasion for exhuming some of the deliverances of official critics of fifty years before. The pronouncements vary from assertions that the paintings cause a nausea like that of sea-sickness, are products of diseased minds—a favorite statement—that they mix at random the most violent colors, to an assertion that they "are denials of all that is *permissible* [characteristic word] in painting, of everything called light, transparence and shade, clarity and design." As late as 1897, a group of academicians (always the favorites of judicial criticism) protested against the acceptance by the Luxembourg Museum of a collection of paintings by Renoir, Cézanne, and Monet, and one of them stated that it was impossible that the Institute should be silent in the presence of such a scandal as reception of a collection of insanities since it is the guardian of tradition—another idea characteristic of judicial criticism.*

There is, however, a certain lightness of touch usually associated with French criticism. For real majesty of pronunciamento we may turn to the outgivings of an American critic on the occasion of the Armory exhibition in New York in 1913. Under the caption of the ineffectualness of Cézanne, it is said that the latter is "a second-rate impressionist who had now and then fair luck in painting a moderately good picture." The "crudities" of Van

*The greater part of the collection is now in the Louvre—a sufficient comment on the competency of official criticism.

Gogh are disposed of as follows: "A moderately competent impressionist who was heavy-handed (!), and who had little idea of beauty and spoiled a lot of canvas with crude and unimportant pictures." Matisse is disposed of as one who has "relinquished all respect for technique, all feeling for his medium; content to daub his canvas with linear and tonal coarseness. Their negation of all that true art implies is significant of smug complacency. . . . They are not works of art but feeble impertinences." The reference to "true art" is characteristic of judicial criticism, never more injudicious than in this case with its reversal of what is significant in the artists mentioned: Van Gogh being explosive rather than heavy-handed; Matisse being a technician almost to a fault, and inherently decorative rather than coarse; while "second rate" applied to Cézanne speaks for itself. Yet this critic had by this time accepted the impressionist painting of Manet and Monet—it was 1913 instead of twenty years earlier; and his spiritual offspring will doubtless hold up Cézanne and Matisse as standards by which to condemn some future movement in the art of painting.

The "criticism" just quoted was preceded by other remarks that indicate the nature of the fallacy that is always involved in legalistic criticism: confusion of a particular technique with esthetic form. The critic in question quoted from a published comment of a visitor who was not a professional critic. The latter said, "I never heard a crowd of people talk so much about meaning and about life and so little about technique, values, tones, drawing, perspective, studies in blue and white, etc." Then the judicial critic adds: "We are grateful for this bit of concrete evidence of the fallacy which more than others threatens to mislead and completely obfuscate the too confiding observers. To go to this exhibition with a solicitude about 'meaning' and about 'life' at the expense of matters of technique is not simply to beg the question; it is to give it away with both hands. In art, elements of 'meaning' and 'life' do not exist until the artist has mastered those technical processes by which he may or may not have genius to call them [sic] into being."

The unfairness of the implication that the author of the comment intended to rule out matters of technique is so characteristic

of alleged judicial criticism that it is significant only because it indicates how completely the critic can think of technique only as it is identified with some one model of procedure. And this fact is deeply significant. It indicates the source of the failure of even the best of judicial criticism: its inability to cope with the emergence of new modes of life—of experiences that demand new modes of expression. All of the post-impressionist painters (with the partial exception of Cézanne) had shown in their early works that they had command of the techniques of the masters that immediately preceded them. The influence of Courbet, Delacroix, even of Ingres, pervades them. But these techniques were suited to the rendering of old themes. As these painters matured, they had new visions; they saw the world in ways to which older painters were insensitive. Their new subject-matter demanded a new form. And because of the relativity of technique to form, they were compelled to experiment with the development of new technical procedures.* An environment that is changed physically and spiritually demands new forms of expression.

I repeat that here we have exposed the inherent defect of even the best of judicial criticism. The very meaning of an important new movement in any art is that it expresses something new in human experience, some new mode of interaction of the live creature with his surroundings, and hence the release of powers previously cramped or inert. The manifestations of the movement therefore cannot be judged but only misjudged when form is identified with a familiar technique. Unless the critic is sensitive first of all to "meaning and life" as the matter which requires its own form, he is helpless in the presence of the emergence of experience that has a distinctively new character. Every professional person is subject to the influence of custom and inertia, and has to protect himself from its influences by a deliberate openness to life itself. The judicial critic erects the very things that are the dangers of his calling into a principle and norm.

* * *

*See *ante,* p. 142.

The blundering ineptness of much that calls itself judicial criticism has called out a reaction to the opposite extreme. The protest takes the form of "impressionist" criticism. It is in effect, if not in words, a denial that criticism in the sense of judgment is possible, and an assertion that judgment should be replaced by statement of the responses of feeling and imagery the art object evokes. In theory, though not always in practice, such criticism reacts from the standardized "objectivity" of ready-made rules and precedents to the chaos of a subjectivity that lacks objective control, and would, if logically followed out, result in a medley of irrelevancies—and sometimes does. Jules Lemaître has given an almost canonical statement of the impressionistic point of view. He said: "Criticism, whatever be its pretensions, can never go beyond defining the impression which, at a given moment, is made on us by a work of art wherein the artist has himself recorded the impression which he received from the world at a certain hour."

The statement includes an implication which, when it is made explicit, goes far beyond the intention of the impressionist theory. To *define* an impression signifies a good deal more than just to utter it. Impressions, total qualitative unanalyzed effects that things and events make upon us, are the antecedents and beginnings of all judgments.* The beginning of a new idea, terminating perhaps in an elaborate judgment following upon extensive inquiry, is an impression, even in the case of a scientific man or philosopher. But to define an impression is to analyze it, and analysis can proceed only by going beyond the impression, by referring it to the grounds on which it rests and the consequences which it entails. And this procedure is judgment. Even if the one who communicates his impression confines his exposition of it, his demarcation and delimitation, to grounds that lie in his own temperament and personal history, taking the reader frankly into his confidence, he still goes beyond the bare impression to something objective to it. Thus he gives the reader ground for an "impression" on his own part that is more objectively grounded than any impression can be

*See *ante*, p. 191.

that is founded on a mere "it seems to me." For the experienced reader is then given the means of discriminating among different impressions of different persons on the basis of the bias and experience of the person who has them.

The reference to objective grounds having begun with statement of personal history cannot stop there. The biography of the one who defines his impression is not located inside his own body and mind. It is what it is because of interactions with the world outside, a world which in some of its aspects and phases is common with that of others. If the critic is wise, he judges the impression that occurs at a certain hour of his own history by considering the objective causes that have entered into that history. Unless he does so, at least implicitly, the discriminating reader has to perform the task for him—unless he surrenders himself blindly to the "authority" of the impression itself. In the latter case, there is no difference among impressions; the insight of a cultivated mind and the gush of the immature enthusiast stand on the same level.

The sentence quoted from Lemaître has another significant implication. It sets forth a proportion that is objective: as his subject-matter is to the artist, so is the work of art to the critic. If the artist is numb and if he does not impregnate some immediate impression with meanings derived from a prior rich funded experience, his product is meager and its form is mechanical. The case is not otherwise with a critic. There is an illicit suggestion contained in the reference to the impression of the artist as occurring at a "certain hour" and that of the critic as taking place "at a given moment." The suggestion is that because the impression exists at a particular moment, its import is limited to that brief space of time. The implication is the fundamental fallacy of impressionist criticism. Every experience, even that containing a conclusion due to long processes of inquiry and reflection, exists at a "given moment." To infer from this fact that its import and validity are affairs of that passing moment is to reduce all experience to a shifting kaleidoscope of meaningless incidents.

Moreover, the comparison of the attitude of a critic toward a work of art to that of the artist toward his subject-matter is so just

as to be fatal to the impressionist theory. For the impression the artist has does not consist of impressions; it consists of objective material rendered by means of imaginative vision. The subject-matter is charged with meanings that issue from intercourse with a common world. The artist in the freest expression of his own responses is under weighty objective compulsions. The trouble with very much criticism, aside from the impressionist label, is that the critic does *not* take an attitude toward the work criticized that an artist takes toward the "impressions he has received from the world." The critic can go off into irrelevancies and arbitrary dicta much more readily than the artist, while failure to be controlled by subject-matter is much more evident to eye and ear than is a corresponding failure on the part of the critic. The tendency of the critic to dwell in a world apart is great enough in any case without being sanctioned by a special theory.

Were it not for the blunders made by the judicial critic, blunders that proceed from the theory he holds, the reaction of the impressionist theory would hardly have been called forth. Because the former set up false notions of objective values and objective standards, it was made easy for the impressionist critic to deny there are objective values at all. Because the former has virtually adopted a conception of standards that is of an external nature, derived from use of standards developed for practical ends, and legally defined, the latter has assumed there are no criteria of any sort. In its precise signification, a "standard" is unambiguous. It is a quantitative measure. The yard as a standard of length, the gallon as a standard of liquid capacity, are as precise as legal definitions can make them. The standard of liquid measure for Great Britain was defined, for example, by an act of Parliament in 1825. It is a container holding ten pounds avoirdupois of distilled water, weighed in air with the barometer at thirty inches and the Fahrenheit thermometer at sixty-two degrees.

There are three characteristics of a standard. It is a particular physical thing existing under specified physical conditions; it is *not* a value. The yard is a yardstick, and the meter is a bar deposited in Paris. In the second place, standards are measures of definite things, of lengths, weights, capacities. The things mea-

sured are not values, although it is of great social value to be able to measure them, since the properties of things in the way of size, volume, weight, are important for commercial exchange. Finally, as standards of measure, standards define things with respect to *quantity*. To be able to measure quantities is a great aid to further judgments, but it is not itself a mode of judgment. The standard, being an external and public thing, is applied *physically*. The yardstick is physically laid down upon the things measured to determine their length.

When, therefore, the word "standard" is used with respect to judgment of works of art, nothing but confusion results, unless the radical difference in the meaning now given standard from that of standards of measurement is noted. The critic is really judging, not measuring physical fact. He is concerned with something individual, not comparative—as is all measurement. His subject-matter is qualitative, not quantitative. There is no external and public thing, defined by law to be the same for all transactions, that can be physically applied. The child who can use a yardstick can measure as well as the most experienced and mature person, if he can handle the stick, since measuring is not judgment but is a physical operation performed for the sake of determining value in exchange or in behalf of some further physical operation—as a carpenter measures the boards with which he builds. The same cannot be said of judgment of the value of an idea or the value of a work of art.

Because of failure of critics to realize the difference between the meaning of standard as applied in measurement and as used in judgment or criticism, Mr. Grudin can say of a critic who is a believer in a fixed standard with respect to works of art: "His procedure has been that of an excursion for words and notions to support his claims, wherever he could find them; and he has had to trust to the meanings he could read into already available odds and ends belonging to various fields and gathered into a makeshift critical doctrine." And this, he adds with not too great severity, is the usual procedure followed by literary critics.

Yet it does not follow because of absence of a uniform and publicly determined external object, that objective criticism of art

is impossible. What follows is that criticism is judgment; that like every judgment it involves a venture, a hypothetical element; that it is directed to qualities which are nevertheless qualities of an *object;* and that it is concerned with an individual object, not with making comparisons by means of an external preëstablished rule between different things. The critic, because of the element of venture, reveals himself in his criticisms. He wanders into another field and confuses values when he departs from the object he is judging. Nowhere are comparisons so odious as in fine art.

Appreciation is said to occur with respect to values, and criticism is currently supposed to be a process of valuation. There is, of course, truth in the conception. But it is fraught, in current interpretation, with a host of equivocations. After all, one is concerned with the values of a poem, a stage-play, a painting. One is aware of them as qualities-in-qualitative-relations. One does not at the time categorize them *as* values. One may pronounce a play fine or "rotten." If one term such direct characterization valuing, then criticism is *not* valuing. It is a very different sort of thing than a direct ejaculation. Criticism is a search for the properties of the object that may justify the direct reaction. And yet, if the search is sincere and informed, it is not, when it is undertaken, concerned with values but with the objective properties of the object under consideration—if a painting, with its colors, lights, placings, volumes, in their relations to one another. It is a survey. The critic may or may not at the end pronounce definitely upon the total "value" of the object. If he does, his pronouncement will be more intelligent than it would otherwise have been, because his perceptive appreciation is now more instructed. But when he does sum up his judgment of the object, he will, if he is wary, do so in a way that is a summary of the outcome of his objective examination. He will realize that his assertion of "good" or "bad" in this and that degree is something the goodness or badness of which is itself to be tested by other persons in their direct perceptual commerce with the object. His criticism issues as a social document and can be checked by others to whom the same objective material is available. Hence the critic, if he is wise, even in making pronouncements of good and bad, of great and small in value, will lay more

emphasis upon the objective traits that sustain his judgment than upon values in the sense of excellent and poor. Then his surveys may be of assistance in the direct experience of others, as a survey of a country is of help to the one who travels through it, while dicta about worth operate to limit personal experience.

If there are no standards for works of art and hence none for criticism (in the sense in which there are standards of measurement), there are nevertheless criteria in judgment, so that criticism does not fall in the field of mere impressionism. The discussion of form in relation to matter, of the meaning of medium in art, of the nature of the expressive object, has been an attempt on the part of the writer to discover some of these criteria. But such criteria are not rules or prescriptions. They are the result of an endeavor to find out what a work of art is as an experience: the kind of experience which constitutes it. As far as the conclusions are valid, they are of use as instrumentalities of personal experience, not as dictations of what the attitude of anyone should be. Stating what a work of art is as an experience, may render particular experiences of particular works of art more pertinent to the object experienced, more aware of its own content and intent. This is all any criterion can do; and if and as far as the conclusions are invalid, better criteria are to be set forth by an improved examination of the nature of works of art in general as a mode of human experience.

Criticism is judgment. The material out of which judgment grows is the work, the object, but it is this object as it enters into the experience of the critic by interaction with his own sensitivity and his knowledge and funded store from past experiences. As to their content, therefore, judgments will vary with the concrete material that evokes them and that must sustain them if criticism is pertinent and valid. Nevertheless, judgments have a common form because they all have certain functions to perform. These functions are discrimination and unification. Judgment has to evoke a clearer consciousness of constituent parts and to discover how consistently these parts are related to form a whole. Theory gives the

names of analysis and synthesis to the execution of these functions.

They cannot be separated from each other, because analysis is disclosure of part as parts of a whole; of details and particulars as belonging to a total situation, a universe of discourse. This operation is the opposite of picking to pieces or dissection, even when something of the latter sort is required in order to make judgment possible. No rules can be laid for the performance of so delicate an act as determination of the significant parts of a whole, and of their respective places and weights in the whole. This is the reason, perhaps, why scholarly dissertations upon literature are so often merely scholastic enumerations of minutiæa, and so-called criticisms of paintings are of the order of analyses of handwriting by experts.

Analytic judgment is a test of the mind of the critic, since mind, as organization into perceptions of meanings derived from past intercourse with objects, is the organ of discrimination. Hence the safeguard of the critic is a consuming informed interest. I say "consuming" because without natural sensitivity connected with an intense liking for certain subject-matters, a critic, having even a wide range of learning, will be so cold that there is no chance of his penetrating the heart of a work of art. He will remain on the outside. Yet, unless affection is informed with the insight that is the product of a rich and full experience, judgment will be one-sided or not rise above the level of gushy sentimentalism. Learning must be the fuel of warmth of interest. For the critic in the field of art, this informed interest signifies acquaintance with the tradition of his particular art; an acquaintance that is more than knowledge about them since it is derived from personal intimacy with the objects that have formed the tradition. In this sense acquaintance with masterpieces, and with less than masterpieces, is a "touchstone," of sensitiveness, though not a dictator of appraisals. For masterpieces themselves can be critically appreciated only as they are placed in the tradition to which they belong.

There is no art in which there is only a single tradition. The critic who is not intimately aware of a variety of traditions is of necessity limited and his criticisms will be one-sided to the point of distortion. The criticisms of post-impressionistic painting that

were cited came from persons who thought they were expert be-
cause of exclusive initiation into a single tradition. In the plastic
arts, there is the tradition of Negro, of Persian, of Egyptian, of
Chinese and Japanese art, as well as the Florentine and Venetian
traditions—to mention a few outstanding ones. It is because of lack
of sense for the variety of traditions that unstable swings of fash-
ion mark the attitude of different periods toward works of art—
the overestimation of Raphael and the Roman school, for example,
at the expense of Tintoretto and El Greco once current. Much of
the unending and sterile controversy of critics adhering exclusively
to "classicism" and "romanticism" has a like source. In the field of
art, there are many mansions; artists have built them.

Through knowledge of a variety of conditions, the critic be-
comes aware of the vast variety of materials that are usable (since
they have been used) in art. He is saved from the snap judgment
that this or that work is esthetically wrong because it has matter to
which he is not accustomed, and when he comes across a work
whose matter has no discoverable precedent he will be wary of ut-
tering an offhand condemnation. Since form is always integral
with matter, he will also, if his own experience is genuinely es-
thetic, appreciate the multitude of special forms that exist and be
safeguarded against identifying form with some technique that he
has come to prefer. In short, not only will his general background
be broadened, but he will become familiar, to the point of satura-
tion, with a more fundamental matter, the conditions under which
the subject-matter of varied modes of experience move to fulfill-
ment. And this movement constitutes the objective and publicly
accessible content of all works of art.

This knowledge of many traditions is no foe to discrimina-
tion. While I have spoken for the most part of the condemnations
passed by judicial criticisms, it would be easily possible to quote
as great egregious blunders in misplaced laudations. Absence of
sympathetic acquaintance with a number of traditions leads the
critic to a ready appreciation of academic works of art provided
they are done with excellent technical facility. Seventeenth century
Italian painting was met with an acclaim that it was far from de-
serving simply because it pushed to an extreme, with technical

skill, factors that earlier Italian art had held within bounds. Knowledge of a wide range of traditions is a condition of exact and severe discrimination. For only by means of such a knowledge can the critic detect the intent of an artist and the adequacy of his execution of intent. The history of criticism is filled with charges of carelessness and willfulness that would never have been brought if an adequate knowledge of traditions had been present, just as it is filled with praise for works that have no merit beyond a skillful use of materials.

In most cases, the discrimination of a critic has to be assisted by a knowledge of the development of an artist, as that is manifested in the succession of his works. Only rarely can an artist be criticized by a single specimen of his activity. The inability is not merely because Homer sometimes nods, but because understanding of the logic of the development of an artist is necessary to discrimination of his intent in any single work. Possession of this understanding broadens and refines the background without which judgment is blind and arbitrary. The words of Cezanne about the relation of exemplars of tradition to the artist are applicable to the critic. "Study of the Venetians, especially of Tintoretto, sets one upon a constant search for means of expression which will surely lead one to experience from nature one's own means of expression. . . . The Louvre is a good book to consult, but it is only an intermediary. The diversity of the scene of nature is the real prodigious study to be undertaken. . . . The Louvre is a book where we learn to read. But we should not be content to keep the formulæa of our illustrious predecessors. Let us leave them so as to study beautiful nature and search to express it according to our personal temperament. Time and reflection gradually modify vision, and at last comprehension comes." Change the terms that need to be changed, and the procedure of the critic stands forth.

Critic and artist alike have their predilections. There are aspects of nature and life that are hard and others that are soft; that are austere even bleak, and that have attractive charm; that are exciting and that are pacifying, and so on almost without end. Most "schools" of art exhibit a tendency in one direction or another.

Then some original mode of vision seizes upon the tendency and carries it to its limit. There is, for example, the contrast between the "abstract" and the "concrete"—that is, the more familiar. Some artists work for extreme simplification, feeling that internal complexity leads to a superfluity that distracts attention; others take as their problem the multiplication of internal specifications to the utmost point consistent with organization.* There is again the difference between the frank and open approach and the indirect and allusive approach to vague matter that goes by the name of symbolism. There are artists who tend toward what Thomas Mann calls the dark and death and others who rejoice in light and air.

It goes without saying that every direction has difficulties and dangers that increase as it approaches its limit. The symbolic may lose itself in unintelligibility and the direct method in the banal. The "concrete" method ends in mere illustration and the "abstract" in scientific exercise, and so on. But yet each is justified when form and matter achieve equilibrium. The danger is that the critic, guided by personal predilection or more often by partisan conventionalism, will take some one procedure as his criterion of judgment and condemn all deviations from it as departures from art itself. He then misses the point of all art, the unity of form and matter, and misses it because he lacks adequate sympathy, in his natural and acquired one-sidedness, with the immense variety of interactions between the live creature and his world.

There is a unifying as well as a discriminating phase of judgment—technically known as synthesis in distinction from analysis. This unifying phase, even more than the analytic, is a function of the creative response of the individual who judges. It is insight. There are no rules that can be laid down for its performance. It is at this point that criticism becomes itself an art—or else a mechanism worked by precept according to a ready-made blue print. Analysis, discrimination, must result in unification. For to be a manifestation of judgment it must distinguish particulars

*While the two examples of animal art are given primarily to indicate the nature of "essence" in art, they also exemplify these two methods.

and parts with respect to their weight and function in formation of an integral experience. Without a unifying point of view, based on the objective form of a work of art, criticism ends in enumeration of details. The critic operates after the manner of Robinson Crusoe when he sat down and made a credit and debit list of his blessings and troubles. The critic points out so many blemishes and so many merits, and strikes a balance. Since the object is an integral whole, if it is a work of art at all, such a method is as boring as it is irrelevant.

That the critic must discover some unifying strand or pattern running through all details does not signify that he must himself produce an integral whole. Sometimes critics of the better type substitute a work of art of their own for that they are professedly dealing with. The result may be art but it is not criticism. The unity the critic traces must be in the work of art as its characteristic. This statement does not signify that there is just one unifying idea or form in a work of art. There are many, in proportion to the richness of the object in question. What is meant is that the critic shall seize upon some strain or strand that is actually there, and bring it forth with such clearness that the reader has a new clue and guide in his own experience.

A painting may be brought to unity through relations of light, of planes, of color structurally employed, and a poem through predominant lyric or dramatic quality. And one and the same work of art presents different designs and different facets to different observers—as a sculptor may see different figures implicit in a block of stone. One mode of unification on the part of the critic is as legitimate as another—provided two conditions are fulfilled. One of them is that the theme and design which interest selects be really present in the work, and the other is the concrete exhibition of this supreme condition: the leading thesis must be shown to be consistently maintained throughout the parts of the work.

Goethe, for example, gave a notable manifestation of "synthetic" criticism in his account of the character of Hamlet. His conception of the essential character of Hamlet has enabled many a reader to see things in the play that otherwise would have escaped attention. It has served as a thread, or better as a centraliz-

ing force. Yet his conception is not the only way in which the elements of the play may be brought to a focus. Those who saw Edwin Booth's portrayal of the character may well have carried away the idea that the key to Hamlet as a human being is found in the lines spoken to Guildenstern after the latter had failed to play on a reed. "Why, look you now, how unworthy a thing you make of me! You would play upon me; would seem to know my stops; you would pluck out the heart of my mystery; you would sound me from my lowest note to the top of my compass; and there is much music, excellent voice, in this little organ; yet cannot you make it speak. 'S blood, do you think I am easier to be played upon than a pipe?"

It is customary to treat judgment and fallacies in intimate connection with each other. The two great fallacies of esthetic criticism are reduction, and confusion of categories. The reductive fallacy results from oversimplification. It exists when some constituent of the work of art is isolated and then the whole is reduced to terms of this single isolated element. Generalized examples of this fallacy have been considered in previous chapters: for example, in the isolation of a sense-quality, like color or tone, from relations; isolation of the purely formal element; or again when a work of art is reduced to the exclusive representative values. The same principle applies when technique is taken apart from its connection with form. A more specific example is found in criticism made from a historical, political or economic point of view. There can be no doubt that the cultural milieu is inside as well as outside works of art. It enters as a genuine constituent, and acknowledgment of it is one element in a just discrimination. The sumptuousness of Venetian aristocracy and commercial wealth is a genuine constituent of the painting of Titian. But the fallacy of reducing his pictures to economic documents, as I once heard done by a "proletarian" guide in the Hermitage in Leningrad, is too evident to need mention were it not that it is a gross case of what often happens in modes so subtle as not to be readily perceptible. On the other hand, the religious simplicity and austerity of French twelfth cen-

tury statues and paintings, which come into them from their cultural milieu, is held up, apart from the strictly plastic qualities of the objects in question, as their essential esthetic quality.

A more extreme form of the reductive fallacy exists when works of art are "explained" or "interpreted" on the basis of factors that are incidentally inside them. Much of so-called psychoanalytic "criticism" is of this nature. Factors that may—or may not—have played a part in the causative generation of a work of art are treated as if they "explained" the esthetic content of the work of art itself. Yet the latter is just what it is whether a father or mother fixation, or a special regard for the susceptibilities of a wife, entered into its production. If the factors spoken of are real and not speculative, they are relevant to biography, but they are wholly impertinent as to the character of the work itself. If the latter has defects, they are blemishes to be detected in the construction of the object itself. If an Œdipus complex is part of the work of art, it can be discovered on its own account. But psychoanalytic criticism is not the only kind that falls into this fallacy. It flourishes wherever some alleged occasion in the life of the artist, some biographical incident, is taken as if it were a kind of substitute for appreciation of the poem that resulted.*

The other chief mode in which this type of the reductive fallacy prevails is in so-called sociological criticism. Hawthorne's *Seven Gables*, Thoreau's *Walden*, Emerson's *Essays*, Mark Twain's *Huckleberry Finn* have an undoubted relation to the respective milieus in which they were produced. Historical and cultural information may throw light on the causes of their production. But when all is said and done, each one is just what it is artistically, and its esthetic merits and demerits are within the work. Knowledge of social conditions of production is, when it is really knowledge, of genuine value. But it is no substitute for understanding of the object in its own qualities and relations. Migraine, eyestrain,

*Martin Schuetze, in his *Academic Illusions*, gives pertinent detailed examples of this kind of fallacy and shows them to be the stock-in-trade of entire schools of esthetic interpretation.

indigestion may have played a part in the production of some works of literature; they may even account, from a causal point of view, for some of the qualities of the literature produced. But knowledge of them is an addition to medical lore of cause and effect, not to judgment of what was produced, even though the knowledge induce towards the author a moral charity we might not otherwise share.

We are thus brought to the other great fallacy of esthetic judgment which indeed is mixed with the reductive fallacy: the confusion of categories. The historian, the physiologist, the biographer, the psychologist, all have their own problems and their own leading conceptions that control the inquiries they undertake. Works of art provide them with relevant data in the pursuit of their special investigations. The historian of Greek life cannot construct his report of Greek life except by taking into account the monuments of Greek art; they are at least as relevant and as precious for his purpose as the political institutions of Athens and Sparta. The philosophic interpretations of the arts provided by Plato and Aristotle are indispensable documents for the historian of the intellectual life of Athens. But historic judgment is not esthetic judgment. There are categories—that is, controlling conceptions of inquiry—appropriate to history, and only confusion results when they are used to control inquiry into art which also has its own ideas.

What is true of historical approach is true of the other modes of treatment. There are mathematical aspects of sculpture and painting as well as of architecture. Jay Hambidge has produced a treatise on the mathematics of Greek vases. An ingenious work has been produced on the mathematically formal elements of poetry. The biographer of Goethe or Melville would be derelict if he did not use their literary products when he is constructing a picture of their lives. The personal processes involved in construction of works of art are as precious data for the study of certain mental processes as records of procedures used by scientific inquirers are significant in the study of intellectual operations.

The phrase "confusion of categories" has an intellectualistic

sound. Its practical counterpart is confusion of values.* Critics as well as theorists are given to the attempt to translate the distinctively esthetic over into terms of some other kind of experience. The commonest form of this fallacy is to assume that the artist begins with material that has already a recognized status, moral, philosophic, historical or whatever, and then renders it more palatable by emotional seasoning and imaginative dressing. The work of art is treated as if it were a reëditing of values already current in other fields of experience.

There can be no doubt, for example, that religious values have exercised an almost incomparable influence upon art. For a long period in European history, Hebrew and Christian legends formed the staple material of all the arts. But this fact of itself tells us nothing about distinctively esthetic values. Byzantine, Russian, Gothic and early Italian paintings are all equally "religious." But esthetically each has its own qualities. Doubtless the different forms are connected with difference of religious thought and practice. But esthetically the influence of the mosaic form is a more pertinent consideration. The question involved is the difference between material and matter so often referred to in previous discussions. The medium and effect are the important matters. For this reason, later works of art that have no religious content have a profoundly religious effect. I imagine the majestic art of "Paradise Lost" will be more, not less, admitted, and the poem be more widely read, when rejection of its themes of Protestant theology has passed into indifference and forgetfulness. And this opinion does not imply that form is independent of matter. It implies that *artistic* substance is not identical with theme—any more than the form of the "Ancient Mariner" is identical with the story that is its theme. The *mis-en-scène* of Milton's portrayal of the dramatic action of great forces need not be esthetically troublesome, any more than is that of the *Iliad*, to the modern reader. There is a profound distinction between the vehicle of a work of

*There is a significant chapter with this title in Buermeyer's *The Æsthetic Experience*.

art, the intellectual carrier through which an artist receives his subject-matter and transmits it to his immediate audience, and both the form and matter of this work.

The direct influence of scientific upon artistic values is much less than that of religion. It would be a brave critic who would assert that the artistic qualities of either Dante's or Milton's works are affected by acceptance of a cosmogony that no longer has scientific standing. As to the future, I think Wordsworth spoke truly when he said: ". . . if the labours of Men of science should ever create any material revolution, direct or indirect, in our condition and in the impressions which we habitually receive, the Poet will sleep then no more than at present . . . he will be at his side, carrying sensation into the midst of the objects of science itself. The remotest discoveries of the Chemist, the Botanist, or Mineralogist, will be as proper objects of the Poet's art as any upon which it can be employed if the time should ever come when these things shall be familiar to us, and the relations under which they are contemplated by the followers of these respective sciences shall be manifestly and palpably material to us as enjoying and suffering beings." But poetry will not on that account be a popularization of science, nor will its characteristic values be those of science.

There are critics who confuse esthetic values with philosophic values, especially with those laid down by philosophic moralists. T. S. Eliot, for example, says that "the truest philosophy is the best material for the greatest poet," and implies that what the poet does is to make philosophic content more viable by addition of sensuous and emotional qualities. Just what the "truest philosophy" is, is a matter of some dispute. But critics of this school do not lack definite, not to say dogmatic, convictions on this point. Without any particular special competency in philosophic thought, they are ready to pronounce *ex cathedra* judgments, because they are committed to some conception of the relation of man to the universe that flourished in some past epoch. They regard its restoration as essential to the redemption of society from its present evil state. Fundamentally, their criticisms are moral recipes. Since great poets have had different philosophies, acceptance of their point of view entails that if we approve the philoso-

phy of Dante we must condemn the poetry of Milton, and if we accept that of Lucretius we must find the poetry of both the others woefully defective. And where, upon the basis of any of these philosophies, does Goethe come in? And yet these are our great "philosophic" poets.

Ultimately all confusion of values proceeds from the same source:—neglect of the intrinsic significance of the medium. The use of a particular medium, a special language having its own characteristics, is the source of every art, philosophic, scientific, technological and esthetic. The arts of science, of politics, of history, and of painting and poetry all have finally the same *material;* that which is constituted by the interaction of the live creature with his surroundings. They differ in the media by which they convey and express this material, not in the material itself. Each one transforms some phase of the raw material of experience into new objects according to the purpose, each purpose demands a particular medium for its execution. Science uses the medium that is adapted to the purpose of control and prediction, of increase of power; it is an art.* Under particular conditions, its matter may also be esthetic. The purpose of esthetic art being the enhancement of direct experience itself, it uses the medium fit for the accomplishment of that end. The necessary equipment of the critic is, first, to have the experience and then to elicit its constituent in terms of the medium used. Failure in either of these respects results inevitably in confusion of values. To treat poetry as having a philosophy, even a "true" philosophy, for its especial material is like supposing that literature has grammar for its material.

An artist may, of course, *have* a philosophy and that philosophy may influence his artistic work. Because of the medium of words, which are already the product of social art and are already pregnant with moral meanings, the artist in literature is more often influenced by a philosophy than are artists who work with a plastic medium. Mr. Santayana is a poet who is also a philosopher and a critic. Moreover, he has stated the criterion which he employs in criticism, and the criterion is just the thing most critics do

*This point I have emphasized in the *Quest for Certainty*, Chapter IV.

not state and apparently are not even aware of. Of Shakespeare he says, "... the cosmos eludes him; he does not seem to feel the need of framing that idea. He depicts human life in all its richness and variety, but leaves that life without a setting and consequently without a meaning." Since the various scenes and characters presented by Shakespeare have each its own setting, the passage evidently implies lack of a particular setting, namely of a total cosmic setting. That this absence is what is implied is not left a matter of conjecture; it is definitely stated. "There is no *fixed* conception of any forces, natural or moral, *dominating and transcending* our mortal energies." The complaint is of lack of "totality"; fullness is not wholeness. "What is required for *theoretic wholeness* is not this or that *system but some system.*"

In contrast with Shakespeare, Homer and Dante had a faith that "had enveloped the world of experience in a world of imagination in which *the ideals of the reason,* of the fancy and the heart had a natural expression." (None of the italics are in the original text.) His philosophic point of view, perhaps, is best summed up in a sentence occurring in a criticism of Browning: "The value of experience is not in experience but in the ideals which it reveals." And of Browning it is said that his "method is to penetrate by sympathy rather than to portray by intelligence"—a sentence one might suppose to be an admirable description of a dramatic poet rather than the adverse criticism it is intended to be.

There are philosophies and philosophies as well as criticisms and criticisms. There are points of view from which Shakespeare had a philosophy, and had a philosophy that is more pertinent to the work of an artist than one which conceives the ideal of philosophy to be the enclosure of experience within and domination of its varied fullness by a transcendent ideal that only reason beyond experience can conceive. There is a philosophy which holds that nature and life offer in their plenitude many meanings and are capable through imagination of many renderings. In spite of the scope and dignity of the great historic philosophic systems, an artist may be instinctively repelled by the constraint imposed by acceptance of any system. If the important thing is "not this or

that system but some system," why not accept, with Shakespeare, the free and varied system of nature itself as that works and moves in experience in many and diverse organizations of value? As compared with the movement and change of nature, the form that "reason" is said to prescribe may be that of a particular tradition which is a premature and one-sided synthesis in terms of a single and narrow aspect of experience. Art that is faithful to the many potentialities of organization, centering about a variety of interests and purposes, that nature offers—as was that of Shakespeare— may have not only a fullness but a wholeness and sanity absent from a philosophy of enclosure, transcendence, and fixity. The question for the critic is the adequacy of form to matter, and not that of the presence or absence of any particular form. The value of experience is not only in the ideals it reveals, but in its power to disclose many ideals, a power more germinal and more significant than any revealed ideal, since it includes them in its stride, shatters and remakes them. One may even reverse the statement and say the value of ideals lies in the experiences to which they lead.

There is one problem that artist, philosopher, and critic alike must face: the relation between permanence and change. The bias of philosophy in its more orthodox phase throughout the ages has been toward the unchanging, and that bias has affected the more serious critics—perhaps it is this bias which generates the judicial critic. It is overlooked that in art—and in nature as far as we can judge it through the medium of art—permanence is a function, a consequence, of changes in the relations they sustain to one another, not an antecedent principle. There is to be found in Browning's essay on Shelley what seems to me to come as near as criticism can come, to a just statement of the relations between the unified and "total"; between the varied and moving, the "individual," and the "universal," so that I shall quote it at length. "If the subjective might seem to be the ultimate requirement of every age, the objective in its strictest sense must still retain its original value. For it is with this world, as starting point and basis alike, that we shall always have to concern ourselves; the world is not to be

learned and thrown aside, but reverted to and relearned. The spiritual comprehension may be infinitely subtilized but its raw material must remain.

"There is a time when the general eye has, so to speak, absorbed its full of the phenomena around it, whether spiritual or material, and desires rather to learn the exacter significance of what it possesses than to receive any augmentation of what it possesses. Then is the opportunity for the poet of loftier vision to lift his fellows, with their half-apprehensions, up to his own sphere, by intensifying the import of details and rounding out the universal meaning. The influence of such an achievement will not soon die out. A tribe of successors (Homerides) working more or less in the same spirit dwell on his discoveries and reenforce his doctrine till, at unawares, the world is found to be subsisting wholly on the shadow of a reality, on sentiments diluted from passions, on the tradition of a fact, the convention of a moral, the straw of last year's harvest. Then is the imperative call for the appearance of another sort of poet, who shall at once replace this intellectual rumination of food swallowed long ago by a supply of fresh and living swathe; getting at new substance by breaking up the assumed wholes into parts of independent and unclassed value, careless of the unknown laws for recombining them (it will be the business of yet another poet to suggest these hereafter), prodigal of objects for men's outer and not inner sight, shaping for their uses a new and different creation from the last, which it displaces by the right of life over death—to endure till, in the inevitable process, its very sufficiency to itself shall require, at length, an exposition of its affinity to something higher—when the positive yet conflicting facts shall again precipitate themselves under a harmonizing law. . . .

"All the bad poetry in the world (accounted poetry, that is by its affinities) will be found to result from some one of the infinite degrees of discrepancies between the attributes of the poet's soul, occasioning a want of correspondency between his work and the varieties of nature—issuing in poetry, false under whatever form, which shows a thing not as it is to mankind generally, nor as it is to the particular describer, but as it is supposed to be for some un-

real neutral mood, midway between both and of value to neither, and living its brief minute simply through the indolence of whoever accepts it in his inability to denounce a cheat."

Nature and life manifest not flux but continuity, and continuity involves forces and structures that endure through change; at least when they change, they do so more slowly than do surface incidents, and thus are, relatively, constant. But change is inevitable even though it be not for the better. It must be reckoned with. Moreover, changes are not all gradual; they culminate in sudden mutations, in transformations that at the time seem revolutionary, although in a later perspective they take their place in a logical development. All of these things hold of art. The critic, who is not as sensitive to signs of change as to the recurrent and enduring, uses the criterion of tradition without understanding its nature and appeals to the past for patterns and models without being aware that every past was once the imminent future of its past and is now the past, not absolutely, but of the change which constitutes the present.

Every critic, like every artist, has a bias, a predilection, that is bound up with the very existence of individuality. It is his task to convert it into an organ of sensitive perception and of intelligent insight, and to do so without surrendering the instinctive preference from which are derived direction and sincerity. But when his especial and selective mode of response is allowed to harden in a fixed mold, he becomes incapacitated for judging even the things to which his bias draws him. For they must be seen in the perspective of a world so multiform and so full that it contains an infinite variety of other qualities that attract and of other ways of response. Even the bewildering aspects of the world in which we live are material for art when they find the form through which they are actually expressed. A philosophy of experience that is keenly sensitive to the unnumbered interactions that are the material of experience is the philosophy from which a critic may most safely and surely draw his inspiration. How otherwise can a critic be animated by that sensitiveness to the varied movements toward completion in different total experiences that will enable him to direct the perceptions of others to a fuller and more ordered appreciation of the objective content of works of art?

For critical judgment not only grows out of the critic's experience of objective matter, and not only depends upon that for validity, but has for its office the deepening of just such experience in others. Scientific judgments not only end in increased control but for those who understand they add enlarged meanings to the things perceived and dealt with in daily contact with the world. The function of criticism is the reëducation of perception of works of art; it is an auxiliary in the process, a difficult process, of learning to see and hear. The conception that its business is to appraise, to judge in the legal and moral sense, arrests the perception of those who are influenced by the criticism that assumes this task. The moral office of criticism is performed indirectly. The individual who has an enlarged and quickened experience is one who should make for himself his own appraisal. The way to help him is through the expansion of his own experience by the work of art to which criticism is subsidiary. The moral function of art itself is to remove prejudice, do away with the scales that keep the eye from seeing, tear away the veils due to wont and custom, perfect the power to perceive. The critic's office is to further this work, performed by the object of art. Obtrusion of his own approvals and condemnations, appraisals and ratings, is sign of failure to apprehend and perform the function of becoming a factor in the development of sincere personal experience. We lay hold of the full import of a work of art only as we go through in our own vital processes the processes the artist went through in producing the work. It is the critic's privilege to share in the promotion of this active process. His condemnation is that he so often arrests it.

ART is a quality that permeates an experience; it is not, save by a figure of speech, the experience itself. Esthetic experience is always more than esthetic. In it a body of matters and meanings, not in themselves esthetic, *become* esthetic as they enter into an ordered rhythmic movement toward consummation. The material itself is widely human. So we return to the theme of the first chapter. The material of esthetic experience in being human—human in connection with the nature of which it is a part—is social. Esthetic experience is a manifestation, a record and celebration of the life of a civilization, a means of promoting its development, and is also the ultimate judgment upon the quality of a civilization. For while it is produced and is enjoyed by individuals, those individuals are what they are in the content of their experience because of the cultures in which they participate.

The Magna Carta is held up as the great political stabilizer of

Anglo-Saxon civilization. Even so, it has operated in the meaning
given it in imagination rather than by its literal contents. There are
transient and there are enduring elements in a civilization. The en-
during forces are not separate; they are functions of a multitude of
passing incidents as the latter are organized into the meanings that
form minds. Art is the great force in effecting this consolidation.
The individuals who have minds pass away one by one. The works
in which meanings have received objective expression endure.
They become part of the environment, and interaction with this
phase of the environment is the axis of continuity in the life of civ-
ilization. The ordinances of religion and the power of law are effi-
cacious as they are clothed with a pomp, a dignity and majesty
that are the work of imagination. If social customs are more than
uniform external modes of action, it is because they are saturated
with story and transmitted meaning. Every art in some manner is a
medium of this transmission while its products are no inconsider-
able part of the saturating matter

"The glory that was Greece and the grandeur that was Rome"
for most of us, probably for all but the historical student, sum up
those civilizations; glory and grandeur are esthetic. For all but the
antiquarian, ancient Egypt is its monuments, temples and litera-
ture. Continuity of culture in passage from one civilization to an-
other as well as within the culture, is conditioned by art more than
by any other one thing. Troy lives for us only in poetry and in the
objects of art that have been recovered from its ruins. Minoan civ-
ilization is today its products of art. Pagan gods and pagan rites
are past and gone and yet endure in the incense, lights, robes, and
holidays of the present. If letters devised for the purpose, presum-
ably, of facilitating commercial transactions, had not developed
into literature, they would still be technical equipments, and we
ourselves might live amid hardly a higher culture than that of our
savage ancestors. Apart from rite and ceremony, from pantomime
and dance and the drama that developed from them, from dance,
song and accompanying instrumental music, from the utensils and
articles of daily living that were formed on patterns and stamped
with insignia of community life that were akin to those manifested

in the other arts, the incidents of the far past would now be sunk in oblivion.

It is out of the question to do more than suggest in bare outline the function of the arts in older civilizations. But the arts by which primitive folk commemorated and transmitted their customs and institutions, arts that were communal, are the sources out of which all fine arts have developed. The patterns that were characteristic of weapons, rugs and blankets, baskets and jars were marks of tribal union. Today the anthropologist relies upon the pattern carved on a club, or painted on a bowl to determine its origin. Rite and ceremony as well as legend bound the living and the dead in a common partnership. They were esthetic but they were more than esthetic. The rites of mourning expressed more than grief; the war and harvest dance were more than a gathering of energy for tasks to be performed; magic was more than a way of commanding forces of nature to do the bidding of man; feasts were more than a satisfaction of hunger. Each of these communal modes of activity united the practical, the social, and the educative in an integrated whole having esthetic form. They introduced social values into experience in the way that was most impressive. They connected things that were overtly important and overtly done with the substantial life of the community. Art was *in* them, for these activities conformed to the needs and conditions of the most intense, most readily grasped and longest remembered experience. But they were more than just art, although the esthetic strand was ubiquitous.

In Athens, which we regard as the home par excellence of epic and lyric poetry, of the arts of drama, architecture and sculpture, the idea of art for art's sake would not, as I have already remarked, have been understood. Plato's harshness toward Homer and Hesiod seems strained. But they were the moral teachers of the people. His attacks upon the poets are like those which some critics of the present day bring against portions of Christian scriptures because of evil moral influence attributed to them. Plato's demand of censorship of poetry and music is a tribute to the social and even political influence exercised by those arts. Drama was en-

acted on holy-days; attendance was of the nature of an act of civic worship. Architecture in all its significant forms was public, not domestic, much less devoted to industry, banking, or commerce.

The decay of art in the Alexandrian period, its degeneracy into poor imitations of archaic models, is a sign of the general loss of civic consciousness that accompanied the eclipse of city-states and the rise of a conglomerate imperialism. Theories about art and the cultivation of grammar and rhetoric took the place of creation. And theories about art gave evidence of the great social change that had taken place. Instead of connecting arts with an expression of the life of the community, the beauty of nature and of art was regarded as an echo and reminder of some supernal reality that had its being outside social life, and indeed outside the cosmos itself—the ultimate source of all subsequent theories that treat art as something imported into experience from without.

As the Church developed, the arts were again brought into connection with human life and became a bond of union among men. Through its services and sacraments, the Church revived and adapted in impressive form what was most moving in all prior rites and ceremonies.

The Church, even more than the Roman Empire, served as the focus of unity amid the disintegration that followed the fall of Rome. The historian of intellectual life will emphasize the dogmas of the Church; the historian of political institutions, the development of law and authority by means of the ecclesiastic institution. But the influence that counted in the daily life of the mass of the people and that gave them a sense of unity was constituted, it is safe to surmise, by sacraments, by song and pictures, by rite and ceremony, all having an esthetic strand, more than by any other one thing. Sculpture, painting, music, letters were found in the place where worship was performed. These objects and acts were much more than works of art to the worshipers who gathered in the temple. They were in all probability much less works of art to them than they are today to believers and unbelievers. But because of the esthetic strand, religious teachings were the more readily conveyed and their effect was the more lasting. By the art in them, they were changed from doctrines into living experiences.

That the Church was fully conscious of this extra-esthetic effect of art is evident in the care it took to regulate the arts. Thus in 787 A.D., the Second Council of Nicea officially ordained the following:

"The substance of religious scenes is not left to the initiative of artists; it derives from the principles laid down by the Catholic Church and religious tradition. . . . The art alone belongs to the painter; its organization and arrangement belongs to the clergy."*
The censorship desired by Plato held full sway.

There is a statement of Machiavelli that has always seemed to me symbolic of the spirit of the Renascence. He said that when he was through with the business of the day, he retired into his study and lost himself in absorption of the classic literature of antiquity. This statement is doubly symbolic. On the one hand, ancient culture would not be lived. It could only be studied. As Santayana has well said, Greek civilization is now an ideal to be admired, not one to be realized. On the other hand, knowledge of Greek art, especially of architecture and sculpture, revolutionized the practice of the arts, including painting. The sense of naturalistic shapes of objects and of their setting in the natural landscape was recovered; in the Roman school painting was almost an attempt to produce the feelings occasioned by sculpture, while the Florentine school developed the peculiar values inherent in line. The change affected both esthetic form and substance. The lack of perspective, the flat and profile quality of Church art, its use of gold, and a multitude of other traits were not due to mere lack of technical skill. They were organically connected with the particular interactions in human experience that were desired as the consequence of art. The secular experiences that were emerging at the time of the Renais-

*Quoted from Lippmann's *A Preface to Morals*, p. 98. The text of the chapter from which the passage is cited gives examples of the specific rules by which the painter's work was regulated. The distinction between "art" and "substance" is similar to that drawn by some adherents of a proletarian dictatorship of art between technique or craft that belongs to the artist and subject-matter dictated by the needs of the "party line" in furthering the cause. A double standard is set up. There is literature that is good or bad as mere literature, and literature that is good or bad according to its bearing upon economic and political revolution.

sance and that fed upon antique culture involved of necessity the production of effects demanding new form in art. The extension of substance from Biblical subjects and the lives of saints to portrayal of scenes of Greek mythology and then to spectacles of contemporary life that were socially impressive inevitably ensued.*

These remarks are intended merely to be a bare illustration of the fact that every culture has its own collective individuality. Like the individuality of the person from whom a work of art issues, this collective individuality leaves its indelible imprint upon the art that is produced. Such phrases as the art of the South Sea islands, of the North American Indian, of the Negro, Chinese, Cretan, Egyptian, Greek, Hellenistic, Byzantine, Moslem, Gothic, Renaissance, art have a veridical significance. The undeniable fact of the collective cultural origin and import of works illustrates the fact, previously mentioned, that art is a strain in experience rather than an entity in itself. A problem has been made out of the fact, however, by a recent school of thought. It is contended that since we cannot actually reproduce the experience of a people remote in time and foreign in culture, we cannot have a genuine appreciation of the art it produced. Even of Greek art it is asserted that the Hellenic attitude toward life and the world was so different from ours that the artistic product of Greek culture must esthetically be a sealed book to us.

In part an answer to this contention has already been given. It is doubtless true that the total experience of the Greeks in presence of, say, Greek architecture, statuary, and painting is far from being identical with ours. Features of their culture were transient; they do not now exist, and these features were embodied in their experience of their works of art. But experience is a matter of the interaction of the artistic product with the self. It is not therefore twice alike for different persons even today. It changes with the same person at different times as he brings something different to

*See *ante*, p. 141.

a work. But there is no reason why, in order to be esthetic, these experiences should be identical. So far as in each case there is an ordered movement of the matter of the experience to a fulfillment, there is a dominant esthetic quality. *Au fond*, the esthetic quality is the same for Greek, Chinese and American.

This answer does not, however, cover the whole ground. For it does not apply to the total human effect of the art of a culture. The question, while wrongly framed with respect to the distinctively esthetic, suggests the question of what the art of another people may mean for our total experience. The contention of Taine and his school that we must understand art in terms of "race, milieu and time" touches the question, but hardly more than touches it. For such understanding may be purely intellectual, and so on the level of the geographical, anthropological and historical information with which it is accompanied. It leaves open the question of the significance of foreign art for the experience characteristic of present civilization.

The nature of the problem is suggested by Mr. Hulme's theory of the basic difference between Byzantine and Moslem art on one side and Greek and Renascence art on the other. The latter, he says, is vital and naturalistic. The former is geometric. This difference he goes on to explain is not connected with differences in technical capacity. The gulf is made by a fundamental difference of attitude, of desire and purpose. We are now habituated to one mode of satisfaction and we take our own attitude of desire and purpose to be so inherent in all human nature as to give the measure of all works of art, as constituting the demand which all works of art meet and should satisfy. *We* have desires that are rooted in longing for an increase of experienced vitality through delightful intercourse with the forms and movements of "nature." Byzantine art, and some other forms of Oriental art, spring from an experience that has no delight in nature and no striving after vitality. They "express a feeling of separation in the face of outside nature." This attitude characterizes objects as unlike as the Egyptian pyramid and the Byzantine mosaic. The difference between such art and that which is characteristic of the Western world is not to be explained by interest in abstrac-

tions. It manifests the idea of separation, of disharmony, of man and nature.*

Mr. Hulme sums up by saying that "art cannot be understood by itself, but must be taken as one element in a general process of adjustment between man and the outside world." Irrespective of the truth of Mr. Hulme's explanation of the characteristic difference between much of Oriental and Occidental art (it hardly applies in any case to Chinese art), his way of stating the matter puts, to my mind, the general problem in its proper context and suggests the solution. Just because art, speaking from the standpoint of the influence of collective culture upon creation and enjoyment of works of art, is expressive of a deep-seated attitude of adjustment, of an underlying idea and ideal of generic human attitude, the art characteristic of a civilization is the means for entering sympathetically into the deepest elements in the experience of remote and foreign civilizations. By this fact is explained also the human import of their arts for ourselves. They effect a broadening and deepening of our own experience, rendering it less local and provincial as far as we grasp, by their means, the attitudes basic in other forms of experience. Unless we arrive at the attitudes expressed in the art of another civilization, its products are either of concern to the "esthete" alone, or else they do not impress us esthetically. Chinese art then seems "queer," because of its unwonted schemes of perspective; Byzantine art, stiff and awkward; Negro art, grotesque.

In the reference to Byzantine art, I put the term nature in quotation marks. I did so because the word "nature" has a special meaning in esthetic literature, indicated especially by the use of the adjective "naturalistic." But "nature" also has a meaning in which it includes the whole scheme of things—in which it has the force of the imaginative and emotional word "universe." In experience, human relations, institutions, and traditions are as much a part of the nature in which and by which we live as is the physical world. Nature in this meaning is not "outside." It is in us and we are in

*T. E. Hulme, *Speculations*, pp. 83–87, *passim*.

and of it. But there are multitudes of ways of participating in it, and these ways are characteristic not only of various experiences of the same individual, but of attitudes of aspiration, need and achievement that belong to civilizations in their collective aspect. Works of art are means by which we enter, through imagination and the emotions they evoke, into other forms of relationship and participation than our own.

The art of the late nineteenth century was characterized by "naturalism" in its restricted sense. The productions most characteristic of the early twentieth century were marked by the influence of Egyptian, Byzantine, Persian, Chinese, Japanese, and Negro art. This influence is marked in painting, sculpture, music, and literature. The effect of "primitive" and early medieval art is a part of the same general movement. The eighteenth century idealized the noble savage and the civilization of remote peoples. But aside from Chinoiseries and some phases of romantic literature, the *sense* of what is back of the arts of foreign people did not affect the actual art produced. Seen in perspective, the so-called pre-Raphaelite art of England is the most typically Victorian of all the painting of the period. But in recent decades, beginning in the nineties, the influence of the arts of distant cultures has entered intrinsically into artistic creation.

For many persons, the effect is doubtless superficial, merely providing a type of objects enjoyable in part because of their individual novelty, and in part because of an added decorative quality. But the idea that would account for the production of contemporary works by mere desire for the unusual, or eccentric or even charm is more superficial than this kind of enjoyment. The moving force is genuine participation, in some degree and phase, in the type of experience of which primitive, Oriental, and early medieval objects of art are the expression. Where the works are merely imitative of foreign works, they are transient and trivial. But at their best they bring about an organic blending of attitudes characteristic of the experience of our own age with that of remote peoples. For the new features are not mere decorative additions but enter into the *structure* of works of art and thus occasion a wider and fuller experience. Their enduring effect upon those

who perceive and enjoy will be an expansion of *their* sympathies, imagination, and sense.

This new movement in art illustrates the effect of all genuine acquaintance with art created by other peoples. We understand it in the degree in which we make it a part of our own attitudes, not just by collective information concerning the conditions under which it was produced. We accomplish this result when, to borrow a term from Bergson, we install ourselves in modes of apprehending nature that at first are strange to us. To some degree we become artists ourselves as we undertake this integration, and, by bringing it to pass, our own experience is reoriented. Barriers are dissolved, limiting prejudices melt away, when we enter into the spirit of Negro or Polynesian art. This insensible melting is far more efficacious than the change effected by reasoning, because it enters directly into attitude.

The possibility of the occurrence of genuine communication is a broad problem of which the one just dealt with is one species. It is a fact that it takes place, but the nature of community of experience is one of the most serious problems of philosophy—so serious that some thinkers deny the fact. The existence of communication is so disparate to our physical separation from one another and to the inner mental lives of individuals that it is not surprising that supernatural force has been ascribed to language and that communion has been given sacramental value.

Moreover, events that are familiar and customary are those we are least likely to reflect upon; we take them for granted. They are also, because of their closeness to us, through gesture and pantomime, the most difficult to observe. Communication through speech, oral and written, is the familiar and constant feature of social life. We tend, accordingly, to regard it as just one phenomenon among others of what we must in any case accept without question. We pass over the fact that it is the foundation and source of all activities and relations that are distinctive of internal union of human beings with one another. A vast number of our contacts with one another are external and mechanical. There is a "field" in which they take place, a field defined and perpetuated by legal and political institutions. But the consciousness of this field does

not enter our conjoint action as its integral and controlling force. Relations of nations to one another, relations of investors and laborers, of producers and consumers, are interactions that are only to a slight degree forms of communicative intercourse. There are interactions between the parties involved, but they are so external and partial that we undergo their consequences without integrating them into an experience.

We hear speech, but it is almost as if we were listening to a babel of tongues. Meaning and value do not come home to us. There is in such cases no communication and none of the result of community of experience that issues only when language in its full import breaks down physical isolation and external contact. Art is a more universal mode of language than is the speech that exists in a multitude of mutually unintelligible forms. The language of art has to be acquired. But the language of art is not affected by the accidents of history that mark off different modes of human speech. The power of music in particular to merge different individualities in a common surrender, loyalty and inspiration, a power utilized in religion and in warfare alike, testifies to the relative universality of the language of art. The differences between English, French and German speech create barriers that are submerged when art speaks.

Philosophically speaking, the problem with which we are confronted is the relation of the discrete and the continuous. Both of them are stubborn facts and yet they have to meet and blend in any human association that rises above the level of brute intercourse. In order to justify continuity, historians have often resorted to a falsely named "genetic" method, wherein there is no genuine genesis, because everything is resolved into what went before. But Egyptian civilization and art were not just a preparation for Greek, nor were Greek thought and art mere reëdited versions of the civilizations from which they so freely borrowed. Each culture has its own individuality and has a pattern that binds its parts together.

Nevertheless, when the art of another culture enters into attitudes that determine our experience genuine continuity is effected. Our own experience does not thereby lose its individuality but it takes unto itself and weds elements that expand its significance. A

community and continuity that do not exist physically are created. The attempt to establish continuity by methods which resolve one set of events and one of institutions into those which preceded it in time is doomed to defeat. Only an expansion of experience that absorbs into itself the values experienced because of life-attitudes, other than those resulting from our own human environment, dissolves the effect of discontinuity.

The problem in question is not unlike that we daily undergo in the effort to understand another person with whom we habitually associate. All friendship is a solution of the problem. Friendship and intimate affection are not the result of information about another person even though knowledge may further their formation. But it does so only as it becomes an integral part of sympathy through the imagination. It is when the desires and aims, the interests and modes of response of another become an expansion of our own being that we understand him. We learn to see with his eyes, hear with his ears, and their results give true instruction, for they are built into our own structure. I find that even the dictionary avoids defining the term "civilization." It defines civilization as the state of being civilized and "civilized" and "being in a state of civilization." However, the verb "to civilize" is defined as "to instruct in the arts of life and thus to raise in the scale of civilization." Instruction in the arts of life is something other than conveying information about them. It is a matter of communication and participation in values of life by means of the imagination, and works of art are the most intimate and energetic means of aiding individuals to share in the arts of living. Civilization is uncivil because human beings are divided into non-communicating sects, races, nations, classes and cliques.

The brief sketch of some historical phases of the connection of art with community life set forth earlier in this chapter suggests contrast with present conditions. It is hardly enough to say that the absence of obvious organic connection of the arts with other forms of culture is explained by the complexity of modern life, by its many specializations, and by the simultaneous existence of

many diverse centers of culture in different nations that exchange their products but that do not form parts of an inclusive social whole. These things are real enough, and their effect upon the status of art in relation to civilization may be readily discovered. But the significant fact is widespread disruption.

We inherit much from the cultures of the past. The influence of Greek science and philosophy, of Roman law, of religion having a Jewish source, upon our present institutions, beliefs and ways of thinking and feeling is too familiar to need more than mention. Into the operation of these factors two forces have been injected that are distinctly late in origin and that constitute the "modern" in the present epoch. These two forces are natural science and its application in industry and commerce through machinery and the use of non-human modes of energy. In consequence, the question of the place and rôle of art in contemporary civilization demands notice of its relations to science and to the social consequences of machine industry. The isolation of art that now exists is not to be viewed as an isolated phenomenon. It is one manifestation of the incoherence of our civilization produced by new forces, so new that the attitudes belonging to them and the consequences issuing from them have not been incorporated and digested into integral elements of experience.

Science has brought with it a radically novel conception of physical nature and of our relation to it. This new conception stands as yet side by side with the conception of the world and man that is a heritage from the past, especially from that Christian tradition through which the typically European social imagination has been formed. The things of the physical world and those of the moral realm have fallen apart, while the Greek tradition and that of the medieval age held them in intimate union—although a union accomplished by different means in the two periods. The opposition that now exists between the spiritual and ideal elements of our historic heritage and the structure of physical nature that is disclosed by science, is the ultimate source of the dualisms formulated by philosophy since Descartes and Locke. These formulations in turn reflect a conflict that is everywhere active in modern civilization. From one point of view the problem of recov-

ering an organic place for art in civilization is like the problem of reorganizing our heritage from the past and the insights of present knowledge into a coherent and integrated imaginative union.

The problem is so acute and so widely influential that any solution that can be proposed is an anticipation that can at best be realized only by the course of events. Scientific method as now practiced is too new to be naturalized in experience. It will be a long time before it so sinks into the subsoil of mind as to become an integral part of corporate belief and attitude. Till that happens, both method and conclusions will remain the possession of specialized experts, and will exercise their general influence only by way of external and more or less disintegrating impact upon beliefs, and by equally external practical application. But even now it is possible to exaggerate the harmful effect exercised by science upon imagination. It is true that physical science strips its objects of the qualities that give the objects and scenes of ordinary experience all their poignancy and preciousness, leaving the world, as far as scientific rendering of it is concerned, without the traits that have always constituted its immediate value. But the world of immediate experience in which art operates, remains just what it was. Nor can the fact that physical science presents us with objects that are wholly indifferent to human desire and aspiration be used to indicate that the death of poetry is imminent. Men have always been aware that there is much in the scene in which their lives are set that is hostile to human purpose. At no time would the masses of the disinherited have been surprised at the declaration that the world about them is indifferent to their hopes.

The fact that science tends to show that man is a part of nature has an effect that is favorable rather than unfavorable to art when its intrinsic significance is realized and when its meaning is no longer interpreted by contrast with beliefs that come to us from the past. For the closer man is brought to the physical world, the clearer it becomes that his impulses and ideas are enacted by nature within him. Humanity in its vital operations has always acted upon this principle. Science gives this action intellectual support. The sense of relation between nature and man in some form has always been the actuating spirit of art.

Moreover, resistance and conflict have always been factors in generating art; and they are, as we have seen, a necessary part of artistic form. Neither a world wholly obdurate and sullen in the face of man nor one so congenial to his wishes that it gratifies all desires is a world in which art can arise. The fairy tales that relate situations of this sort would cease to please if they ceased to be fairy tales. Friction is as necessary to generate esthetic energy as it is to supply the energy that drives machinery. When older beliefs have lost their grip on imagination—and their hold was always there rather than upon reason—the disclosure by science of the resistance that environment offers to man will furnish new materials for fine art. Even now we owe to science a liberation of the human spirit. It has aroused a more avid curiosity, and has greatly quickened in a few at least alertness of observation with respect to things of whose existence we were not before even aware. Scientific method tends to generate a respect for experience, and even though this new reverence is still confined to the few, it contains the promise of a new kind of experiences that will demand expression.

Who can foresee what will happen when the experimental outlook has once become thoroughly acclimatized in a common culture? The attainment of perspective with reference to the future is a most difficult task. We are given to taking features that are most prominent and most troublesome at a given time as if they were the clues to the future. So we think of the future effect of science in terms derived from the present situation in which it occupies a position of conflict and disruption with reference to great traditions of the western world, as if these terms defined its place necessarily and forever. But to judge justly, we have to see science as things will be when the experimental attitude is thoroughly naturalized. And art in particular will always be distracted or else soft and overrefined when it lacks familiar things for its material.

So far, the effect of science as far as painting, poetry, and the novel are concerned, has been to diversify their materials and forms rather than to create an organic synthesis. I doubt if there were at any time any large number of persons who "saw life steadily and saw it whole." And, at the very worst, it is something to have been freed from syntheses of the imagination that went

contrary to the grain of things. Possession of a quickened sense of the value for esthetic experience of a multitude of things formerly shut out, is some compensation amid the miscellany of present objects of art. The bathing beaches, street corners, flowers and fruits, babies and bankers of contemporary painting are after all something more than mere diffuse and disconnected objects. For they are the fruits of a new vision.*

I suppose that at all times a great deal of the "art" that has been produced has been trivial and anecdotal. The hand of time has winnowed much of this away, while in an exhibition today we are faced with it *en masse*. Nevertheless, the extension of painting and the other arts to include matter that was once regarded as either too common or too out of the way to deserve artistic recognition is a permanent gain. This extension is not directly the effect of the rise of science. But it is a product of the same conditions that led to the revolution in scientific procedure.

Such diffuseness and incoherence as exist in art today are the manifestation of the disruption of consensus of beliefs. Greater integration in the matter and form of the arts depends consequently upon a general change in culture in the direction of attitudes that are taken for granted in the basis of civilization and that form the subsoil of conscious beliefs and efforts. One thing is sure; the unity cannot be attained by preaching the need of returning to the past. Science is here, and a new integration must take account of it and include it.

The most direct and pervasive presence of science in present civilization is found in its applications in industry. Here we find a

*Mr. Lippmann has written as follows: "One goes to a museum and comes out with the feeling that one has beheld an odd assortment of nude bodies, copper kettles, oranges, tomatoes, and zinnias, babies, street corners and bathing beaches, bankers and fashionable ladies. I do not say that this person or that may not find a picture immensely significant to him. But the general impression for any one, I think, is of a chaos of anecdotes, perceptions, fantasies and little commentaries which may be all well enough in their way, but are not sustaining and could readily be dispensed with."—*A Preface to Morals*, pp. 103–104.

more serious problem regarding the relation of art to present civilization and its outlook than in the case of science itself. The divorce of useful and fine art signifies even more than does the departure of science from the traditions of the past. The difference between them was not instituted in modern times. It goes as far back as the Greeks when the useful arts were carried on by slaves and "base mechanics" and shared in the low esteem in which the latter were held. Architects, builders, sculptors, painters, musical performers were artisans. Only those who worked in the medium of words were esteemed artists, since their activities did not involve the use of hands, tools and physical materials. But mass production by mechanical means has given the old separation between the useful and fine a decidedly new turn. The split is reënforced by the greater importance that now attaches to industry and trade in the whole organization of society.

The mechanical stands at the pole opposite to that of the esthetic, and production of goods is now mechanical. The liberty of choice allowed to the craftsman who worked by hand has almost vanished with the general use of the machine. Production of objects enjoyed in direct experience by those who possess, to some extent, the capacity to produce useful commodities expressing individual values, has become a specialized matter apart from the general run of production. This fact is probably the most important factor in the status of art in present civilization.

There are, however, certain considerations that should deter one from concluding that industrial conditions render impossible an integration of art in civilization. I am not able to agree with those who think that effective and economical adaptation of the parts of an object to one another with respect to use automatically results in "beauty" or esthetic effect. Every well-constructed object and machine has form, but there is esthetic form only when the object having this external form fits into a larger experience. Interaction of the material of this experience with the utensil or machine cannot be left out of account. But adequate objective relationship of parts with respect to most efficient use at least brings about a condition that is *favorable* to esthetic enjoyment. It strips

away the adventitious and superfluous. There is something clean in the esthetic sense about a piece of machinery that has a logical structure that fits it for its work, and the polish of steel and copper that is essential to good performance is intrinsically pleasing in perception. If one compares the commercial products of the present with those of even twenty years ago, one is struck by the great gain in form and color. The change from the old wooden Pullman cars with their silly encumbering ornamentations to the steel cars of the present is typical of what I mean. The external architecture of city apartments remains box-like but internally there is hardly less than an esthetic revolution brought about by better adaptation to need.

A more important consideration is that industrial surroundings work to create that larger experience into which particular products fit in such a way that they get esthetic quality. Naturally, this remark does not refer to the destruction of the natural beauties of the landscape by ugly factories and their begrimed surroundings, nor to the city slums that have followed in the wake of machine production. I mean that the habits of the eye as a medium of perception are being slowly altered in being accustomed to the shapes that are typical of industrial products and to the objects that belong to urban as distinct from rural life. The colors and planes to which the organism habitually responds develop new material for interest. The running brook, the greensward, the forms associated with a rural environment, are losing their place as the primary material of experience. Part at least of the change of attitude of the last score of years to "modernistic" figures in painting is the result of this change. Even the objects of the natural landscape come to be "apperceived" in terms of the spatial relations characteristic of objects the design of which is due to mechanical modes of production; buildings, furnishings, wares. Into an experience saturated with these values, objects having their own internal functional adaptations will fit in a way that yields esthetic results.

But since the organism hungers naturally for satisfaction in the material of experience, and since the surroundings which man has made, under the influence of modern industry, afford less fulfill-

ment and more repulsion than at any previous time, there is only too evidently a problem that is still unsolved. The hunger of the organism for satisfaction through the eye is hardly less than its urgent impulsion for food. Indeed many a peasant has given more care to the cultivation of a flower plot than to producing vegetables for food. There must be forces at work that affect the mechanical means of production that are extraneous to the operation of machinery itself. These forces are found, of course, in the economic system of production for private gain.

The labor and employment problem of which we are so acutely aware cannot be solved by mere changes in wage, hours of work and sanitary conditions. No permanent solution is possible save in a radical social alteration, which effects the degree and kind of participation the worker has in the production and social disposition of the wares he produces. Only such a change will seriously modify the content of experience into which creation of objects made for use enters. And this modification of the nature of experience is the finally determining element in the esthetic quality of the experience of things produced. The idea that the basic problem can be solved merely by increase of hours of leisure is absurd. Such an idea merely retains the old dualistic division between labor and leisure.

The important matter is a change that will reduce the force of external pressure and will increase that of a sense of freedom and personal interest in the operations of production. Oligarchical control from the outside of the processes and the products of work is the chief force in preventing the worker from having that intimate interest in what he does and makes that is an essential prerequisite of esthetic satisfaction. There is nothing in the nature of machine production *per se* that is an insuperable obstacle in the way of workers' consciousness of the meaning of what they do and enjoyment of the satisfactions of companionship and of useful work well done. The psychological conditions resulting from private control of the labor of other men for the sake of private gain, rather than any fixed psychological or economic law, are the forces that suppress and limit esthetic quality in the experience that accompanies processes of production.

As long as art is the beauty parlor of civilization, neither art

nor civilization is secure. Why is the architecture of our large cities so unworthy of a fine civilization? It is not from lack of materials nor from lack of technical capacity. And yet it is not merely slums but the apartments of the well-to-do that are esthetically repellent, because they are so destitute of imagination. Their character is determined by an economic system in which land is used—and kept out of use—for the sake of gain, because of profit derived from rental and sale. Until land is freed from this economic burden, beautiful buildings may occasionally be erected, but there is little hope for the rise of general architectural construction worthy of a noble civilization. The restriction placed on building affects indirectly a large number of allied arts, while the social forces that affect the buildings in which we subsist and wherein we do our work operate upon all the arts.

Auguste Comte said that the great problem of our time is the organization of the proletariat into the social system. The remark is even truer now than when it was made. The task is impossible of achievement by any revolution that stops short of affecting the imagination and emotions of man. The values that lead to production and intelligent enjoyment of art have to be incorporated into the system of social relationships. It seems to me that much of the discussion of proletarian art is aside from the point because it confuses the personal and deliberate intent of an artist with the place and operation of art in society. What is true is that art itself is not secure under modern conditions until the mass of men and women who do the useful work of the world have the opportunity to be free in conducting the processes of production and are richly endowed in capacity for enjoying the fruits of collective work. That the material for art should be drawn from all sources whatever and that the products of art should be accessible to all is a demand by the side of which the personal political intent of the artist is insignificant.

The moral office and human function of art can be intelligently discussed only in the context of culture. A particular work of art may have a definite effect upon a particular person or upon a

number of persons. The social effect of the novels of Dickens or of Sinclair Lewis is far from negligible. But a less conscious and more massed constant adjustment of experience proceeds from the total environment that is created by the collective art of a time. Just as physical life cannot exist without the support of a physical environment, so moral life cannot go on without the support of a moral environment. Even technological arts, in their sum total, do something more than provide a number of separate conveniences and facilities. They shape collective occupations and thus determine direction of interest and attention, and hence affect desire and purpose.

The noblest man living in a desert absorbs something of its harshness and sterility, while the nostalgia of the mountain-bred man when cut off from his surroundings is proof how deeply environment has become part of his being. Neither the savage nor the civilized man is what he is by native constitution but by the culture in which he participates. The final measure of the quality of that culture is the arts which flourish. Compared with their influence things directly taught by word and precept are pale and ineffectual. Shelley did not exaggerate when he said that moral science only "arranges the elements that poetry has created," if we extend "poetry" to include all products of imaginative experience. The sum total of the effect of all reflective treatises on morals is insignificant in comparison with the influence of architecture, novel, drama, on life, becoming important when "intellectual" products formulate the tendencies of these arts and provide them with an intellectual base. An "inner" rational check is a sign of withdrawal from reality unless it is a reflection of substantial environing forces. The political and economic arts that may furnish security and competency are no warrants of a rich and abundant human life save as they are attended by the flourishing of the arts that determine culture.

Words furnish a record of what has happened and give direction by request and command to particular future actions. Literature conveys the meaning of the past that is significant in present experience and is prophetic of the larger movement of the future. Only imaginative vision elicits the possibilities that are interwoven

within the texture of the actual. The first stirrings of dissatisfaction and the first intimations of a better future are always found in works of art. The impregnation of the characteristically new art of a period with a sense of different values than those that prevail is the reason why the conservative finds such art to be immoral and sordid, and is the reason why he resorts to the products of the past for esthetic satisfaction. Factual science may collect statistics and make charts. But its predictions are, as has been well said, but past history reversed. Change in the climate of the imagination is the precursor of the changes that affect more than the details of life.

The theories that attribute direct moral effect and intent to art fail because they do not take account of the collective civilization that is the context in which works of art are produced and enjoyed. I would not say that they tend to treat works of art as a kind of sub-limated Æsop's fables. But they all tend to extract particular works, regarded as especially edifying, from their milieu and to think of the moral function of art in terms of a strictly personal relation between the selected works and a particular individual. Their whole conception of morals is so individualistic that they miss a sense of the *way* in which art exercises its humane function.

Matthew Arnold's dictum that "poetry is criticism of life" is a case in point. It suggests to the reader a moral intent on the part of the poet and a moral judgment on the part of the reader. It fails to see or at all events to state *how* poetry is a criticism of life; namely, not directly, but by disclosure, through imaginative vision addressed to imaginative experience (not to set judgment) of pos-sibilities that contrast with actual conditions. A sense of possibili-ties that are unrealized and that might be realized are when they are put in contrast with actual conditions, the most penetrating "criticism" of the latter that can be made. It is by a sense of possi-bilities opening before us that we become aware of constrictions that hem us in and of burdens that oppress.

Mr. Garrod, a follower of Matthew Arnold in more senses than one, has wittily said that what we resent in didactic poetry is not that it teaches, but that it does not teach, its incompetency. He

added words to the effect that poetry teaches as friends and life teach, by being, and not by express intent. He says in another place, "Poetical values are, after all, values in a human life. You cannot mark them off from other values, as though the nature of man were built in bulkheads." I do not think that what Keats has said in one of his letters can be surpassed as to the way in which poetry acts. He asks what would be the result if every man spun from his imaginative experience "an airy citadel" like the web the spider spins, "filling the air with a beautiful circuiting." For, he says, "man should not dispute or assert, but whisper results to his neighbor, and thus, by every germ of spirit sucking the sap from mold etherial, every human being might become great, and Humanity instead of being a wide heath of Furze and briars with here and there a remote Pine or Oak, would become a grand democracy of Forest Trees!"

It is by way of communication that art becomes the incomparable organ of instruction, but the way is so remote from that usually associated with the idea of education, it is a way that lifts art so far above what we are accustomed to think of as instruction, that we are repelled by any suggestion of teaching and learning in connection with art. But our revolt is in fact a reflection upon education that proceeds by methods so literal as to exclude the imagination and one not touching the desires and emotions of men. Shelley said, "The imagination is the great instrument of moral good, and poetry administers to the effect by acting upon the causes." Hence it is, he goes on to say, "a poet would do ill to embody his own conceptions of right and wrong, which are usually those of his own time and place, in his poetical creations. . . . By the assumption of this inferior office . . . he would resign participation in the cause"—the imagination. It is the lesser poets who "have frequently affected a moral aim, and the effect of their poetry is diminished in exact proportion as they compel us to advert to this purpose." But the power of imaginative projection is so great that he calls poets "the founders of civil society."

The problem of the relation of art and morals is too often treated as if the problem existed only on the side of art. It is virtually assumed that morals are satisfactory in idea if not in fact, and

that the only question is whether and in what ways art should conform to a moral system already developed. But Shelley's statement goes to the heart of the matter. Imagination is the chief instrument of the good. It is more or less a commonplace to say that a person's ideas and treatment of his fellows are dependent upon his power to put himself imaginatively in their place. But the primacy of the imagination extends far beyond the scope of direct personal relationships. Except where "ideal" is used in conventional deference or as a name for a sentimental reverie, the ideal factors in every moral outlook and human loyalty are imaginative. The historic alliance of religion and art has its roots in this common quality. Hence it is that art is more moral than moralities. For the latter either are, or tend to become, consecrations of the *status quo,* reflections of custom, reënforcements of the established order. The moral prophets of humanity have always been poets even though they spoke in free verse or by parable. Uniformly, however, their vision of possibilities has soon been converted into a proclamation of facts that already exist and hardened into semi-political institutions. Their imaginative presentation of ideals that should command thought and desire have been treated as rules of policy. Art has been the means of keeping alive the sense of purposes that outrun evidence and of meanings that transcend indurated habit.

Morals are assigned a special compartment in theory and practice because they reflect the divisions embodied in economic and political institutions. Wherever social divisions and barriers exist, practices and ideas that correspond to them fix metes and bounds, so that liberal action is placed under restraint. Creative intelligence is looked upon with distrust; the innovations that are the essence of individuality are feared, and generous impulse is put under bonds not to disturb the peace. Were art an acknowledged power in human association and not treated as the pleasuring of an idle moment or as a means of ostentatious display, and were morals understood to be identical with every aspect of value that is shared in experience, the "problem" of the relation of art and morals would not exist.

The idea and the practice of morality are saturated with con-

ceptions that stem from praise and blame, reward and punishment. Mankind is divided into sheep and goats, the vicious and virtuous, the law-abiding and criminal, the good and bad. To be beyond good and evil is an impossibility for man, and yet as long as the good signifies only that which is lauded and rewarded, and the evil that which is currently condemned or outlawed, the ideal factors of morality are always and everywhere beyond good and evil. Because art is wholly innocent of ideas derived from praise and blame, it is looked upon with the eye of suspicion by the guardians of custom, or only the art that is itself so old and "classic" as to receive conventional praise is grudgingly admitted, provided, as with, say, the case of Shakespeare, signs of regard for conventional morality can be ingeniously extracted from his work. Yet this indifference to praise and blame because of preoccupation with imaginative experience constitutes the heart of the moral potency of art. From it proceeds the liberating and uniting power of art.

Shelley said, "The great secret of morals is love, or *a going out of our nature* and the identification of ourselves with the beautiful which exists in thought, action, or person, not our own. A man to be greatly good must imagine intensely and comprehensively." What is true of the individual is true of the whole system of morals in thought and action. While perception of the union of the possible with the actual in a work of art is itself a great good, the good does not terminate with the immediate and particular occasion in which it is had. The union that is presented in perception persists in the remaking of impulsion and thought. The first intimations of wide and large redirections of desire and purpose are of necessity imaginative. Art is a mode of prediction not found in charts and statistics, and it insinuates possibilities of human relations not to be found in rule and precept, admonition and administration.

> "But art, wherein man speaks in no wise to man,
> Only to mankind—art may tell a truth
> Obliquely, do the deed shall breed the thought."

Abercrombie, L., 69, 251
"Abstract" art, 97, 326
Academic, in art, 143–4, 147–8, 280–1, 300
Adams, Henry, 31
Alexander, Samuel, 67
Appreciation, Esthetic, 55–6, 183–4, 190, 193, 207, 265–6, 320–1
Architecture, 5, 230–1, 241, 358; "Architecture and Humanism," 132; Media of, 239–40
Aristotle, 42, 100n., 195, 230, 236, 295–6, 301, 330
Arnold, Matthew, 49, 313, 360
Art, 1, 2, 3, 4–5, 6–7, 17, 25–6, 27, 30–1, 46, 47, 48, 49, 65, 70, 71, 86–7, 110–11, 115, 116, 124, 126, 128, 134, 140, 143–4, 147–8, 149, 157, 166, 168, 214, 222–3, 228–9, 230, 276–7, 282, 339, 344, 345; "artistic" and "esthetic," 48, 65–6, 123–4; and civilization, 339–63; fine, 6–7, 83–4, 84; medium through which it touches the world, 202–3; as a mode of knowledge, 299–300
Arts, 3, 5–6, 39–40, 77; The common substance of the, 194–221; Varied substance of the, 222–54, 281–2, 308–9
Associational psychology, 103–6
Attitudes and interests, 275
Austen, Jane, 178

Balance, 12–13, 267–8. See also Symmetry.
Barnes, A. C., viii, 97–8, 122, 123, 123n., 180, 209, 229

Beauty, 134–5, 167, 192, 198–9, 232, 258–9, 261, 302–3
Beethoven, 116, 216, 232
Blake, 214
Body, Cultivation of the, 236; and mind, 21–2
Booth, Edwin, 328
Bosanquet, B., 304
Botticelli, 96, 176
Boucher, 133
Bradley, A. C., 112, 114–15, 117
Breughel the elder, 196
Browning, 292–3, 335, 362
Buermeyer, L., 98n., 331n.

Capitalism and art, 7
Carlyle, T., 304
Catholic Church, The, 342–3, 343
Censorship, Plato's idea of, 6
Cézanne, 49, 96, 126, 134, 149, 195, 218, 219, 245, 270, 299, 314, 316
Challenge to Philosophy, The, 283–309
Change, Permanence and, 335–8
Chardin, 134, 196
Charm, 308. See also Decorative quality in art.
Chinese paintings, 147, 148, 217
Christian tradition, 351–2
Civilization, Art and, 339–63
Clark–Maxwell, 206
Classic, The, 1, 147–8, 150–2, 175–6, 293–4
"Classicism" and "Romanticism," 324
Classification of arts. See Temporal and Spatial; Varied Substance of the Arts.
Claude, 306
Coleridge, 3–4, 33–4, 114, 162, 196, 201–2, 223, 278–9
Color, 147, 211, 243–4
Colvin, Sir Sidney, 100, 227
Common patterns in various experiences, 14–15; Substance of the arts, 194–221
Communication, 108–9, 247, 253–4, 281–2, 298, 348–50

Compartmental conception of art, 84
Com–pression and ex–pression, 68–9, 189
Conceptions in philosophy and science, creative, 286–7
Conflict and struggle, 42–3. See also Resistance.
Consciousness, 22–3, 25–6, 55, 272, 277
Constable, 184, 280–1, 306
Consummatory Experience, 15–16, 18–19, 36–7, 42–3, 57–8, 69–70, 142–3, 144–5, 178–80, 339–40
Contemplation, 262–7
Contribution, The human, 255–82
Control, Oligarchical, of artist and critic, 357
Conventions, 158–60
Corot, 219
Courbet, 184, 305–6
Craftsmanship, 48–9, 236. See also Technique.
Creature, The Live, 2–3
Critic, The, 114–15, 117–18, 134–5, 151–2, 224–5, 234–5, 325–6, 327, 328, 336–8
Criticism, Theory of, 10–11, 151–2, 310–38; Judicial, 315–16, 317
"Critique of Judgment," Kant's, 263
Croce, 191, 301
Culture, Greek, 344, 345; Meaning of, 28

Dante, 115, 301, 332, 333
Darwin, 162
Daumier, 195
Decorative quality in art, 133–6
"Decorum" and "propriety," 206
Degas, 184, 195
Delacroix, 126, 151, 208, 294
Descartes and Locke, 351
Design, 121–2, 125–6
Dewey, J., 125, 284, 333
Diderot, 83, 195, 269
Direct esthetic experience, 232

Disassociation, in art, 260
Discrimination, 157
Doing and undergoing, 45–52, 53–8.
 See also *Interaction*.
Dürer, 301
Dutch school, 245

Eastman, Max, 140–1, 272
Egyptian art, 177, 340
Egyptian sculpture, 177
Einfuehling, 105
Elegance and form, 145–6
El Greco, 96
Eliot, George, 17*n*.
Emerson, R. W., 29, 329
Emotions, 43–5, 66–72, 79–80, 81–2,
 82–3, 122–3, 126–7, 162, 245–8
Empathy, 105–7
Energy, 50, 56–7, 161–2, 167–93
Enjoyment of works of esthetic art, 27;
 "Enjoyment of Poetry," Max
 Eastman, 140–1
Environment, 11–19, 22–3, 57–8, 60*ff.*
 See also *Interaction*.
Epstein, 177
Equilibrium, result of tension, 12–13.
 See also *Balance*.
Essence, and Art, 224–5, 232, 234–5,
 303–6
Esthetic, 2, 3, 8–9, 10, 13, 14, 17–18,
 27–8, 31, 40–4, 48, 54–5, 79–80,
 81–2, 82–3, 90–104, 119–20,
 123–4, 131, 134–5, 150–1, 151–2,
 155, 168–9, 172–3, 175–6, 179–80,
 202–3, 224–5, 226–7, 232, 255–6,
 260–1, 262–3, 265–6, 278–9,
 283–4, 305
"Etherial Things," 20*n*.
Experience, 2–3, 9, 14–15, 18–19,
 20–1, 21–5, 27–8, 28, 36–7; esthetic
 and non–esthetic, 41–2, 50–1, 56–7,
 60–1, 87–8, 101–2, 108–9, 137–8,
 142–3, 150–1, 201–2, 215, 220–1,
 224–5, 232, 239–40, 255–7, 281–2,
 283–4, 339–40
Experiment in art, 149–50, 353

Expression, 23–4, 60–84, 88–107,
 281–2; "Expression of the
 Emotions," Darwin, 162

Fallacies, of Criticism, 328–31
Feeling, 215. See also *Emotion*.
Fine and Useful Arts, 27, 120–1, 183,
 240, 270–3
Fine art, 83–4, 84
Fine arts, philosophy of, 2, 291–309,
 333–25; and religion, 5
Fixation, 42–3, 196
Flemish school, 214
Florentine School, 147, 179, 343
Form, 24, 78–9, 118–19, 120–1, 129,
 133–4, 137–8, 139–67, 209–10; of
 Gothic sculpture, 147–8; Greek
 philosophy and esthetic, 155;
 musical, 237; Natural History of,
 139–67
Fragonard, 133
French painting, Decorative in, 133
Frescoes, 231
Fry, Roger, 90, 92–3
Functionalism, in art, 119–20, 132,
 354–6

Giorgione, 232
Giotto, 95
Goethe, 292, 309, 327, 330
Gothic buidings, 231; sculpture, Form
 of, 148
Goya, 96, 132
Greece, 26, 340
Greek culture, 344, 345; games and
 gymnasia, 236; science and
 philosophy, 155, 206, 351;
 sculpture, 148–9, 177
Guardi, 134
Guercino, 148

Hambidge, Jay, 330
Hamlet, 327, 328
Happiness, 15–16
Harmony, 12–13, 15–16, 90–1, 166–7
Hazlitt, William, 294

Hegel, 158, 301
Hesiod, 341
Housman, 196, 224
Hudson, W. H., 28–9, 130
Hulme, T. E., 79–80, 345
Human Contribution, The, 255–82

Ibsen, 195
Ideals and material, 17, 28, 251–2, 302–3
Illusion, in art, 208–9, 286–9
Imagination, 277–81, 283–6
Imitation, 6, 295. See also *Representation.*
Immediacy, of esthetic values, 123–4, 305
Impulsion, 60–1, 265–6
Individualization, 70*ff.*, 85–6, 210–14, 288–9, 295, 300
Industrialism, an art, 7–8, 26, 236, 351, 354–8
Inertia of habit and imagination, 281–2
Ingres, 316
Inspiration, 67–9, 277–8
Instinct, 266
Instrumental, 145
Intellectual, and Esthetic, 14–15, 46–7, 56–7, 76–8, 97–8
Intelligence and Intelligibility, 22–3, 46–7, 139–40, 143–4, 178–9, 221, 299–302
Interaction, of Organism and Environment, Chs. I and II *passim,* 11–19, 22–3, 36–7, 51*ff.*, 153, 256–7, 283–4
Interest, 99, 197, 274
Intuition, 277, 306–7

James, William, 58, 75, 95, 124, 128, 175, 214–15, 218, 225
Johnson, Samuel, 83, 100
"Joie de Vivre," by Matisse, 131, 288
Judicial criticism, 315–16, 317

Kant, 130, 226, 307; "Critique of Judgment," 263

Kantian psychology, The, 265–6
Keats, 32–4, 73–4, 115, 129, 150, 214, 224, 243, 265, 268, 361
Knowledge, art as a mode of, 299–300, 301, 303

Lamb, Charles, 146, 294–5
Lancret, 133
Language, Objects of art as, 110–11, 298–9, 348–9. See also *Medium.*
Lee, Vernon, 105–6, 107
Leibniz, 212
Lemaitre, Jules, 317, 318
Leonardo, 179, 301
Line and form, 209–10
Lines carry the properties of objects, 104–5
Lippmann's "A Preface to Morals," 343, 354
Literature, the medium of, 237
Living, experience and process of, 36–7
Locke, Descartes and, 351; Hume and, 39
Louvre, 7, 314, 325
Lucretius, 301
"Lucy Gray," Wordsworth, 137

Macbeth, 203, 214
Machiavelli, 343
Make–believe Theory, 286–9
Man and nature, 282; art as distinguishing trait of, 26–7
Manet, 149, 182
Mann, Thomas, 220, 326
Mantegna, 147
Marin, John, 212
Masaccio, 95
Mass and volume, 218, 220
Material, 28, 78–9
Matisse, 86, 111, 117–18, 123, 133–4, 141, 288, 315
Matter and form, 133, 137–8
Meaning, in art, 61–2, 74, 87*ff.*, 103–4, 289–90. See also *Representation.*

"Mean proportional," The, and
 Aristotle, 42
Means and medium, 204–7
Medium and media, 65–8, 121–2,
 203–10, 234–5, 239–40, 245–6,
 249–50, 288–9, 298–300, 333
Melville, 330
Memories and art, 17n., 74–7, 93–4,
 126–7
Michael Angelo's "Moses," 243
Mill, John Stuart, 49
Milton, 82, 114, 129, 159, 301, 331–2,
 333
Mind, 21–2, 22–3, 43–4, 274–7, 284,
 284n.
Molière, 249
Monet, 314, 315
Morals, 20–1, 21–2, 26, 40–1; function
 of art, 358–63
Motor dispositions, 101–2, 106
Movement, in direct experience, 215
Murillo, 95
Murray, Gilbert, 303
Museum art, 6–8
Music, 5, 6, 77, 164, 232, 245–8, 308
Musical form, 237

Natural History of Form, 139–67
Nature, 12–13, 28, 82–3, 104–5,
 145–6, 157–9, 345–6
"Negative capability," Shakespeare a
 man of, 33–4
Newton, 310
Non–esthetic, The, 41–2, 50–1, 106–7
Notre Dame, 55
Novel, The, 164
Nude, the, and pornographic, 99, 185

Object, Artist defines by use of color,
 211; The expressive, 85–109
Objective and subjective, 88–9
Objective materials, 288–9
Objects, 104–5, 110–11, 120–1
"Ode on a Grecian Urn," Keats, 214
O'Neill, Eugene, 188
Order, akin to the esthetic, 13–14

Organism, and environment, 11–19,
 22–3, 60ff. See also Interaction.
Organization of Energies, The, 167–93

Painters, 76–7, 149, 208, 243–5, 313
Painting, 6, 77, 94–5, 133, 146–9, 164,
 217, 231, 243–5, 331
"Paradise Lost," Milton, 114
Paradox, Diderot's, 83, 269
Parkhurst, Dr. Helen, 233
Parthenon, The, 2–3, 113, 116, 231,
 236
Participation and communication, 22–3
Pater, 31–2, 238, 295
Patterns, common, in various
 experiences, 14–15
Perceptible form, 78–9
Perception, 9, 45–6, 50–1, 101, 135–6,
 142–3, 168–9, 183–4, 203, 234–5,
 266–7; and criticism, 310–38
Permanence and change, 335–8
Philosophers, and scientists, 76–7
Philosophy, 2, 10, 103–4, 124–5, 155,
 283–309, 350–1
Plato, 6, 26, 257–8, 302–3, 307, 330,
 341–2, 343
Play Theory, of art, 289–93
Plotinus, 303
Poe, Edgar Allen, 77, 201
Poetry, 33, 114–15, 224, 250–1
Poets and painters, 76–7; dramatists and
 musicians, 6
"Pointillist" technique, 126–7
Politics, Compartmenta1ization of,
 20–1; and morals, 26
Popularity and communicability, 108–9
Poussin, Nicholas, 262
Practical, the, and the Esthetic, 41–2,
 56ff., 270–3
Preface to Morals, A, Lippmann's, 343
"Prelude," Wordsworth's, 171
Product of art and work of art, 168–9,
 222–3, 228
Projection, 259–60
Proletarian Art, 311, 343n.
Prose and poetry, 250–1

Psychological aspects and elements of esthetic experience, 255–6
Psychology, The Kantian, 265–6; and theory of art, 255–82
Pure Reason operation as a demand upon Pure Will, 263

Qualitative Thought, 124n., 150–1, 198–9, 200n., 202–3, 209–10
Qualities, Sensory, 21–2, 106–7, 124ff., 129, 201–2, 223–4, 265–6, 269–70, 305

Raphael, 179
Reason, 33, 263–4. See also Intelligence and Intelligibility.
"Reason in Art," Santayana, 236
Receptivity, 54–5, 162
Recognition, 24, 54, 118–19, 270
Reconciliation, Meaning of, 193
Recurrence, Esthetic, 175ff.
Reflection, 14, 73, 118–19, 210, 305
Relations, 25–6, 105–7, 121–2, 140, 172–3
Religion and fine art, 5, 31–2; Compartmentalization of, 20–1
Religious feeling, 202–3; paintings, 331–2
Rembrandt, 96, 117, 214
Renascence, The, 147, 261, 343–4
Renoir, 99, 133, 174, 184, 314
Representation, in art, 86–7, 91ff., 116–18, 206–7, 229–32, 263–4, 295–300
Resistance, 23–4, 62, 143–4, 150–1, 153, 161, 166–7, 173–4, 186, 189, 245–6, 272–3, 279–80, 292, 293, 353
"Revelation" in art, 281
Reverie and Art, 287–8; cerebral, 229
Reynolds, Sir Joshua, 195, 296, 312–13
Rhythm, 12–13, 14–15, 142–3, 153, 156–63, 168–76, 182–3
Ribera, 148
Richards, I. A., 261

Roman School, 195, 343; and "classicism," 324; "romanticism," 294–5
Rousseau Douanier, 196, 245
Rubens, 55, 214
Rules, and subject–matter, 234–5

"St. Agnes Eve," Keats, 265
Santayana, G., 17, 146, 163, 236, 304, 333–4, 343
Sargent, 49
Schiller, 199
Schools of art, 146–7, 179, 195, 276–7, 343
Schopenhauer, 240, 248, 301, 307, 308–9
Science, 87–8, 125–6, 350–1
Scientific, the, and the esthetic, 13–14, 26–7, 34–5, 47–8, 78–9, 87–8, 98–9, 155–7, 190–1, 299–302, 331–3, 350–5
Scientists and philosophers, 76–7, 149–50
Scott, Geoffrey, "Architecture and Humanism," 132n.
Scott, Sir Walter, 178, 294
Sculpture, 147–9, 176–7, 231, 241–2
Sensations, 21–2, 255–6, 265–6. See also Qualities.
Sense, 22–3, 106–7, 119–20, 132, 137–8. See also Qualities, Sensory.
Sense–perception, 54ff., 105–7, 119–20
Serenity in art, 166–7
Shakespeare, 33–4, 129, 149, 165–6, 198, 213
Shape, and form, 106–7, 118ff.
Shaping and automatic arts, 236
Shelley, 115, 301, 361–3
Social Conditions, and Art, 20ff., 84–7, 108–9, 272–3, 339–44, 350–63
Socrates, 26
Sound, 218, 245–6
Space, 190–1, 214, 217–21. See also Temporal and Spatial.
"Speculations," Hulme, 79–80, 345
Spencer, H., 119

Spenser, 292
"Spiritual" experience, Ideal and,
 29–30
Spontaneity, in art, 72ff., 290–1
Statement, versus Expression, 88ff.
Stein, Leo, 164, 213
Subjective and objective, 88–9, 287–8
Subject–matter, 91–3, 97–8, 115–16,
 118–19, 234–5
Substance and form, 109–41
Substance of the arts, Varied, 222–54
Supernatural, 30–1
Symbols, 30, 86–7, 156–7
Symmetry and rhythm, 185–6, 190;
 Dynamic and functional, 189

Technique, "Pointillist," 126–7;
 relativity of, 146–9, 237, 317–18,
 343–4
Technological and shaping arts, 236
Temporal and Spatial, in art, 23–4,
 169–70, 181–2, 191, 214–23,
 226–30
Tennyson, 82, 201
Tension, Equilibrium result of, 12–13,
 143–4. See also Resistance.
Theory, 1, 9–11, 15–16, 105–6, 132,
 165–6, 251–2, 262–3, 290–1,
 344–6
Thinking, in Art, 39–40, 76–7, 124
Thoreau's "Walden," 329
Thorwaldsen, 148
Time, 23–4, 218. See also Rhythm.
Tintern Abbey, 89
Tintoretto, 96, 148, 324, 325

Titian, 96, 117, 133, 148, 184, 217,
 328
Tolstoi, 109, 197, 207–8
Tradition, 165–6, 276, 323–5, 351–2
Tragedy, 100
Truth and the Good, 263

Ugly, the, 99–100, 119–20, 179–80,
 212n.
Umbrian and Roman painters, 313
Undergoing, 45–6, 137–8, 161
Unity, 36–7, 166–7, 190
Utrillo, 306

Values, 321–2; transferred, 122–3,
 233
Van Eyck, 217
Van Gogh, 73, 75, 89, 314–15
Variation, 173–6, 336–7
Varied substance of the arts, 222–54;
 Substance, and form, 177–8
Variety, 23–4
Velasquez, 133
Venetian painters, 148–9; School, 147,
 196, 214
Vision, Esthetic, 260–1

"Walden," Thoreau's, 329
Watteau, 133
Whistler, 174
Winged Victory, 243
Wordsworth, 89, 116–17, 137, 157,
 159, 171, 196, 301
Work of art, 1, 9–10, 27, 86–7, 168–9,
 222–3, 227–8